DESIRE AND EXCESS

DESIRE AND EXCESS

THE NINETEENTH-CENTURY CULTURE OF ART

JONAH SIEGEL

PRINCETON UNIVERSITY PRESS

PRINCETON AND OXFORD

To Nancy Yousef

Copyright © 2000 by Princeton University Press
Published by Princeton University Press, 41 William Street Princeton, New Jersey 08540
In the United Kingdom: Princeton University Press, 3 Market Place, Woodstock,
Oxfordshire OX20 1SY

Library of Congress Cataloging-in-Publication Data

Siegel, Jonah, 1963–

Desire and excess : the nineteenth-century culture of art / Jonah Siegel.

p. cm.

Includes index.

ISBN 0-691-04913-0 (cl : alk. paper) — ISBN 0-691-04914-9 (pb : alk. paper)

1. Arts, Modern—19th century—Historiography. 2. Art and literature—History—19th
century. 3. Artists—History—19th century. I. Title.

NX454 .S54 2000

709'.03'4—dc21 00-020897

This book has been composed in Janson Typeface

The paper used in this publication meets the minimum requirements of
ANSI/NISO Z39.48-1992 (R 1997) (*Permanence of Paper*)

www.pup.princeton.edu

Printed in the United States of America

10 9 8 7 6 5 4 3 2 1

10 9 8 7 6 5 4 3 2 1
(Pbk.)

CONTENTS

LIST OF FIGURES

ACKNOWLEDGEMENTS

THIS BOOK is about the difficult relationships between past work and modern workers on the one hand and between excess and admiration on the other. Both themes come into play as I stop to thank the many who have contributed to the production of *Desire and Excess*. To begin with, I must express my gratitude to the myriad strangers whose names run through the references in this book. A project of this scope relies on the work of others to a greater degree than may be comfortable, but the amount of careful, detailed, measured, and passionate work I have found on almost every theme and topic this book touches has been a constant source of wonder to me. Coming from literary studies into a project involving not only the visual arts but the history of the arts and their institutions has only been possible because art historians have produced books and articles hospitable and even inspiring to a stranger from another discipline.

As I turn to institutions and people who have had a more direct impact on me personally, I am distressed by the near certainty of losing admiration in numbers; given the many particular and individual debts I have acquired in the production of this book over nearly a decade, it troubles me to dilute the real force of my gratitude in the sheer quantity of those I cite. To begin with institutions:

The research and production of this book were aided by grants from Rutgers University, as well as from the Robinson and Rollins funds of the Harvard English Department, and two Clark grants from Harvard University. The final stages of revision took place during a leave year at the National Humanities Center made possible by a grant from the National Endowment for the Humanities. I was fortunate to be able to revisit this material in such a congenial environment, while benefiting from the conversation and many kindnesses of a notable collection of gifted scholars.

I am grateful to Eliza Robertson and Jean Houston at the Center for their cheerful aid in tracking down obscure sources. I must also thank Karen Carroll and Brian R. MacDonald for painstaking work in editing the text, and Virginia Middlemiss in New York for creative and dedicated labor as a picture researcher. The earliest and most entertaining aid I received in this was from my friend and quondam research assistant, Scott Karambis. More recently, I have become greatly indebted to Ellen Foos and Mary Murrell at Princeton University Press for the imagination and patience they have brought to this project.

This book has been extremely lucky in the readers it has encountered

thus far, and it is with pleasure and gratitude that I acknowledge them. In the long course of writing, I benefited from the counsel of many readers of individual chapters; my thanks to Michel Chaouli, Jed Esty, Monica Feinberg, Nick Jenkins, Karl Kroeber, Michael Matin, Jesse Matz, Franco Moretti, Sophia Padnos, John Rosenberg, Elaine Scarry, Michael Seidel, Joe Viscomi, and Sherri Woolf. The close attention of friends and strangers to material often quite distant from their own interests has been nothing short of inspiring. Readers of the entire manuscript in its various stages have included James Eli Adams, Isobel Armstrong, Ian Duncan, Carol Forney, Rochelle Gurstein, Andreas Huyssen, Bob Kiely, Martin Meisel, Robert Rosenblum, Helen Vendler, and Lynn Wardley. While the creativity and generosity of these readers have aided this project immeasurably, my embarrassment at the need to commemorate so much individual care and thoughtful exchange in a set of undifferentiated lists is only compounded when I consider how far I still am from bringing this book to the level that others envisioned for it—or challenged it to reach.

Desire and Excess began as graduate work at Columbia University supervised by Steven Marcus. I am happy to have the opportunity to acknowledge my long-standing debt to his forbearance, rigor, and intellectual commitment. I am grateful, also for the astute eclecticism and playful imagination of David Damrosch and the wide ranging erudition of Richard Brilliant, the two other early supporters of the project. I can only wonder at the cheerful engagement of these individuals in an endeavor that often must have seemed at risk of exploding at the seams. Stephen Donadio will recognize the roots of this volume in work we did together long ago.

Desire and Excess gained much from the encouragement and collegiality I was fortunate to experience while at the Harvard English Department. I must acknowledge in particular the two thoughtful and responsive chairs under whom I served, Leo Damrosch and Larry Buell, as well as Isobel Armstrong, Elaine Scarry, and Helen Vendler, whose guidance and support have been unexpected, multifaceted, and invaluable. For solidarity and what was, all things considered, an unusually pleasant introduction to the life of an assistant professor I would like to thank those who preceded me and set the tone, Phil Harper, Jeff Masten, Meredith McGill, Wendy Motooka, and Lynn Wardley in particular. Outside of the department, I am extremely grateful to Sue Lonoff for inviting me to chair with her the Victorian Seminar of the Center for Literary and Cultural Studies at Harvard.

Moving from lists of names to only more inadequate collective nouns, I would like to register my gratitude to the remarkable family and friends who have been, whether near or far, a consistent source of emotional and

intellectual support during the long and eventful period in which *Desire and Excess* was conceived and written. This book is dedicated to Nancy Yousef, who is both family and friend. I write these acknowledgments on the anniversary of our marriage, counting it my special fortune to have had her as the first and last reader of this manuscript. Her sympathetic imagination and uncompromising intellect have done so much in aid of this endeavor that I can only wonder at the thought that it is not the most she has done for me.

THE APPARENT PERMANENCE OF THE MUSEUM
AS AGAINST ITS ACTUAL PERMANENCE:
THE NINETEENTH-CENTURY CULTURE OF ART

I F THE WALLS of the museums were to vanish, and with them their labels, what would happen to the works of art that the walls contain, the labels describe? Would these objects of aesthetic contemplation be liberated to a freedom they have lost, or would they become so much meaningless lumber? To pose this question in such exaggerated terms is one way to begin to consider the productive work of institutions in culture, the manner in which institutions not only contain cultural desires but shape them as well. The uncertain and contentious nature of art in contemporary culture has been made clear by any number of recent controversies. This book argues that such uncertainty, far from being a late development, has sources traceable to the very foundations of the modern system of art as it was established in an earlier era. It identifies in particular the embattled accounts of the artist that have typically been understood as resulting from the challenges of self-consciously new movements—of modernism or even postmodernism—as having sources deep in the nineteenth-century culture of art that gave rise to the modern artist in the first place.[1]

Neither a history of institutions nor an examination of literary representations of the painter, *Desire and Excess* is a study of how nineteenth-century drives toward the organization of admired objects from the past shaped nineteenth-century culture, thereby contributing to the formation of modern ideas about institutions and art. Chief among those ideas (and institutions) is that of the artist, a figure that so preoccupied the era that it was never able to arrive at a satisfactory explanation of its form. Almost every definition of the word "artist" offered by *The Oxford English Dictionary* is identified as obsolete, its obsolescence traceable to the nineteenth century in which the entry was written. Like rivulets in an inhospitable terrain, some of the meanings have simply evaporated, while others have survived only as they have blended with a more powerful stream. "One who practices or is skilled in any art," the first quite simple and broad definition given, is followed by instances almost every one of which is identified as having been lost to current usage:

"One skilled in the 'liberal' or learned arts"
"One skilled in the useful arts"

"One who follows any pursuit or employment in which skill or proficiency is attainable by study or practice; hence ... A skilled performer, a proficient, a connoisseur ... A practical man, as opposed to a theorist."

Certainly, it would be odd today to call a connoisseur an artist, or to think of an artist as a practical man. But to do so would be no odder than to understand by the word artist "A follower of a manual art; an artificer, mechanic, craftsman, artisan." This last definition is also obsolete, barring one telling exception: "One who practices a manual art in which there is much room for display of taste; one who makes his craft a 'fine art.'" The recognizable character of this final description does not make it any less strange. Has the meaning of the term been broadened or narrowed when it is understood to depend not on an activity but on the value placed on that activity? The idea that an artist is someone who does something (craft) so well that he is in fact doing something else (art)— and thereby becoming another kind of person (artist)—is not unrelated to the principal and apparently most untroubled definition offered by the dictionary: "One who cultivates one of the fine arts, in which the object is mainly to gratify the æsthetic emotions by perfection of execution, whether in creation or representation."

It is worth giving a sense of the distance the word's meaning has traveled, not simply as a reminder of the instability of the term, and of the crucial role of the period considered in this study in attempting to fix its meaning, but because the relation of excess to definition is one of the central concerns of this book. As I have attempted to suggest by recourse to a definition first published in 1885, the nineteenth century was clearest when explaining what it had determined an artist was *not*, or not any longer. After a brief turn to the performing arts, the dictionary offers its final and most familiar account of the modern meaning of the term, concluding with a definition it identifies (almost with relief it seems), as usual, current, and restricted: "Now especially: One who practices the arts of design; one who seeks to express the beautiful in visible form. In this sense sometimes taken to include sculptors, engravers, and architects; but popularly, and in the most usual current acceptation of the word, restricted to: One who cultivates the art of painting as a profession." The critic might dwell on the self-evident conceptual gaps over which the dictionary account reaches, but the student of culture may be as intrigued by the now lost material that the lexicographers remind us was once included in the meaning of the word.

The nineteenth century has been called the Age of the Museum; it is also the period which saw the rise of the concept of the artist still dominant in our own era. By discussing together literary texts, cultural docu-

ments, and works of art, *Desire and Excess* attempts to offer a dynamic account of the place of institutions and the imagination of institutions in culture.[2] I hope to demonstrate not only the fruitful results of bringing the development of institutions of art such as the academy and the museum into relation with the study of text and idea, but that doing so helps to clarify the history of that unstable figure, the modern artist.

The most successful lessons are those we forget having learned. This book attempts to remember something in this sense forgotten. In order to illustrate what is strange about museums, and what is traditional about the modern artist, I begin with two instances meant at once to evoke a now largely forgotten cultural moment and to remind the reader of the remarkably thorough cultural amnesia separating us from ideas of art and of the museum that dominated in a past that is not so very distant. A few years ago, I found myself at Chicago's noted Art Institute as it celebrated its hundredth anniversary with a commemorative exhibition featuring the most popular paintings in its collection as well as some historical documents. My companions and I paused over a number of archival photographs of the museum in its early days, struck by the number of statues evidently crowding the halls that we were now walking with ease (Fig. 1). We were only further bemused to recognize many of these works as self-evidently belonging to different institutions; it was a clear impossibility for the pieces in the museum to have been what they looked like, the *Apollo Belvedere*, the *Medici Venus*, the Elgin Marbles, and so on. The solution to the mystery was almost immediately clear, but it only raised further questions, and even a feeling not unrelated to embarrassment; the objects looming so large in the photographs were plaster reproductions of statues that had been on display in the museum soon after its founding. In a sense, these were not works of art at all but something else. Why, my friends asked, would a museum display counterfeit art, material that was not original—particularly *this* material? Did it have something to do with the museum's role as a place of instruction for artists? If so, what kind of lessons would all this smooth white plaster carry for students?

The historical importance of the cast is largely unknown to contemporary art lovers and museumgoers. Indeed, the possession of casts and other forms of reproductions seems not infrequently to result in an institutional version of the feelings my friends and I experienced in Chicago.[3] Ambivalence or worse is suggested by the disposition of these materials. The collection we saw in the photographs was dispersed in the late 1950s. The large cast collection at the Ashmolean Museum in Oxford is apparently intact, but is kept in a building separate from the main museum, an unglamorous shed generally kept locked and reached through

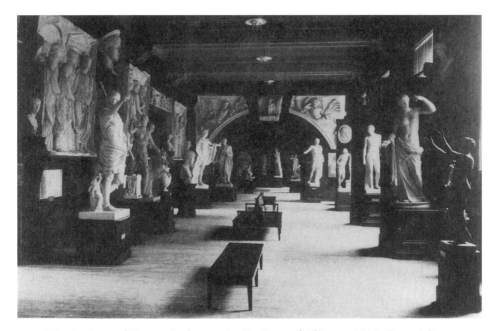

Fig. 1. Casts of Roman Sculpture, Art Institute of Chicago, 1914. *General Catalogue of Paintings, Sculpture and Other Objects in the Museum,* (1914). The *Venus de Milo* stands just in front of the *Medici Venus* at the center of the picture. The *Apollo Belvedere* stands in the middle left. The head of the *Ludovisi Juno* high up on the left wall, looks toward the *Townley Venus* on the right. The originals of the major pieces on display, themselves Hellenistic copies of earlier works, would have been identified as *Greek*, not Roman, well into the nineteenth century.

the winding and narrow back streets behind the actual imposing museum building designed in the nineteenth century—no doubt with the housing of these now-banished objects as one of its aims. The Victoria and Albert Museum keeps its reproductions of famous works alongside its exhibition of counterfeits. It is to be praised for being so open with its fascinating holdings, but the display of the work contributes to that museum's reputation as a national attic; it suggests a store of kitsch souvenirs from someone else's lifetime of trips abroad.

Like the remnants of the concrete symbols of a long-banished regime, these substantial objects have the power simultaneously to fascinate and puzzle the viewer who comes across them, suggesting the existence of once developed passions and ideas that are now irrecoverable. A common solution to the problem of the cast collection, one with an even more

thorough effect than banishing it to a seldom visited location, is to hide it in plain sight, to dispose of its elements by turning them into the source of unobtrusive decoration. Elgin Marble friezes, for example, decorate the cafeteria at the British Museum and the basement walls of the library of the design school at Harvard University; Michelangelo's *Day and Night* are discreetly placed to be seen out of the corners of the eyes as one *leaves* the Sackler Museum at the same institution. If one happens to come across a complete cast collection, the effect of so much matter, of the jumble of culture, is a kind of mystified wonder, like that felt when confronting the remnants of a World's Fair. Fascination is in part provoked by puzzlement. When objects are so massive yet so haphazardly disposed, they seem to demand an answer to the question, What is to be done with them?—even as they inescapably bring up the more fundamental question of the need for such exuberant accumulation in the first place.

On the same trip to Chicago, I found on a table at a second-hand bookstore a volume that I have beside me now as I write. Reddish-orange covers fade to sun-bleached gold at the spine of the first and only edition of C. Lewis Hind's *The Education of an Artist*, suggesting its infrequent absence from the bookshelf. Published in England in 1906–around the time in which the photographs that had drawn our attention at the museum were taken—this novel is a remarkably poor piece of writing. Nevertheless, as an object the book has a surprising appeal; it opens with special decisiveness at the heavy glossy paper on which are printed what are described on its title page as "Ninety-one full-page illustrations," good-quality black-and-white photographs showing works of art mentioned in the text: the Elgin Marbles, a detail of Botticelli's *Venus*, some Mantegnas, a Giotto, a number of works by Rembrandt and Velazquez, and more.

The novel that these images illustrate tells the story of Claude Williamson Shaw's education in art, a process that unfolds with all the undermotivated drive of a religious allegory or tale of sexual awakening. As the narrative opens, Shaw is discontented in the publishing house to which he has devoted ten years of his life. His malaise and the predisposition motivating his alienation are indicated in one memorable scene when, while on holiday in Eastbourne, he cannot help purchasing a gilded miniature cast of the *Winged Victory of Samothrace*—a work he does not know but simply recognizes as majestic. He spends long hours on the beach fantasizing about the statue (a dramatic image of the *original* in profile is provided (fig. 2). Subsequently, inspired by a fortuitous encounter with Lund, an erudite and uncompromising artist, Shaw decides to leave his unsatisfactory life at the publishing house and turn

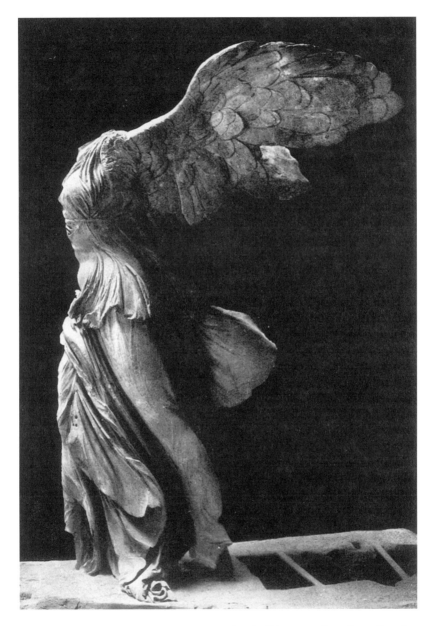

Fig. 2. The *Winged Victory*. C. Lewis Hind, *The Education of an Artist* (London: A. and C. Black, 1906).

painter. The rest of the novel traces what the novel invites us to call Shaw's aesthetic education. In the process of his travels in Europe, Shaw

instantiates the values and tastes of a moderately sophisticated art lover at the turn of the century (he learns to dislike Frith, he mistrusts Rubens, adores early Italians and Rembrandt). His passions adhere so closely to conventional preferences that there is not one moment of idiosyncratic taste in the book. Photographs, which might have been used to reproduce objects heretofore unseen by the reader, wonders evanescent or rare, are used simply to *re*-present established taste. The *Winged Victory* is located in the text with a striking nesting reiteration; its presence in the shop in a seaside town is a form of acknowledgment of its canonical status, as is its actual location at the Louvre and in this text. In such a context, Shaw's taste becomes an affirmation of acknowledged value rather than any kind of personal determination.

It is precisely in its unidiosyncratic use of the photograph that the interest *The Education of an Artist* begins, in being so thoroughly and laboriously representative. But the interest does not end there; at least two more elements are worthy of notice. To start with, we may ask whether the pedagogic premise of the novel makes sense to a contemporary reader, whether it is self-evident that the "education" of an artist should take the form of an immersion in beautiful accredited objects from the past akin to that provided for the reader in the book's reproductions.

The final element that makes the book interesting to the historian of culture is a strange twist that I have withheld from the reader, much as Hind withholds it until the very end of the work. Ultimately, Shaw does *not* become a painter. He realizes that his real talent lies in writing and by the end of the tale, his first work is about to be published, a philosophic novel with an incongruous title—given Shaw's engagement with received artistic traditions—*The Inner Memory*. Wrong turns and early misunderstanding of one's temperament and interests are stock elements in the *Bildungsroman*. Nevertheless, the true mystery of the novel is how it could possibly make sense to devote so much energy to the *visual* arts if the ultimate goal was to represent the birth of a writer. Hind, an editor and prolific reviewer and critic, was responsible for a large number of books illuminating the virtues of canonical works (*The 100 Greatest Paintings* is a typical title), and this novel, with its slight scaffolding of a plot, is certainly a part of his work as a popularizer of the fine arts. Still, I think it is worth considering whether this particular confusion of artistic aspiration and professional development is itself more than accidental. The muddled relation of the particular artistic practices—writing or painting—may be as much a sign of Hind's committed participation in the values of his day as the canon of art he celebrates. In its way *The Education of an Artist* enacts something that *Desire and Excess* seeks to illuminate: the deep presence of the fine arts in literary culture, not merely as a topic or setting, but as the element that trains the artist, and in relation to which author or painter must be understood.

It is little surprise that neither the original passion nor the training it provoked are satisfied in the outcome of the novel. Indeed, the protagonist of *The Education of an Artist*, once painter then novelist, returns in a 1911 sequel in a third guise. *The Consolations of a Critic* includes "thirty-two full-page illustrations," images from the collection that Shaw, convalescing after a long illness, consoles himself by arranging into constantly changing displays. Critic and curator, and yet still not done with his metamorphoses: at the end of *Consolations*, Shaw once again sets off for France, to apprentice himself to a painter. Painter, author, critic, and aspiring painter again: it is just this unstable, even unsatisfactory, interplay of figures whose possibility *Desire and Excess* seeks to clarify.

What was needed in culture to make possible the existence in the middle of the United States of an immense collection of casts largely of Roman copies of Greek works? What allowed their place of honor in the museum of art? What motivated the gathering of ninety-one photographs of European art in England for *The Education of an Artist*? What has been lost in cultural knowledge when we are unable to understand as more than an unlikely coincidence that, in the very year in which *The Education of an Artist* was written, the Louvre's *Winged Victory*, which has pride of place at the opening of the novel and of Shaw's desire, is also the focal point of the classical art displayed at the Chicago Art Institute, that it beckons the visitor standing in the main Hall toward the gallery of Greek art? Ultimately, the surprise or confusion I have described in relation to casts in the museum provokes questions not only about continuity in the nature of the museum but also about our *current* expectations from art collections. What we unexpectedly encountered in Chicago was evidence that the building is permanent enough to outlive its particular contents.[4] Such a possibility not only surrounds the aesthetic objects we are currently able to appreciate with a nimbus of uncertainty; it also suggests that we may be less than clear on the role and function of the accumulation of art in culture.

The fortunes of the *Winged Victory* (found in 1863) rose dramatically from the time it was moved from its undistinguished position in the museum's collection of Greek statues to the top of the Daru staircase leading to the pictorial treasures of the Louvre in 1884. More than an admired work of art, it became an emblem for the excitement and grandeur of the museum itself. It was in response to this symbolic role that the curators of the Art Institute of Chicago consistently violated the otherwise straightforwardly chronological arrangement of their collection when it came to placing the *Victory*. In the early years, it was lodged in the room devoted to "Later Greek" sculpture, rather than in the hall housing fourth- and fifth-century Greek statues, which is where its entry

Fig. 3. Classical sculpture galleries viewed from Main Entrance Hall, Art Institute of Chicago. *Twenty-Sixth Annual Report* (1905).

is to be found in the catalog but which would have stranded it around the corner and out of sight of the entering public. In this position, and at the end of a long run of rooms, it served to draw the eye of the visitor toward the promise of the museum's collection (fig. 3). In later years, in closer emulation of the Louvre, the statue was moved to a staircase overlooking the entrance and leading up to the paintings (the *Venus de Milo*, another Louvre icon, taking over its duties on the ground floor). The emblematic role and pride of place of the *Victory* would lead to another claim to fame in the first decade of the twentieth century; it is the only work mentioned by name in the course of that great *anti*museum polemic, Marinetti's 1909 futurist manifesto.[5] The appearance of the statue at the outset of *Education of an Artist*, at the inception of Shaw's passion, is an indication that his education and longing may best be understood as taking place inside the museum.

When, on a warm June day in 1904, Joyce's Leopold Bloom goes out of his way to inspect the posterior of a cast of Venus in a Dublin Museum,

it is quite likely that his studies of divine anatomy have led him to the same statue Keats vivified and placed in a poetic landscape in "I stood tip-toe upon a little hill" in 1817. Without question, it is a work Bloom might have found at major museums in Chicago, New York, Oxford, Paris, Mexico, or any number of cities at the turn of the century. The presence of the *Winged Victory* in several places at one time (in novel, poem, and manifesto as well as in museums and shops around the world) is a remarkable enough instance of reiteration. The ubiquity of the Venus evoked by Keats and Joyce a century apart is perhaps all the more striking in what it suggests about the longevity of certain works of art—or at least of copies of those works. These brief instances are evidence of a network of relationships, involving not only antiquity but its mediated presence in culture, which this book as a whole attempts to illuminate. Neither the instances themselves nor the network underlying them is liable to being understood in the aesthetic terms that have generally been available in our own day, or by reference to values generally brought to bear in the explication of the effect, function, or value of the work of art. Although issues raised by the proliferation of reproductions or by the commercialization of art have come to interest artists and critics, these issues have tended to receive attention as particularly and necesarily late developments. With a few exceptions, the values that have predominated in the twentieth century have tended to push instances such as those I have cited to the margins or even further, beyond the pale, and yet, they are part of a remarkably influential historical phenomenon: the nineteenth century culture of art.

In art history as in literary studies, relatively recent cultural developments—including not only the remarkable predominance of formalism in the twentieth century and the centrality of a heroic antiacademic, antirepresentational account of the rise of modern art, but the emphasis on what might be termed the subjectivist model of art appreciation—have contributed to the neglect of the existence of a coherent, interconnected, rich, and sophisticated nineteenth-century culture of art, one with particular significance for literary studies. Given that it is a relatively late development in art-historical circles to take seriously a good deal of the art the nineteenth century itself admired (the bringing together of impressionist *and* academic art at the founding of the Museé d'Orsay in the 1970s is a milestone in this regard), it is not surprising that literary scholars have tended to underestimate the power, persistence, and coherence of a culture of art that is so evidently important for writers from Reynolds to James, from Keats to Wilde, and beyond.[6]

No century before the nineteenth saw greater public engagement with the fine arts, in large part because the widespread acceptance of the importance of this sort of engagement and the possibility of its satisfaction

were both developments of this era (building largely on late-eighteenth-century developments).[7] If authors from early and late in the century, such as Keats and James—who lacked the personal commitment to the fine arts of artists and critics such as Blake, Hazlitt, or Ruskin—could not avoid constant recurrence, both broad and specific, to the fine arts, it is because the world in which they came to understand their own ambition and relation to culture was committedly and inescapably engaged by the experience of the visual arts. This experience, or set of experiences, was no less affecting because of the dynamic and ever changing form of its mediation: viewing prints of varying quality, sighting occasional works of art during difficult voyages abroad or to the country houses of the wealthy, visiting recently founded museums, or reading descriptions in literary or art-historical texts. The cultural activities and self-understanding of a range of classes were involved with the fine arts—making art, traveling to see it, reading about it. It is striking how quickly the aspiration toward a relationship with art is evident, for example, in the press. In 1832, the very first issue of the Society for the Diffusion of Useful Knowledge's *Penny Magazine* featured careful instructions on the etiquette working-class people should observe when visiting the British Museum—a place made available to a widening spectrum of classes as the century progressed. Taking advantage of the reduction in costs resulting from revolutionary changes in reproductive technology, periodicals throughout the century devoted important pages to the fine arts, including regular reproductions of Old Masters and contemporary painters along with instruction on their merits. In 1843, between 20,000 and 30,000 viewers daily attended the exhibition of cartoon drawings for the frescoes that were to decorate the new Houses of Parliament. In the 1860s and 1870s, attendance at the annual Summer Exhibitions of the Academy averaged around 300,000 visitors.[8] The idea of the modern artist naturally took shape in the interplay of cultural debates with those new institutional and social developments that allowed such debates to take place in the first place.

Changing taste and, even more, our fundamentally different ideas about taste itself have made it difficult to see just how much the writers discussed in this study were participating in wider cultural concerns. It is not just that more people today prefer the *Mona Lisa* to the *Last Supper*, Botticelli to Guido, the Elgin Marbles or the *Venus de Milo* to the *Laocoön* or the *Apollo Belvedere*, or, indeed, that some will prefer objects from Africa, the Far East, or elsewhere to any of these, but that we now believe we have—and in part do have—different ways of understanding the nature of individual responses to the fine arts. The sources determining taste in our own day have proved difficult to trace in large part because of the methodological challenge of engaging past aesthetic values.[9] The

instances I cite represent simple shifts in taste for which it is easy to correct; what is a challenge for the student of the nineteenth century is to recuperate something of the values, institutions, and desires behind these differences and, indeed, behind these changes.

The inescapable if surprising truth is that an individual experiencing art in the nineteenth century can be assumed to have had a clearer sense of what he or she was seeing and why it was important than the tourist or museumgoer of today, who by and large has to rely on monitoring what is understood to be an almost entirely personal response to an aesthetic object (typically based on the briefest of encounters). The emphasis on immediate personal response in modern art appreciation will often mislead the student of earlier periods. James Buzard has described the tendency for the experience of foreign culture in the nineteenth century to be "scripted," as much in the Grand Tour as in the middle-class tourist holiday that followed in its footsteps. But it is precisely for this reason that the nineteenth-century traveler stood a better chance of knowing the reasons he or she was going to a given sight, a certain museum. Although such knowledge cannot be taken to *determine* the nature of the experience of art, it is nevertheless certain that it contributed in important ways to its form.[10]

Not only was society at large more involved than ever in the fine arts, but the nineteenth century saw a number of special relationships between literature and the fine arts in particular, only a few of which are still active and therefore still clearly present to students of culture. Literature was a source for artists throughout the period. From the Greek myth and Roman history that inspired neoclassical painters to the scenes from novelists that were a mainstay of genre painters, to the illustrations of more recondite poems of the Pre-Raphaelite Brotherhood, there was a constant borrowing from literature by the plastic arts. Work from the avant-garde of the late eighteenth century to the kitsch of the early twentieth drew on implicit and explicit narrative, theatrical, and poetic reference for its effects.[11] Still, the use the visual arts made of literature in the nineteenth century is straightforward compared with the roles literature made the visual arts fill. Throughout the period discussed in this study there was a tendency for writers to help themselves liberally to the terms, images, and history of the visual arts when they wanted vivid symbols for their own practices or ambitions. The more formal and systematized nature of the career of the visual artist in the nineteenth century allowed it to be used as an animated version of the artistic career and life broadly understood. As we will see in this study, the trajectory of the analogy was not only between visual artists and writers, but between the visual *arts* and artist figures (literary or visual). Ultimately, however, all these relations pale in comparison to the rich symbiotic interplay of concrete and

ideal that literature provided to the culture of art. If the visual arts offered authors images of what they could aspire to be and what they could admire, it was only in literature that the perfection of art and its institutions could be manifested. The perfect museum, the ideal artist—there was a demand for versions of these throughout the century, a demand that could only be met by the written word.

DESIRE AND EXCESS

INTRODUCTION

THE MUSEUM AS MORTUARY

WHY SHOULD a museum provoke tears? What might it mean for an author to dream or have nightmares about institutions designed for the display of art? My aim in this book is to place the nineteenth century's aspirations toward an ordered world of art in relation to the emergence of a figure that was one of that world's most powerful but troubled elements, that of the artist. For this reason, the discussion that follows dwells on moments in which the imbrication of artistic ambition with the structures of the culture of art is most vividly manifested. The writers and visual artists discussed in this book are taking things personally, taking them to heart. When Henry Fuseli represents himself in Rome in tears at the foot of a statue at the entrance to a museum, he is participating in an overlapping set of discourses (of history, archaeology, the sublime, artistic sensibility), but he is also recording one instance of the ways in which such cultural discourses hit home. The complex nature of the interplay of self and institution needs to be recognized in order to do justice to the compelling power and the very form of overdetermined instances such as this one, or William Hazlitt's nightmares of an irrecoverable Louvre (for him a political as well as an aesthetic loss), or Keats's visions of the history of poetry while drowsing in the midst of a friend's collection of reproductions. The passionate reach of cultural institutions evidenced in these moments suggests that what is at stake in the arrangement of the past is not mere antiquarianism, the turning over and charting of mute rubble. The psychological explanation has merits not to be shunned—not merely such general, and not unlikely ideas as the presence of a human urge to create, but also a darker set of urges: to admire, to feel abject before something, to love what is gone or irrecoverable, to invent a tale of loss in order to provoke the passion of mourning.[1]

The museum has proved to be a surprisingly powerful emblem for the aspirations and fears of modernity. Nevertheless, the nineteenth-century museum can be a strange place to which to bring contemporary notions of art. In order to avoid the idea that this strangeness should be understood as the simple result of development away from a stable and straightforward earlier model, I will cite two museums of significance. One imaginary and the other concrete and still in existence, both structures capture some of the more disturbing qualities present at the very inception of the nineteenth-century culture of art.

In Dulwich, now a sleepy part of southwest London, an unusual building stands adjacent to a school. The Dulwich Picture Gallery is among England's oldest public galleries devoted to the display of paintings, and the very first built for that purpose. Hazlitt and Ruskin were two of the many art lovers whose early experiences of original works of art took place in this gallery, which housed until well into the nineteenth century England's most important readily accessible collection of paintings. Sir John Soane was responsible for its design, and after a mixed reception when it was built between 1811 and 1813 appreciation for the building has risen along with Soane's own reputation. Soane himself has received much attention in recent years. He is famed for his design of the Bank of England and noted also for the elaborate museum he made of his own home, a dazzling combination of design and compilation. The Dulwich Picture Gallery has been claimed as inspiration by any number of later architects, but there is one element it is unlikely many will emulate. The visitor enters the building at its center, and can then walk either right or left to see rows of paintings typical of eighteenth-century taste. Alternatively, without turning and after a few steps, the visitor arrives at a mausoleum which was designed from the first to be an integral part of this museum (figs. 4–5). An idiosyncratic neoclassical pastiche of Greek and Egyptian funerary design elements, the mausoleum houses the remains of the gallery's chief benefactors, the painter Sir Francis Bourgeois and his wife, who endowed the museum, and Noel Desenfans, the man who assembled the original collection. Not only does the structure form the hub of the museum, its importance is further manifested by the manner in which it dominates the building, suggesting an alternative (and grander) entrance when viewed from the outside.[2]

The intertwining of art gallery and mausoleum effected by Soane in the Dulwich gallery had an important literary antecedent. At some un-

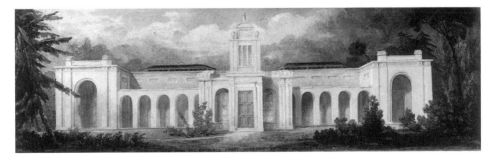

Fig. 4. J. M. Gandy, *Dulwich Picture Gallery*, circa 1823. London, Sir John Soane's Museum. This somewhat idealized picture of the rear of the gallery captures the effect of Soane's design, whereby the mausoleum, already the highest element in the building, appears to be the principal entrance to the gallery.

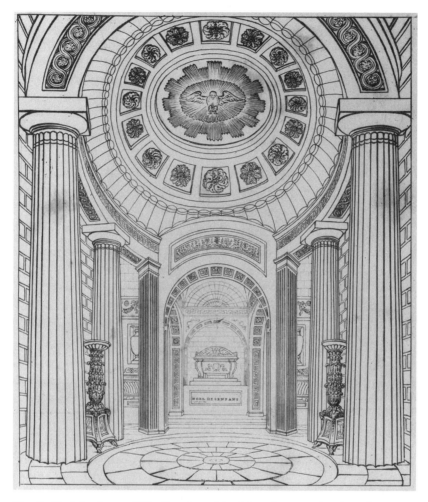

Fig. 5. Sir John Soane, "The Interior of the Mausoleum. Dulwich College." *Designs for Public and Private Buildings* (London, 1828).

specified time in the eighteenth century a strange young girl, an uncanny polyglot singer and dancer, dies of a broken heart. She is laid to rest in a sepulcher, which itself is recognizably a museum. Goethe's *Wilhelm Meister* (1795–96) closes at a redoubled museum-mausoleum. The tower at which one of the novel's many climaxes takes place houses an art collection of particular significance for Wilhelm (containing, as it does, the collection of his grandfather, which his Philistine father had sold off). But the grounds on which the tower stands also include "the Hall of the Past," a mausoleum-cum-art-gallery to which the body of Mignon, Goethe's figure for unsatisfiable artistic longing, is consigned after her

death. The "Hall of the Past" houses the sepulcher of Mignon. The description of the structure suggests a kind of symmetrical reversal of the Dulwich gallery and a sensibility closely aligned with Soane's. Wilhelm is led "through a wide corridor up to a portal guarded by two granite sphinxes. The portal itself was narrower at the top than at the bottom, after the Egyptian fashion, and its solid iron doors led one to expect a somber, perhaps gruesome interior. It was therefore a pleasant surprise to find this gloomy anticipation replaced by a world of brightness and light." Wilhelm's apprehension is replaced by an extraordinary exhilaration when he considers the gallery of images with which the mausoleum is decorated: " 'What life there is in this Hall of the Past!' he cried, 'One could just as well call it the Hall of the Present and of the Future. This is how everything was, and this is how everything will be. Nothing perishes except him who observes and enjoys.' "[3] In his pleasure, Wilhelm seems untroubled by the darker implications of what he is suggesting. In this place of death, which—like the Dulwich gallery—houses the sepulcher of its patron, it is the experience of the art on its walls, not the dead man at its center, that serves as a *memento mori*.

The notion of the museum as standing for or leading to death is often understood as a modern one—a form of rebellion against the past typically traced to Nietzsche's "Untimely Meditation" *On the Advantage and Disadvantage of History for Life* (1874). The futurists were the most open in their declarations but not the only ones to share the view: "Museums: cemeteries! . . . Museums: public dormitories where one lies forever beside hated or unknown beings. Museums; absurd abattoirs"—Marinetti's colons dispense with syntax in order to emphasize the absolute connection he is proclaiming. Adorno is more measured, but the aesthetic dislike for a simple adjective he expresses at the opening of his treatment of the topic serves a similar purpose: "The german word, '*museal*' [museumlike], has unpleasant overtones. It describes objects to which the observer no longer has a vital relationship and which are in the process of dying. . . . Museum and mausoleum are connected by more than phonetic associations. Museums are like the family sepulchers of works of art."[4]

With such powerful declarative formulations, it is little surprise that the tradition of the museum as mausoleum has had so strong a presence in the modernist sensibility that its (often contradictory) elements have seldom been subjected to scrutiny. It can seem that when one says "museum: abattoir" or "museum: sepulcher," one has said enough—that one has made clear the association of the museum and mortality. And yet, an abattoir is self-evidently very different from a sepulcher. Generally speaking, four related but distinct critiques may be intended by the museum-mausoleum analogy. One presents the museum as housing (and

therefore identifying) work that no longer has a vital (meaning living) relation to culture. By this account, the museum is a house of the dead, due whatever honor we reserve for the deceased, but not looked to for any further active role in life. In this view, the museum is not so much cause as sign of a loss. A second idea, closer to that expressed by Marinetti, sees the actual material accumulation in the museum as enacting a deadening effect on the sensibilities, a kind of undifferentiated crowding that kills the individual work by destroying the possibility of attention. This view generally represents modernity as trapped within such a museum and needing to break out of it in order to live or create. A third form, closely related to this second one, sees the problem with the museum as being that excessive admiration of past achievements will stop the production of new work, so that it is not a house of death (or sepulcher), so much as an abattoir in which later creative workers are the slaughtered sheep. Beyond these three views, which are clearly present in the works of Nietzsche, Marinetti, and Adorno, among others, there is a fourth, which sees the taint of death as spreading beyond the walls of the collection. This sensibility, perhaps best represented by Heidegger, sees the fact of the presence of an object in a museum as a sign not merely of its own demise but of the death of the world from which the object has been removed (or, as he says, "torn out"):

> The Aegina sculptures in the Munich collection, Sophocles's *Antigone* in the best critical edition, are, as the works they are, torn out of their own native sphere. However high their quality and power of impression, however good their state of preservation, however certain their interpretation, placing them in a collection has withdrawn them from their own world. But even when we make an effort to cancel or avoid such displacement of works—when, for instance, we visit the temple in Paestum at its own site or the Bamberg cathedral on its own square—the world of the work that stands there has perished.[5]

We may think we recognize what motivates the mortuary impulses of the authors I have briefly cited, but it seems to me that the one great mistake in considering these views is in seeing fatality as a simple condemnation. Three years after Heidegger first delivered his remarks on the work of art, another late modernist, W. H. Auden, presented to the world his own lethal collection:

About suffering they were never wrong,
The Old Masters: how well they understood
Its human position; how it takes place
While someone else is eating or opening a window or just walking dully
 along;
How, when the aged are reverently, passionately waiting

> For the miraculous birth, there always must be
> Children who did not specially want it to happen, skating
> On a pond at the edge of the wood:
> They never forgot
> That even the dreadful martyrdom must run its course
> Anyhow in a corner, some untidy spot
> Where the dogs go on with their doggy life and the torturer's horse
> Scratches its innocent behind on a tree.

Out of all the dreadful martyrdom's to be found in European art, it is notable that Auden selects an instance that is not so dreadful, and not really a martyrdom at all, in any of the usual senses. The poet draws our attention not to some gruesome Saint Catherine or Peter Martyr, but to a figure from an entirely different cultural register:

> In Breughel's *Icarus*, for instance: how everything turns away
> Quite leisurely from the disaster; the ploughman may
> Have heard the splash, the forsaken cry,
> But for him it was not an important failure; the sun shone
> As it had to on the white legs disappearing into the green
> Water; and the expensive delicate ship that must have seen
> Something amazing, a boy falling out of the sky,
> Had somewhere to get to and sailed calmly on.

Auden's "Musée des Beaux Arts" places us not merely in a specific location, the museum in Brussels where Breughel's canvas is to be found, but in a kind of place, one in which we find not only a dying Icarus given scant attention, but an understanding of the particular virtue of the Old Masters as residing in the fact that they instantiate a kind of *impossibility* of focused attention (it is about this that they are never wrong).[6]

Reading Auden after Marinetti, it seems only reasonable to understand the death of Icarus as not accidentally related to the inattention in which it takes place; the demise of the ambitious artificer in the museum is, after all, what Marinetti claims to fear. *Desire and Excess* does not deny the mortuary associations of the museum, but it proposes not only that these are not the discovery of a modernist sensibility at war with tradition, but that such associations cannot essentially and at all times be understood as forms of defying the value of the past. To cite one more key document of literary Modernism, it is worth noting that the defense of tradition in T. S. Eliot's 1919 "Tradition and the Individual Talent," depends on a recalibration of what may be meant by two frightening terms, not only "impersonality" but also "death." Heidegger, for one, makes it clear that admiration is not always lost by the recognition of death in the museum. Although we are likely to be repelled by the abat-

toir, we cannot deny the uncanny attractions of a sepulcher, the chilling appeal of a family crypt.[7]

Desire and Excess is intended as a contribution to the history of the concept of the artist in the nineteenth century that puts that phenomenon in relation to conceptual and institutional attempts to organize art in the period. The analysis I offer attempts to take seriously an era's response to art and the productive conflict of aspiration and experience evident in texts and institutions even when that response takes the form of troubled love and the brooding melancholy of mourning. I cited the museum-tombs that Goethe and Soane designed for their artists because they seem to me to offer compelling evidence that the museum-mausoleum tradition is not, as is sometimes assumed, a challenge to an otherwise straightforward nineteenth-century love of tradition and its institutions. When it is remembered that almost none of the museums that would take such preeminence in the nineteenth century existed when these grim temples were designed, it becomes impossible to avoid the conclusion that the fatal link they suggest is more than a twentieth-century response to a superannuated system of artistic or aesthetic values. What appears at first blush to be the rebarbative challenge of one era to another, may be nothing other than the latest movement in a complex pattern of love and fear that is precisely the inheritance of the nineteenth-century culture of art.

The museum-as-mortuary tradition has had a long life in this century, receiving its most compelling recent revival as an element in the death-of-the-author theories propounded in France in the late 1960s. In works such as "The Death of the Author" (1968) and "From Work to Text" (1971), Roland Barthes presented the demise of the creative figure as a necessary precondition for achieving a fruitful new critical autonomy; the author must die—or must be recognized as dead—in order for the reader to liberate the plenitude bound in the aesthetic object. A related but far more ambitious attempt to challenge the limitations imposed by overreliance on the academic category of "the man and his work" is to be found in the writings of Michel Foucault. In "What Is an Author?" his 1969 lecture before the Société française de Philosophie, Foucault develops the proposition that the particular structural function of an identified and admired creative figure is to *limit*. Anxiety precipitates the author—a category not limited to literature (Foucault cites "the author-function in painting, music, and other arts" (153). "The author," he writes, "is the principle of thrift in the proliferation of meaning." Anxiety as to the otherwise limitless possibilities of interpretation, Foucault postulates, leads to the creation of a figure who will serve as a relief and mark an end to otherwise boundless significance. Like his modernist

forebears, Foucault sees the figure of a creator standing against a vast world of potentially threatening experience. In a symmetrical reversal of his predecessors (which does not at all remove him from their ambit), Foucault's response to the threat is to welcome it.[8] Because he celebrates proliferation as a boon, the critic condemns any element that might try to limit its reach, particularly the author, "the ideological figure by which one marks the manner in which we fear the proliferation of meaning" (159). If Marinetti was emphatic on the risk that the artist may die in the museum, Foucault proposes that it might be just as well were he to do so.[7] Such a death might best be understood as a sacrifice for fertility; it is expected to result in the release of the cornucopian proliferation of meaning otherwise held in check by that fearful construct.

It is striking to a reader only thirty years after "What Is an Author?" was first presented that its author seems to have an inordinate faith in the unchecked benefits of freedom and excess, a remarkable contempt for thrift.[10] As I show in the body of this book, that there is no necessary absolute benefit in proliferation was a recurrent lesson in nineteenth-century culture. It is certainly the case that the figure of the artist emerges in relation to an excess of material demanding conceptual and physical organization. As Foucault anticipated, stories about authors become stories about anxious attempts to come to terms with a steadily accruing amount of information and objects. But it is an anxiety that many might be unwilling to disdain. It is worth adding that to insist on the artificiality of the "author function," as Foucault does, is to use language that appears technical in order to disguise what is a remarkable fantasy—that there could be anything like art as we know it without artists as we know them. Arguably, polemical writings on the death of the artist have done as much to mystify the relationship between creative agency and culture as have more conservative approaches, perpetuating that paradoxical nineteenth-century tradition that celebrated the artist by insisting on his demise.

This book suggests that the organization and experience of art objects need to be understood as vital elements affecting the history of letters in the nineteenth century. *Desire and Excess* is not a consecutive history, however, but a set of interconnected analyses of instances demonstrating the complex forms produced in the relations of admired objects, the institutions designed to house them, and texts and images that respond to both. These analyses demonstrate in practice an idea straightforward enough in principle: that it is not simply the case that institutional pressures constrain the form or reception of works of literary or visual art, but that cultural developments drive the production of objects, texts, *and* institutions, whose interactions in turn further affect the changing form

of culture. The argument of the book is presented in four distinct but overlapping sections, an approach that surrenders thoroughness of coverage for the goal of demonstrating continuities in material generally kept separate by field divisions and academic periodization.[11]

Nineteenth-century anxieties about the past did not emerge naturally, as it were, from a simple recognition that there was more history to account for than ever before, or that the achievement of the past was self-evidently better than the promise of the future. These anxieties were learned or acquired, and closely accompanied the development of ideas and institutions that depended on conceptually organizing the past. The first part of the book, "Art in the Museum: Artist and Fragment at the Turn of the Nineteenth Century," traces the beginning of the difficult encounter between art object and artist to the aspirations and frustrations of neoclassical art theory. The troubled relationship between art of the past and the contemporary artist in the late eighteenth and early nineteenth centuries had its source in inescapable instabilities in the institutions and art theories associated with this important movement. That a growing emphasis on originality was destined to conflict with artistic practices based on orchestrating images from a more perfect classical past is a theme that has already been well developed by critics and historians. Less known, however, though as significant, is the manner in which the broader cultural preoccupation with origins that characterized the period inspired a new interest in archaeology, which destabilized even this simple competition between ancient and modern. In analyses of texts and images by Henry Fuseli and Jacques-Louis David, I demonstrate the manner in which the material uncovered by excavation and travel revealed that the art and culture of antiquity were not what the aesthetic theorists of neoclassicism had needed them to be. The heterogeneity, triviality, and even obscenity discovered in classical works did not confirm, but rather challenged, the concepts of ideal beauty and integrated culture motivating neoclassicism. Through examination of the works of James Barry and William Blake alongside such apparently distinct cultural developments as Boydell's Shakespeare Gallery and the growing dissemination of knowledge of antique art in casts and prints, I demonstrate that among the most long-lived strategies for overcoming the inhibitions generated by the fragments of antiquity was the turn toward idealized versions of the *artist* of the past. Abasement before the past, which had been established as the appropriate position from which to create, was not abandoned, but from now on it would be a canon of artists, rather than of works, that would receive this homage.

The impact of the nineteenth-century culture of art owes a great deal to the fact that its diffusion was not limited to the writings of visual artists or art historians. Indeed, the growing fascination with the figure of

the artist was not solely or principally manifested in texts devoted to the fine arts. The rapid increase in popularity of biographies of writers was a clear sign of the growing importance of the artist. After all, it was only in the early years of the nineteenth century that the "Life" of the author emerged as a freestanding genre. Bourdieu has argued forcefully for the need to take into account more than the visual arts in developing the history of the modern artist, for the need in particular to recognize the important interplay of authors and painters in the development of nineteenth-century concepts of the artist. In England it was consistently literature that provided the models of artistic achievement, particularly in the first half of the century. Nevertheless, although *writers* were the pre-eminent figures of creative achievement in nineteenth-century Britain, the second part of the book, "The Author as Work of Art," demonstrates the reliance of influential biographies on structures and language drawn from the fine arts.[12] Authors become busts, portraits, or cathedrals, their biographies museums.

While the first and last parts of this book may be read as a continuum, focusing as they do on writings of authors evidently responding to the fine arts, I offer Part Two, on literary biography, not simply as an attempt to demonstrate the pervasiveness of themes and motifs drawn from the culture of art, but because it is in discussions of literature that claims about artistic selves are given their fullest and most complex treatment in England. The development of Keats's posthumous fame provides an exemplary case study of the interplay between literature and the culture of the fine arts, allowing for the examination of how the question of artistic accumulation and organization, which had become pressing for artists and writers at the beginning of the century, entered a wider sphere. The growing debate at midcentury on the role and function of national museums and exhibitions—provoked in part by the vertiginous and anxiety-provoking acquisition of nonclassical art by imperial Britain—is an important hidden subtext in Monckton Milnes's *Life and Letters of Keats*, a work I link to Milnes's participation in important parliamentary committees considering the intertwined questions of the significance and proper arrangement of the national art collections. As I demonstrate in Part One, however, the organization of admired objects does not necessarily result in simple satisfactions. Analysis of motifs drawn from the visual arts in Lockhart's *Life of Scott* and Hazlitt's writings on contemporary poets reveals an issue that also shapes Milnes's seminal life of Keats, the paradoxical manner in which the creative figure must be obscured and distanced in order for it to achieve the full measure of admiration it is now taken to deserve.

Although the first two parts explore the manner in which artists and authors imagined their situation in the emerging culture of art, develop-

ments in nineteenth-century culture led inexorably to the rise of a kind of writer particularly concerned with engaging the forces shaping the artist. The period required and quickly saw the development of a sophisticated, remarkably flexible yet powerful, tradition of critical writing that was devoted to understanding the encounter with art and the passions it provoked. The third part, "Absence and Excess: The Presence of the Object," considers William Hazlitt and John Ruskin not only as key critics of the nineteenth century, but as representative figures engaged in a complex often troubled relationship to the visual arts. In comparing Ruskin's seminal midcentury remarks on reproduction and exhibition to those of Hazlitt on painting and on great art collections in essays written during the first decades of the century, it becomes inescapably clear that whereas Hazlitt's relationship to art was shaped around a yearning desire for rarely accessible objects, Ruskin's develops in response to a disturbing surfeit. These critics return to the structures and institutions established in the eighteenth century and challenge not simply the virtue of objects that had been central to earlier accounts of art but the values that had supported their admiration. Forms of desire dating back to the previous century were overwhelmed by a fear of proliferation that had practical as well as conceptual sources. Not only were the museums becoming ever more crowded, but the increasing ease of travel had begun to turn Europe itself into a vast site for the experience of art. Meanwhile, the powerful historical self-consciousness that only gathered force throughout the century, inspired as much by science as philosophy, provoked a growing sense that the preoccupation with the past that had driven an earlier era was at once inescapable and redundant. Not only was the past precisely what could not be avoided, its returns were often as troubling as they were impossible to escape.

"The Deaths of the Critics," the fourth and concluding part of the book, brings its arguments into relation with one of the most self-evident of modern inheritances from the nineteenth century, the troubled primacy of the critic. "Modernity as resurrection in Pater and Wilde" analyzes the prevalence of figures of death and resurrection in the work of two of the most cosmopolitan and subversive students of the nineteenth-century culture of art. The sharp distinctions of Ruskin are as impossible for Pater as is Hazlitt's mournful nostalgia, precisely because, for the later author, the past is always impinging on the present. The longing for a lost golden age that had motivated artists throughout the century is thrown into question by Pater's historicist sensibility. The result is a new primacy for the critic, but one in which, as Wilde demonstrates, aspirations to originality are misguided, and death comes as a relief from excess.

I conclude this section and the book with a contemporary author. "*Las Meninas* as Cover" is a brief discussion intended to suggest the complex

and surprising presence of the issues raised in the book as a whole in contemporary culture. Focusing on Michel Foucault's use of Velazquez's *Las Meninas* to open his influential analysis of history, *The Order of Things*, I ask what it may mean for such a work to begin with an extended bravura treatment of one of art history's most ambitious self-portraits. To conclude with Foucault is to connect recent claims on the death of man and the nature of contemporary critical work with a tradition going back a hundred years. While Foucault offered a sophisticated return to the museum-mausoleum tradition I have briefly sketched out, he also vividly demonstrates the manner in which death and admiration are often two sides of a mirror in our own museum culture.

PART ONE

ART IN THE MUSEUM: ARTIST AND FRAGMENT
AT THE TURN OF THE NINETEENTH CENTURY

Chapter One

DAVID AND FUSELI:

THE ARTIST IN THE MUSEUM,

THE MUSEUM IN THE WORK OF ART

JACQUES LOUIS DAVID'S epochal *Oath of the Horatii* (1785) is currently at the Louvre, continuing a centuries-old institutional affiliation; Henry Fuseli's more modest drawing, *The Artist in Despair before the Magnitude of Antique Ruins* (1778–79), is to be found at the Zurich Kunsthaus. We are used to thinking about what it might mean for a work of art to be in a museum; in the late eighteenth century, it is worth reversing the question—to consider the presence of the museum in a work of art.

What is the relationship of a generation of artists to the masterworks that preceded it? A poem is written, a sculpture carved, a painting painted in one era and the work keeps or finds its power in a later period. Such, with rare exceptions, has been the best hope or promise of art—to stand outside the general decay of time, to engage the imagination of an unknown future. It is conceivable that later creative workers might look at admirable work that preceded their own with comfort, as a model of the possible longevity of their efforts; it is not self-evident that the emotional lesson of the past should be anxiety, that the backward look of admiration should result in a sense of despair at the unmatchable achievement of past artists. Nevertheless such lessons and such despair are a recurrent theme at the turn of the nineteenth century. That the imaginative relationship between contemporary artists and art of the past was a troubled one in this period has long been recognized; the anxieties of its authors and artists have been well documented and ambitiously conceptualized in the past three decades. The argument in the first part of this book follows on the work of earlier critics in literary studies and art history, but it seeks to establish the *institutional* causes of that previously rare complex that became widespread between the close of the eighteenth century and the beginning of the nineteenth, the sense that the achievements of the past presented a challenge unmatchable by the modern creative imagination.[1] This approach allows the identification of one telling paradox: belatedness was a strikingly premature development. It is a sensibility that arose not, as might be expected, in the late stages of

the life of institutions of art but was, on the contrary, connate with the establishment of the organized bodies and conceptual models that were to determine the development of art in the nineteenth century. Examination of the institutions of art at the moment of their formation quickly reveals the deep roots of the challenge of the past, its formative presence at the birth of the modern concept of the artist. I begin my discussion with neoclassicism, the movement whose recourse to antiquity allowed for the emergence of the modern figure of the artist but whose principal works of art reveal, shimmering on their surfaces, the specter of later disappointments.[2]

David: The Oaths

In a cool light, in an atrium of arched porticoes, three men in Roman tunics and armor stand in profile. Their feet are apart, their arms extended toward an older man who gestures above them with his right hand while raising three swords in his left. Behind him a group of women and children huddles together (fig. 6). Jacques Louis David's *Oath of the Horatii* was first exhibited in David's studio in Rome in 1785; it was subsequently shown at the Paris Salon of the same year, eliciting great public acclaim in both capitals. From early in its history the painting has been identified as a work that intersects with the history of Europe at the same time as it marks a turning point in the history of art. Provoking description as "the picture of our century" by one of its earliest reviewers, the painting has been recognized since its first public appearances as among the most successful productions of eighteenth-century neoclassicism.[3] To the historian of the artist it is a remarkable work for what its production says about the new power of the artist himself.

The stark tableau gives the impression of elements deployed with rare precision. The intersection of the visual arts with literature is one characteristic of neoclassical art that is immediately apparent; the scene before us is a moment from Roman history. The question of subject was integral to neoclassicism's ambitions of improving the social rank of painting; the theoretical antipathy of the movement for such popular genres as portraiture, still life, and landscape was due to the desire for a subject that would validate art as more than simply an object of popular pleasure or pleasant decor. In response, several critics were moved to offer lists of possible themes drawn from the classics and appropriate for representation—as the Comte de Caylus did in his *Tableaux tirés d'Homère et de Virgile* (1757). Even more typical subjects for neoclassical brushes than the literary moments identified by Caylus were the virtuous acts of

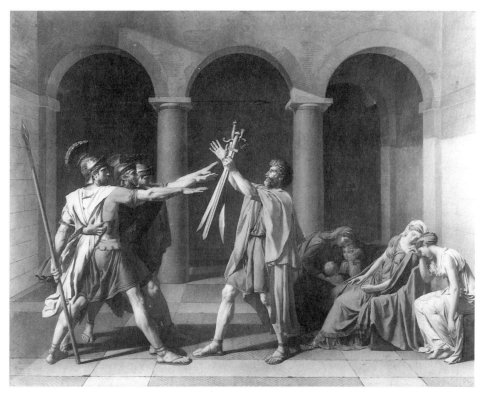

Fig. 6. Jacques-Louis David, *Oath of the Horatii*, 1785. Paris, Louvre.

heroes from antiquity: the generosity of Alexander, the continence of Scipio, the noble death of Germanicus. That being said, the tale that David dramatizes is not simply heroic, and its textual source is far from clear. Two families, the Horatii and the Curiatii have been chosen to fight the battles of their respective communities, Rome and Alba. Unfortunately, the families are related by a marriage and a betrothal. The picture captures the moment in which the three Horatii brothers swear an oath to their father that they will defend the honor of Rome. The women are shown on the side of the image, overwhelmed by the tragedy of the moment, anticipating its repercussions.

Despite the simplicity of its design, and its instantaneous and well-recognized success, the picture has proved strangely opaque to the art historian. "[T]he very function of the art historian is called into question by the genesis of this picture," writes Anita Brookner (69).[4] The problem, generally speaking, has been one of sources. Brookner's formulation acknowledges the issue and the challenge it offers to interpretation: "The

brilliant singleness of the image hides—or resolves—an unbelievable confusion of sources" (69). The moment depicted has been traced to a variety of texts; David himself cited Corneille's *Les Horaces* (1640) as his inspiration. But, as many have pointed out, the focus of Corneille's play is substantially different from that of David's painting. The playwright focuses on the disgust of one of the sisters at the death of her fiancé, her *own* murder at the hands of her brother, and their father's defense of his vengeful son when he is brought to judgment by the laws of Rome. If David did draw his inspiration from this play, he warped his source substantially in making it into that recurrent theme of history painting of the period, a heroic tale of civic duty overcoming family love. Alternatively, David may be reading far more deeply than is sometimes thought; the element of the tragedy which he illuminates in the painting is precisely the untraceable form of origins that is at stake in Corneille's drama. As is the case with the image itself, the challenge is one of sources. Alba is the original city that predated the foundation of Rome; the battle the oath anticipates will serve to reincorporate and subsume the primal matrix into the body of the new imperial city. Sabine—born in Alba but married in Rome, sister of the eldest of the Curatii and wife of the eldest of the Horatii—gives voice to the tragic situation in a figurative address to her adoptive city during an early dialogue: "Alba is thy one source. / Stop and bethink thee that with sword thou stabbest thy mother's breast."[5] The eerie counterpoint of elements on David's canvas reflects the formative struggle that is at the heart of the play, the wrenching contention between origins that cannot be abandoned and a new order aspiring to claim its own foundational power.

"I Have Abandoned the Picture I Was Doing for the King"

In considering the history of the artist, there are two aspects under which this painting falls: his power and his weakness. The vexed question of sources and their use affects both aspects. To begin with, the most re-marked upon point: the moment David depicts never occurs in any of the texts cited by the critics. Although various antecedents have been suggested for the representation of an oath in art, it is clear that this moment is one that David wanted or needed to depict. It is difficult to avoid the conclusion that at the heart of this masterpiece of eighteenth-century historical painting stands a fiction created by and originating from the artist himself.[6] David was keenly aware that the autonomous power of creation was his to claim at this stage in his career, as is evident in a letter he wrote to one of his protectors, the marquis de Bièvre, after the success of the canvas in Rome and before it came to Paris: "I have abandoned the picture I was doing for the King and have done one for myself instead.

No-one will ever make me do anything detrimental to my reputation, and it now measures thirteen by ten feet. You need not doubt my desire to please the King, as I do not know whether I shall ever paint another picture like it; moreover, when I offered it to M. Pierre I told him that I was not guided by self-interest and that I would charge as much for the thirteen feet as for the ten. He said I could not do that, that it would provoke my colleagues, I did not see the matter in this light, and only considered my own development."[7] The force of David's claim cannot be missed. He has put the king's commission aside and done a painting for himself *instead*. The subject is of his own choosing and invention, and he will not even be limited as to size (an important issue in the hierarchy of French academic painting). While the evidence for the depth of David's commitment to the ideals of the French Revolution is ultimately uncertain, I would suggest that in this letter and picture he identifies himself with a revolution in the nature of the artist—a revolution almost always implicit, and seldom as clearly visible as in this text. The point is not simply that David has placed his "own development" as an artist ahead of the (at least tacit) wishes of the king. What did it mean for an artist to make a painting *for himself*? For himself rather than for the monarch?[8] That social as well as aesthetic questions are at stake is indicated by his offer to M. Pierre: "I told him that I was not guided by self-interest and that I would charge as much for the thirteen feet as for the ten." Behind this statement moves one of the central changes underway in the social position of art and artist alike. We might compare an exchange written by Louis de Carmontelle (Louis Carrogis), a contemporary critic and David partisan, on a work shown at the same salon as the *Oath*:

> *Painter*: The artist knows his trade perfectly.
> *Narrator*: All the better if painting is a trade, then we will value the work by the yard.[9]

This passage is quoted in Thomas Crow's discussion of the failure of the clichés of historical painting in the eyes of radical critics such as de Carmontelle. What allows for the irony of the exchange, however, is the casting off not of the moribund aesthetic demands of the academy, but of the workmanlike paying by the yard of the craftsman. "*If* painting is a trade, *then* we will value the work by the yard." This is the logical proposition behind David's letter to a marquis, who would have been instantly aware of the difference between the means of paying a laboring craftsman and of rewarding a loyal intellectual vassal.[10]

The abandonment of craft associations was a vital prerequisite for the inclusion of the fine arts among the ranks of liberal accomplishments; as such it was a central, and anxiously reiterated, element of neoclassical thought. Speaking to his students at the Royal Academy in England in

1771, only fourteen years before David's own confident claim, Joshua Reynolds is stark in his presentation of the options:

> The value and rank of every art is in proportion to the mental labor employed in it, or the mental pleasure produced by it. As this principle is observed or neglected, our profession becomes either a liberal art or a mechanical trade. In the hands of one man it makes the highest pretensions, as it is addressed to the noblest faculties: in those of another it is reduced to a mere matter of ornament; and the painter has but the humble province of furnishing our apartments with elegance.[11]

For Reynolds the balance is ready to swing either way. Social considerations are an integral part of the argument in a text that has been described as "perhaps the most representative single embodiment in English of eighteenth-century aesthetic principles."[12] The president of the academy insists that it is each artist's responsibility to make sure that his profession is not returned to the baroque boudoir to make a living among the carpenters and furniture makers. To understand the depth and nature of Reynolds's anxieties, compare an anecdote involving the painter which Boswell transcribed into the *Life of Johnson*, and which is nearly contemporary with the Carmontelle dialogue:

> The then Duchess of Argyle and another Lady of high rank came in. Johnson thinking that the Miss Cotterells were too much engrossed by them, and that he and his friend were neglected, as low company of whom they were somewhat ashamed, grew angry; and resolving to shock their supposed pride, by making their great visitors imagine that his friend and he were low indeed, he addressed himself in a low tone to Mr. Reynolds, saying, "How much do you think you and I could get if we were to *work as hard* as we could"—as if they had been common mechanicks.[13]

In this account, relayed by Reynolds himself, claims of class prerogative for both visual artist and author are explicit, as is the source of their anxiety. Reynolds and Johnson feel themselves to deserve as much attention as the two ladies of rank, and working for money is the crude practice crudely ironized in response to the class-based neglect of the two artists. This is the basis of Carmontelle's insult and the background for David's presumption. As was the case in Italy and France, the foundation of the academy in England was intended to formalize a distinction between artist and craftsman that was in no way entirely certain or self-evident.[14]

Though the intellectual groundwork for academies had been laid in the Renaissance, it was the eighteenth century that saw the widespread appearance and formalization of the actual institutions. In 1740 no more than ten academies of art were active in Europe; fifty years later, over

one hundred were in existence.[15] The need for an institution that would validate the social position to which artists were now aspiring had been felt for many years before the 1768 founding of the Royal Academy of Arts in London. But aspirations toward social advancement are by no means the same thing as the achievement of such advancement.

New Gestures and Old

Because an insistence such as David's on fidelity to his development as an artist has become a cliché of artistic life in the modern period, it is all the more important to pause over this dramatic early instance. The painting, after all, lived up to much more than David could have expected. Not only did his imagination find a moment of his own choosing to represent, but the very gesture he represented entered the vocabulary of politics as the physical form of the famous "Oath of the Tennis Court," in which the members of the Chamber of Deputies swore not to dissolve until they had drawn up a new constitution for France. As an exclamation point for this new acknowledgment of what the artist could mean in public life, David himself was commissioned to paint a work commemorating the event (fig. 7).[16]

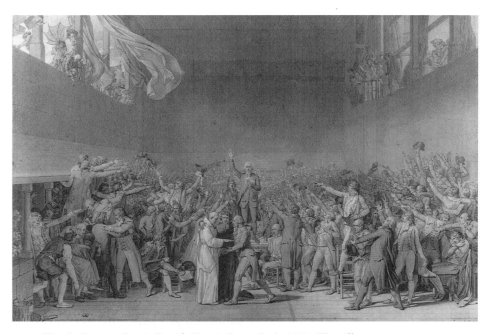

Fig. 7. Jacques-Louis David, *Tennis Court Oath*, 1791. Versailles.

In light of the fear, expressed by Reynolds, of a return to the position of artful crafter of trivialities for the boudoir, it is undeniable that *The Oath of the Horatii* does represent a triumph. David has chosen a story, invented a scene, and at least indirectly defied the king. Years later he will be able to depict the gesture at its heart as part of France's national history. It should be possible to understand the aspirations and success of *The Oath of the Horatii* as marking a remarkable victory on the part of the artist. Even if it were not easy to admire the emphatic form of the representation of individuals pledging to sacrifice themselves for the greater good, the entry of the gesture into the public sphere and of the image into history would demand recognition. And yet, as recent critics have pointed out, taken as a whole, the image depicted on the canvas is strangely disquieting.[17] The rigid determination readable in the angular gestures and taut muscles of the men is offset by the drooping women at the side of the canvas, anticipating the loss of brother and husband. Recent criticism generally concurs in finding a fatal subversion in the latter group. The right side of the tableau admits a weakness in the covenant it celebrates on the left. At the conclusion of the tale—as David's contemporaries knew from Corneille—a brother will kill his sister and their father will defend this action. There are as many victims as heroes on the canvas. The price of patriotic unity is the violent rupture of a range of family ties.

The disjunction between family affection and patriotism was a frequent theme in the period. David's own *Brutus Receiving the Bodies of His Sons from the Lictors* (1789) is a particularly brutal version of the theme—and one that resonated widely in French culture just prior to and during the revolutionary period. The *Horatii*, however, is remarkable for the ambiguities present both in its sources and in David's treatment. There is a terrible simplicity to the *Brutus*—the Roman consul sitting in semidarkness; the feet of his sons, dead at his order, just entering the canvas as they are brought home for burial; the women weeping in a bright light. There is not a like clarity in the inescapable contrast between not yet realized commitment and anticipatory despair, which is balanced in the *Horatii*. The representation of the moment of the oath as coterminous with the time of mourning makes the resolution the image ostensibly commemorates strangely troubling.

Aside from the tensions within the narrative on which it draws, the construction of the image itself legislates against an overconfident reading of the artist's power. I have cited evidence that in making this painting David is claiming a new freedom from the demands of patronage, but he is still bound to a method of work starkly dependent on art that has preceded it. It would be misleading to read *The Oath of the Horatii* as a work representing in any simple way a free creative act of the individual

imagination. The piece, like all works we call neoclassical, establishes its meanings in a network of artistic references. There is a notable contrast between the goal of a new independence of the artistic will, such as that which motivates David's letter, and an aesthetic that is inextricably enmeshed in a web of quotation. While the exact textual source of the *Horatii* seems to be forever indeterminate, the picture itself is constructed on a scaffolding of borrowings from other, generally identifiable, works. Generations of art historians have traced the visual sources of this sparse work: the tableau from Gavin Hamilton's *Oath of Brutus* (1763–64); the brothers' stance from Poussin's *Rape of the Sabine Women* (ca. 1636); the pike from Poussin's *Death of Germanicus* (ca. 1627); the old woman and Camilla from his *Testament of Eudamidas* (1650s); and the whole composition from Jacques-Antoine Beaufort's *Serment de Brutus* (1771). Even the architectural backdrop of the action has been linked to a sketch David made of the Palazzo Vecchio in Florence. Not only have the objects in the painting been borrowed; even its space is secondhand. David's manner of grouping figures as well as the shallowness of his space has been traced to "antique sculpture, descriptions of paintings by Polygnotus, and the 'single plane' compositions of Perugino."[18] David did not in any way originate the concept of art as cultural collection or quotation, but one suspects that something of the power he had for contemporaries resided in the purity of his use of this method.

Norman Bryson offers a stark description of the problems implicit in the procedure so openly used by David: "Neo-classicism issues a mandate of repetition which blocks the painter's self-individuation against the tradition's background and threatens him directly with his own death as artist" (29). Although I do not think the evidence bears out Bryson's argument that the neoclassical artist is waging a war with "tradition," it is evidently true that, in its perpetual harkening back, "Neo-classical style constantly risks the loss of inaugural power" (29). There is a troubling paradox in an art movement that claims a new level of autonomy in the production of work while at the same time relying on models from the past to such an extent that the actual art object created verges on a pastiche of anterior creations. The increased dignity of the artist—that which would allow David to ignore the pleasure of the king if it came into conflict with his own development—was accompanied by a new prestige for the art of the past, which itself set the limits of the new power of the living artist.

The grouping of the figures, in starkly separated units set in a shallow space, is often pointed to as typical of David's neoclassicism.[19] The space he creates is indeed not an innovation, but characteristic of neoclassicism's strategy of reaching for validation by stripping itself of the fanciful elaborations and virtuoso illusionism of the recent rococo past. This pro-

cess had not only an art-historical but also a wider cultural context; it was one manifestation of an urge toward the original that was evident throughout the eighteenth century. But what is the graphic result of this urge to simplicity of form and intention as it is manifested in David's painting?—a Spartan purity that throws the figures to the front and denies the illusion of depth, which had been the given, and often the joy, of art earlier in the century.[20] The effect of *The Horatii* is not achieved without evident sacrifices; as Michael Levey notes, "Men toe the line. . . . there is no place for anything else: nothing to break the unrelenting claustrophobic courtyard of bare brick which completely fills the background" (190).

The setting of David's painting, like that of other neoclassical representations of historical moments, is the result of an insistence on archaeological accuracy and purity of treatment. But the artist achieves this purity at the risk of abandoning his characters (the word seems appropriate for the deeply literary genre of history painting) to a somehow lonely fate. If we compare the *Horatii* to earlier depictions of vital spiritual commitments, say a marriage of Mary, or a Nativity, we see that what has been lost is the space in which details of daily life inescapably fill the world.[21] It is precisely the inclusion of an indifferent world that made Auden so sure that the Old Masters were never wrong about suffering. Denying at once the pleasures of the illusionistic and of the contingent, David presents us with a museum. Because the painter works from a limited set of objects, his work risks becoming a theater of fragments. Bryson picks up on this quality when he remarks that "the presence of antiquity in the *Oath* is that of statuary" (82)—that is, firm, strong, out of context, on display. The crisp realism of David's depiction, the suppression of mere contingent signs of the world—all of these conspire against the *human* drama the figures are meant to evoke.[22]

The very manner in which David goes about fulfilling his triumphant commission for the *Tennis Court Oath* demonstrates the problem at the heart of the neoclassical project. The effectiveness of an old Roman story in inspiring a modern public is demonstrated by the reception of the *Oath of the Horatii*, but how is the artist to represent a claim of *contemporary* national self-determination? A new power of communal self-definition was claimed at the *jeu de paume*, but it was commemorated by an art that reduced the act of creation to the deployment of a limited set of preexistent gestures. The oath of the tennis court cannot be depicted but in the manner of the *Oath of the Horatii*, and *The Oath of the Horatii* is an instance of creativity by selection and orchestration. A typical preliminary sketch for the later project shows David working to depict the recent revolutionary past through the academic prism of his training (fig. 8).

Fig. 8. Jacques-Louis David, Sketch for *Tennis Court Oath*, circa 1790. Versailles, Musée national du Château.

It is an incongruous procedure; David assembles his cast of statues and endows them with the heads of his contemporaries. Simon Schama points out that the figure in the lower left corner of the finished drawing, meant to stand for the revolutionary lower classes, is not taken from the life of revolutionary France; this representative sans-culotte is "modeled like an antique statue and posed like a Michelangelo fresco" (569).

As Brookner has noted, although the *Horatii* is understood to be France's great contribution to neoclassical painting, the rigor of his application of theoretical principles compromises the aspirations of the movement: "David does not imitate; he copies. And he copies very blatantly" (79). The blatant nature of David's copying indicates that it is not an accident, but a strategy. Nevertheless, the procedure implies a weakening of creative power on one hand, and a coldness in depiction on the other. The return to the past which has been inscribed in the very name of the movement is effected at a high cost. Neoclassicism aligned itself with an antiquity that provided inspiration and cultural validation at the price of a disquieting intimacy with the broken manifestations of antiquity in the present.

FUSELI: BEFORE RUINS

In 1778–79, while David was completing his five years of study in Rome, another artist just back from that center of artistic education was setting down, in a medium more personal than oils, his own response to what he had seen there. Although the art of Henry Fuseli has at no point been so important for European culture as that of David, Fuseli's career is in many ways richly indicative of the development of the artist in the late eighteenth century.[23] Born into a family of intellectual achievement and apparently fated for a life of letters, he came to painting late and made his name as the artist of the *Nightmare* and various literary subjects, and as professor of painting at the Royal Academy (1799–1825). There was not a hint of the craftsman in Fuseli's background, or in his practice.

The Artist in Despair before the Magnitude of Ancient Ruins (*Der Künstler, verzweifelnd vor der Grösse der antiken Trümmer*) is a drawing in chalk and sepia of a man sitting on a stone with one arm flung over the immense fragment of statuary beside him—a massive foot, larger than he is and set on a pedestal (fig. 9). The hand that evidently accompanied the foot is close behind it, also set on a base, and pointing up. An imposing wall of heavy stone rises behind the sculptural fragments, making up the entire background of the picture. Although it has been given a title that generalizes its content, the drawing in fact represents ruins that would have been recognized by Fuseli's fellow artists and by other visitors to Rome;

Fig. 9. Henry Fuseli, *The Artist in Despair*, 1778–79. Zurich, Kunsthaus.

the artist has depicted himself with the remains of the Colossus of Constantine, which is to say he has shown himself in the courtyard of the Capitoline museums, where these fragments have been on display since the end of the fifteenth century.

What does it mean to be able to make this drawing? The question of genre is important: a drawing of this sort is a lyric poem to the epic of history painting. It is an expression of personal emotion identified as such by the title. And yet, what is the source of the figure's anguish? His gesture echoes what the title tells us; the human arm is draped over an

object—as if affectionately. Yet the arm also gives the measure of the thing and indicates that it dwarfs the human form beside it. This is a self-portrait, yet the face of its subject is obscured. The title identifies the figure as the artist, but it is an odd representation. One might expect the symbols of a craft: pen, brush, even chisel; or alternatively, the representation of a prosperous middle-class burgher, or thoughtful votary at the altar of intellectual beauty. (We might compare Reynolds's contemporary self-portrait in a Rembrandtesque mood, dressed in the robes of an honorary Oxford doctor of civil law, and accompanied by a bust of Michelangelo.) Why is the artist this vague and mournful figure whose face has been hidden by the signs of his misery? Why is his shape so indeterminate? In fact, what is Fuseli doing with these carved fragments? He was a painter and an author, but never worked as a sculptor.

Behind these questions are two mysteries: what is the source of the painter's anguish? and why is he depicting himself in this way? The answer to both questions is given by the title; he is moved by the fragments.[24] But, what is the cause of his emotion? The admiration of ruins always implies questions: what was this thing before it was destroyed? Could it have been this (moving, important, significant) before its collapse? What would it mean to put it together? The viewer's challenge in this instance is to ascertain what is troubling the artist. The individual emotionally affected by ruins is, of course, a characteristic figure of the eighteenth century.[25] Typically viewed through eyes trained in the glories of classical culture, ruins were generally seen as evidence of inevitable human decay. Nevertheless, it is important to note that quite varied attitudes toward fragments from the past are evident in the second half of the eighteenth century. To give a sense of how it was possible to represent man in relation to these objects, I will place two pictures alongside Fuseli's. Consider Gavin Hamilton's *Discovery of Palmyra by Wood and Dawkins*, 1758 (fig. 10). This painting by the great entrepreneur-artist of early neoclassicism is as clear as the contrast of dark and light.[26] The two English explorers are represented in senatorial togas, emblems of their quest for antique knowledge. They stand in a dark landscape evocative of the ignorant foreign worlds that had to be traversed in order to recover the light of the past. The ruins of Palmyra (the biblical Tadmor) are seen in the distance as the luminous goal at the end of a dark tunnel. One of the men points with a gesture of magisterial confidence while both calmly survey what lies before them. The natives, largely indifferent to the wonder uncovered by European exploration, are set at the periphery of the painting like exotic bookends. (The togas that the European explorers incongruously wear identify them with the classical past they have uncovered, in contrast, again, with their exotically garbed attendants.) The two natives who do seem moved by what they have found

Fig. 10. Gavin Hamilton, *Discovery of Palmyra by Wood and Dawkins*, 1758. Edin-
burgh, National Gallery of Scotland.

lean back slightly on their horses, struck with the emotional admiration
of the unsophisticated aborigine, setting off the calm of the Europeans'
contemplation. The painting gives barely a hint of the wastes behind
those arches; the light of the desert gilds the ruins with a warm glow.

Wood and Dawkins did not in any real sense discover Palmyra. It was
known to Europe from classical texts and the Bible and it was first visited
by a modern European in 1691. It would be more accurate to say that the
men retrieved Palmyra's image by means of the extraordinary edition of
prints, *The Ruins of Palmyra*, which they published in London in 1753,
only five years before Hamilton immortalized them in this canvas (fig.
11).[27] The cultural impact of the voyage and the book was impressive.
James Grainger's 1760 ode, "Solitude," opens with a description of Pal-
myra drawn directly from Wood and Dawkins.[28] Much of Diderot's ac-
count of the sublime of ruins in his Salon of 1767 was based on images
from the same text, either directly or in adaptations by Hubert Robert.[29]

Fig. 11. "A View of the Ruined City of Palmyra, Taken from the North East."
Robert Wood, *The Ruins of Palmyra, otherwise Tedmor in the Desart* (London,
1753). This is one of three large plates comprising the view. Note the artist
sketching in the Foreground.

Hazlitt's 1821 evocation of "a fallen column in Tadmor's marble waste
that staggers and over-awes the mind, and gives birth to a thousand dim
reflections" (discussed in chapter 3) reveals that the link between the
place and a sublime response to the past was long-lasting. Palmyra is
what we might term a good ruin. Said to have been built by Solomon
and referred to in Roman history, for all its physical decay it nevertheless
buttressed received notions of the past.[30] Also, the dead city was located
far enough away from Europe that it was almost impossible to visit; it
had to be retrieved in verbal description or in engraved images. As we
shall see, there are some ruins that are less good for neoclassicism.

Around 1791, Constantin-François Chasseboeuf, comte de Volney, a
member of the French constitutional assembly, published in Geneva a
work of historical-political meditation entitled *Les Ruines, ou Méditations
sur les révolutions des empires*. Like a complacent "Ozymandias," it presents
the fragments of the past as eternal ironic counterpoints to the ambitions
of tyrants. The invocation that opens the work is larded with religious
terms and hints of religious phrases addressed to the walls of Palmyra. In
his lyric flight Volney ascribes extraordinary powers to his fragments:
"HAIL, ye solitary Ruins, Ye sacred Tombs, and silent Walls! 'Tis your
auspicious aid that I invoke, 'Tis to You my Soul wrapt in meditation
pours forth its prayer."[31]

The revelatory powers Volney proclaims in the invocation are subse-
quently manifested in the body of the work. Near the outset of the philo-
sophical tale, an unnamed narrator makes a fictional visit to Palmyra and,

moved by the ruins to think on the transience of human affairs, he too, like Fuseli's artist, covers his eyes. "The very thought shot tears into my eyes; and, covering my head with the skirt of my mantel, I lapsed into the most gloomy meditations on human affairs.... My senses sunk into a motionless stupor, drowned by the tide of profound melancholy" (16).[32] The narrator is soon shaken from his melancholy by a voice that encourages him to survey the nature of the world and the benevolent logic of its working, a voice belonging to a genie who will move him physically as well as mentally outside the narrow scope of his meditations.

I turn from Fuseli's work to this document as a near contemporary counterexample of the possible response to ruins. Although, as I have suggested, the response of the first-person narrator is not unrelated to the emotion of the "artist" in Fuseli's image, demonstrating the prevalence of the trope of the overwhelming encounter with ruins, there is a fundamental difference in the relationship of actual author or artist to the ruins in question. For one thing, whereas Fuseli would have had many opportunities to gauge his response to the remains of the Colossus of Constantine as he made his way to the Capitoline Museums, Volney never saw Palmyra. The images in his work, both textual and pictorial, are adapted from other narratives and images, especially those of Wood and Dawkins.[33] Differences are also evident in the style and form of representation. Although both images show an emotional response to antique fragments, there is a spaciousness in the relationship of Volney's narrator to the ruins that Fuseli's "artist" lacks. Consider the frontispiece to *Ruines*. This engraving (following closely those of Wood and Dawkins) is faithful to Volney's text (fig. 12). The narrator is depicted seated amid archaeological fragments and vegetation, on a hill that affords him a long vista. He is shaded by a tree heavy with bunches of dates and an owl; a friendly looking jackal stands at the lower left-hand corner. The traveler rests comfortably on a fragment of pillar, his hand draped not over a monumental member, but over his own instep, surveying a Palmyra that is shrunk by perspective and further reduced by contrast to the desert and sky that stretch behind it. (The image of the meditating intellectual, strangely comfortable among the ruins of the past bears a resemblance to Wilhelm Tischbein's well-known painting of 1787, *Goethe in the Roman Campagna*.) Birds fly in the distance, emphasizing the opening out of space, of deserts of vast eternity.

The sense of space is founded in the text:

> Every day I walked out to visit some of the monuments which bespread the plain; and one evening when lost in reflection, I had advanced as far as the *Valley of Sepulchres*, I ascended the heights that bound it, from which the eye commands at once the whole of the ruins and the immensity of the desert. The

Fig. 12. Frontispiece. Constantin-François Volney, *Les Ruines, ou Méditation sur les révolutions des empires* (Paris, 1791).

sun had just sunk below the horizon; a radiant wreath tinged with a reddish hue still marked the place of his retreat behind the distant perspective of the mountains of Syria: the full moon in the east reposing on a ground of deep blue, rose from the smooth bank of the Euphrates: the sky was cloudless . . . the eye was not accosted by a single motion amidst the monotonous gloom of the dusky plain; through the whole desert all was solemn stillness. . . . The dusk increased, and my sight could no longer distinguish through the grey twilight any thing besides the shadowy and paler apparitions of walls and columns. . . . I sat down on the base of a broken column; and there resting my elbow on my knee, and supporting my head upon my hand, sometimes directing my eye towards the desert, sometimes fixing it on the ruins, I sunk insensibly into a profound reverie. (*The Ruins*, 15–16)[34]

The eye of the philosophic narrator is as much occupied by the open desert as by the ruins. From where he sits, they are both "commanded" by his eye; both contribute to the sense of a vastness that dwarfs human achievement. As is evident from the Grainger and Hazlitt passages quoted earlier, the coupled image of desert and ruin was part of the lasting effect of Palmyra in culture.[35] The opening movement goes to the horizon and beyond (ruins to sun to sky to far horizon to "*vaste*"—not solemn, as our translator has it—silence), as celestial events foreshadow the cosmic instruction the genie will unfold for the narrator.[36] Indeed, in the first phase of the narrator's education the genie will lift him high above the planet, prior to his exposition on the principles of universal justice.

For Gavin Hamilton the encounter with ruins serves as the occasion for the production of an unambiguous memorial commemorating the triumph of power and knowledge over dark inchoate ignorance; for Volney, ruins are emblems of the paradoxically liberating power of the decay of human endeavors over time. What do they mean to Fuseli? Returning to his drawing, it is hard to miss a striking sense of claustrophobia. Whereas the "discoverers" in Hamilton's work gesture to a distant space at the back of the canvas, and the narrator in Volney gazes into a distance that locates the ruins in a boundless desert beneath an open sky, the entire rear of Fuseli's world is a massive stone wall that admits nothing. Neither is there much space in the foreground of the piece, and none of the marginal activity of human or animal we see in the other two works. The subject is massed in the foreground, as though the background had consumed all the space available. And the artist in Fuseli's piece does not see. He is not gazing in complacent meditation or triumphant discovery; rather, he covers his eyes in despair.

The ruins themselves are different in Fuseli's drawing. Whereas the other works concentrate on decayed buildings, Fuseli chooses a sur-

prisingly ignoble subject. When Shelley writes of "[t]wo vast and trunk-less legs of stone" standing in a desert, the effect of two limbs standing for nothing, supporting nothing, is bathetic and meant to be so. Fuseli had the choice of a range of fragments, and of contemporary models (such as the prints of Piranesi) on which he could have drawn if his theme were the *grandeur* of the crumbling relics of Rome, or their pic-turesqueness. I take his choice of *human* fragments to be evocative of two things: personal disintegration and artistic ambition. As we shall see shortly, the major pedagogic materials for training the artist in this pe-riod were the remains of antique statues. By locating his despair amid such fragments, and not in the remains of ruined habitations, Fuseli hints that "the artist" in this self-portrait is indeed being represented *as* artist, and that this artist has an uneasy relationship with the objects of the past. The specific parts of the body present in this instance—the extremities—speak of irremediable separation, a loss of vital connecting middle, of trunk and head.

Hamilton's painting of the "discovery" of Palmyra offers a confident invitation to partake of the glory of the human past, to even partake in the glory of *reclaiming* a lost human past. Volney's narrator seems to ac-cept the invitation; he seats himself at a comfortable distance and surveys the view while monitoring his entirely conventional meditations, his rote emotions. It is only Fuseli's artist who has made the further step, de-scending to the level of the ruins. Once there, he has found a mute, massive, and disintegrated world that reduces him to tears. His own countenance becomes vague in response; he is effaced by the hand that marks his emotion and blocks the possibility of further sight. I want to suggest that the difference I am attempting to identify is to a large de-gree professional, that Fuseli's overwhelmed despair should be under-stood as a melodramatic representation of one of the central relationships between the art of the past and *artists* at the end of the eighteenth cen-tury. It is a relationship that was of necessity far different from the dis-tant observations celebrated in Hamilton's canvas and Volney's text, and that would have an important, if sometimes subterranean, life in time to come.

If, as we saw in the case of David, the artist was fighting for and gain-ing new prestige, the art object itself was almost outstripping him. An important document in the history of museums, the memorandum writ-ten by Aloys Hirt, a historian of ancient architecture, to the king of Prussia in 1798 provides evidence of the rise in prestige of the art object at the end of the century. While arguing the case for a public museum, Hirt makes a comment that would go without saying in a later era; he notes that it is "beneath the dignity of an ancient monument to be dis-played as an ornament."[37] It was neoclassical art theory that firmly estab-

lished the idea that art objects had a dignity aside from pleasing their owners. For a sense of the change hinted at in Hirt's words, consider Iain Pears's description of the function of paintings in upper-class homes in the *middle* of the eighteenth century: "the majority of these were portraits whose aim was to act as a convoluted form of name-dropping, impressing the visitor with the number and range of powerful friends and relations that the owner knew" (158). What was impressive was the *subject* of the painting, not its execution or artist. It was the project of the neoclassical theorists to reverse this hierarchy. I wish to suggest that, at least as far as artists were concerned, they may have been too successful. The new valuation of the social position of the contemporary artist depended on a more than proportional increase in the value of the artists and art of the past.[38]

Whereas the second half of the eighteenth century witnessed the rapid emergence of the academy as a center of artistic organization, the end of the century was marked by an inexorable increase in the foundation of museums.[39] It was precisely in this period that the museum made the historic change from being by and large (a few well-established collections such as those of Rome and Florence aside) an idiosyncratic gathering of curiosities shaped by the whims and passions of an individual to being a cultural necessity for every capital of Europe, the physical manifestation of an ever growing urge toward access to the works of a noble past. The admiration of the past institutionalized by the academy saw concrete and more public results in the proliferation of the museum which it encouraged. The first museum built expressly for the purpose of the public display of art was in 1769 in Kassel. The creation of public museums was a notable interest of revolutionary France; the Louvre, which was declared a public museum in 1792, and opened as such in 1793, was joined in the ten years between 1795 and 1805 by four more museums in Paris alone, and by twenty-two in the French provinces.[40] In the first decade of the nineteenth century the greatest museum in history would exist briefly at the Louvre, made up of the booty Napoleon's troops methodically gathered from all over Europe, including Rome. Other institutions would prove longer-lasting: The National Gallery would open in London in 1824, and the Prussian Museum in Berlin in 1824–28.

The neoclassical discovery of the past has been compared with the opening of Pandora's box.[41] Like Hamilton's Wood and Dawkins, neoclassicists such as Winckelmann and Reynolds—and even Hamilton himself—had gestured to a golden land of ruins. When these fragments were retrieved from foreign parts, however, they were found oddly to undermine artistic power, both because of the values that had dictated their acquisition and because of the forms the objects themselves were discov-

ered to have. The attentive artist found a mute and heterogeneous assortment of material, not the order and clarity he had been promised. The new relationship to the past was at once more coercive than it had ever been and more difficult.

It is worth remarking that this impulse toward the past is part of a wider cultural tendency. The interest in origins is widespread throughout the period. Seeing its prime intellectual expression in Rousseau's *Second Discourse* (1755), it manifests itself in the arts by a steady movement toward the most original or primal. Several observers have noted that a tendency to celebrate artists as coequal pairs (Homer and Virgil, Michelangelo and Raphael) at the beginning of the century, with the later figure having perhaps a slightly higher cultural valuation, gives way at the end of the century to a lessening of esteem for the later figure in the process of extolling the earlier.[42] Originality is not only a question of chronology (after all, Michelangelo was born only eight years before Raphael), but of a rugged power and lack of finish. Irwin cites the intriguing switch, in the course of Reynolds's *Discourses* (delivered from 1769 to 1790), from Raphael to Michelangelo as the model painter. It is the latter whose name is the last word of the *Discourses*, whose bust Reynolds placed in his self-portrait (ca. 1780). The passionate new interest in such primal bards as Homer and Ossian was a related phenomenon, as was the remarkable number of texts and authors associated with the earliest antiquity that were eighteenth-century rediscoveries. The 1770s saw the first translations into English and French of Aeschylus, the earliest of the tragedians. Hesiod and Pindar both found new appreciation in the eighteenth century, as did the *Nibelungenlied*. The Germanic epic was a particular enthusiasm of Fuseli's mentor, Johann Jakob Bodmer, but Fuseli's upbringing and circle of acquaintances as a young man afforded him an unusually direct access to all of the cultural developments I have been describing—including the opportunity to meet the much admired Jean-Jacques Rousseau.

Although the gesture toward a golden past has ancient roots and was a well-established trope for Renaissance writers on art, one need only glance at a work such as Vasari's *Lives of the Artists* in order to see the differences that may be hidden behind similar gestures. After allowing himself some general platitudes on the lost greatness of antiquity, Vasari bends to his true theme, which is the steady *improvement* in modern art. The confident humanism of Florence in the sixteenth century is not unrelated to the fraught neoclassicism of the eighteenth, but there is no mistaking Vasari's satisfaction with the achievements of his day: "*In our time* there have been so many marvels and so many miraculous, indeed, well-nigh impossible artistic triumphs to see every day that we have come

to the point that no matter what is done, even if it seems superhuman, no one is astonished." In a similar vein, consider Alberti:

> It must be admitted that *it was less difficult for the Ancients*—because they had models to imitate and from which they could learn—to come to a knowledge of those supreme arts which today are most difficult for us. *Our fame ought to be all the greater*, then, if we discover unheard-of and never-before-seen arts and sciences without teachers or without any model whatsoever.[43]

As we will see, the same evidence leads Winckelmann to quite a different conclusion. What the eighteenth century hoped it could locate at the earliest moment was the simplest expression of natural genius and the relics of a coherent, harmonious culture in which the artist played a central and respected role.[44] The impulse toward reclaiming the power of past work is evident throughout the period; what I am suggesting is that this impulse posed as many dangers for the artist as it held benefits.

Chapter Two

"MONUMENTS OF PURE ANTIQUITY":

THE CHALLENGE OF THE OBJECT

IN NEOCLASSICAL THEORY

AND PEDAGOGY

EXCESSIVE FASCINATION with the antique art object was not simply the complaint of contemporary artists resentful of the competition of the dead for the attention of the public. That it was, rather, a heresy constantly tempting the neoclassically trained artist is evident in the way neoclassical theorists deal with the issue of copying—the primary method of instruction in the academies and, as demonstrated by the instance of David, an important method of creation in the studios. This passage from Winckelmann's seminal 1755 essay, "On the Imitation of the Painting and Sculpture of the Greeks," turns quickly from a generalized account of ideal beauty to a celebration of very specific works of art:

> The imitation of beauty is either reduced to a single object, and is individual, or, gathering observations from single ones, composes of these one whole. The former we call copying, drawing a portrait; it is the straight way to Dutch forms and figures; whereas the other leads to general beauty and its ideal images, and is the way the Greeks took. But there is still this difference between them and us: they enjoying daily occasions of seeing beauty. . . . It would be no easy matter, I fancy, for our nature, to produce a frame equal in beauty to that of Antinous and surely no idea can soar above the more than human proportions of a deity, in the *Apollo* of the Vatican, which is a compound of the united force of nature, genius, and art.

Typically, Winckelmann cannot avoid the swerve toward the antique *object*. Even as he gestures to the generalized beauties of ideal nature, he cannot escape his infatuation with specific Greek sculptures.[1] These statues represent for Winckelmann an achieved ideal, but they stand also for a historical myth of a beautiful lost state. Modernity is a different world; the Greeks enjoyed frequent occasions of seeing beauty now lost to us and so produced works of art that are unmatchably ideal. The momentum of the passage is inescapable and somewhat counter to its ostensible argument; if we want to be artists approaching the level of the

Greeks, we must look to the beautiful in general, but this beauty is to be found in its best form in certain *specific* works (the *Apollo* and *Antinous* in this case) on display in Rome.

Reynolds's *Discourses*, delivered from his position as first president of the British Academy, demonstrate neoclassicism's ties to a specific institutional and pedagogic context. While showing fewer of those wrenching contradictions that mark Winckelmann's passionate classicism, the compromise Reynolds works out between originality and the reproduction of the past still seems unlikely to hold. His touchstones are typical of the period, a group of statues in Rome (he can speak familiarly of "the Torso"—all his students would know where to look for it, at the Belvedere gallery in the Vatican) and the paintings of a small set of Renaissance painters (especially Raphael in the early lectures and Michelangelo in the later ones).

Instructing his students in what they must look for in the art of the past is a central concern of Reynolds's lectures. Thus, in Discourse VI:

> We must not rest contented even in this general study of the moderns; we must trace back to its fountain-head; to that source from whence they drew their principal excellencies, the monuments of pure antiquity. All the inventions and thoughts of the Antients, whether conveyed to us in statues, bas-reliefs, intaglios, cameos, or coins, are to be sought after and carefully studied. (106)

Reynolds invites his students to a scavenger hunt so that they may reach the originary power of the ancients. His terms are of beginnings: fountainhead, source, principal. The engagement with things is meant to result in access to an original ideal; its end is not meant to be intimacy with the objects themselves. And yet, four paragraphs later, Reynolds embarks on some fine distinctions on plagiarism:

> We come now to speak of another kind of imitation; the borrowing a particular thought, an action, attitude, or figure, and transplanting it into your own work: this will either come under the charge of plagiarism, or be warrantable, and deserve commendation, *according to the address with which it is performed.* There is some difference likewise, whether it is upon the antients or the moderns that these depredations are made. It is generally allowed, that no man need be ashamed of copying the antients: their works are considered as a magazine of common property. . . . (106; my emphasis)

As usual, we find the president carefully guarding the middle ground. Under certain circumstances copying is plagiarism, but if done correctly, it is not. The scene of instruction of the artist, be it practical or theoretical, suggests why such a warning might be necessary (figs. 13, 14). The academy creates an environment in which the student is perpetually sur-

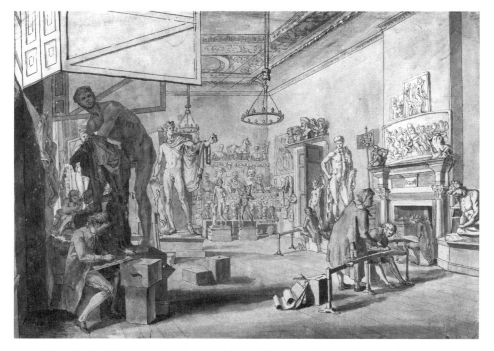

Fig. 13. E. F. Burney, *The Antique School of Somerset House*, 1779. London, Royal Academy. Students copy from the *Dying Gladiator*, the *Apollo Belvedere*, and other antique works.

rounded—not to say, loomed over—by casts of antique statues, which it is his main duty to admire, his principal task to copy. It is little wonder that this approach to study should be internalized as a method of creation, that the exercise of the student becomes the practice of the artist. The sculptor Joseph Nollekens's painstakingly measured drawings of canonical statues provide striking evidence of the commitment to the antique among artists of the period. But they suggest at once practical aims and obsession (figs. 15, 16). Ann Hope writes of the effect of this form of study: "Others, too, became slaves of the marbles, narrowing their vision to a single cast or a few genuine fragments, and seeking to capture to their final satisfaction the vital elusive essence of the original" (94). Nollekens's obsessive analysis of the statues making up the canon was not a private mania so much as the rigorous application of principles implied in fundamental neoclassical formulations and in the instruction of the academy, though frequently denied.[2] As the artist was trained in taking the measure of a limited set of works from the past whose elements could be analyzed but never matched, his practice became the skillful placing of inherited forms. Hope points out that Nollekens has done enough pain-

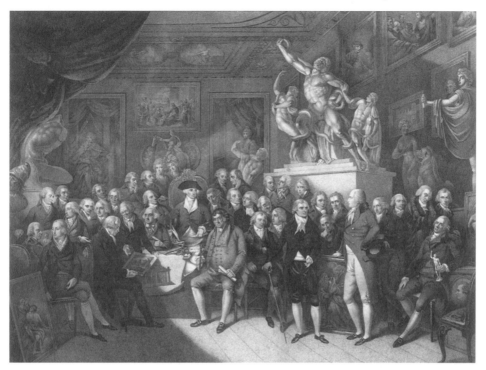

Fig. 14. C. Bestland after Henry Singleton, *The Royal Academicians in General Assembly*, 1795. London, Royal Academy. The academicians are framed by the *Belvedere Torso* on the left and the *Apollo Belvedere* on the right. Other classical works surround them, including the *Medici Venus* and the looming *Laocoön*. Paintings evoking royal patronage hang at the rear. A self-portrait of Reynolds with a bust of Michelangelo gazes down from the right wall.

staking work (more than fifty exact measurements of the Venus in a number of drawings, each one of Laocoön's toes individually analyzed) not only to copy the statues just as they are but also to be able to reproduce them in *different* positions and situations. His diagrams show Nollekens carefully preparing for a sort of pedantic reverse Pygmalionism which will allow the artist to endow new life and movement to statues by means of profound intimacy with their parts.

The challenge for the artist in neoclassicism is immense: instructed to base himself on the ancient art which is the justification and foundation of everything he hopes to accomplish, in order to create "original" work, he must nevertheless to some degree break out of the cycle of repetition in which he has been trained. Reynolds is disingenuous in his recommendation of "sufficient address" as a solution. There is an odd blend of

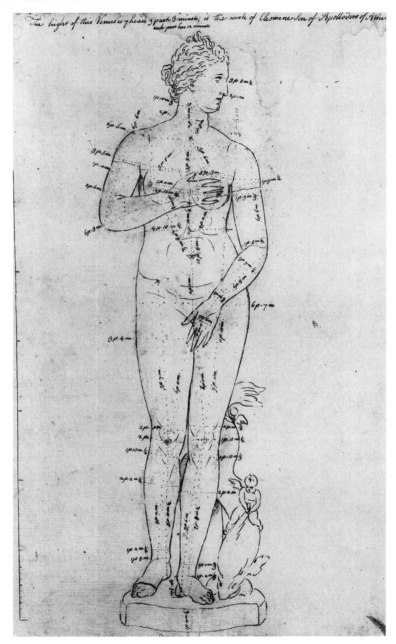

Fig. 15. Joseph Nollekens, "Medici Venus." Oxford, Ashmolean Museum.

Fig. 16. Joseph Nollekens, "Proportions of the Laocoön at Large." Oxford, Ashmolean Museum. Measurements include various stomach muscles and the relation of kneecap to calf.

professorial wisdom, artful hedging, and rakish tip in his exposition in Discourse VI:

> It must be acknowledged that the works of the moderns are *more* the property of their authors; he who borrows from an antient, or even from a modern artist not his contemporary, and so accommodates it to his own work, that it makes a part of it, with no seam or joining appearing, *can hardly* be charged with plagiarism: poets practice this kind of borrowing without reserve. But an artist should not be contented with this *only*; he should enter into a competition with his original, and endeavor to improve what he is appropriating to his own work. *Such* imitation is so far from having any thing in it of the servility of plagiarism, that it is a perpetual exercise of the mind, a continual invention. *Borrowing or stealing with such art and caution*, will have a right to the same lenity as was used by the Lacedemonians; who did not punish theft, but the want of artifice to conceal it. (107; my emphasis)

Fig. 17. Henry Fuseli, *Satirische Selbstkarikatur*, 1778. Zurich, Kunsthaus.

This advice from a practicing artist of the late eighteenth century to his students shows the surprising detours on the way toward a pure ideal nature. What Reynolds proffers is no vague philosophic suggestion to search out the ideal behind existing work; instead, he encourages the artist towards a difficult balancing act, to incorporate seamlessly *and* to "enter into competition" with what he copies. "Art" is the result of clever theft, and the paradox is complete: "Such imitation . . . is . . . a continual invention."

Reynolds's recommendations not only limit the possibilities of artistic creation, they also demonstrate the ultimately unstable circularity of neo-classicism; the artist is constantly sent to the "inimitable" objects of the past for his models, but they are by definition and common agreement impossible to reproduce or challenge. The creative impetus of the artist will always be checked at the very sources of its inspiration.[3] When Hazlitt came to write his important critique of Reynolds, first in his list of disagreements with the *Discourses* is that in the system they describe, *"genius or invention consists chiefly in borrowing the ideas of others, or in using other men's minds."*[4] As we have seen, Hazlitt is barely exaggerating when he suggests that "It is a leading and favourite position of the Discourses that genius and invention are principally shewn in borrowing the ideas, and imitating the excellences of others" (18:64). Hazlitt identifies Reynolds's artist as compendium, as the intricate arranger of past beauties he cannot hope to match. Fuseli could not have been the only one of Reynolds's students to feel that he was below what he had been taught to worship. In the first of his own lectures as professor of painting, Fuseli readily acknowledges the "unattainable superiority" of Greek art; in a later lecture he places even his much admired Michelangelo below it, describing the Sistine chapel as full of unachieved imitations of the antique.[5]

THE STATUE AND THE PENIS

I have proposed Fuseli's *Artist in Despair* as a suggestive image for the relationship of the artist to the art of the past at the end of the eighteenth century, not simply overwhelmed by the magnitude of earlier achievements, but inescapably placed in the courtyard of a museum whose objects he is constrained to copy. This reading of the drawing is supported by a related but lesser known representation of himself as artist, which is contemporary with *The Artist in Despair* and also linked to Fuseli's departure from Rome (fig. 17). It is a caricature he included in a letter from Lugano to James Northcote, a fellow painter still in that city—a humorous declaration of his situation and ambition sent to a

Fig. 18. *Sleeping Faun*. Hellenistic bronze, found 1756. Naples, Museo Arche-
ologico Nazionale.

friend. In this self-representation Fuseli's shape is not indeterminate as it is in *The Artist in Despair*; rather, in good neoclassical fashion, he has made himself into a statue. A recent exhibition catalog describes the model of the image as "an antique hero," but what Fuseli has drawn is in fact a statue of the type he (like Northcote) had been studying during his time in Italy.[6] Fuseli has given himself a massively muscled body, which he has inclined backwards, arm bent over the head to improve the line and make sure the allusion to sculpture is not missed. Unlike Nollekens, Fuseli has not limited his frame of reference to the best known of the classical statues; the figure he inhabits is indicative of more recondite knowledge, adapted as it is from one of the most impressive recent finds in Herculaneum, the *Sleeping Faun* (fig. 18).

This artist is not sitting lost in misery in front of a stone wall, a stone sculpture; he *is* the sculpture. For all its humorous intention, Fuseli's drawing captures one of the few options that have been left the self-conscious artist in this period. There is no wall closing off this sketch, as was the case with *The Artist in Despair*; rather, the artist dominates a horizonless and perspectiveless world. His homeland of Switzerland becomes the base and receptacle of the immense commode on which he sits to defecate. His forward foot moves him toward England, where mice represent the artists now there. He gazes longingly at Italy, or rather at a phallus winging its way back to the fecund source of his art, of the very model he is inhabiting. The image suggests a complex combination of strength and weakness not unrelated to that present in the public work of David. The position of the artist in the cartoon is one of great power; he looms over the entire continent. And yet he must appropriate the form of a particular sculpted figure, fit himself into its stony pose, in order to take on its massive authority. The ambition represented in the image, to escape mere national boundaries by means of ambitious artistic work, is linked inextricably to the assumption of prior forms. In the terms of the drawing: Fuseli may dominate his world and defecate on his homeland, but only by taking on this preestablished shape. The translator of Winckelmann's "Thoughts on the Imitation of the Greeks" into English (1765) has taken those thoughts quite a distance by the time his career as a professional artist begins.[7] Imitation is not merely his method of creation; it becomes a figure for what he is as an artist.

The inextricable links between Fuseli's artistic ambition and past art that are suggested in the caprice he sent to Northcote are evident in his more ambitious work. To take one example from many demonstrating the nature of Fuseli's imitation, consider a work painted around 1800, *Nude Woman Listening to a Girl Playing upon a Spinet* (fig. 19). The piece has received the attention of art historians as an undisguised variation on one of Titian's *Venus and the Organ Player* canvases (fig. 20).[8] The open-

Fig. 19. Fuseli, *Nude Woman Listening to a Girl Playing upon a Spinet*, 1799–1800. Basel, Öffentliche Kunstsammlung.

ness of Fuseli's imitation allows us to ask, What has Fuseli done to Titian's voluptuous Venus? In his title he makes her into a woman, no longer a goddess; and yet, she is a stony creation. Titian himself unquestionably owes something of his Venus to an antique marble, but, in simplifying the shading and color of his original, it is Fuseli who seems to set a statue on his couch. Though they differ in every other respect, it is worth remarking on the qualities that make the work reminiscent of David's *Oath*—its suppression of background and contingent detail, and its use of statuary forms to represent what should be a fundamentally human subject, in this case the nude.

The picture is a vivid instance of the constant presence of previous art in Fuseli's productions, but this phenomenon is only more remarkable in his works based on literature. Fuseli concentrated much of his energy into illustrations of the poets, especially of Dante, Shakespeare, and Milton. In this period new developments in art implied new methods of patronage. One innovation of the late eighteenth century was the practice of earning money from a painting by either charging admission to see it, or by selling engravings, or both. (Probably the best-known example of the first practice is David's 1799 exhibition of the *Intervention of the*

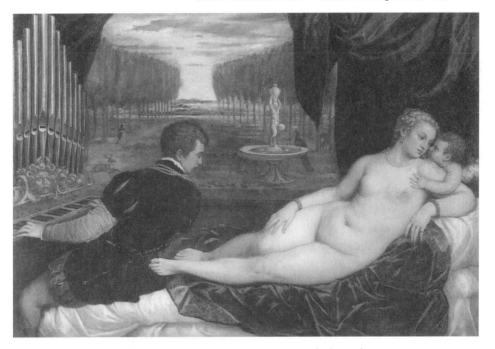

Fig. 20. Titian, *Venus and the Organ Player*, 1548. Madrid, Prado.

Sabine Women.) As we will see, the new prestige of the artist played an important part in the dramatic growth in the number of projects involving the illustration of works of major English poets, often intended as examples of the genre of history painting, which was meant to revitalize English art. Fuseli was one of the artists John Boydell commissioned for his Shakespeare gallery, and he would go on to create an entire Milton gallery on his own.[9] But even before Boydell, Fuseli was preoccupied with ways to make art from Shakespeare's works. His idea for a Shakespearean Sistine Chapel never got beyond sketches (ca. 1775–76), but it is an interesting conflation of two vital artists who would always be at the center of Fuseli's modern pantheon. When we consider the transposition of subject from the original Sistine chapel to Fuseli's, we find further evidence of how far the artist has come; the works of Shakespeare were to take the place of the Creation and of the ancestors of Christ represented by Michelangelo.

The great importance Fuseli places on the poet makes his 1771 treatment of the poisoning of Hamlet's father particularly remarkable (fig. 21). The extraordinary image has been traced to a representation of homosexual sex on a vase by the fifth-century Berlin Dinos Painter (fig. 22).[10]

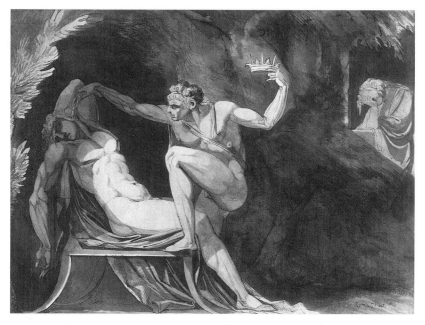

Fig. 21. Fuseli, *The Danish King Poisoned While He Sleeps*, 1771. Zurich, Kunsthaus.

The presence of his model is such that Fuseli has been moved to alter the scene from Shakespeare that he is ostensibly depicting. There may be some point to sexualizing the moment of poisoning, but the nudity of the elder Hamlet and his brother is extraordinary—especially if compared with Fuseli's own depictions of scenes from Shakespeare in Boydell's gallery and elsewhere. The "inexplicable youth" of the king of Denmark has been remarked upon, and it has been suggested that the image is based on a descriptive phrase from *Hamlet* (1.2.139–40): "So excellent a king: that was to this / Hyperion to a satyr."[11] Hamlet's filial hyperbole may have played some part in shaping Fuseli's depiction, but it seems less likely when we consider that, other than nudity, Claudius is represented with none of the attributes of a satyr. A more likely interpretation of the piece would have to admit that, rather than controlling his deployment of the shapes of the past, the artist has allowed his model to bleed through the surface of his subject. Instead of simply illustrating the figurative passage from the play, the striking image may demonstrate Fuseli's scopophilic sensibility reacting to the spying and voyeurism that shape life at Elsinore. The selection of his model may demonstrate Fuseli's sensitivity to the complex sexual jealousy that underlies the play as a whole. Nevertheless, as in the case of the depiction of the nude woman

Fig. 22. Homosexual scene, Berlin Dinos Painter. [D'Hancarville, ed.], *Collection of Etruscan, Greek and Roman Antiquities from the Cabinet of the Honorable William Hamilton*, vol. 2 (Naples, 1767).

listening to the spinet, this representation carries its art-historical model remarkably close to the surface. In both instances, the moment depicted clings with disturbing closeness to the form used to give it shape. As I will shortly suggest, the erotic element evident in both these instances is characteristic and worth particular attention.

"A Shadowy Outline Left of the Object of Our Wishes"

By the late eighteenth century, culture had acquired the interest and resources to support a project such as the Shakespeare gallery; a development related in every way was the assembly, organization, and reproduction of collections of antique work that resulted in the diffusion of models such as the vase of the Berlin Dinos Painter. The theorists of the early part of the century had succeeded beyond their expectations. Winckelmann and Gavin Hamilton had gestured toward a place of beauty and knowledge, and the world had gone there to look and retrieve what it could. This growing intimacy with the past was an important change from an earlier era, which had tantalized itself with the secondhand.[12] Between the end of the seventeenth century and the second half of the eighteenth, the cultural institutions that would support the

growing interest in art were established. The period between 1680 and 1760 saw what has been described as "the virtual invention of the English art market." Once in place, the invention quickly expanded. By the 1770s, not only were the English the principal buyers of sculptures from Rome, but the Society of Dilettanti and other organizations were in place to collect, analyze, and publish prints of the works that were purchased or surveyed.[13] The case of Greece was particularly important; dramatic claims had been made about its art by Winckelmann and others, yet it was largely terra incognita until well into the second half of the century. Whereas earlier writers on its wonders, including Winckelmann, had had to rely on the descriptions of others, or on what was available in Roman collections, from 1762 to 1816 the Society of Dilettanti brought out Stuart and Revett's *Antiquities of Athens*, four folio volumes providing a reliable and minutely detailed illustrated account of Greek ruins based on sketches made on the spot.

New knowledge led to new discriminations. Although the respective merits of Greece and Rome had been the object of debate throughout the last half of the century, it was from the 1780s that collectors and artists in England began to distinguish with increasing sharpness between the two cultures.[14] The vision of a unitary antiquity proved unstable at its heart. Meanwhile, a range of culturally unwarranted foreign objects entered the museum: "Ossianic and North American wildernesses, Greek and Roman funerary rituals, French Gothic and Italian Renaissance costume—from the late eighteenth century on, all times, all places, all peoples could be entered into an encyclopedic repository of knowledge and could be reconstructed with a growing precision of detail."[15]

If, as several historians have noted, the English were uncharacteristically early in their adoption of neoclassicism, it may be because they had the prime qualification; the absence of a continuous indigenous tradition in the visual arts.[16] The energy of neoclassicism is derived from an anxious reaching toward what is not there. In his 1764 *History of Ancient Art*, Winckelmann acknowledges the force of the absent object in motivating his efforts:

> I could not refrain from searching into the fate of works of art as far as my eye could reach; just as a maiden, standing on the shore of the ocean, follows with tearful eyes her departing lover with no hope of ever seeing him again, and fancies that in the distant sail she sees the image of her beloved. Like that loving maiden we too have, as it were, nothing but a shadowy outline left of the object of our wishes, but that very indistinctness awakens only a more earnest longing for what we have lost, and we study the copies of the originals more attentively than we should have done the originals themselves if we had been in full possession of them. (4:292)

Winckelmann's language evokes a favorite neoclassical subject, the story of Dibutade, the abandoned Corinthian maid said to have invented the art of painting when she drew a departing lover's silhouette on the wall (fig. 23). With this allusion Winckelmann identifies the passionate engagement with available works of art that characterizes his writings as a compensation for the loss or absence of what is truly desired. The close attention of neoclassicism is inverted into distant gazing toward objects that can never be recovered, that are beloved but forever lost.[17] As such, the beauties of antiquity can *only* be mourned as they are spied or "fancied" in distant images. What is being described is an erotics of absence in which the lover is always a longing maiden and satisfaction may even seem vulgar when compared with the evocative silhouette of desire.

Separation was more than an accidental part of the neoclassical admiration for antiquity. It was only when viewed from an unbridgeable distance that the figures of antiquity maintained their coherent unity. Once things were retrieved and considered closely, it was hard to feel the same way about them, not only because of the loss of the desire that had motivated the search, but because of the troubling nature of the objects themselves. The proliferation of museums at the end of the century institutionalized the reverence for the past taught by the theorists of neoclassicism and others, but questions about the consequences of the dramatic increase in access (or even potential access) to art afforded by these collections were unavoidable. The psychological effect of the ever growing quantity of material on the general viewer or artist was particularly uncertain. Reynolds, giving voice to the idea motivating the development of the museum, is uncharacteristically strong in his claims in 1774: "A mind enriched by an assemblage of all the treasure of ancient and modern art, will be more elevated and fruitful in resources. . . . There can be no doubt but that he who has the most materials has the greatest means of invention" (Discourse VI; Reynolds, 99). By the end of the century the certainty that more was better was coming under some strain. Not only is a general principle at play, which suggests that when a museum culture becomes visibly heterogeneous the worship of any particular object is threatened, but exploration and study revealed that the past was quite a different place from the one celebrated by Winckelmann and Reynolds. It was a discovery, or set of discoveries, at once liberating and troubling for the artist.[18] The city of Rome had been the cultural center of Europe since the Renaissance, remnants of its classical glory combining with the presence of other admired cultural artifacts.[19] But now the city was to be subjected to competition from many sides. Winckelmann himself represents an early instance of the insistence on the priority of Greece. But his was a Greece that had never existed, based on the centrality of works, largely in Rome, whose pedigrees were coming into question by the end

Fig. 23. "The Origin of Painting." Joseph Wright, *The Corinthian Maid*, 1782–84. Washington D.C., National Gallery of Art, Paul Mellon Collection. The lover's pose is based on a classical Endymion. The ceramic vessel at the feet of the maid and the fire in the other room serve as reminders of her father, the potter, Butade.

of the century—as were the very standards Winckelmann had used to praise them.

It was in the interplay of canon and standard that the crisis of neoclassicism was fated to occur. The special quality of the canon to which Winckelmann referred his students was its *unity*: the objects themselves were understood simultaneously and necessarily to fit into a coherent historical pattern *and* to present the ideal beauty of nature better than the dispersed accidental experience of a contingent world ever could: "the beauties of the Greek statues being discovered with less difficulty than those of nature, are of course more affecting; not so diffused, but more harmoniously united" ("On Imitation," 67). The art historian's celebration of the past is predicated on a pure unitary vision of antiquity.

Classical works are valued because they are not subject to the motions of the passions or the vicissitudes of the nonideal world. Thus, in the *History*:

> The highest beauty is in God; and our idea of human beauty advances towards perfection in proportion as it can be imagined in conformity and harmony with that highest Existence which, in our conception of *unity and indivisibility*, we distinguish from matter. . . . *All beauty is heightened by unity and simplicity.* . . . Everything which we must consider in separate pieces, or which we cannot survey at once, from the number of its constituent parts, loses thereby some portion of its greatness." (2:40–41; my emphasis)

Even after turning away from the art historian on many matters, Fuseli still follows Winckelmann on the question of unity. Hence the painter's convoluted insistence on this quality in his own discussion of the virtues of Greek art in his lectures:

> Above all that simplicity of their end, that uniformity of pursuit which in all its derivations retraced the great principle from which it sprang and like a central stamen drew it out into one immense connected web of congenial imitation; these, I say, are the reasons why the Greeks carried the art to a height which no subsequent time or race has been able to rival or even to approach. (Fuseli, 2:24–25)

End, pursuit, derivation, central stamen, web—all of Greek creation winds into a constantly collapsing unity in which to be born is to be finished and to develop is to go back to the beginning. Fuseli's odd phrase "congenial imitation" verges on paradox; it implies both a process of happy copying and some wishful thinking about the possibilities of neoclassicism: Greek art is so self-contained that its imitation is born at the same time as its creation. This powerful unity was the achievement of the Greeks in sculpture; the gathering of dispersed beauty for its better appreciation was a related achievement of the popes and princes who collected Greek antique works in modernity. It was up to the modern artist to go to these cultural centers and emulate the tranquillity and coherence he found there.

Winckelmann's neoclassicism can be distinguished from that of Fuseli in one important regard, which is not simply personal, but rather characteristic of the recalibration of desire in the period. For all his notoriously heated descriptions of statues, Winckelmann could not have had the calm and open lust of the Berlin Dinos Painter's vase in mind when he described Greek art in his famous formulation as characterized by "eine edle Einfalt und eine stille Grösse" (a noble simplicity and sedate grandeur ["On Imitation," 72]). Kant's aesthetics are typical of the Enlightenment in ruling out desire as a constituent element of beauty.[20] The sensu-

ality of Winckelmann's descriptions is an important element of his art history, but these accounts are the records of his own erotic response as viewer; his principles had no room for the frankness that often characterized sexuality in antique art.[21] The stasis Winckelmann celebrated was closely tied to the ideal beauty of his aesthetic theory. The sexual neutrality of the object went hand in hand with the idea that the role of art was to collect in order to refine the scattered beauty in nature. The imitation of those images of masculine beauty, the *Antinous* and the *Apollo* in the Vatican, was carried out in order to bring together "every beauty diffused through nature," but it is a process that can only take place in a realm far above the base senses: "the pitch to which the most perfect nature can elevate herself, *when soaring above the senses*, will quicken the genius of the artist, and shorten his discipleship: he will learn to think and draw with confidence, seeing here the fixed limits of human and divine beauty" ("On Imitation," 67; my emphasis). The merit of the statues in Rome is their purity and unity, two qualities that are intimately linked. The question confronting artistic culture at the end of the century was, What happens when this unity is broken, when the canon becomes an encyclopedia of temporally and spatially scattered and heterogeneous works?

"Another Authority"

The cultural power of the Belvedere statues would have a long life; George Eliot places Dorothea Casaubon in front of the Ariadne (then known as the Cleopatra) in the early 1830s, on her honeymoon trip to Rome. But the weakness of the claims of these works was already evident by the end of the eighteenth century. As early as 1791 the important connoisseur Richard Payne Knight suggested that such canonical work as the *Apollo Belvedere*, the *Belvedere Torso*, and the *Farnese Hercules* were in fact Roman copies from the second century A.D. By 1809 he was ready to consider the possibility that the *Belvedere Antinous*, the *Dying Gladiator*, and the *Niobe Group* were also copies. These speculations were of course largely correct. At best, the works of great originary genius to which Winckelmann had paid homage were Hellenistic copies of irretrievably lost Greek bronzes; worse, others were from periods he had considered too decadent to produce such masterpieces. A fault line now ran right through the system of judgment that had praised these works for their earliness and inimitability and had, in turn, validated itself by its access to the same qualities.[22]

As research began to undermine the unchallenged power of works whose preeminence had been a tradition since the Renaissance, archaeology and politics were also doing their part to trouble received opinion. It

was only possible to envision the project of transferring the Elgin Marbles to England (and petitioning Parliament for reimbursement of costs) because the culture of the eighteenth century had made having them at least arguably desirable (fig. 24). But, when they were brought before the public, the Marbles were notably unsettling; the testimony of expert witnesses invited to speak before Parliament on the merits of the purchase shows clear signs of the developing aesthetic crisis. When Flaxman is asked to compare one of the pedimental statues of the Elgin Marbles with the Apollo Belvedere, he has no trouble ranking the latter higher, but the mere fact that in doing so he identifies it as a copy troubles his questioner:

> —I should prefer the *Apollo Belvidere* [*sic*] certainly, though I believe it is only a copy.... I should value the Apollo for the ideal beauty, before any male statue I know.
> —Although you think it a copy?

Fig. 24. Archibald Archer, *The Temporary Elgin Room*, 1819. London, British Museum. Note the painting materials in the foreground on the left, the artist at work on the right.

—I am sure it is a copy; the other is an original, and by a first-rate artist.

—The Committee is very anxious to know the reason you have in stating so decidedly your opinion, that the Apollo is a copy.[23]

That much of the importance of the Elgin Marbles resided in their being *warranted* statues in the aftermath of a general challenge to the authenticity of other works is evident in the words of the architect Charles Robert Cockerell in his preface to an early description of the collection:

> It is the opinion entertained by some competent judges of high authority in matters of this kind that none of the collections of Europe contain any of those original monuments of sculpture which were held in general estimation by the ancients, with the exception only of the Laocoon and the Torso of Belvedere; but *here* [before the Elgin Marbles] the connoisseur and the artist *may be perfectly certain* that they are contemplating a variety of these sculptures, *the authority of which cannot be controverted*.[24]

Hazlitt, for one, wasted no time in turning to account the new knowledge the Marbles provided of the art of classical antiquity:

> *Another authority*, which has been in some measure discovered since the publication of Sir Joshua's Discourses, is to be found in the Elgin Marbles, taken from the Acropolis, and supposed to be the works of the celebrated Phidias. The process of fastidious refinement, and flimsy abstraction, is certainly not visible there. The figures have all the ease, the simplicity, and variety of nature, and look more like living men turned to stone than anything else. . . . This is true nature and true history. (18:81; my emphasis)

When Hazlitt goes on to compare the marbles to "the *Apollo*" and "the *Hercules*," he finds the latter statues comparatively wanting in *grandeur* and *nature*, turning two terms from the neoclassical vocabulary of highest praise against their previous objective correlatives (the purpose also served by the reference to "history" in the preceding passage).[25] My point is not that everyone would have been aware of the archaeological evidence against the works on which Winckelmann had built his argument, but that as soon as "[a]nother authority" can be adduced, one of the principal pillars of neoclassicism begins to totter.[26] No longer could the previously sacrosanct canon be looked to for a unitary original cultural validation. To make matters worse, as Hazlitt quickly recognized, the realism and vitality of the Elgin marbles were directly contrary to neoclassical principles of ideal nature.

Debate as to the merits of the Elgin Marbles tended to revolve around two issues: the broken nature of the objects themselves, and whether Phidias had had a direct hand in sculpting them. Which is to say, the argument was on the one hand about the beauty of fragments, and on the other about class in the sense Reynolds had understood it. Richard Payne

Knight resisted the Marbles on both counts, but his argument is most telling when he stakes it on the distinction between craftsman and artist:

> These are merely architectural sculptures, executed from Phidias' designs and under his direction, probably by workmen scarcely ranked among artists. . . . they can throw but little light upon the more important details of his art. . . . They are evidently the works of many different persons, some of whom would not have been entitled to the rank of artists in a much less cultivated and fastidious age.[27]

Payne's remarks occur in a volume which represents the last gasp of a dying aesthetic of antiquity, *Specimens of Ancient Sculpture* (1809), a sumptuously produced and carefully etched production commemorating the works that a previous generation had celebrated. The attack Knight makes on the marbles is entirely of a piece with the values (and anxieties) Reynolds had expressed in his discourses thirty years before. He is also playing on the same insistent separation between craftsman and artist in a letter on the carvers of the Elgin Marbles, "I do not think the workers of them deserve a better title than common *Stonehewers*."[28]

The battle over this question is still motivating Cockerell more than twenty years later, when he writes in 1830:

> The building of the Parthenon, together with the names of the two architects employed in constructing it, is recorded by Plutarch in the life of Pericles. . . . It may, therefore, be reasonably inferred that the sculpture, which adorned this noble temple, was designed by that great master, and executed by the disciples of his school under his immediate direction.[29]

What is remarkable is how close Cockerell and Knight are on the facts; only their interpretation differs. It is evident to both of them that even a heroic sculptor working for years could not have accomplished the decoration of the Parthenon. Knight responds to this evidence by declaring those who did carve the marbles to have been mere journeymen craftsmen, entirely below the level of the creative artist. Cockerell on his side envisions a great school, like the studio of a Renaissance artist, in which the latter's vision is flawlessly enacted, not by tradesmen, but by "disciples" under "his immediate direction."

The most pressing aesthetic challenge offered by the Elgin Marbles, however, was their actual condition. Knight and other lovers of antiquity were accustomed to the smooth finish and complete form of restored statues such as those in the Townley Gallery—the most important collection of classical art in England before the advent of the Marbles (fig. 25). Even when the relatively well preserved metopes and frieze were admired, the pitted surfaces and ravaged forms of the pedimental statues were often felt to be intolerable (fig. 26).[30] In order for the Elgin Marbles

Fig. 25. The *Townley Venus*. Hellenistic marble discovered by Gavin Hamilton in 1775, and restored in Rome. London, British Museum.

Fig. 26. *Nike*, Elgin Marbles, fifth century B.C. London, British Museum.

to become a practical manifestation of the sublime, they had to be seen as Keats would see them, through the prism of time, and admired for what they had been through, not only for what they had been. Ultimately, the acceptance of these works in culture indicates not so much a break, but rather a culmination or even a triumph of the tradition of the admiration of antique sculpture. However, rather than looking through these objects to a harmonious ideal world, beholders now gazed on them as they were, in their actual unrestored condition—even more damaged than those fragments on which Fuseli had sat and wept.

THE PENIS AND THE STATUE

The disintegration of the neoclassical ideal under the weight of its own knowledge is hinted at in the cartoon Fuseli drew of himself as he left Rome. The penis winging its way to Italy is an overdetermined sign of fragmentation. The organ of generation is separated from a human form and flies back to its source. This is the problem at the heart of the neo-classical project from the outset; Fuseli, like David, is committed to an art movement that must rely on distant fragments of the past for generation. Still, the specific image Fuseli chooses to draw speaks not only of inherent contradictions, but also of pressures that were at work *outside* the logic of the movement. The winged penis reentered the vocabulary of art with the excavation of Herculaneum. Page after folio page of engravings of winged phalli occur in the same sumptuous volume of engravings as that which diffused the image of the *Sleeping Faun* to European connoisseurs (fig. 27). The cities of Herculaneum (discovered in 1738) and Pompeii (1748) were the greatest finds of eighteenth-century archaeology, yet they were a disaster for idealized visions of classical antiquity. Finally modernity would have a glimpse of the painting which it had tried to see and emulate through the study of sculpture. But what the visitor to Herculaneum and Pompeii found was not a world of cool pillars and dignified statues, of restrained stoical citizens surrounded by heroic history paintings. Desire was written on the walls of the cities and sculpted into its ruins (fig. 28).[31]

Fuseli, who visited and sketched at these famous sites before he left Italy, clearly took away with him the memory of a sexualized antiquity (fig. 29). Images from an erotic past return in fevered fantasies he drew while still in Rome, most notably in the series of designs (still carefully guarded at the Museo Horne in Florence today) that feature flamboyant, sometimes ritualistic, sexual acts carried out in front of exaggeratedly phallic herms. The symbols of ancient desire evidently struck a responsive cord in Fuseli's phallic preoccupations and in that darkly voyeuristic

Fig. 27. Tintinnabuli. Raffaelle Ajello et al., *Antichità di Ercolano*, vol. 6 (Naples, 1771). The same volume, devoted to Bronzes, contains the Sleeping Faun (fig. 18).

Fig. 28. Erotic painting from Pompeii, first century A.D. Naples, Museo Archeologico Nazionale.

sexuality that infuses even his more public work. But this was not merely a personal discovery. Although the loves of the gods had been a recognized theme in art since the Renaissance, this was precisely the kind of work that it had been the ambition of neoclassical theorists to escape. Worse, graphic artists came to draw directly on the archaeological evidence of a passionate antiquity. The relics of a sensuous past—vases, herms, winged phalli, and more—were soon available to an audience that found in them more libertinage than "still simplicity" or "sedate grandeur." In a remarkably short time, these figures became part of the language of eighteenth-century pornography (fig. 30).[32] *Parapilla*, an anonymous tale in verse traces the amorous adventures of precisely the sort of flying penis Fuseli drew in his sketch; the notorious *Therese Philosophe* culminates in an irresistible seduction by means of an art collection.[33] In a similar vein, Thomas Rowlandson makes his "Modern Pygmalion" (ca. 1812) a carnival of sexualized voyeurism in which even the walls expose themselves and peep (fig. 31). In the process, Rowlandson heterosexualizes the same vase Fuseli used for his *Hamlet* drawing, but he in no way

Fig. 29. Fuseli, *The Kiss*, from a wall painting in Herculaneum, 1775. London, British Museum.

obfuscates the frank sexuality of the original, the sculptor is overwhelmed by the realization of his desire for the object he has created. Rowlandson—who drew on observations made in the studio of Joseph Nollekens in representing this "modern" artist—has evidently made his sculptor's creation a Venus, that is another statue from the past.[34] We may also read a revision of the "Origin of Painting" motif in this drawing. Instead of outlining her departing lover's shadow as Dibutade had done, however, the antique figure has a firm grasp on the organ of the artist's pleasure and reproduction. Although pleased, he seems ready to fall off his chair.

In *The Secret Museum: Pornography in Modern Culture*, Walter Kendrick identifies the influential role of the art of the cities of Vesuvius in the development of modern pornography and the related crisis in art-historical circles. The interwoven evidence of sexuality and common life in the ruins was impossible to deny. This is how an early cataloger expressed the inescapable sexuality of the objects found in Herculaneum: "Their imaginations, inflamed by the lure of pleasure, desired that all objects,

Fig. 30. Antoine Borel, title page, *Parapilla*, 1782. London, The British Library (PC.29.B.86.F.P).

Fig. 31. Thomas Rowlandson, *The Modern Pygmalion*, circa 1812. London, Victoria and Albert Museum.

even the most indifferent and alien to this purpose, should remind them of what seems to have been the sole focus of their existence."[35] Given what was evidently an inescapable quantity of material evidence to the fact, it is striking that the rampant and open sexuality of the city *seems* largely to have escaped remark in Winckelmann's writings on the city. His letter on Herculaneum mounts a subtle campaign in defense of a view of the past in danger of being rewritten—in part, in response to the very evidence around him. He mentions the notorious statue of a satyr copulating with a goat, but only to explain that he had not dared to ask permission to see it (*Critical Account*, 42–43). The winged penises and images of Priapus (49–51) are given an anthropological gloss, but there is something remarkable in his avoidance of the ubiquitous sexuality of the place.

In an intriguing example of misdirection, the most sexualized part of Winckelmann's entire account of the ruins of Herculaneum and Pompeii is a passage of great passion and unmistakable heat on the subject of the antique vessels found among the ruins:

> All those beautiful forms are founded on the principles of good taste, and may be compared with those of a handsome young man. . . . The chief beauty of these vessels consists in the softness and smoothness of their contours, little differing from those, which, in the bodies of well-made youths, have a certain elegance not to be met with, in equal perfection, in those of grown up persons. . . . The secret sensation our eyes experience, when we look at pure and simple forms, is like that produced by the touching of a tender and delicate skin. (*Critical Account*, 77)

This long passage, which ends the section on ancient objects, is an odd combination of perversely misplaced lust and a plea for unity in response to antique pots:

> Our ideas become easy and distinct, like those communicated by *the sight of an object simple in its unity*. . . . It looks, I say, as if our own feelings and reflections should alone be sufficient to bring us back to the beautiful simplicity of the ancients. *They* scrupulously adhered to what was once acknowledged to be beautiful. *They* knew that *the beautiful is always one*. . . . *We*, on the contrary, cannot, or will not, keep steady to any thing . . . but blindly give ourselves to an ill understood imitation, and, like children, are continually pulling down what we had, but the moment before, raised with *the greatest anxiety*. (*Critical Account*, 78–79; my emphasis)

With this comparison between the constancy of the ancients and the fickleness of the moderns, the lust of the plea for unity gives way to a worried jealousy. Longer analysis would illustrate the anxious sexual passion coloring the entire passage; suffice it to say that Winckelmann's re-

sponse to the fragments of Herculaneum gives evidence of the fear driving his insistence on unity ("the beautiful is always one"). Hence, also, the other part of the polemic running through Winckelmann's account—his ascription of everything of value in Herculaneum to Greece. Beautiful busts found there, he asserts remarkably, *cannot* be representations of Seneca, or of any Roman men or women (46–47).

"Frigid Reveries"

Fuseli left for Italy the year before Winckelmann's letter on Herculaneum was published in London. This fact, and the generally low quality of the translation, suggest that it is unlikely he was involved with its transmission to England. Nevertheless, he did translate Winckelmann's earlier thoughts on Herculaneum in the late 1760s, and it would be hard to believe that he was not familiar with the letter before he left. What is certain is that with him on his return from Italy Fuseli brought a new antipathy toward the art historian.[36] Although he still carried the banner of ideal nature and Greece in his lectures, he was not satisfied with the pattern of longing and admiration that Winckelmann had worked so long to establish.

In the introduction to the lectures he delivered as professor of painting at the Royal Academy, Fuseli provides a clear synopsis of the failures of the art historian. He charges Winckelmann with two apparently unrelated faults, his coldness and his blindness to the details of specific art-historical moments. But what draws Fuseli's most sustained fire is what he describes as the "shackles" Winckelmann has placed on artists following his teachings. "He reasoned himself into frigid reveries and Platonic dreams on beauty," writes Fuseli, conflating in a few words—"frigid reveries," "Platonic dreams"—the homoerotic passion in Winckelmann's description of antique statues, his willful blindness to the sexuality of the past, and his insistence on the primacy of ideal nature. Perhaps unfairly, Fuseli takes the older critic to task for his unwillingness to discriminate in his vision of antiquity. We hear the voice of new knowledge in Fuseli's attack:

> He has not . . . in his regulation of epochs, discriminated styles, and masters, with the precision, attention, and acumen, which from the advantages of his situation and habits might have been expected; and disappoints us as often by meagerness, neglect, and confusion, as he offends by laboured and inflated rhapsodies on the most celebrated monuments of art. To him Germany owes the shackles of her artists, and the narrow limits of their aim; from him they have learnt to substitute the means for the end, and by a hopeless chace [*sic*] after what they call beauty, to lose what alone can make beauty interesting, expression and mind. (2:14)

Fuseli is far from abandoning many of the principles of the art historian, or even the canonical works whose praise wearies him in Winckelmann. IIe was, for example, resistant to the Elgin Marbles when they began to supplant the statues of Rome as representatives of the new aesthetic ideal. Nevertheless, we see in this passage the movement toward a new valuation of the relationship of the artist to the past. The shackles follow directly after the rhapsodies on the canon. When Fuseli suggests that Winckelmann is responsible for the substitution of means for end, it is the obsession with the *thing* he has in mind; whereas imitation of the ancient canon had been presented as the means of achieving modern greatness, this emulation had become in itself a (dead) end. This is the reason that he prefaces his discussion of Winckelmann with an attack on the formalized method of instruction of the French Academy (2:13). His target is not so much Winckelmann's scholarship as the kind of training with which it was implicated, one leading to the tyranny of "celebrated monuments."[37]

The relationship to the past insisted on by Winckelmann and institutionally supported by the French Academy could not stand unchallenged because it was in conflict with new claims for "expression and mind." No longer is the received canon enough, nor is an idealized beauty the aim. A new standard has been proposed, one that insists on the artist's freedom to create. The abstract ideal of beauty ("Platonic dreams") leads to Winckelmann's worst crime, the inhibition of German creativity. "Expression and mind" represent the new standard, one that requires that the artist (the only source of these qualities) should take precedence over the art of the past. Fuseli would never entirely shed his neoclassical roots, yet he points toward an escape from the walls of antiquity which had so early overwhelmed him. "Expression and mind" are terms of value he shares with Hazlitt, a critic who made a more emphatic break with the worship of the past. Nevertheless, even in its collapse, and even as new systems of artistic validation emerged, the heritage of neoclassicism would inform and profoundly affect later accounts of the possibilities available to the artist in modernity.

Chapter Three

"UNITED, COMPLETER KNOWLEDGE": BARRY,
BLAKE, AND THE SEARCH FOR THE ARTIST

ALTERNATIVE ORIGINS

I T WAS FAR from obvious how to make useful what the eighteenth-
century drive to knowledge had thrown up in its wake. How could a
philosophy that had looked to the past because it embodied the vir-
tues of the original and ideal—purity and coherence—be reconciled with
the heterogeneous material that the search of the past had uncovered?
After the reveries and theories of the eighteenth century, the age of the
museum saw its greatest challenge in finding satisfactory arrangements
for a burgeoning assortment of material. In the balance of this section I
will discuss some of the rich strategies that emerged early in the nine-
teenth century in response to the crisis of neoclassicism. Even though
these solutions mark the collapse of aspirations toward the kind of rela-
tionship to antiquity described by such theorists as Winckelmann and
Reynolds, they nevertheless cannot be understood as instantiating any
kind of complete break. On the contrary, the alternatives described in
this chapter are remarkable precisely because of the way in which they
bear witness to the rich afterlife of the very ideas they sought to replace.

The nineteenth century was heir to both parts of the neoclassical leg-
acy: the urge to locate a point of origin that—like Winckelmann's an-
cient Greece—would validate contemporary work *and* the accumulation
of information that challenged any simple account of origins. Two of the
most long-lasting strategies of response are already in evidence at the
turn of the century: a new celebration of the *artist* (rather than the work)
of the past as ultimate source of validation; and the search for a powerful
new archaeology able to give meaning to the accumulation of pasts now
available. As an example of the former approach, here is John Boydell in
the preface of the 1789 catalog to his Shakespeare gallery:

> No subject seems so proper to form an English school of History Painting,
> as the scenes of immortal Shakespeare, yet it must be always remembered, that
> he possessed powers which no pencil can reach; for such was the force of his
> creative imagination, that though he frequently goes beyond nature, he still
> continues to be natural, . . . it must not, then, be expected that the art of the
> Painter can ever equal that of our Poet.[1]

The desire to establish an English school of painters along neoclassical lines underlay Reynolds's lectures and the foundation of the academy in which they were delivered, and the same ambition would still be an important part of cultural discourse throughout the 1820s and 1830s. Even as he couches his proposal in terms of history painting, the neoclassical genre of choice, Boydell anticipates, in his praise of Shakespeare, one of the most important strategies for finding a new basis for art.[2] Boydell's terms and tone would not be out of place in Winckelmann; although his aim is to describe the value of the native bard, not of some foreign statues, Shakespeare's works are ringed by the same aura that Winckelmann had found around the *Apollo Belvedere*. The most striking similarity between the sensibility of this passage and that of the art historian is the insistence on the impossibility of imitation at the very moment when emulation is being proposed. In both cases imitation is simultaneously presented as the sine qua non of the revitalization of the arts and as an act doomed to perpetual frustration. Like the Greeks, Shakespeare has a special relationship with nature, embodying it even as he goes beyond it. The pattern for both difficult idols is the faint ghost of another ideal, that of Christ—of whom it might well be said that "such was the force of his creative imagination, that though he frequently goes beyond nature, he still continues to be natural."[3] The odd combination of tenses in the passage, the easy slide from past to present, shows the strain on Boydell as he writes of this slippery natural/unnatural–timely/timeless subject. A phrase such as "the painter can [n]ever equal our . . . poet" is entirely of a piece with the demand for abjection, which is at the heart of neoclassicism and which, in this instance, has merely shifted its object of admiration from inimitable works of art to inimitable artist. The work of patriation has been done—this will be an English school of painters—but the same limits exist in this new invitation to illustration as were present in the challenge to imitate. An exemplary artist has become a true and undeniable ground zero of creativity, but the effect of such an apotheosis is a perpetual reproach to later artists.

Substituting the figure of the artist of the past for the object of abjection that antiquity itself had formerly been was one way to attempt to overcome the crisis of heterogeneous knowledge. Another strategy preserved neoclassicism's relation to cultural origins, but simply changed the actual location of those origins; it sought behind the rubble thrown up by archaeology for the real roots that earlier classicism had simply missed or mistaken. Among the most revealing examples of this approach is the notorious letter the neoclassical painter James Barry wrote to the Society of Dilettanti in 1793, in which he expressed his belief in the lost continent of Atlantis. The very variety of past civilizations, Barry argues, is

evidence of a unified anterior culture now lost. The existence of the is-land of Atlantis is the only way to make sense of the heterogeneity of the fragments of the past: "some almost unknown people, now buried in the remoteness of antiquity, must . . . have been in the possession of a body of extensive and complete knowledge, of which the Chaldeans, Egyp-tians, Gentoos, and other ancient nations, possessed only the fragments, which Homer, Thales, Pythagoras, Plato and others brought to Greece."[4] As was the case with the introduction of the Elgin Marbles, the recogni-tion of alternatives tended to undercut faith in previous accounts of an-tiquity. If Chaldean, Egyptian, and Hindu work predates the Greek, the erstwhile cradle of civilization becomes a governess—tending not a birth but an adolescence. The Greeks themselves, rather like the moderns, become the guardians and arrangers of fragments still more ancient than they. Barry's view saves the possibility of "the possession of a body of extensive and complete knowledge," but only at the expense of sacrificing the Greeks. As we shall see, this strategy is closely related to the one Blake uses in addressing the problem of originality.

Barry's frequent returns to this subject speak of an anxious defensive-ness. The passage just quoted, for example, is bolstered by a footnote that merely reiterates the same argument: "The actual existence of the ancient people above alluded to, who appear from so many unquestion-able vestiges to have been in possession of so much *united, completer knowledge*, is a fact of which I have no doubt" (2:583n; my emphasis). It may be noted that Barry's standard, "united, completer knowledge," is the same as Winckelmann's; it is only the objects of that knowledge, the sources of the unity, that have changed. In the course of his lectures on painting at the Royal Academy, Barry goes so far as to deny the charm-ing myth of the Corinthian maid who invented painting by tracing her departing lover's silhouette. He reads the tale as a vain attempt by the Greeks to co-opt the origins of painting; Barry insists that "[n]o such beginnings are traceable" (1:359). His preoccupation with origins is such that three pages into the printed version of his opening lecture Barry inserts a thirteen-page footnote on the question. This is not strange from a painter of the neoclassical school, but what is remarkable is his insis-tence on getting *behind* the Greeks. Athens was founded by an Egyptian; the Ethiopians preceded the Egyptians; and the Ethiopians in their turn, "seem themselves to have derived their knowledge from a still more an-cient people—from the Atlantides, those Titanic descendants of Ouranus . . ." (1:352 n).

The urge to locate a single origin that would make sense of the con-stantly accruing objects of past culture was not Barry's alone, though "Atlantis" took many forms. Richard Payne Knight gained notoriety with the publication of his *Discourse on the Worship of Priapus* (1786), a work

that linked a variety of symbols and ancient art works, including the Christian cross itself, to the male sexual organs. What was lost in the ensuing scandal was Knight's aim—to arrive at a theory that would explain not only the range of different fragments but also the sexual content of so much antique art. Beyond his largely unsuccessful effort to redirect prurient interest, Knight's work is only an extreme version of the attempt we have seen already in a number of forms, to trace the source of true absolute origins. The "united, completer knowledge" Barry had postulated and sought for in the past is found, but it is discovered to have the precise shape of the thing that had caused notions of a *pure* unity to collapse, the shape of the sexual organs.

Knight's work followed from the researches of Pierre François Hugues, a remarkable figure known as the "baron d'Hancarville," who was not only the editor of the highly influential book of engravings of William Hamilton's antiquities mentioned earlier, but who also produced one of the most notorious examples of the pornographic response to antiquity, *Monumens du Culte secret des dames romaines*, a text of uncertain date purporting to reproduce antique images illustrative of an ancient cult of sexual worship, but made up almost entirely of modern compositions based on classical erotic motifs. With such a background, Hugues was well equipped to write *Recherches sur l'origine, l'esprit et les progrès des arts de la Grèce* (1785), a work, partly financed by Knight, in which the antiquarian and pornographer attempted to trace all art to a primary source, the representation of human sexuality; this effort to rescue antiquity from the charge of mere obscenity was widely supported by the Dilettanti. These speculative texts by Knight and d'Hancarville represent a notable methodological development: the move away from attempting to explain the past and its objects by recourse to a classical literature that naturally had little to offer those who would plumb the mysteries of nonclassical traditions or who aspired to discover hidden elements in the culture of antiquity.[5] The option remaining was to interrogate the objects themselves for the secrets they seemed to hold. Rather than succumbing to the crush of information (including by the early nineteenth century an ever increasing knowledge of non-European arts), these writers sought in the accumulation of objects a pattern indicative of an acceptable unitary moment of origin.

JOSEPH OF ARIMATHEA: BLAKE AND THE WORK OF ART

Around 1773, when William Blake was still an apprentice, he produced what one of his biographers calls his first "original engraving"—an odd description for a work that would seem to have little do with origins: a print of a drawing (by Salviati) of a detail of Michelangelo's *Martyrdom of St. Peter*.[6] A simple piece, it depicts a pensive man standing by the ocean

among craggy rocks, his arms and legs bulky with an exaggerated aware-
ness of Michelangelo's style. More than thirty years later Blake returned
to this work and reengraved it (fig. 32). He added a touch more detail
and he lit a gentle halo of soft light around the man. Behind the rocks,
Blake also added the glow of a sunset or sunrise. But what gave the
picture a meaning it could not have had before were Blake's annotations,
identifying its subject by etching into the rock his name and situation:
"Joseph of Arimathea among the rocks of Albion."[7] The new light in the
picture suggests a halo, emphasizing the religious presence of the man
who took Christ down from the cross and may have brought the Holy
Grail to Glastonbury. Beneath the picture Blake has also added the fol-
lowing words:

> Engraved by W. Blake 1773 from an old Italian Drawing This is one of
> the Gothic Artists who Built the Cathedrals in what we call the Dark Ages
> Wandering about in sheep skins & goat skins. of whom the World was not
> worthy such were the Christians in all Ages
> Michael Angelo Pinxit

The etching presents a complex problem of recognition; an open contra-
diction complicates the double identification. This is a picture of a cathe-
dral builder and of Joseph of Arimathea, who of course existed before
cathedrals were ever thought of. Blake's echoes of Hebrews—"they [the
prophets] wandered about in sheepskins and goatskins; being destitute,
afflicted, tormented (Of whom the world was not worthy)"—make the
figure into an Old Testament prophet, thereby moving the frame of ref-
erence of the image even further back in time. The represented figure is
one of those who lived lives of faith but could not be saved because they
lived *before* the coming of Christ (Hebrews 11:32–40).

It is not only the subject of the engraving that can seem to telescope
back in time; Blake draws attention to the fact that, much like the figure
at its center, the work itself has a layered identity and history. Several
artists and even media are acknowledged when Blake notes that his figure
is taken "from an old Italian Drawing . . . Michael Angelo Pinxit." All the
stages of the image are present at once, from its origin, through the
drawing—or an engraving of it, which is all that Blake ever saw of
the "original" picture—to Blake's youthful exercise, to its current mani-
festation:

THE FIGURE:	THE IMAGE:
A medieval mason	Blake's mature work
Joseph of Arimathea	Blake's early work ("1773")
An Old Testament prophet	The drawing of Salviati
	The painting of Michelangelo

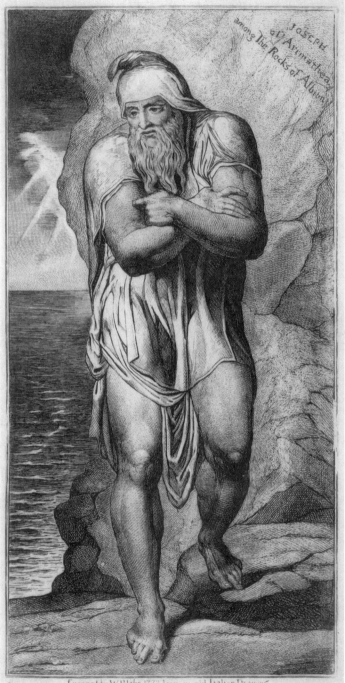

Fig. 32.
William Blake,
*Joseph of Arimathea
among the Rocks of
Albion*, 1805–20.
Cambridge,
Fitzwilliam
Museum.

This print offers a complex representation of the artist, and of the artist's relationship to the past, that bears comparison to related works by Fuseli. As in *The Artist in Despair*, a figure dominates the foreground, but there is no object to which he is paying the homage of tears. Far from it, Blake presents a confident self-possessed image of resurrection, incorporation, and patriation. The artist is not confronted with an object of the past; instead, as in Fuseli's satirical self-portrait, he himself has become that object.

Blake creates an image of an artist far stronger than those drawn by Fuseli. With his reference to Joseph of Arimathea, Blake conflates his artist figure with the man who took the dead Christ down from the cross and laid Him in his own tomb, from whence He was resurrected. By making his ideal artist someone instrumental in the resurrection, Blake suggests a powerful new relation to a dead past. Instead of a simple human tomb, Joseph's sepulcher becomes the site of miraculous rebirth. In placing Joseph of Arimathea "among the rocks of Albion," Blake further evokes his traditional role as the man who was said to have brought the Grail to England. The image hints at a relationship to art that may bring solace, not despair (as in Fuseli's drawing) or disintegration (as in his caricature).

Blake identifies Joseph as one of the builders of the cathedrals, following a tradition that linked him with the construction of Glastonbury. It is here that the artists *in* and *of* the picture come together, and they meet in the figure of the craftsman. It is notable, in this regard, that the image carries with it each stage of its physical creation. Blake even identifies the place of the piece in the history of his training when he writes on a proof at an early stage of the plate: "Engraved when I was a beginner at Basire's from a drawing by Salviati after Michael Angelo." Basire was Blake's master, the distinguished topographical and antiquarian engraver for whom Blake, as a sixteen-year-old apprentice craftsman, produced his "original" image. In celebrating Joseph as both prophet and craftsman, and evoking his own training in craft, Blake puts a new value on the carver of the stone (Joseph's name is carved/etched into the rocks of England). "This is *one* of the Gothic Artists," Blake writes, implying that he is writing in praise of a class of which there were more. This artist does not gaze at the stones of antiquity, he shapes them, and he includes in himself both the foreign and powerful (Michelangelo) and the native and strong (the builder of England's spiritual center).

That religion and art are closely related practices for Blake is one sign of the success of the eighteenth century in investing art with a significance beyond merely providing pleasure. Joseph identified with the unsaved Old Testament prophets represents the uncredited genius that comes before the modern era. Blake anticipates both Carlyle and Ruskin

in his turn to the medieval workman, the unselfconscious and therefore powerful creative force of the Middle Ages. The contempt for the crafts-man expressed by both Knight and Reynolds is rejected; instead, a pow-erful creative impulse is located in the hands of the mason. Blake directly rebuts Reynolds's great fear of the social abasement of art by labor in his annotations to the *Discourses*: "The Man who does not Labour more than the Hireling must be a poor Devil" (451). Similarly, Blake asks (with a pun on "art," which is not undeserved by Reynolds): "Why are we told that Masters who could Think had not the Judgment to Perform the Inferior Parts of the Art, as Reynolds artfully calls them" (449). Again, it is a paradoxical indication of the success of neoclassicism in validating art that its abandonment of craft could be reconsidered.

THE *LAOCOÖN*: STUPENDOUS ORIGINALS

Blake's strategy for overcoming the weight of the antique is twofold. He shares with what would come to be known as romanticism the charac-teristic of making himself a principal presence in his art. The artist avoids the neoclassical danger of losing originary power and becoming the mere cataloger and selector of the works of the past by being himself the strongest presence in his work. The second part of Blake's strategy does not avoid, but rather continues, the post-Enlightenment desire we have seen to reach behind the heterogeneity of actual objects and toward an earlier fundamental moment. Blake's linking of religion and art in *Joseph of Arimathea among the Rocks of Albion* represents the triumph of art in validating *itself*, in escaping the need to purvey the erudite morality tales of the history painter without risking a return to the decorative role feared by Reynolds. In Blake the creation of art is itself a religious prac-tice; the cathedral builder is a prophet and agent of salvation. That Blake was self-consciously rewriting the values of his neoclassical training be-comes evident in considering an engraving in which Blake has set himself the task of redefining while reproducing one of the most storied art ob-jects of classical antiquity. The interpenetration of art and religion as a challenge to neoclassical values is the theme of Blake's extraordinary *Lao-coön*, a work in which the interplay of text and image reaches far beyond the effects of *Joseph* (fig. 33). Art in the museum demands explanation; when the function of a work is more than simply purveying pleasure to the senses, then the standards by which the appeal of the object is to be understood must be defined. After a point, all art is supported by an invisible web of words. In his *Laocoön*, it is as though Blake has held the image up to a candle and revealed the secret writing that defined its place in the history of art. He chose well, because it is unquestionable that

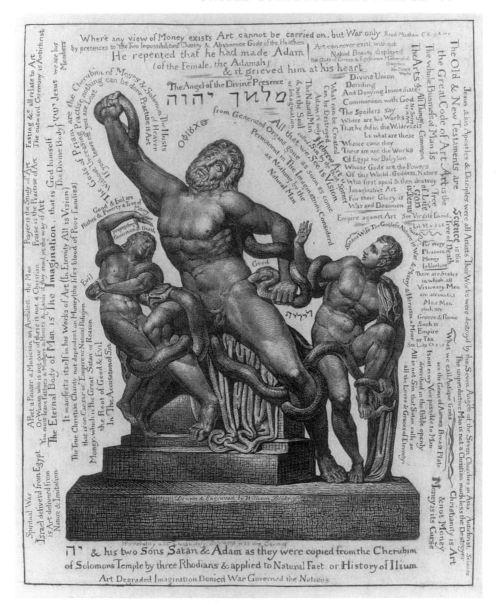

Fig. 33. William Blake, *Laocoön as Jehovah with Satan and Adam*, circa 1818. Cambridge, Fitzwilliam Museum.

much of the cultural value of the sculpture resides in its literary life. Like the city of Palmyra, the *Laocoön* has impeccable credentials.[8] The earliest commentators on the statue after its discovery in 1506 identified it as a work mentioned in Pliny (*Natural History*, 36.37). The subject itself—the Trojan priest and his sons set upon by sea snakes—was naturally (though probably mistakenly) linked in the educated mind with the *Aeneid*, the masterpiece of classical literature, which starts with the history of the Greeks and culminates with the foundation of Rome.

The sculpture was charged with importance for the neoclassical artist. From its discovery, the group, praised by Raphael and Michelangelo, has had a place in the galleries of the pope and in the cultural histories of Europe. It plays an important part in Winckelmann's treatise on the modern imitation of ancient artists, and in response it gave title and theme to Lessing's own study of the relation of the visual to the literary arts. As a model for the depiction of action and stress, and because of its apparent literary pedigree, the group lent itself as readily to debates over stoicism and expression in antiquity as to meditations on the limits of representation in different arts. We have seen how Nollekens looked to what its stones could say about proportion. Indeed the *Laocoön* had been described by Winckelmann himself as not only a model to be copied, but as part of the tradition of imitation in which neoclassicism found its pedigree, "the standard of the Roman artists as well as ours" ("On Imitation," 61). The received opinions on the *Laocoön* would of course not have been new to Blake, who was familiar from early in his career with Winckelmann's effusions, which he read in Fuseli's translation. In the very encyclopedia entry on sculpture for which Blake first copied the piece, his friend John Flaxman—influential sculptor, engraver, and teacher—echoes the words of Pliny on "a work to be preferred before all both of painting and statuary."[9]

Blake was hired to engrave the *Laocoön* for Abraham Rees's *Cyclopedia; or, Universal Dictionary of Arts, Science, and Literature* (1819), along with other canonical works of classical sculpture (fig. 34), and with a separate page of Etruscan, Persian, Egyptian, and Chinese pieces (fig. 35). Blake based his drawing and subsequent engraving on the cast in the Antique School of the Royal Academy. (A well-known anecdote records a meeting between Blake and Fuseli as he was engaged in this work.) As with the picture of Joseph of Arimathea, Blake was unwilling or unable to let the image go; he returned to it to produce a work that would locate a new meaning behind the stones. The second (ca. 1826–27) etching of the *Laocoön* is an extraordinary instance of the effects Blake achieves by overlapping or entangling the generations of the arts. Like the encyclopedic work for which the original plate had been commissioned, Blake's comments bring distant times and places together in one conceptual

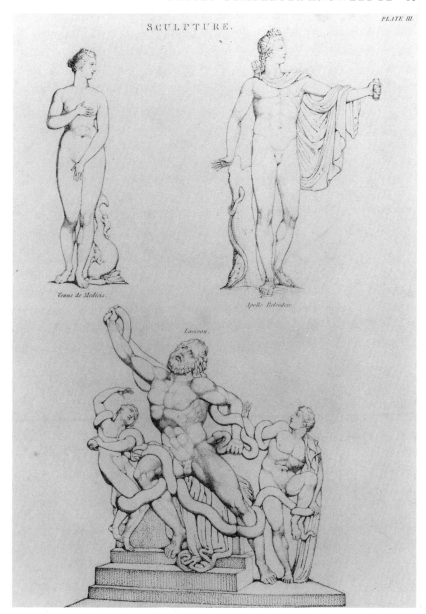

Fig. 34. William Blake, "Sculpture," plate III. Abraham Rees, *Cyclopedia; or Universal Dictionary of Arts, Science, and Literature* (London, 1819).

Fig. 35. William Blake, "Sculpture," plate IV. Abraham Rees, *Cyclopedia; or Universal Dictionary of Arts, Science, and Literature* (London, 1819).

frame. Unlike the *Joseph*, the words on this piece cannot be transcribed in any convincing order, or even separated from the work around which they wind—much as the snakes enmesh the priest and his sons. Words surround the statue suggesting at once such contradictory effects as definition, containment, and explosion. Once again Blake draws attention to the fact that the represented object is a copy going back many generations: etching to drawing to cast to sculpture. At the base of its pedestal Blake inscribes his own name, claiming both the drawing and engraving. Around the statue a variety of dicta proclaim three principal ideas: classical art is a corrupt version of sacred art; the creation of art is independent of money; imagination is the most important component of art. I would suggest that these three ideas come together in their shared relation to the theme of Blake's piece, the need to locate the true meaning hidden behind the art object.

At the bottom of Blake's etching the statue is identified as portraying Jehovah and his sons, Satan and Adam (the identification is in Hebrew, so that, like the Greek Blake also includes, the very language and alphabet send the viewer-reader to origins).[10] This, then, is an image of the original creator and his two earliest creations. Typically, for Blake, the creator is inextricably entwined with his fallen products. Blake's topic is artistic and religious origins, and his choice of the *Laocoön* serves him well. He maneuvers behind the facsimile he is reproducing by claiming that the original itself was "copied from the Cherubim of Solomons Temple by three Rhodians & applied to Natural Fact or [the] History of Illium." Blake's words allude to and draw on Pliny, so it is worth noting that Pliny himself mentions the work specifically in the context of his discussion of the problem of artistic fame when creative credit must be shared:

> The fame of many is not great, for in certain instances the number of artists involved stands in the way of their achieving individual renown even in the case of outstanding works, since no single person received the glory and since many names cannot all be recognized equally. Thus it is with the Laokoön . . . , a work which must be considered superior to all the products of the arts of painting and sculpture.[11]

With his own description, Blake explodes the problem that had concerned Pliny; no single person *should* "receive the glory." In Blake's account the Laocoön on display at the Vatican is no longer one of the great original works of art—to be measured and analyzed to its very fingertips; it is itself a second generation copy of a truer original lost to all but the visionary.

Not only is the piece a copy, but it is very much a *degradation* of the primary ideal because it has been applied to "Natural Fact or [the] History of Illium." Blake's "On Homer's Poetry & On Virgil," a text closely

related to the *Laocoön*, makes clear just how low Blake has placed this work: "Sacred Truth has pronounced that Greece & Rome, as Babylon & Egypt, so far from being parents of Arts and Sciences, as they pretend, were destroyers of all art. Homer, Virgil & Ovid confirm this opinion & make us reverence the word of God, the only light of antiquity that remains unperverted by War." Blake challenges the virtue of the classics at an ethical level by declaring them to be a falling away from the ideal into a warlike modernity (compare Barry: "The Greeks, the most Belligerent of all people" [2:423]). Part of Blake's strategy is to place Greek and Roman canonical texts on a level with nonclassical antiquity (i.e., Babylon and Egypt). As we have seen, when antiquity displays such diversity, the imagination is freed to seek prior origins. Blake, in his return to this piece, has not abandoned the ambitions of the Enlightenment, even when he admits a competition between sacred scripture and the classics.

The phrase, "the great code of art," which appears on the upper right corner of the print, has been traced to a similar formulation used by Robert Lowth in his influential translation of Isaiah (1778):

> Of all the precious remains of antiquity, perhaps Aristotle's Treatise on Poetry is come down to us as much injured by time as any: as it has been greatly mutilated in the whole, some considerable members of it being lost; so the parts remaining have suffered in proportion, and many passages are rendered very obscure, probably by the imperfection and frequent mistakes of the copies now extant. Yet notwithstanding these disadvantages, this treatise, so much injured by time and so mutilated, still continues to be *the great code of criticism*.[12]

To describe the *Poetics* Lowth uses the vocabulary of monument and ruin typically encountered in descriptions of ancient marbles. Though distance from the source has undermined the integrity of the object itself, it nevertheless retains its power precisely by standing in for a vital originary document otherwise lost. John Villalobos points out that Lowth's introduction places Aristotle's *Poetics* at the same level as the Bible, both being foundational texts that have suffered greatly over time:

> All writings transmitted to us, like these, from early times, *the original copies of which have long ago perished*, have suffered in their passage to us by *mistakes of many transcribers*, through whose hands we have received them; errors continually accumulating in proportion to the number of transcripts, and *the stream generally becoming more impure, the more distant it is from the source*. Now the Hebrew writings of the Old Testament being for much the greatest part the most antient of any; instead of finding them absolutely perfect, we may reasonably expect to find, that they have suffered in this respect more than others of less antiquity generally have done.[13]

The language of source and stream in this passage is reminiscent of Reynolds's *Discourses*, with which it is contemporary. Its argument is of a piece with the valuation through antique originality that motivated neo-classical theorists on art. And yet, the celebration of the original in this text brings with it as a corollary the denigration of the cultural value of the transmitted object currently in hand. The Bible *as it is* is not the original document; the stream that carried it has gathered impurities. To thus contextualize Blake's description of the Bible leads to a surprising conclusion; the Bible is both celebrated and lowered from its privileged position as Ur-text.[14] Bible and statue are both instances of admired cultural objects whose meaning has been lost or confused over time. In elucidating the true history of the *Laocoön* group, Blake reveals the visionary message that has become inaccessible to both art *and* religion. The work of his print is the deciphering of a code, a procedure that will untangle the true nature of things from their appearance. For this reason, the structure he gives the aphorisms with which he surrounds the *Laocoön* is that of simple translation: "x is y." On either side of the pedestal holding the *Laocoön* are statements against materiality in art; "Spiritual War / Israel delivered from Egypt / is Art delivered from Nature and Imitation," written on the left, is an indication of the antiacademic vision of art underlying the work. Nature and imitation are, of course, the two pillars of neoclassicism as taught by Winckelmann and Reynolds. On the other side of the pedestal we read: "Christianity is Art / & not Money / Money is its curse." This motto is illuminated by another which runs along the left side of the page: "Money, which is the Great Satan of Reason / the Root of Good & Evil / In the Accusation of Sin." Money is equated with reason, which is graphically paralleled to the captivity in which the imagination is placed by the academic practice of copying and celebrating ideal nature. Blake is making an argument against the doubly materialist approach to art in the period, which demanded fealty to the material creations of a dead past in return for making art a lucrative and respected profession. It is worth noting that the impulse behind Blake's disdain is in no way new with him. As was evident in the discussion as much of David and Reynolds as of Knight, the topic of working for money was a troubling one for entirely mainstream eighteenth-century artists and critics.

Blake's solution, as it would be for more and more artists throughout the nineteenth century, was to turn to the artist and the imagination as the true standards of achievement. "Jesus & his Apostles & Disciples were all artists." The admired object itself turns out to be ultimately inadequate and misleading, as it is a debased physical manifestation of the experiences of the imagination. Blake rips the *Laocoön* from its place

in the textbooks of art of the period and makes it into a model of the fall. All the players in that first quest after knowledge are present: God, Adam, Satan, the wives of Adam in their names, and the snakes called good and evil. Art itself is upheld, succinctly equated with true religion in a range of aphorisms: "A Poet, a Painter, a Musician, an Architect, the Man/Or Woman who is not one of these is not a Christian."

Addressing the challenge of neoclassicism (while not entirely escaping its influence) by identifying the belatedness of classical models is an important strategy not only in Blake's visual art, but in his poetry as well. *Milton* (1804–8), Blake's autobiographical epic, not only offers a celebration of the anterior artist closely related to that of *Joseph of Arimathea among the Rocks of Albion* (with which it is contemporary); it also serves, like that image, as an overdetermined representation of the patriation of art. In the poem, Blake's great literary predecessor returns to Albion to inspire Blake and save the nation. From the very preface of this complex poem Blake is engaged with challenging the terms used to discuss the great classical literary forebears—what he describes as "The Stolen and Perverted Writings of Homer & Ovid, of Plato & Cicero" (480). The writers of antiquity have mistranscribed (and therefore perverted) an earlier knowledge that was not originally their own. As was the case with the *Joseph of Arimathea*, the answer to the debilitating domination of ancient art is to declare that the very force its objects represent is also already native, that it is a power residing in each individual imagination and in England itself:

> We do not want either Greek or Roman Models if we are but just & true to our imaginations, those Worlds of Eternity in which we shall live for ever in Jesus our Lord.

> And did those feet in ancient time
> Walk upon England's mountain green?
> And was the holy Lamb of God
> On England's pleasant pastures seen? (480)

The themes of the *Joseph* and the *Laocoön* are brought together in these lines. The imagination can reach a more powerful antiquity and thereby engages a native tradition of grace that cannot be relayed by the classics. In alluding to the legend that Christ, like Joseph of Arimathea, may have walked in England before his death, Blake gestures toward a history of patriated grace in which the artist can partake.

The impulse that motivates the opening of *Milton* also drives the contemporary *Descriptive Catalogue* (1809), in which Blake describes his work to an indifferent public. Following his neoclassical training, Blake has produced history paintings showing the valiant actions of contemporary

heroes in the forms of ancient sculpture. But as we might expect, he traces his representations of Nelson and Pitt to an antiquity Reynolds and Winckelmann had never dreamed of:

> The two pictures of Nelson and Pitt are compositions of a mythological cast, similar to those Apotheoses of Persian, Hindoo, and Egyptian Antiquity, which are still preserved on rude monuments, being copies from some *stupendous originals* now lost or perhaps buried until some happier age. The Artist having been taken in vision into the ancient republics, monarchies, and patriarchates of Asia, has seen those *wonderful originals* called in the Sacred Scriptures the Cherubim ... being originals *from which the Greeks and Hetrurians [Etruscans] copied* Hercules Farnese, Venus of Medicis, Apollo Belvidere [*sic*], and all the grand works of ancient art. *They were executed in a very superior style to those justly admired copies.* (565; my emphasis)

Blake uses the competing antiquities, which were such a challenge to Barry and Knight, as a means of escaping the burden of Greek art. Though he is not as contemptuous of the received opinion as he might be in this account (the earlier statues are "justly admired"), it is clear that the works of the past actually available (he calls them "translations," in his *Public Address*, 595) in no way measure up to the originals from which they derive. Blake's own history paintings are based on true originals, not on the copies of copies that are the Greek work.

The *Descriptive Catalogue* contains a slashing attack on Enlightenment interpretations of history, which is paralleled with a discussion of artistic education: "It has been said to the Artist, 'take the Apollo for the model of your beautiful Man, and the Hercules for your strong Man, and the Dancing Fawn for your Ugly Man.' Now he comes to his trial. He knows that what he does is not inferior to the grandest Antiques" (579). Because he stakes his claim on inspiration, Blake's achievement can be no greater than that of past inspired art, but it can also be no less. Such claims move a great distance from the world of David and even Fuseli, in which the selection of models was done from a limited museum of masterpieces. In Blake's writing and art we still see evidence of the struggle to claim some measure of independence from a neoclassical education; his terms are often those of a system he despises, his tools are frequently borrowed from the enemy. Nevertheless, he is a vivid representative of the vital turn from art to artist, a shift that would guarantee new powers, along with new anxieties, to artists who would follow.

PART TWO

THE AUTHOR AS WORK OF ART:
ACCUMULATION, DISPLAY, AND DEATH
IN LITERARY BIOGRAPHY

Chapter Four

HAZLITT, SCOTT, LOCKHART: INTIMACY, ANONYMITY, AND EXCESS

"That Which Is Unseen": The Life of Genius

I N 1825, the young Scottish man of letters, Robert Chambers, published in Edinburgh the much enlarged second edition of a volume entitled *Illustrations of the Author of Waverley: Being Notices and Anecdotes of Real Characters, Scenes, and Incidents, Supposed to Be Described in His Works*. This long title was faced on the verso page by an engraving depicting an ornate frame attached to the page as to a wall (fig. 36). Decorated with stylized vegetation as well as leaves and Scottish thistles, the frame holds within it an image of the clothed torso of a man posed before a vague landscape or cloud. The figure is partially covered with a cloth, lifted just enough to reveal his body while hiding his face. Underneath the portrait there is a line from Tacitus: "Eo Magis Praefulgit, Quod Non Videtur" (that which is unseen, shines the brighter).

Engraving and text illuminate Chambers's project: the identification of an assortment of "originals," the historical bases for events and characters in the still officially anonymous novelistic oeuvre of Walter Scott. My discussion will not explore those illustrations; it will stop, rather, on the frontispiece. What interests me is the manner in which image and title together demonstrate an emerging new valuation of the figure of the author—one that manifests itself, paradoxically, in hiding, in being "unseen." The tantalizing shape in the frame, as much as the Latin tag, indicates the attraction through tantalization ascribed to the "Author of Waverley," a charm not unrelated to the sort of fascination once reserved for artists of a more distant past. In this instance, however, that fascination is being provoked by a contemporary author. The original model for Chambers's project, in title and content, is certainly Francis Douce's important *Illustrations to Shakespeare* (1807), a work tracing the sources behind the writings of a figure whose indisputable canonicity easily justified the project.[1] As Douce did with Shakespeare, Chambers will do with Scott, plumbing the author's texts for their historical bases. Still, everything about the title page indicates that, as much as the writings, it is the author himself who fascinates, who is half-hidden, half-revealed. The "illustrations" referred to in the title illuminate not the novels but the au-

Fig. 36. Frontispiece. Robert Chambers, *Illustrations of the Author of Waverly* (Edinburgh, 1825).

thor, as though the aim were not better understanding of texts so much as greater intimacy with a nameless, faceless figure, a hidden presence.

Scott's ostensible anonymity—emblematically represented by the mysterious image facing the title—is a complex topic to which I return in my subsequent discussion of Lockhart's biography, but it is important to keep in mind the notional quality of his secret. Although Scott had been an extraordinarily successful and well-known poet since the publication of *The Lay of the Last Minstrel* in 1805, almost all of his works of prose fiction, beginning with *Waverley* (1814), were published with no author named on the title page. Arguably the most successful author of the nineteenth century, Scott was identified to the public through most of his prolific publishing life by the name of his first novel—as "The Author of *Waverley.*" Nevertheless, while much is made in Lockhart's monumental biography of Scott and elsewhere of the lengths to which Scott would go in order to hide the authorship of his novels from the world, it was a secret shared by most literary people in England and Scotland. Indeed, although Scott only explicitly acknowledged his prose fiction in 1827, the very year he brought out *Waverley* we find Jane Austen commenting ironically in a letter on the novel that would give a description to his anonymity: "Walter Scott has no business to write novels . . . I do not like him and do not mean to like *Waverley.*"[2] Still, Lockhart supports Scott's unlikely contention that no more than twenty people knew of his novel writing before 1826.[3] Indeed, though there were plenty of hints dropped as to Scott's authorship, there were also works written to *prove* this premise—most notably John L. Adolphus's *Letters to Richard Heber* (London, 1821), an effort that so gratified Scott he invited its young author to his home.[4]

Chambers's project and the manner in which he chooses to illustrate it are part of a new fascination with the figure of genius that in England was most frequently identified with the literary artist. That fascination also led to the popularity and rapid rise of a new genre: the author biography. As I hope to indicate in this section, the use of the fine arts in framing the author in this instance is more than a conceit, and the role of the unseen is more than an accidental element in the formation of Scott's reputation. The fiction of Scott's anonymity evidently played a part in the cultural placement of the author aimed at by both Scott and Lockhart. Chambers's evocation of that convention by means of the veiled figure in his frontispiece may serve to remind us of the power of anonymity in culture. It is the hidden author that gives shape to Chambers's fascinated researches. The use of this concealed figure as an emblem of a greater materiality to be found beneath the surface of literary texts suggests that the real substrate in question may be the author himself. Nevertheless, the somber tease of the engraving implies a notion that the

Latin tag clinches, that the interest of a thing may be *due* to, not in spite of, its being hidden and mysterious. These pages offer a useful summary of the complex and unstable determinants of the cultural presence of the creative artist in the first decades of the nineteenth century, at once inviting study and remaining hidden—"shining the brighter" for keeping covered.

If, as I suggested in Part One, the artist came to replace the art object as a figure of unattainable perfection, what then was the lot of the living practitioner of the art? A developing sense of the importance of the artist resulted in uncertainty about how to reconcile life with mystery, presence with authority. Part Two, like the remainder of the book, is dedicated to following the interplay of the accumulation of art and the representation of artist figures in the nineteenth century. As the emergence of Shakespeare and Milton as key points of reference for artistic achievement will have suggested, it is in authorship that English culture found its particular call to admiration. More writers became objects of a fantastic admiration in the first half of the nineteenth century than in all previous centuries combined, not because of any dramatic increase in the quality of English writing but because of a notable increase in the need to admire.[5] Nevertheless, the valuation of the artist in the nineteenth century depended on maintaining a difficult balance between fascination and repulsion; the increasing desire to learn more about authors led to a preoccupation with their lives, which often threatened to undermine the very qualities supporting their status in culture.

Robert Chambers would become an influential figure in later life, producing, along with his brother, literary biographies and miscellanies, as well as the *Chambers Cyclopedia* and *Journal*, all works with evident links to this his first one. But the production most intriguingly related to the project of *Illustrations*—the searching out of the originals of an unknown author—is certainly that by which Chambers found his own anonymous notoriety some twenty years later, *Vestiges of the Natural History of Creation* (1844). This volume, an important if flawed precursor to Darwin's work, was published with a methodical secrecy worthy of Scott himself. It was a warranted caution, as Chambers's attempt "to connect the natural sciences into a history of creation" provoked a firestorm of controversy.[6] Chambers's literary debut and the notorious production of his maturity are linked at once in method and in concept. Both works demonstrate the drive to locate an absent and unreachable original source of creation by focused attention on the evidence of the created world. The very language of his ambitious scientific theodicy demonstrates the congruence of the two projects. To put the matter baldly, it is more than a coincidence that Chambers describes his aim as the search of creation for an "Almighty Author," for "the author of Nature."[7] That the similarity of

approach demonstrated in the two projects is motivated by a correspond-ence in object of study is suggested by the religious terms in which their author describes his first meeting with the man whom he doubtless knew to be the Author of *Waverley*: "I was overwhelmed with the honor, for Sir Walter Scott was almost an object of worship to me."[8]

Chambers's reverential response to Scott raises important questions as to the connection between an admiration verging on idolatry and the peculiar anonymity involved in Scott's cultural impact. The half-hidden image of the Author of *Waverley* appended to Chambers's text may be taken, along with the project it illustrates, as a representation of the con-temporary artist in a culture in which the high expectations from that category fit only uneasily actual living practitioners. The parallels Cham-bers suggests and openly draws between his author and divinity (or the primal creative forces treated in *Vestiges*) demonstrate that the place of the artist could be high indeed. But simple humanity will rarely satisfy such exalted expectations; it may be that it is only in being hidden, in being partially known, that the author can maintain such an aura. My concern in Part Two is to demonstrate the tension between knowledge and admiration shaping some of the most important literary biographies of the period.[9] I treat the genre as a manifestation of the urge to the organization of admired cultural artifacts discussed in Part One. My focus, for this reason, is on the presence of the language of the culture of art in accounts of literary lives. It is not a coincidence that Chambers's engraver placed the Author of *Waverley* in a picture frame: the organiza-tion and reception of the plastic arts provided forms in which to express the significance and cultural value of other treasured material. To a re-markable degree, authors came to be included in this category.

Some Biographical Influences

Literary biography achieved standard forms and a firm place in culture in the nineteenth century.[10] Though the "life" had already become a com-mon feature of editions of poets' work in the previous century—John-son's own extraordinary contribution to the genre being a culmination of the practice—in the early nineteenth century there was an increasing tendency to publish the lives of authors independently. Generally speak-ing, examples of the genre in the period follow the quite distinct models presented by two great eighteenth-century predecessors, Johnson and Boswell. But nineteenth-century biographers drew on a variety of often contradictory strategies for representing the significance of the artistic life. Johnson's *Lives of the Poets* was the last great expression of an attitude toward literature and the writer that, though it would never disappear in the nineteenth century, was gradually overwhelmed by a growing fascina-

tion with genius and personality, with the artist's self. Boswell's *Life of Johnson*, a monument to admiration, offered an argument by example that the life of an author deserved and could sustain an account of great breadth and microscopic detail. The values implied in Boswell's project are given voice in Lockhart's answer to criticism of the length of his biography of Scott: "I suggest that if Scott really was a great man, and also a good man, his life deserves to be given in much detail" (Lockhart, 7:viii). The nuanced critical eye of Johnson, evaluating an established canon for strength and weakness of character and style and producing an essay-length response, came to be replaced by a frequently expansive, nearly always partisan defense of the author's life and celebration of the work, a genre of biography owing more to Boswell than to his master. (Boswell himself describes his own project as correcting "the notion [of Johnson] that has gone around the world.")[11] The contrast between these two approaches to the task of biography is most evident in the different relationship between author and public that each instantiates. Johnson—making his case to a public whose overall opinion is the ultimate bar of judgment—represents an idea of criticism that was to be steadily eroded though it never entirely disappeared (at least in biography; it has had a long and often unfortunate life in the critical press). Later biographers, like Boswell, would often work to create the climate of reception for the work of their subjects by means of their presentation of the life; sometimes—as in the case of Milnes's life of Keats, discussed later—this pros-elytizing would take place alongside report of their subject's ostensible indifference to public opinion. Johnson's voice is that of a cosmopolitan magisterial sensibility taking moral judgments as seriously as aesthetic ones; Boswell is the fascinated myopically focused partisan, explaining away each fault, obsessed with the minutiae of the life of his subject.

Along with these imposing forebears, it is important to include the less known but pervasive influence of the pedantic *psychologizing* of Isaac D'Israeli.[12] It was not the writing of full-blown life narratives that interested the father of Benjamin Disraeli; D'Israeli gathered biographical details into essays and compilations that served to describe and promote interest in an artistic personality *type*. D'Israeli vividly represents both the growing fascination with genius and a new interest in the life of the person bearing its mark. His work shows the traces of its development out of such eighteenth-century concerns as the analysis of the faculties of consciousness, but it was most influential in the romantic and Victorian eras.[13] In the heterogeneous yet consistent project that is his literary history—especially in the *Literary Character of Men of Genius* and the *Calamities and Quarrels of Authors*—the life of the artist becomes argument and subject. D'Israeli notes that "theories of genius are the peculiar constructions of our own philosophical times," but his own work is far from what is usu-

ally called theorizing; he rather assembles examples from an ever more extensive canon of biography in literature and art.[14] Not only is his argument quite literally written from within the library, but D'Israeli draws attention to the fact that his project can only exist in a culture with a large and heterogeneous quantity of printed information available and requiring organization. Consider the method described in his 1795 preface, "To seise [*sic*] the dispositions of the literary character I looked into Literary History and my collections exceeded my hopes" (1795, iv). Research is collection for D'Israeli; his response to literary history is to accumulate instances. Biography is his tool for establishing the parameters of the artistic character, the nature of his subject as well as his method of research having both been determined by the diffusion of print culture throughout Europe.[15] The proliferation of sources of knowledge and its relation to the identification or neglect of genius was a constant concern: "Since, with incessant industry, volumes have been multiplied, and their prices rendered them accessible to the lowest artisans," he notes as early as 1795, "the Literary Character has gradually fallen into disrepute" (xv; see also xix). The growth of knowledge—and, more specifically, of access to texts disseminating that knowledge—is at once the enabling factor for D'Israeli's work and a challenge he seeks to answer.

Twenty-three years later, in the first nineteenth-century edition of *The Literary Character*, D'Israeli expresses less anxiety to defend authors from the decline in status into which printing had driven them. Rather, he suggests that printing has led to the existence of a coherent culture of authorship:

> Since the discovery of that art which multiplies at will the productions of the human intellect, and spreads them over the universe in the consequent formation of libraries, a class or order of men has arisen, who appear throughout Europe to have derived a generic title in that of literary characters; a denomination which, however vague, defines the pursuits of the individual, and serves, at times to separate him from other professions. (1818, 7)

Although later editions will be more confident in their formulations of the distance between authors and other ranks of society, this text expresses clearly the importance of the diffusion of knowledge for the formation, as much as for the identification, of this class:

> These literary characters now constitute an important body, diffused over enlightened Europe, connected by the secret links of congenial pursuits, and combining often insensibly to themselves in the same common labours. At London, Paris, and even at Madrid, these men feel the same thirst, which is allayed at the same fountains; the same authors are read, and the same opinions formed. (9)[16]

D'Israeli devotes himself to uncovering those hidden links among men of genius which both define their common role and distinguish them from other classes of society. His project insists on the presence of a family resemblance, even among those who cannot see it: "the same feelings, and the same fortunes have accompanied them who have sometimes, unhappily, imagined that their pursuits were not analogous" (1818, 16). Difference from the rest of the world, even a hostile relationship to the world, is an important constitutive part of artistic identity at its highest pitch: "The modes of life of a man of genius . . . are in an eternal conflict with the monotonous and imitative habits of society" (69).

It is important to note that by the time his work enters the nineteenth century, the specific artistic practice has become irrelevant to D'Israeli's psychologizing; what concerns him is a kind of mind and the resulting temperament: "In the history of men of genius let us not neglect those who have devoted themselves to the cultivation of the fine arts; . . . they pass through the same permanent discipline. The histories of literature and art have parallel epochs; and certain artists resemble certain authors.—Hence, Milton, Michael Angelo, and Handel!" (16).[17] D'Israeli is wide-ranging in his comparisons, at one point drawing parallels between the early lack of promise of Domenichino and Goldsmith; an Italian painter of one era and a man of letters of another meet in the type of genius (35). It is little wonder, given this sensibility, that D'Israeli draws attention to what might strike others as merely incongruous, Montesquieu's quoting of Correggio at the conclusion of the preface to *The Spirit of the Laws*: "Ed io anche son pittore" (I too am a painter, 67–68).

The Lives of the Novelists

The literary biographer could draw on a variety of models by the early decades of the nineteenth century, and so it is that a journeyman effort such as Walter Scott's *Lives of the Novelists* reveals a range of not entirely harmoniously deployed antecedents. Johnson's tone of magisterial public judgment is an influence, but so is D'Israeli's preoccupation with the artistic character. Scott's essays are workmanlike productions, following Johnsonian form with little variation—three sections comprised of life, character, and work. But the influence of Johnson is more than formal; it shapes as much the humane tone recounting the events of the lives as the unelaborated suggestions of generic progress from life to life.[18] Alongside such elements, however, one can see in Scott's *Lives* newer and not entirely assimilated features owing more to D'Israeli than to Dr. Johnson; in the midst of the measured Johnsonian sensibility, which provides so much of the structure to the lives, Scott's evident interest in the peculiar

character of men of genius, and his sense that such men stand outside the parameters of normal social evaluations, are notable divagations.[19]

Scott expresses the nascent public fascination with literary figures at the level of anecdote or gossip ("who loves not to know the slightest particulars concerning a man of his genius?" [12]). But he also draws attention to a paradox that could have been transcribed from the work of D'Israeli, the posthumous near worship of figures who have led obscure and miserable lives:

> The distinguished men of genius whom, after death our admiration is led almost to canonize, have the lot of the holy men, who, spending their lives in obscurity, poverty, and maceration, incur contempt, and perhaps persecution, to have shrines built for the protection of their slightest relics, when once they are no more. Like the life of so many of those who have contributed most largely to the harmless enjoyments of mankind, that of Le Sage was laborious, obscure, and supported with difficulty by the precarious reward of his literary exertions. (390)

The role of the public is the point of ambiguity in this passage. It is, after all, an incongruous practice to build shrines to the source of mere "harmless enjoyment." Scott's account oscillates between a nineteenth-century celebration of the artist, its language drawing explicitly on religious models (the genius as almost saint, as holy man, his suffering validated, or even required, by his high position), and a more prosaic and conventional view of literature as the source of mere "harmless pleasure."

The heterogeneity of sources shaping Scott's *Lives* demonstrates not only the coexistence of contradictory impulses and methods in the representation of the author, but a real uncertainty as to the ultimate source of value of the creative figure. The explicit valuation of the author varies markedly even within a single text as the complex web of possible attitudes toward this figure is disturbed by shifts in emphasis. Although we may understand Scott's work to be carrying the conflicting elements in unassimilated suspension on its surface, with none of the contradictory versions of the artist taking precedence for long, in the image of the half-exposed author reproduced in the frontispiece to Chambers's *Illustrations* we see one extreme resolution of the tension between intimacy and distance. The author in the latter instance becomes a fixed element, like the Scottish thistles that surround the frame, or the historical correlatives to Scott's fictions that make up Chambers's actual text. The author in the frame also becomes an art*work*, with all the attendant distance from the viewer implied by that category in the period. And yet, the very fascination with the person of the author admitted by Scott in the foregoing passage is also evident in the half-revealed image and its tantalizing hint

at the possibility of greater intimacy. This unstable play between intimacy and admiration is the never resolved challenge of nineteenth-century biography.

TALKING IN A TEMPEST: HAZLITT ON CONTEMPORARY LIFE

In 1825 William Hazlitt published *The Spirit of the Age*, a collection of essays combining biographical sketches of prominent contemporaries into a mosaic representing the culture of his era. This brilliant polemical summary shares the moral seriousness and willingness to judge of a Johnson, but its underlying sense of the role of art and artist owes much to late eighteenth-century debates on art and to romantic theories of the artist. Hazlitt's inclusion of authors in the same gallery as philosophers and religious thinkers implies the important status of artists in culture. Imaginative writing can be included in the company of philosophy and religion if it is understood to be far more than what Scott termed a "harmless pleasure." It is all the more striking, then, that the situation of the modern artist described in the text is so remarkably difficult.

The essay on "Mr. Coleridge" in *The Spirit of the Age* is typical of Hazlitt's methods and concerns. A cacophonous damp wind blows through the piece, evoking not only its subject's notorious loquacity, but also the maelstrom of culture that eventually drowns it out. Unchecked speech is Coleridge's identifying trait throughout Hazlitt's work, but the storm of noise Hazlitt raises in this essay has a wider significance.[20] The failure of Coleridge to achieve any of his ambitions, or—what is the same to Hazlitt—to *be* any one thing, is the result of succumbing to the fragmentary heterogeneity of past culture. The noisiness of the essay is a figure for this collapse and the text becomes as much a diagnosis of cultural crisis as a critique of a gifted but flawed contemporary. The well-known opening of the essay enacts its theme; its baldly stated original premise starts in the present and with reason, with conversation, but immediately swerves to the past, or the past's presence in the present. In the process it develops from a set of calmly expressed dicta into a frenzy of noise:

> The present is an age of talkers, and not of doers; and the reason is, that the world is growing old. We are so far advanced in the Arts and Sciences, that we live in retrospect, and doat [*sic*] on past achievements. The accumulation of knowledge has been so great, that we are lost in wonder at the height it has reached, instead of attempting to climb or add to it; while the variety of objects distracts and dazzles the looker-on. What *niche* remains unoccupied? What path untried? What is the use of doing anything, unless we could do better than all those who have gone before us? What hope is there of this? We are

like those who have been to see some noble monument of art, who are content to admire without thinking of rivalling it; or like guests after a feast, who praise the hospitality of the donor and "thank the bounteous pan"—perhaps carrying away some trifling fragments; or like the spectators of a mighty battle, who still hear its sound afar off, and the clashing of armour and the neighing of the war-horse and the shout of victory is in their ears, like the rushing of innumerable waters. (11:28–29)

Hazlitt's prose enacts the cascading tumult of culture it describes, jumbling together effect and cause, the quandary and its source.[21] His argument appears simple enough, yet his exposition evokes a complex set of references. The despair in the museum I described in chapter I here merges with panic in the library. Bromwich and others have traced the motif of belatedness that is central to Hazlitt's writings on art; what is particularly noteworthy about its expression in this instance, however, is the use of motifs drawn from the culture of fragment and museum.[22] What Hazlitt calls "knowledge" has such a physical presence in the passage that it accumulates into a pile that leaves the individual "lost in wonder" at the height of it. He describes the relationship of modern persons to past culture as resembling that of travelers to a celebrated ruin: "like those who have been to see some noble monument of art," we may carry away "some trifling fragments," but our souvenir serves merely to remind us of our distance from its source. Hazlitt's use of the word "*niche*" underlines the point that sculptural objects are an important component in the cultural crowding he describes. The museum is full; the only task left is to look on in admiration.

The previous year, in "Pope, Lord Byron, and Mr. Bowles" (1821), Hazlitt had presented a similarly dark view of the effect on a sense of human achievement of the admiration of fragments of antiquity:

> What is the use of taking a work of art, from which "all the art of art is flown" a mouldering statue, or a fallen column in Tadmor's marble waste that staggers and over-awes the mind, and gives birth to a thousand dim reflections, by seeing the power and pride of man prostrate, and laid low in the dust; what is there in this to prove the self-sufficiency of the upstart pride and power of man? (19:73)

The terms in this passage are similar to those at the opening of the piece on Coleridge, two instances of what we might call the "what is the use?" motif. In both cases, a paradoxically prostrate position is ascribed to the viewer, brought low and incapacitated along with the fragments of antique ruins. In the essay on Coleridge, however, it becomes clear that the problem is not accumulation alone; the *heterogeneity* of the material uncovered further incapacitates, reducing the individual to a mere voyeur of

culture: "the variety of objects distracts and dazzles the looker-on." For weak, if fascinated, gazers, the past becomes an object of wonder and violence, the confusion of an unexpected battlefield. Such onlookers, writes Hazlitt, drawing on classical and biblical resonances for his rhetoric, are "like the spectators of a mighty battle, who still hear its sound afar off, and the clashing of armour and the neighing of the war-horse and the shout of victory is in their ears, like the rushing of innumerable waters."

The unlikely progression of images in this last sentence—from monument to feast to fragment to battle to cataract—is worth dwelling on, and is peculiar enough to imply some particular substrate giving it shape. I believe that behind the watery battle and the very language used to describe it is, first of all, a doubled textual antecedent: not only echoes of the Old Testament but of a classical text, the description of the massacre carried out by an enraged Achilles at the beginning of book 21 of the *Iliad*, when he drives the Trojans into the river Xanthus:

> Part plunge into the Stream: Old Xanthus roars
> The flashing Billows beat the whiten'd Shores:
> With Cries promiscuous all the Banks resound,
> And here, and there, in Eddies whirling round,
> The flouncing Steeds and shrieking Warriors drown'd.
>
> The clust'ring Legions rush into the Flood:
> So plung'd in Xanthus by Achilles' Force,
> Roars the resounding Surge with Men and Horse.
>
> Deep groan the Waters with the dying Sound.[23]

It may seem strange that the violent confused roar of horses, men, and waters in Homer should be echoed in the conclusion of Hazlitt's paragraph describing the situation of modernity, but the point is precisely that the problem of modernity is the accumulation of the past—an accumulation that in this essay takes the shape of noise. It should not be surprising that we find, embedded in this account of the crowded museum, pieces of some of its most celebrated textual monuments.

As Hazlitt's theme is excess, it may not be unreasonable to detect still another classical monument behind this overdetermined introduction. The reference to retrieved antique fragments followed by the memory of distant battles serves to evoke some quite specific fragments of that past art we have recovered on visits to "noble monuments." That odd battle of men and horses emerging at the text's culminating moment carries with it not only a clamorous echo of Homer, but also the ghost image of fragments on which Hazlitt had written and with which he was deeply

engaged. It is worth considering whether the Elgin Marbles and their companions at the British Museum, the Phigalian Marbles from Bassae, are the stones giving texture to this passage. These antiquities were displayed together in a temporary gallery at the British Museum from 1817 to 1832. Hazlitt, who participated in the campaign to acquire the Elgin Marbles as early as 1816, would have visited them there in the 1820s, particularly when he wrote his 1822 essay "On the Elgin Marbles"—only three years before "Mr. Coleridge."[24]

The rushing waters of this passage and essay may seem an unlikely site for such a reference, but dynamic aquatic images are not unusual in Hazlitt's writing on these works. When Hazlitt compares the pieces from the Parthenon to a cast of the Torso as reproduced by Michelangelo, he writes of "that 'alternate action and repose,' . . . *as inseparable from nature as waves from the sea.*"[25] Two pages later he offers a particularly kinetic passage:

> *It seems here as if stone could move*: where one muscle is strained, another is relaxed, where one part is raised, another sinks in, *just as in the ocean*, where the waves are lifted up in one place, they sink proportionally low in the next. (9:329)

Again, five pages later:

> The Ilissus, or River-god, is floating in his proper element, and is, in appearance, *as firm as a rock, as pliable as a wave of the sea*. The artist's breath might be said to mould and play upon the undulating surface. The whole is expanded into noble proportions, and *heaves* with general effect. . . . [the parts] *float upon the general form, like straw or weeds upon the tide of ocean*. (9:344; my emphases)

These examples demonstrate Hazlitt's predilection for aqueous imagery when writing on sculpture, his readiness to shift from stone to water. In order to understand the presence of these particular statues in the essay, however, it is important to remember that besides the calm friezes depicting processions to sacrifice, and the tranquil pedimental statues of gods in repose that Hazlitt praises, the Parthenon Marbles brought to England by Lord Elgin also included a number of large metopes representing quite vividly—if in a fractured form—a battle between Lapiths and Centaurs (men and horse-men) (fig. 37). The Phigalian marbles immortalize the same mythic contest (fig. 38), along with a battle with Amazons, itself depicted as a symphony of clashing shields. The noise overwhelming modern man in Hazlitt's introduction to his essay on Coleridge takes its form from the silent violence depicted in these pieces because the clamor stands for the disturbing presence of objects representing not only the surfeit of knowledge but its broken manifestations in the present. Antique ruins are both instance of and metaphor for what

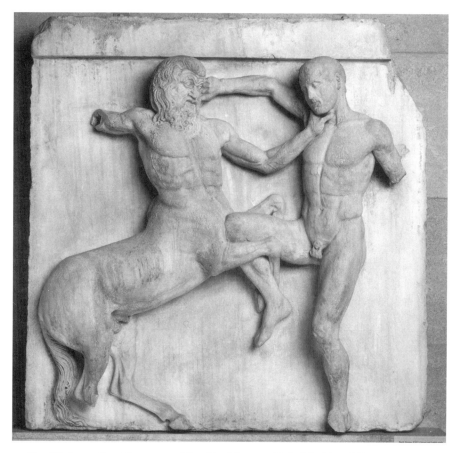

Fig. 37. Struggling Centaur and Lapith. Metope, Elgin Marbles, fifth century B.C. London, British Museum.

has sometimes been called the "burden of the past." But for Hazlitt and others the problem with the past is precisely that it does not cohere into anything like a single burden. The jumble of cultural fragments evoked in this introductory passage leads straight to the incoherent noise made by Coleridge, the subject of the essay, and they are intimately linked. Like those artists who found themselves looking up to productions of the past and seeing their own inadequacy, the modern artist, of which Coleridge is a symbol, has been overwhelmed by the inexorable accumulation of knowledge and objects. Antique ruins are at once instances of the weight of past knowledge and symbols of the overwhelming nature of its accumulation.

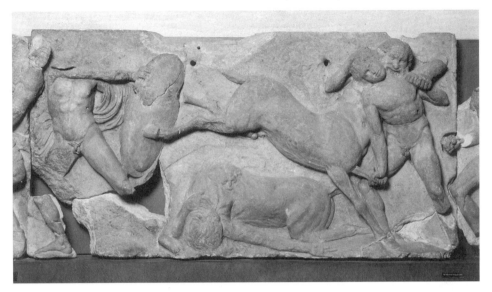

Fig. 38. Battle of Lapiths and Centaurs, Frieze slab, Phigalian Marbles, fifth century B.C. London, British Museum.

Hazlitt's essay flows without interruption from the disorganized clamor of culture in the first paragraph to the incoherent noise made by the subject of the essay, and they are intimately linked; the stormy environment of the essay is emblematic of the cultural crisis behind Coleridge's failure. In a typical strategy, Hazlitt uses quotation and reference to insist on this connection, dissecting Coleridge along the very lines of weakness where he is already disintegrating: "Mr. Coleridge has 'a mind reflecting ages past,'" Hazlitt writes, invoking a Miltonic description of Shakespeare that Coleridge had used in his (1818) lectures on the poet.[26] But it is a Shakespeare identified with the power-losing, power-forfeiting magician, Prospero, who is evoked in *this* tempest. In a direct reference to that work (*The Tempest*, 1.2.50), Hazlitt describes Coleridge's voice—his main identifying feature—as "the echo of the congregated roar of the 'dark rearwards and abyss' of thought" (11:29). Like the studious Prospero, deposed from his position as duke of Milan while preoccupied with his books, Coleridge cannot maintain himself in power, even with his vast knowledge and skill. Quite the opposite: for both, the past is a *dark* backward, an abyss. But whereas Prospero uses this phrase when he invites Miranda to think back to a time before his loss of power, Coleridge's voice cannot so beckon the past; it can only be its echo.

In an age of talkers (not doers), Coleridge reverberates in response to the noise of a past that has become loud and unintelligible because so

multitudinous and fragmentary (a "congregated roar"). The poet is a living instance of the crisis of accumulated knowledge; he embodies the qualities of disintegration of the culture around him. While his voice is characterized as an echo of the noise of the past, the "intelligence of his eye" is described as a ruined tower hidden by mist and reflected only in water (11:29). In Hazlitt's account, his very mind becomes a polymorphous cloud, whose destiny is its dissolution in water. In describing this organ, Hazlitt quotes Antony's language as he becomes aware of his own imminent collapse in *Antony and Cleopatra*:

> That which was now a horse, even with a thought
> The rack dislimns, and makes it indistinct
> As water is in water. (11:29)[27]

These images of the loss of form—of a cloud in the wind, of water in water—are apposite for an essay in which the account of Coleridge's failure has both personal and cultural implications. Like water in water, the context so overwhelms the subject as to rob it of identity.

Hazlitt's response to Coleridge is complex: the writer—at once monument and ruin—partakes of the grandeur of the art object, while at the same time he is a central example of the crises brought on by a burgeoning knowledge and exposure to past art. Hence the odd transference of Promethean qualities to Coleridge himself in the account of the critic's exposition on *Prometheus Bound* later in the essay: "As the impassioned critic speaks and rises in his theme, you would think you heard the voice of the Man hated by the Gods, contending with the wild winds as they roar, and his eye glitters with the spirit of Antiquity!" (11:42). In this manifestation Coleridge challenges those overwhelming winds that flow through the essay; as he leaves behind the enervation of the "spirit of the age," his eyes acquire the luster of "the spirit of Antiquity." And yet, all that Coleridge is doing is speaking into the wind ("contending with the wild winds"). Even this powerful image results in fruitless noise. Hazlitt further deflates the dubious power of the critic by his brilliant change of register from the sublime height of Coleridge's possession by the Promethean spirit of antiquity to a prosaic and weak conjunction, "Next"— followed by a sentence of several pages' duration listing in a paratactic jumble the remainder of Coleridge's helter-skelter career, and the dissipation of his promise: his progressive passionate engagements with Hartley's philosophy, Berkeley's, Christian controversy, Leibnitz, dissent, Spinoza, poetry, Plato, Rousseau, Voltaire, Renaissance painting, the German idealists, the French Revolution, Pantisocratic fantasies, and so on. The glitter in Coleridge's eye as he speaks of antiquity serves to transpose him not only into Prometheus, but also into the Ancient Mariner, yet another evocation of maelstrom, frustration, and unstoppable

speech.[28] By identifying Coleridge with his creation, Hazlitt hints at an analogy between the eventful yet ultimately circular voyage of the Mariner, and the disappointing trajectory of his author. Like Coleridge, the Ancient Mariner cannot establish a useful equilibrium between tempest and doldrums. His punishment for killing "The bird / That made the breeze to blow" (lines 93–94) is that he must perpetually accost strangers to repeat his story.

Although Coleridge is the principal subject of Hazlitt's "First Acquaintance with Poets," the essayist's preoccupation with tallying the list of Coleridge's failed commitments means that he discusses little of the poetry in *The Spirit of the Age*. The early ode on Chatterton is presented as an example of Coleridge's youthful promise, but the figure of Chatterton, the forger-poet whose early death cut short his own career, also serves as a contrast to the later poet's inability to make good on his own early promise—without the excuse of death. Hazlitt does transcribe the entire Sonnet on Schiller, a work whose subject is the poet's frank abasement before the superior achievement of another:

> Schiller! that hour I would have wish'd to die,
> If through the shudd'ring midnight I had sent
> From the dark dungeon of the tower time-rent,
> That fearful voice, a famish'd father's cry—
> That in no after-moment aught less vast
> Might stamp me mortal! (11:35)

All the possible comparisons between author and subject in the poem are unfavorable. In contrast to Coleridge's enervated residence among the debris of the past, Schiller sends his voice out of "the dark dungeon of the tower time-rent." The terms in which Coleridge expresses his admiration are particularly morbid; the hyperbolic desire for death is the response to genius in the very first line. The juxtaposition of authors is emphasized by the context in which they are both found; note where Coleridge places Schiller in his invocation:

> Ah! Bard tremendous in sublimity!
> Could I behold thee.
>
> Beneath some vast old tempest-swinging wood!
> Awhile, with mute awe gazing, I would brood,
> Then weep aloud in wild ecstasy. (11:35)

The German denizen of the tempest is productive, writing poetry, plays, philosophy. The response that Coleridge predicts for himself is silence ("mute gazing"), but only before embarking on another bout of damp incoherent noise ("weep aloud in wild ecstasy").

The Robbers was an early, and long-lasting, passion of Hazlitt's, and this is not the only place in which he praises Coleridge's sonnet on its author. But in the context of this essay, it is worth noting that the play itself is an overwrought fantasy of parental disappointment.[29] In a telling footnote on the names of Coleridge's children, appended to the long account of his failed projects, Hazlitt emphasizes the progression from commitment to commitment to dissolution: "Mr. Coleridge named his eldest son . . . after Hartley, and the second after Berkeley. The third was called Derwent, after the river of that name. Nothing can be more characteristic of his mind than this circumstance. All his ideas indeed are like a river, flowing on for ever, and still murmuring as it flows" (11:32n). Every set piece in the essay on Coleridge has the same structure: a deep engagement with some field of knowledge is followed by another, usually contradictory, and then by a whole series, all of precisely the same intensity; the final result is a never ending stream of change resulting in useless babble. In naming his children Coleridge declares his serial allegiance to antithetical philosophies; we are meant to understand his finally settling on the name of a river as a more accurate representation of the mutability of his commitments. Even the fundamental authorship of giving a name to his children is drowned in the current that Coleridge cannot resist. It is a current that sweeps along texts and monuments—and well it might, as these are the very content of the tempest.

A Veil of Egotism

Hazlitt addresses the relationship between artistic persona and artistic work directly in the chapters of *The Spirit of the Age* dealing with Byron and Scott. Whereas Coleridge stands for the promise that never realizes itself because it is dissipated in the effort to include too much, Byron and Scott represent two contrasted possibilities of achieving success as a productive artist, if only in severely limited terms. Although Scott gets credit for his popularity, his limitations draw Hazlitt's attention, particularly a creative impersonality of which Scott's anonymity is only the most extreme manifestation: "A poet is essentially a *maker*; that is, he must atone for what he loses in individuality and local resemblance by the energies and resources of his own mind. The writer of which we speak is deficient in these last" (11:60; emphasis in the original). In Byron and Scott, Hazlitt finds the two extremes of artistic presence and absence: "In reading the *Scotch Novels*, we never think about the author, except from a feeling of curiosity respecting our unknown benefactor: in reading Lord Byron's works he himself is never absent from our minds" (11:72).

The difference between constant presence and careful absence is not simply a matter of style; real achievement is only possible near one ex-

treme, that of absence. Hazlitt's theme received its most famous develop-
ment from Keats, his most careful student; much as the poet will find his
extremes between the impersonality of Shakespeare and Wordsworth's
egotistical sublime, Hazlitt celebrates Scott—"the most *dramatic* author
now living" (11:72; emphasis in the original)—over the insistently per-
sonal Byron.[30] In this context, drama is associated with impersonal cre-
ation and Byron is its antithesis because he "hangs the cloud, the film of
his existence over all outward things ... we are still imprisoned in a
dungeon, a curtain intercepts our view, we do not breathe freely the air
of nature or of our own thoughts—the other admired author [Scott]
draws aside the curtain and the veil of egotism is rent" (11:71). The
figure of the veil, represented in Chambers's frontispiece as emblematic
of a tantalizing anonymity, appears here with a contrary meaning, as the
film of personality obstructing our view of the object itself. Presence
itself is a cover, but the veil of egotism does not belong to Byron alone;
indeed, Byron is really a stand-in for Wordsworth and the modern sensi-
bility Hazlitt takes the older (and for Hazlitt far more important) poet to
represent. "The three greatest egotists that we know of," he declares in
his 1816 essay "On the Character of Rousseau," "are Rousseau, Words-
worth, and Benvenuto Cellini ... we defy the world to furnish out a
fourth" (4:92–93). It is the poet's inescapable concern with self that leads
Hazlitt, when discussing Wordsworth's favorite artists, to make a point of
omitting Shakespeare, "the least of an egoist of any body in the world"
(11:92).[31] On the same page in *Spirit of the Age* Hazlitt again turns to
Scott for a countermodel; two years before Scott acknowledged author-
ship of his fiction, the critic notes that his strength is not most clearly
manifested in poetry—what he calls Scott's named work—"it is in his
anonymous productions that he has shown himself for what he is!"
(11:92).

Bright Condition, Hard Reversion: The Living Poets

Coleridge is in some ways a special case; he served for Hazlitt as a per-
sonal model and source of disappointment. "There is no one who has a
better right to say what he thinks of him than I have," he comments
in "On the Living Poets" (1818), proceeding to identify himself with
Brutus—the archetypal principled assassin of a friend (5:165–66). But
contemporaneity and intimacy are much wider issues for Hazlitt. As so
often, he is simply the clearest in stating the paradox: "Genius is the heir
of fame; but the hard condition on which the bright reversion must be
carned is the loss of life" (5:143). With this opening to the concluding
lecture on the English poets, he introduces the problem that life presents
for the valuation of the modern artist. Hazlitt claims that he is unable to

judge his contemporaries: "I would speak of the living poets as I have spoken of the dead (for I think highly of many of them); but I cannot have the same authority to sanction my opinion" (5:145). Hazlitt's proposition that his familiarity with his contemporaries makes it impossible for him to sustain the kind of admiration that is now necessary can be contrasted to Johnson's readiness to judge contemporaries such as Savage or Goldsmith by the same standard he used for Cowley or Pope. In Hazlitt, the mode of evaluation that has raised authors to great heights cannot comfortably accommodate their lives: "The temple of fame stands upon the grave" (5:143–44). Hazlitt presents the problem as a general proposition: "We often hear persons say, What they would have given to have seen Shakespeare! For my part, I would give a great deal not to have seen him; at least not if he was at all like any body else that I have ever seen" (5:146). The dilemma is clear in the modifying "at all." Hazlitt's view of the poet and his task is such that disappointment will not come from the kind of immoral behavior that might have drawn the condemnation of Johnson, but rather from being "at all like any body else." The demand is for a difference that goes beyond the condition of being human. "It is always fortunate for ourselves and others, when we are prevented from exchanging admiration for knowledge" (5:146). Hazlitt tellingly conflates the language of Wordsworth's Immortality Ode with the title of "My First Acquaintance with Poets," his own record of joyous encounter and eventual disappointment with Coleridge: "The splendid vision that in youth haunts our idea of the poetical character, fades, upon acquaintance, into the light of common day" (5:146). Disappointment follows on too close an intimacy, as inescapably as the disillusioning maturity that Wordsworth identifies in his ode.[32]

The insurmountable distance between contemporary poets and poets of the past is a recurrent theme of the lectures. Hazlitt distinguishes his discussion of living poets from the rest of the text before he even begins his discussion; none of the other lectures opens with a quotation, and only the introductory lecture ("On Poetry in General") does not carry the names of some poets in the title. Instead of identifying any contemporaries at the head of his text, Hazlitt offers a quotation from Milton on the loss of intimacy with the original creator:

> No more talk where God or Angel guest
> With man, as with his friend, familiar us'd
> To sit indulgent.— (5:143)

This passage is the opening of book 9 of *Paradise Lost*. Whereas book 8 had been the account of friendly conversation between angel and man, book 9 announces itself as the account of the Fall, of the loss of ready access to the divine.

A Writing Hand: The *Life* of Scott

One June evening in either 1814 or 1818, John Gibson Lockhart found himself in Edinburgh at a party of young men destined for the bar. His well-known narrative of events after dinner has the flavor of a nine-teenth-century ghost story:

> When my companion's worthy father and uncle, after seeing two or three bottles go round, left the juveniles to themselves, the weather being hot, we adjourned to the library, which had one large window looking Northwards. After carousing here for an hour or more, I observed that a shade had come over the aspect of my friend, who happened to be placed immediately opposite to myself, and said something that intimated a fear of his being unwell. "No," said he, "I shall be well enough presently, if you will only let me sit where you are, and take my chair; for there is a confounded hand in sight of me here, which has often bothered me before, and now it won't let me fill my glass with a good will."

The early language of festivity gives way to a moral, and the tale resolves itself in a half recognition:

> I rose to change places with him accordingly, and he pointed out to me this hand, which, like the writing on Belshazzar's wall, disturbed his hour of hilarity. "Since we sat down," he said, "I have been watching it—it fascinates my eye—it never stops—page after page is finished and thrown on that heap of MS. and still goes on unwearied—and so it will till candles are brought in, and God knows how long after that. It is the same every night—I can't stand the sight of it when I am not at my books."—"Some stupid, dogged, engrossing clerk, probably," exclaimed myself, or some other giddy youth in our society. "No boys," said our host," I well know what hand it is—'tis Walter Scott's." This was the hand that, in the evenings of three summer weeks, wrote the two last volumes of Waverley. (3:128)

The most striking evidence of the fictive nature of the recollection is the ambiguous suggestion that the hand spied by the young men is indeed writing *Waverley*—that is to say, Scott's first novel and the text that will give a name to his anonymity. This marvelous coincidence is achieved only by moving the anecdote back four years, to 1814. Edgar Johnson points out that the date of the incident has to be 1818, and the text therefore the less epochal *Heart of Mid-Lothian*.[33] Lockhart depicts himself as first encountering the person of Scott, his future father-in-law and biographical subject, at the very moment in which he is making himself "the Author of *Waverley*" or "The Great Unknown." Why, then, does this encounter take the odd shape of a confused and partial vision? Like Chambers's frontispiece or Scott's writing hand itself, the account

needs to be elaborate and even fantastic because it attempts a paradoxical task, to draw attention to the peculiar power of the author in his anonymity. The hand in another room seen from the window—the part shown impressing all the more for the face being hidden—is evidently a close cousin of the obscured portrait. A window and a picture frame share the same mundane use broadly understood; both are structures that invite view. The vision in each of these instances is blocked, however, and further surrounded by a Gothic penumbra of mystery.[34]

The passage is the site of a variety of overlapping strategies for representing the significance of the artist and the artistic life. What the young men see is an emblematic representation of the creative process: page follows page; the author's work is the fluid production of manuscript. Scott's remarkable speed of literary creation was a topic of comment in his day. And yet, this incident is more than an anecdotal illustration of Scott's notorious facility; the account is laced with features taken from the genre of Victorian moral biography and also with a more mysterious quality. The moral impulse is indicated at the introduction of the story: "A trifling anecdote . . . I shall here set down . . . in the hope that my humble record may impart to some active mind in the rising generation a shadow of the influence which the reality exerted upon . . . [Lockhart's friend William Menzies]" (3:127–28). As the anecdote makes abundantly clear, the lesson to be learned is the virtue of diligence, the gospel of work. The "carousing" and "hilarity" of "giddy" "gay and thoughtless" young men, "with little remembrance of yesterday, or care of the morrow" (3:308), is put to shame by the tireless hand always at its appointed task.

In this aspect of the biography Lockhart is following the lead of Scott himself, as suggested in his "Memoir," a text written in 1808 but published only in 1837 as the first section of Lockhart's work:[35]

> From the lives of *some* poets a most important moral lesson may doubtless be derived, and few sermons can be read with so much profit as the Memoirs of Burns, of Chatterton, or of Savage. Were I conscious of any thing peculiar in my own moral character which could render such development necessary or useful, I would as readily consent to it as I would bequeath my body to dissection, if the operation could tend to point out the nature and the means of curing any peculiar malady. . . . Yet, those who shall hereafter read this little Memoir may find in it some hints to be improved, for the regulation of their own minds, or the training those of others. (Lockhart, 1:2; my emphasis)[36]

Interest in the analysis of the poetical temperament—reminiscent of D'Israeli but fundamentally different—is yoked to a moral sensibility somewhere between Johnson's ethical analysis of character and the Victorian exemplary life. Lockhart describes Scott as being opposed to the

D'Israelian idea that "those who, gifted with pre-eminent talents for the instruction and entertainment of their species at large," should "fancy themselves entitled to neglect those every-day duties and charities of life" (Lockhart, 6:59). The passage from the "Memoir" is intended to make clear that the interest of the life of an author will reside in the specific *moral* lessons to be drawn from it and not in the description of the special qualities inherent in the character of authors. Scott places himself in direct moral opposition to the kind of figures described in the work of D'Israeli, just the sort of antisocial beings most likely to neglect "every-day duties and charities of life."[37] As we will see, however, by the end of Lockhart's biography D'Israeli's formulations make a strong return.

The justification for the significance of the figure of the writer oscillates throughout Lockhart's text in an unstable way. Wherein lies the value of the artist, of the artistic life? The answer varies as different facets of Scott's figure are held to the light. Sometimes the significance ascribed to the figure of the author by both Lockhart and Scott requires that the stereotypical narrative of the artistic life be brought to the fore; just as often it demands that the life be dismissed altogether. In the foregoing discussion of the great value of *some* artistic lives, Scott makes it clear that it is not the account of the formation of the artist per se that is important, but the cautionary moral content of specific lives—the dissipation of Burns, the tragedy of Chatterton, the tragic dissipation of Savage. On the other hand, Scott depicts himself in the "Memoir" at an early age "musing what there could be in the spirit of authorship that could inspire its votaries with the courage of martyrs" (Lockhart, 1:20). To indicate, as Scott does in the "Memoir," that the moral profit to be had from reading tragic lives of poets is greater than that to be found in most sermons hints at a high value indeed. The moral effect of biography not surprisingly also varies throughout the *Life*. One impulse in the text is to insist on the simple humanity of the author, that his existence should be interpreted and evaluated using standard moral values; a countervailing tendency is to see the author as belonging to a different type and therefore as existing entirely outside the purview of these very values.

The anecdote of the hand is presented as being a lesson in duty and discipline, but what Lockhart and his friends have seen, and what they have learned, is only a half-truth. The hand is revealed to be that of Walter Scott, one of the chief poets of the age, but it in fact belongs to "the author of *Waverley*"—the anonymous novelist—at his secret work. And, of course, the uncanny vision of a disembodied hand is in itself not reducible to a simple lesson ("write late at night," "write without ceasing"). Rather than providing mere practical guidance, the image serves as a fantasy of pure production that is part of the treatment of literary work

in relation to social rank central to Lockhart's project. The biography
revolves around three issues and their complex interplay: money, produc-
tivity, and recognition. Consider Scott's own report of the relation of his
rank to his work: "my habits of thinking and acting, as well as my rank in
society, were fixed long before I had attained, or even pretended to, any
poetical reputation, and ... it produced, when acquired, no remarkable
change upon either" (Lockhart, 1:2). Scott insists that his rank owes
nothing to his artistic practice: "I cannot tell of difficulties vanquished,
and distance of rank annihilated by the strength of genius," he claims,
denying that ready source of interest for his story (1:2). In a note to this
passage written eighteen years later, he tries to have it both ways, finally
only exaggerating his claim:

> I do not mean to say that my success in literature has not led me to mix
> familiarly in society much above my birth and original pretensions. . . . But
> there is a certain intuitive knowledge of the world to which most well-educated
> Scotchmen are early trained, that prevents them from being much dazzled by
> this species of elevation. . . . I have therefore never felt much elevated, nor did I
> experience any violent change in situation, by the passport which my poetical
> character afforded me into higher company than my birth warranted. (Lock-
> hart, 1:2n)

Scott protests too much; in the straightforward contradiction and bad
faith of this passage we find evidence of an instability to which the whole
biography bears witness. Not only is *everything* that is remarkable about
Scott's social status the result of his writing, but the biography cannot
keep itself from dwelling on the high social circles into which he was
brought by his success. Scott's extraordinary social rise, from middle-
class gentleman to friend of royalty, is the burden of much of Lockhart's
book, but it is an account which he—like Scott—often mystifies.

Scott sets the tone, which Lockhart echoes. His own *Lives* demon-
strates an anxious concern to establish the class of his authors.[38] In a
particularly telling instance, to which I will return, Samuel Johnson's her-
oism is ascribed to the status he achieved for himself and for his profes-
sion:

> When we consider the rank which Dr. Johnson held, not only in literature,
> but in society, we cannot help figuring him to ourselves as the benevolent giant
> of some fairy tale, whose kindnesses and courtesies are still mingled with a part
> of the rugged ferocity imputed to the fabulous sons of Anak, or rather, perhaps,
> like a Roman Dictator, fetched from his farm, whose wisdom and heroism still
> relished of his rustic occupation. (Scott, 267–68)

Johnson, in Scott's account, is memorable for having opened the door for
a new rank of literary man. He is comparable with primeval giants or (in

an intriguing reconfiguration of the role of the public) a political leader sought out by the public and made dictator by acclamation. But Scott's gratitude to Johnson takes an odd form; the sons of Anak, after all, had to be driven from the promised land before the Israelites could claim a home.[39] The novelist's imagination remakes the critic into either one of a tribe of creatures whose principal role in history was to be displaced, or into a formerly rustic tyrant (a sort of Cincinnatus) who is in fact out of place in the society he leads.[40] Scott's concern with social rank is such that even his praise for one of his acknowledged forebears has an air of social condescension. The images he uses in the passage, like the contradictory argument of his "Memoir," indicate that Scott's ambivalence is toward the *establishment* of rank; it is movement from one class to another that he finds disturbing.

In Johnson's *Lives of the Poets* William Congreve disgusts Voltaire— and Johnson too, evidently—"by the despicable foppery of desiring to be considered not as an author but a gentleman." Voltaire's response is given as follows: "if he had been only a gentleman, he [Voltaire] should not have come to visit him."[41] There is a moment in Lockhart reminiscent of this anecdote. In it, Scott turns to a friend in the course of what he thinks a too effusive display of popular enthusiasm and remarks: "Author as I am, I wish these good people would recollect that I began with being a gentleman, and don't mean to give up the character" (Lockhart, 2:185–86). Scott's snobbery is not as remarkable as his declaration that he "*began* with being a gentleman." The claim in such a passage is that his social rank predates his success as an author. And yet, the fastidious claims of subject and biographer notwithstanding, Lockhart's account cannot avoid the fact that one of the most remarkable circumstances of his career is the wealth, fame, and position Scott acquired through his writing: "At this moment [1818], his position, take it for all in all, was, I am inclined to believe, what no other man had ever won for himself by pen alone. His works were the daily food, not only of his countrymen, but of all educated Europe. His society was courted by whatever England could show of eminence" (4:144).

The biography charts in detail the emblems of Scott's social rise; it is a narrative that is more than incidental to the work. Consider the breathless tone of this passage:

> It would hardly . . . be too much to affirm, that Sir Walter Scott entertained, under his roof, in the course of the seven or eight brilliant seasons when his prosperity was at its height, as many persons of distinction in rank, in politics, in art, in literature, and in science, as the most princely nobleman of his age ever did in the like space of time.—I turned over, since I wrote the preceding sentence, Mr. Lodge's compendium of the British Peerage, and on summing up

the titles which suggested to myself some reminiscence of this kind, I found them to be nearly as one out of six. (5:5)

Lockhart will go on to make the same point about the foreign nobility who came calling. Scott and Lockhart find no difficulty in admitting the glory accompanying his literary fame; it is the lucrative details that sometimes prove embarrassing. The text is rife with references to social position, especially to the uncertain borderline place occupied by publishers and booksellers. The concern with rank is not strange for this period; what is noteworthy is Scott's and Lockhart's ambivalence toward social position in relation to literature. There is a quality of damning with faint praise in descriptions of such important figures in Scott's life as the publisher, Archibald Constable, and the printers, James and John Ballantyne. "Their father was a respectable tradesman," Scott notes of the two brothers (1:116). Constable and John Ballantyne are juxtaposed in their response to the wealth they have acquired through literature; the latter spends his fortune on ostentatious parties, the former on the sober accoutrements appropriate for his social standing. Still, though Constable carries himself with emphatic respectability, a certain taint of condescension is inescapable in Scott's account of wealth acquired, as Constable's was, through the book *trade*.

Consider the deepening levels of contempt expressed in this exchange between Scott and his biographer. Lockhart notes with surprise, "I had not been prepared to find the great bookseller a man of such gentlemanlike and even distinguished bearing." With a reference to Fielding, Scott suggests that Constable certainly *looks* like a gentleman to those who have not seen many (4:170–71). Even Constable's fine home is made to seem not rightfully his: "I found the bookseller established in a respectable country gentleman's seat." The publisher becomes an interloper in his own residence, pretending to a birthright that is not truly his: "doing the honours of it with all the ease that might have been looked for had he been the long-descended owner of the place . . . to all appearance the plain abundance and simple enjoyment of hereditary wealth" (4:173). The point on which Lockhart's text insists is that it is indeed not hereditary wealth that Constable is enjoying.

Lockhart's strategy for indicating Scott's achievement of extraordinary social stature while avoiding the taint of new money is to seed the text with parallels between Scott and established great men. Thus, Thomas Lawrence is cited as saying that the two greatest men he ever painted were the duke of Wellington and Scott (4:361). If the interview between George III and Samuel Johnson in the king's library is an important moment in establishing the possibility of social mobility through literature in Boswell's *Life of Johnson*, the relationship of Scott with George IV in

the *Life* demonstrates the comfortable achievement of high social rank by a writer.[42] When the king decides to add a wall of portraits of his distinguished subjects to the wall of monarchs, ministers, and generals, he begins with Scott (4:360). Lockhart even depicts the granting of Scott's title as somehow an act of *mutual* appreciation: "Scott's baronetcy was conferred on him, not in consequence of any Ministerial suggestion, but by the King personally, and of his own unsolicited motion; and when the poet kissed his hand, he said to him—'I shall always reflect with pleasure on Sir Walter Scott's having been the first creation of my reign'" (4:366). "Creation" reverberates strongly in this passage, the creative work of the author leading to the creative work of the sovereign. The glory of Scott only increases throughout the work, from recognition to something more. Lockhart gives Scott the credit for the success of the king's tour of Scotland: "his Majesty mainly owed to Scott's personal influence, authority, and zeal, the more than full realization of the highest hopes he could have indulged on the occasion of this progress" (5:191).

There is a strong hint of mutual debt between king and subject in the biography, or of almost competitive identification. Scott goes to watch the king's procession, thinking the crowd, as he puts it, "entirely absorbed in loyalty." Instead, Robert Peel, his companion on this excursion, reports that Scott is surprised to be "recognized from the one extremity of the street to the other." Peel goes further, "never did I see such an instance of national devotion expressed" (5:203). The last seems an almost treasonous claim to make while recounting the first visit to Scotland by a king of Great Britain. The royal overtones in descriptions of Scott become only more marked toward the close of the work, as Lockhart sets himself the task of recording the time of "the highest elevation of his literary renown—when princes bowed to his name, and nations thrilled at it" (7:406). At one point Scott intervenes in print to assure a positive reception for the dethroned Charles X of France—a further grace from author to royalty (7:224–28). When Scott goes abroad for his health, he is treated like a "Prince of the Blood" on shipboard (7:54). In recounting his death Lockhart becomes explicit: "Almost every newspaper that announced this event in Scotland, and many in England, had the signs of mourning usual on the demise of a king" (7:394).

If the celebration of Scott's social position is the principal concern of Lockhart's work, what is the alternative that is being denied? One answer is that it is the shadow of work for money that is meant to vanish in all this brilliance. As Scott puts it in a letter to Byron, responding to the lord's charges of venality in "English Bards and Scotch Reviewers": "I may well be excused for a wish to clear my personal character from any tinge of mercenary or sordid feeling in the eyes of a contemporary of genius" (2:400; see also 2:250–52).[43] At issue is more than the opinion of

his fellow writers; after his bankruptcy, Scott worries in his journal: "I much doubt, the general knowledge that an author must write for his bread, at least for improving his pittance, degrades him and his productions in the public eye. He falls into the second-rate rank of estimation" (6:164). The image of the writing hand divorced from a body in Lockhart's anecdote stands for tireless unmotivated creative energy. What Lockhart witnessed was the author becoming either a natural or a supernatural force, the creative moment separated from any mere human need or profit. Neither glibness nor greed stand behind the productions of Scott; rather he manifests an unstoppable impersonal urge to create. The maker's hand—as in Dürer's famous etching of his own, or that of God that reaches out to Adam in the Sistine Chapel—carries power at its extremity, a force focused and separated from human design. What Lockhart saw was *only* making, no person profiting.

If the parallels Lockhart used to indicate Scott's rarefied status brought him level with princes, they also removed him far from the sphere of the mere "literary character" as described by D'Israeli. The spirit of the unresting disembodied hand is present in a passage that makes more overtly the case for Scott's distinct achievement:

> Compared to him all the rest of the *poet* species that I have chanced to observe nearly—with but one glorious exception—have seemed to me to do little more than sleep through their lives. . . . I am persuaded that, taking all ages and countries together, the rare examples of indefatigable energy, in union with serene self-possession of mind and character, such as Scott's, must be sought for in the roll of great sovereigns or great captains, rather than in that of literary genius. (5:207–8; emphasis in the original)

Scott is not a mere poet. The library of stories to which his life belongs is not merely the D'Israeli collection of artistic anecdotes; it is the history of kings and generals. But far more extraordinary is the manner in which the *creative* difference implied in the word "poet" qualifies this passage. "[I]ndefatigable energy, in union with serene self-possession of mind and character" is a combination that hints that the highest form of artistic work may be characterized by a radically autogenous nature. In this biography, "self-possession" means more than tranquillity. The important moments of artistic productivity have no genesis; the artist creates himself: "As may be said, I believe, with perfect truth of every really great man, Scott was self-educated in every branch of knowledge which he ever turned to account in the works of his genius" (1:130–31). Autogenesis is a demonstration of a power so supreme as to require no outside aid. A contemporary of Scott describes his forays into isolated parts of Scotland as follows: "He was *makin' himsell* a' the time . . . but he didna ken maybe what he was about till years had passed" (1:195–96;

emphasis in the original). Both the fact of self-making and its unconscious nature are constitutive of the kind of genius Scott represents.

The unconscious quality of Scott's creativity is insisted on in the details of Lockhart's biography. In a remarkable instance of absentmindedness, Scott finds "the forgotten MS. of the first two or three chapters of *Waverley*" while "searching an old desk for fishing flies" (1:261). The casual engagement with his productions that made possible the loss of the manuscript (not just lost, but "forgotten") is only underlined by the indifference as to how much of it was actually recovered. This odd relationship to his own work is apparent not only in Scott's early career; years later he writes the *Bride of Lammermoor* while ill and is said not to remember a single incident when he first sees it (4:274–75).[44] The theme of Scott's unconscious production shapes Lockhart's language in his description of the first encounter between Scott and James Hogg: "Scott found a brother poet, a true son of nature and genius, hardly conscious of his powers" (1:329). Superhuman qualities are evoked in the following passage in Lockhart, which ostensibly describes the writing of *The Life of Napoleon* (1825) but is really about the novels:

> That miracle had to all appearances cost him no effort. Unmoved and serene among the multiplicities of worldly business, and the invasions of half Europe and America, he had gone on tranquilly enjoying, rather than exerting his genius, in the production of those masterpieces which have peopled all our firesides with inexpensive friends, and rendered the solitary supremacy of Shakspeare, as an all-comprehensive and genial painter of man, no longer a proverb. (6:87–88)

With all the circularity of a description of God's experience of his own creation, Lockhart presents the miraculous productions of the Author of *Waverley* as the result of genius disporting with itself. The importance of this lack of effort is that it makes Scott—as in Hazlitt's description—a *Shakespearean* genius. Like the master dramatist, Scott effortlessly produces a world of characters who cannot be identified with himself. *Both* authors share that quality of natural impersonal disengaged creation that the romantics discovered in Shakespeare and which later came to be attributed to Dickens as well.

Anonymity and Self-Presentation in the Prefaces

It is worth emphasizing that Scott lived in a culture in which anonymous writing was a common social convention—articles were unsigned, poems often unattributed. Nevertheless, Scott seems to have had a particular affinity for this practice. In a telling instance recorded in the *Life*, Scott refuses to recite any of his own work while at dinner with Coleridge and

others, and instead repeats an anonymous poem. The response to the work is lukewarm, but Scott defends it from persistent attack, until—after particularly sharp criticism—Coleridge finally acknowledges "Fire, Famine, and Slaughter" as his own (2:245–46). The *Life* insists that Scott inhabits anonymity with rare comfort; it is somehow typical of the man that he should select for recitation an anonymous poem written by his host.

In a more self-conscious instance of his special affinity for the anonymous, Scott went to extreme lengths to convince the public that *The Bridal of Triermain* was written by his friend William Erskine. He first published fragments of the poem as *Imitations of Walter Scott* and included in these texts references to the character and personal life of his friend (3:46–48). Lockhart followed Scott in the celebration of the half anonymity of his subject, commenting that John Ballantyne's publication parties were most enjoyable for those who were least certain of the identity of the Author of *Waverley*.

These games of identity and anonymity are given their most extensive textual development by Scott in those prefaces to his novels in which "the Author of *Waverley*" actually appears to the various humorous personae to whom Scott had attributed his works.[45] The Gothic tone of the passage in which Lockhart witnessed the hand of Scott at work is—not coincidentally—also typical of Scott's own treatment of these texts. In the "Prefatory Letter" to *Peveril of the Peak* (1823), the Author of *Waverley* appears to Jonas Dryasdust, the putative author of the work, as the vision of a half-drunk afternoon (in a typical trope of the ghost story, the servant who introduces the author later denies ever having seen him). But it is in the earlier "Introductory Epistle" to *The Fortunes of Nigel* (1822) that the supernatural treatment is most closely linked to the practice of literature. In this preface, Captain Cuthbert Clutterbuck writes to the Rev. Dr. Dryasdust of his encounter with their shared progenitor, his jocular pomposity blending the language of Gothic literature with the reality of an Edinburgh publishing house:

> I strolled onward in that labyrinth of small dark rooms or crypts, . . . which form the extensive back settlements of that celebrated publishing-house. Yet, as I proceeded from one obscure recess to another, filled, some of them with old volumes, some with such as, from the equality of their rank on the shelves, I suspected to be the less saleable modern books of the concern, I could not help feeling a holy horror creep upon me, when I thought of the risk of intruding on some ecstatic bard giving vent to his poetical fury. (41–42)

As one pseudonymous creation goes to his encounter with another, he moves through a set of crypts. The word, which Scott superadds to his narrative ("dark rooms *or crypts*"), evokes secrets—encryption—and the

subterranean passages of churches. These hidden spaces hint at a mystery behind the banal reality of the merchandising of literature. Similarly, the anxiety of Captain Clutterbuck is a diffuse malaise, apparently blending both the fear of low sales and of encountering the inspired *vates* mid-frenzy. In the broad humor of the juxtaposition of bard and venality, Scott is raising the incongruous image of a romantic artist driving the mercantile world of Edinburgh publishing.

Scott's presentation of anonymity in these fictional accounts is linked to his insistence on the independent nature of his production. When Captain Clutterbuck finally reaches the "Author of *Waverley*," this almost principal author figure borrows an image from Johnson and describes the relationship between writer and public as being like that between a mailman and the recipient of a letter: "To the public I stand pretty nearly in the relation of the postman who leaves a packet at the door of an individual" (*Prefaces*, 48).[46] Images of Johnson recur in the *Prefaces*; "The Author of *Waverley*" appears to the Rev. Dryasdust in a suit "cut in imitation of that worn by the great Rambler" (*Prefaces*, 61; see also 64). He resembles Johnson physically, being "a bulky and tall man."[47] When we remember the description of Johnson in Scott's *Lives*, as a primeval figure looming on the horizon, or as a tyrant by acclamation who is merely tending his grounds when glory comes to him, we have a figure of the fantasy of the author Scott wishes at once to evoke for himself and to hide. A postman leaving an envelope, or a set of risible alter egos writing about their encounters with a more distant source, the authors in these images are indications of a perpetual distance from the original.

Finally acknowledging his authorship to his reading public in the introduction to *Chronicles of Canongate* (1827), Scott assembles a set of reasons for his anonymity, which are the less convincing for their variety.[48] At one point he blames mere "humour or caprice" (*Prefaces*, 78), at another he evokes D'Israelian fears in his defense:

> When I made the discovery—for to me it was one—that by amusing myself with composition, which I felt a delightful occupation, I could also give pleasure to others, and became aware that literary pursuits were likely to engage in future a considerable portion of my time, I felt some alarm that I might acquire those habits of jealousy and fretfulness which have lessened, and even degraded, the character even of great authors, and rendered them, by their petty squabbles and mutual irritability, the laughing-stock of the people of the world. (*Prefaces*, 79)

Although the description of the misfortunes of genius is like a transcription from D'Israeli's analytic chapter headings to *Literary Character* ("Of the irritability of genius. . . . Of the jealousy of genius—Jealousy often proportioned to the degree of genius.—A perpetual fever among authors

and artists …" [chaps. 7–13]), the idea that authorship implied "petty squabbles" had its clearest expression in D'Israeli's work devoted to that very subject, *Quarrels of Authors* (1814). It is as though by denying the literary name, Scott would avoid the "literary character." But, as he was one of the nation's most popular poets before he became a novelist, this argument seems as inadequate as the rest, even taking into account the higher status of poetry in early-nineteenth-century culture.

In this "Introduction," Scott evokes an image familiar from his discussion of Johnson in the *Lives*: "like Jack the Giant-Killer, I was fully confident in the advantage of my 'coat of darkness'" (*Prefaces*, 80). If Johnson, like a son of Anak, was a rough titanic figure—like all Titans, in need of supplanting—Scott would take on the enabling characteristic of a slayer of giants. Johnson stood for both tremendous achievement through writing and for the disturbing memory of the need to establish class rank. What Scott was able to slay in his darkness—or at least to avoid with the intrepidity of Jack—was that looming shadow not so much of a Bloomian strong precursor, but of the stigma of upward climbing and writing for money, which his mystique did everything to erase. For Scott, there is a challenge in both parts of the double image of Johnson, that of the man who did the most to *establish* the position of man of letters in England and that of the subject of the most probing intimate *Life*.[49] It is this complex of qualities that Scott avoids when he declines to be a giant and seeks the safety of shadows. The Johnson hinted at in Scott's *Prefaces*, may be the massive ghostly father of his work, but Scott is the fabled killer of giants, compensating for his smaller power and size by his invisibility. The author-as-Johnson accommodates larger-than-life claims by taking on, in Scott's hands, the characteristics of a creation of the past, but the figure Scott chooses for himself is a puny creature whose strength resides in not being seen. It is little wonder, then, that after making the public declaration of his authorship Scott anticipates the obvious play on his previous nickname; rather than "the Great Unknown," he imagines, he will now be identified as the "Small Known"—directly linking his erstwhile massive presence to an invisibility that compensated for his real human dimensions (Lockhart, 7:20).

The Statue or the Cathedral

The engraving in Chambers's *Illustrations of the Author of Waverley* and the hand that is Lockhart's first introduction to his future father-in-law are emblems of a withholding of contact, which seems to be necessary for the celebrations of the artist. The scrutiny of a contemporary biography, or of a work designed to "illustrate" the sources of a contemporary author, threatens the author's aura. The project of the *Illustrations*, like that

of the mammoth biographies of which Lockhart's is one example, is only conceivable when the artist has become a figure that a culture has imbued with great significance. And yet, how is knowledge to enhance admiration, rather than destroy it? The image of the half-hidden picture, of a magnificence the more impressive for being obscure, can be read as a representation of the problem—or, perhaps, of one solution. In a monumental biography such as Lockhart's, distance and detail are in a complex relationship; the desire to document coexists with a need to celebrate.

Consider Lockhart's use of the language of the art object in his description of Scott's figure as a young man:

> His figure, excepting the blemish in one limb, must in those days have been eminently handsome; tall, much above the usual standard, it was cast in the very mould of a young Hercules, the head set on with singular grace, the throat and chest after the truest model of the antique, the hands delicately finished, the whole outline that of extraordinary vigour, without as yet a touch of clumsiness. (1:163)

This is, of course, and quite openly, the description of a statue; its terms are an instance of the language of art analysis bleeding into and blurring the description of the artist himself. The biographer makes a noble creation of the author, but only by sacrificing an accurate depiction of the man.

After Scott's death the bust of Shakespeare in a niche in Abbotsford was replaced by a monumental bust of Scott by Chantrey. Lockhart protests slightly too much the naturalness of this event: "Anxiety to place the precious marble in the safest station induced the poet's son to make the existing arrangement on the day after his father's funeral. The propriety of the position is obvious" (7:811). As in Hazlitt's formulation, "bright reversion" demands a "hard condition." Hazlitt could not speak about the living with the authority he could claim with respect to the dead, and it is only in death that Scott can take on the position of his recognized antecedent. It seems unlikely that the bust was in any more danger after his death that it was before; rather, Scott's demise has made room for a new level of admiration—hard condition leading to bright reversion.

The precipitous social rise in Lockhart's *Life* is checked by one important calamity. In no way is Lockhart more of a Victorian than in finding Scott's financial carelessness "the enigma of his personal history" (6:114). The biographer returns to this theme repeatedly in the later parts of the biography, in references both direct and oblique. It is remarkable at these moments that it is only by engaging in the very sort of artistic psychologizing that Scott had opposed and Lockhart had resisted in earlier sections of the biography that Lockhart can spin the disaster of Scott's fi-

nances into the moral strand of the tale. As the account of Scott's bank-
ruptcy progresses, ever increasing reference is made to that artistic tem-
perament which he had claimed to escape. Not only is the functioning of
Scott's mind far from being that of a practical man, but this, Lockhart
suggests, may be the price of his creative gift: "We cannot understand,
but we may nevertheless respect even the strangest caprices of the mar-
velous combination of faculties to which *our debt* is so weighty" (6:120;
my emphasis). If Scott's debts are unrepayable, Lockhart hints, ours may
be even more so. In explaining the issue of Scott's finances the *Life* re-
turns us to D'Israeli. For all of the social success and analogies drawn to
men in more practical spheres, Scott really lived "in other worlds than
ours":

> He had, on the whole, a command over the powers of his mind—I mean,
> that he could control and direct his thoughts and reflections with a readiness,
> firmness, and easy security of sway—beyond what I find it possible to trace in
> any other *artist's* recorded character and history; but he could not habitually
> fling them into the region of dreams throughout a long series of years, and yet
> be expected to find a corresponding satisfaction in bending them to the less
> agreeable considerations which the circumstances of any human being's practi-
> cal lot in this world must present in abundance. . . . He must pay the penalty,
> as well as reap the glory of this life-long abstraction of reverie, this self-
> abandonment of Fairyland. (6:121; emphasis in the original)

Tallying the story of Scott's life with that of other artists, Lockhart finds
a more disciplined mind, but one that cannot escape entirely without
paying a price for his frequent visits or long stay (the passage has it both
ways) in the imagination. It is a remarkable turn for a biography that has
insisted for most of its length on the depiction of Scott as an altogether
practical man—one who kept his position at the Scottish bar, who in-
volved himself with political affairs of the time, who prided himself on
his participation in the cultivation of trees on his estate. By the end of
the text Scott is revealed to be none other than the D'Israelian tortured
artist; it is the only way to explain his grievous failure of fiscal respon-
sibility.

Lockhart brings in Scott's journal—begun in this period and in direct
imitation of Byron—as evidence: "Imagination renders us liable to be the
victims of occasional low spirits. All belonging to this gifted, as it is
called, but often unhappy class, must have felt, that but for the dictates of
religion, . . . they would have been willing to throw away life as a child
does a broken toy" (7:11). From the pragmatic lesson in duty of the
writing hand, the biography turns to the tormented soul of the artist
class, the Faustian bargain of creativity; imagination is a heavy burden
indeed, if it results in such dark thoughts. The number of these reports

increases from none to many after Scott's financial fall (see, e.g., 7:89). It is one of the extraordinary strategies of the work that Lockhart manages to transmute the issue so that Scott's worries over his financial crisis become the expression of his artistic sensibility. If the theme of the first part of the life is Scott's effortless accretion of glory, that of the second— after Scott sets out to repay his creditors rather than declaring simple bankruptcy—is that writing for money may not always be shameful, but is rather Scott's moment of greatest personal honor (see, e.g., 7:408). The journal becomes Lockhart's key piece of evidence and his best tool for painting a double portrait of genius:

> His Diary . . . shews (what perhaps many of his intimates doubted during his lifetime) that, in spite of the dignified equanimity which characterized all his conversation with mankind, he had his full share of the delicate sensibilities, the mysterious ups and downs, the wayward melancholy, and fantastic sunbeams of the poetical temperament. It is only with imaginative minds, in truth, that sorrows of the spirit are enduring. (7:81)

The biographer places the problem squarely in D'Israeli's world of the comparative lives of genius:

> In the case of extraordinary force of imagination, combined with the habitual indulgence of a selfish mood . . . in this unhappy case, which *none who has studied the biography of genius* can pronounce to be a rare one, the very power which heaven bestowed seems to become, as old age darkens, the sternest avenger of its own misapplication. (7:193; my emphasis)

It is a difficult task for Lockhart to draw the threads of his narrative together; the Victorian model life is not entirely borne out by the facts of the life in question, and so another strand of nineteenth-century thought is brought to play; the Baronet has the unconscious life of a *poète maudit*.

Lockhart's *Life* demonstrates the difficult relationship between knowledge and admiration. If it is significant that Lockhart writes into his text the moment of his first encounter with its subject, his own future father-in-law, it is all the more intriguing that this original encounter should be so elaborately staged. The first inkling he has of the presence of the writing hand comes when he sees it disturbing his companion, "I observed that a shade had come over the aspect of my friend." A direct view of the man—or of a part of him at least—comes only when Lockhart places himself in his friend's seat, presumably under the metaphorical shade that had fallen on his friend. Both shade and the difficulty of finding a proper angle of view return in Lockhart's summary of his biography:

> On the whole I have no doubt that, the more the details of his personal history are revealed and studied, the more powerfully will that be found to

inculcate the same great lessons with his works. . . . Where can we see the "follies of the wise" more strikingly rebuked, and a character more beautifully purified and exalted in the passage through affliction to death? *I have lingered so long over the details, that I have, perhaps, become, even from that circumstance alone, less qualified than more rapid surveyors may be to seize the effect in the mass.* But who does not feel that there is something very invigorating as well as elevating in the contemplation? His character seems to belong to some elder and stronger period than ours; and, indeed, I cannot help likening it to the architectural fabrics of other ages that he most delighted in, where there is such a congregation of imagery and tracery . . . half, perhaps, seen in the clear daylight, and half by rays tinged with the blazoned forms of the past—that one may be apt to get bewildered among the variety of particular impressions, and not feel either the unity of the grand design, or the height and solidness of the structure, until the door has been closed upon the labyrinths of aisles and shrines, and *you survey it from a distance, but still within its shadow.* (7:417–18; my emphasis)

Lockhart claims for the life of Scott the same power of moral instruction—"the same great lessons"—as for the work. In the writer's desperate efforts to pay back his creditors, in his uncomplaining assumption of this duty, he becomes a model of an important type of Victorian hero. And yet, even in this passage, we find the odd shifting from a heroism that is to be emulated, to a fragment from the past that can only be admired. The sense of belatedness that was characteristic of earlier theories of art in relation to the art object has now firmly attached itself to the artist. Scott *himself* becomes an ancient building (the description is clearly meant to evoke a Gothic cathedral). Though Lockhart characterizes the effect of contemplating Scott's life as "elevating," possible sight lines are disturbed by the shifting perspective of the passage. Interest and affection are demonstrated by intimacy, but understanding requires distance. Aisles and shrines that express the "endless indulgence of whim and fancy, the sublime blending here with the beautiful, and there contrasted with the grotesque" (7:418)—all these must be shut out, for they become "labyrinths" when the aim is seeing the whole of the structure of character or life. The proper way to see the ancient pile is from far enough away to appreciate its magnificence, but close enough to be beneath its shadow. Maintaining this subtle balance of intimacy and distance becomes the challenge for the representation of the artistic personality.

It is necessary to stand within the penumbra of the cathedral in order to appreciate the grandeur of the structure, but when the shadow reappears a few pages later, it has been transmuted into an image of far less positive, although far more intimate, relationship. When Lockhart re-

turned to his text, a decade after its publication, to make the abridgment of 1848, his account of Scott's children also includes a shadow. He begins with the caveat that "the great sons of great fathers have been few. . . . The shadow of the oak is broad, but noble plants seldom rise within that circle."[50] Does the shadow of the cathedral have the same effect as that of the oak? That the question is personal to Lockhart is made clear in the final naming of the line of descent: "The only descendants of the Poet now alive are my son, Walter Scott Lockhart . . . and his sister" (804). Coming as it does after the admission of the enervating effect of intimacy with greatness, this is a disturbing reminder of the closeness of subject and biographer. The meeting at the name of Lockhart's son, Scott's grandson (the granddaughter had already changed her name by marriage), is sign of an intimacy that includes the closest of connections: familial, sexual, generative. But the shadow of fatality hovers over this proximate relationship.

Chapter Five

KEATS: IN THE LIBRARY, IN THE MUSEUM

UNCERTAINTY generates metaphors. The faceless figure framed in the frontispiece of Chambers's volume on Scott and the Gothic cathedral that stands for the same author in Lockhart's biography are instances of the recurring urge to draw on the plastic arts in order to represent the literary artist. These borrowings from the register of images do not result, however, in a clearer vision, so much as they indicate the presence of something ungraspable.[1] Vague through effacement, overwhelming in massiveness, or indigestible in detail, such analogies demonstrate the difficulty of arriving at adequate representations of a figure whose putative significance far exceeded any cultural consensus on the qualities on which it might be based. Nevertheless, though the draped portrait and the looming cathedral both exemplify frustrated perception, the change from one image to the other does indicate an important development in culture. The power arising from the unseen evoked by the engraving decorating Chamber's text is a recognizable romantic topos given its most ringing exposition in Shelley's contemporary "Defence of Poetry." If "unacknowledged legislators" had state portraits, this might be one, or the model for all of them.[2] Lockhart's cathedral, on the other hand, like the biography it closes, is a manifestation of the urge to account for art by close observation and accumulation—an approach that would come to characterize the later nineteenth century. Like the immense halls of glass and iron constructed at the exhibitions staged throughout Europe in the middle decades of the century, Lockhart's cathedral indicates importance by the magnitude of the structure as well as by the details it includes.

Keats, whose career was contemporary with Shelley's but whose posthumous reputation was a product of the second half of the century, came to be associated with elements of both the powerful absence and the detailed display. Both traits come together in Monckton Milnes's 1848 biography of the poet. Indeed, the development of Keats's reputation, in which Milnes's biography played a vital role, must be understood in relation to the formation of a culture of artistic organization that his work anticipates, but which reached a point of wider social significance only at the middle of the century.

> To the Poet, if to any man, it may justly be conceded to be estimated by what he has written rather than by what he has done, and to be judged by the

productions of his genius rather than by the circumstances of his outward life. . . . the Poet, if his utterances be deep and true, can hardly hide himself even beneath the epic or dramatic veil, and often makes of the rough public ear a confessional into which to pour the richest treasures and holiest secrets of his soul. His life is his writings, and his Poems are his works indeed.

The biography therefore of a poet can be little better than a comment on his Poems.[3]

By 1848 it had become possible to assume the almost complete identification of work and life outlined in this passage. If for Hazlitt Byron's egotism was an obtrusive film over all he wrote, for Milnes it is the text that risks becoming a veil, albeit one barely able to separate the poet from his audience. The sense of so close a connection between the poet and his creation necessarily had a profound impact on the writing of a biography. And yet, for all his emphasis on the life revealed in the poet's work, Milnes's own language complicates simple biographical readings, especially when his terms are drawn from the museum: "Truncated as is this intellectual life, it is still a substantive whole, and the complete statue, of which such a fragment is revealed to us, stands perhaps solely in the temple of the imagination" (280). In response to the fragments of antiquity available to him, and in the quest for originary purity, Blake arrived at the idea of a hidden temple accessible only to the imagination in which the perfect models of debased modern productions were to be found. Milnes also responds to the fragmentary by positing a wholeness waiting in a "temple of the imagination." But for Milnes, the poet's own potential intellectual apotheosis is hidden from earthbound eyes. The life of the poet is only a piece of what it could have become in fact, of what it might become in the mind of the sympathetic reader.

It is useful to keep in mind the passion for Shelley shared among the members of Milnes's university circle, and the resulting Shelleyan accent to their appreciation of Keats. Milnes's Keats is haunted by the ghost of Adonais; the poet is bound from the outset for the empyrean ideal envisioned by Shelley.[4] Milnes's idealism, however, does not preclude the presence of a more material register; his biographical project finds important terms and forms of evaluation in the museum. Keats's intellectual life validates his work by functioning like a fragment from antiquity, as a representative part of a lost grandeur, the whole of which is to be found in the pristine world of the imagination.

The nature of biography is affected when the poet's self-ideal must be understood in order to appreciate the poems. Evaluation in the *Life* is made from deep within the library. Moral judgments are limited; the standards of the poet crowd out those of the public: "There is indeed progress, continual and visible, in the works of Keats, but it is towards

his own ideal of a poet, not towards any defined or tangible model. All that we can do is to transfer that ideal to ourselves, and to believe that if Keats had lived, that is what he would have been" Milnes, (280). The self-generated ideal has become a goal that is not only culturally comprehensible but also a standard that the public must assume ("transfer . . . to ourselves") in order to understand the poet at all. Needless to say, we are a long way from the public of Johnson, or even of Scott. Or, rather, the attitude toward the public hinted at in Lockhart's magnificent analogies for Scott—those kings and generals—is here made explicit. The author is the arbiter of his own reception; his goal is not to achieve a body of work or an ethical character, but to arrive at a self-defined concept of the poet. As becomes evident from the letters Milnes prints, the values of the public are unlikely to result in the proper response to genius.[5]

The complex of ideas behind the attitude Milnes depicts can be found in earlier romantic (and even neoclassical) formulations, but what I am interested in exploring is its paradoxical manifestation in a text aimed at instructing the public through the narrative of a life. The need to educate the world in one's poetic values was, of course, important in much of romanticism; Wordsworth's use of his Preface to *Lyrical Ballads* to elucidate the program behind his poetry is only the most famous instance. In the foregoing passage from Milnes, however, the ideal is not a vision of the future of *poetry*, so much as of the possible glory of the *poet*. Milnes's project is to create an audience for a poet whom he presents as forthrightly rejecting the claims of the public. Though this would become a common undertaking in later accounts of the artist, we should not be blind to the originality of the positions here of poet and biographer. Lockhart, for example, did not need to clear a space in the popular imagination for Scott, nor did Hazlitt for Coleridge, and what contempt Scott expressed for the public was couched emphatically in terms of class prerogative, not artistic disdain.

The treatment of the public in Milnes's biography is particularly significant because of the crucial part played by the work in the development of Keats's reputation. Although the popular indifference to his poetry in the first half of the nineteenth century has been at times exaggerated, it is certain that in the 1840s Keats's reputation was at its lowest ebb. Original editions of his poems were offered at a discount by booksellers, and Rossetti and Holman Hunt claim that when they came across these volumes, they thought they had discovered an unknown poet. Indeed, Milnes did not immediately convert everyone to his view of Keats's genius; the poet's reputation can only be described as in a process of consolidation from the 1850s to the 1870s.[6] The role Milnes played in defining Keats's place in the nineteenth-century imagination is typical of his career. He was a remarkable agent for establishing the links between

art and society. His support of Swinburne and Tennyson is well known, but as early as 1838 he was working with Carlyle toward the founding of The London Library. In 1853 he served as a member of the parliamentary committee considering the future of the great national art collections, and in 1873 he became a trustee of the British Museum.[7] Milnes's description of Keats's fragmentary life ("the complete statue, of which such a fragment is revealed to us, stands perhaps solely in the temple of the imagination") takes on a deeper significance when considered in relation to his involvement with the arrangement and display of art for the public.[8] Indeed, in order to identify the nature of the "temple of the imagination" Milnes built for Keats it will be necessary to explore not only the *Life* of the poet, but also to relate it to the urge, discussed earlier, to uncover a principle by which to organize an otherwise overwhelming surfeit of knowledge.

The Museum: Accommodating Art

With both Keats and his biographer, there is never any exit from museum or library.[9] The 1853 Parliamentary Select Committee on the National Gallery on which Milnes served was a manifestation of the institutionalization of museum culture or, rather, of the will to institutionalization.[10] The panel found itself dealing with wider issues than those raised by the day-to-day management of the gallery. It invited witnesses to answer questions aimed at elucidating the fundamental mission of the national art collections, as well as to make suggestions on how that role could best be fulfilled.[11] Discussion included the shape of a building or buildings to house the material—indeed, whether it should be one building or more—as well as the aim of the collection: was it meant to instruct the public or to teach artists, should it contain a history of art irrespective of quality, or be a selection of the greatest examples that could be assembled?[12]

The panel's questions demonstrate the troubled coexistence of a desire to rationalize the presentation of art with the growing realization that the history of art itself might not offer the same clear lessons as had once been assumed.[13] The committee understood its mandate to be to clarify at a fundamental level the aim of the national museums: "It has been alleged by numerous witnesses, and admitted by members of the Trust, that the additions to the Collection have not been made on any definite principle; whether with a view of imparting to it completeness, of illustrating the history of art, or of raising the standard of national taste."[14] The commission was eager to find a justification and organizing principle for the objects already in the nation's possession and steadily accruing. At

ANSWERS to QUERIES

QUESTIONS.	ANSWERS FROM BELGIUM.	ANSWERS FROM BERLIN.	ANSWERS FROM FLORENCE.
1. Are the national collections of antiquity and fine art in united in a single building, or in buildings contiguous to each other? Or,	1. The collections of this kind in Belgium are, the Royal Museum of Painting and Sculpture, and the Royal Museum of Armour and Antiquities. Each of these museums is placed in a separate building appropriated to itself, and at a considerable distance from each other.	1. The Royal Collections of Antiquity and Fine Art took their rise in the Cabinet of Art (so called Kunstkammer) formed by the Electors, in the Palace. During the late King's reign, everything that was considered conducive to the purpose of a comprehensive and instructive collection, and that was scattered among the royal palaces, was united	1. The Florentine Gallery includes every object of art, as well ancient as modern, and in sculpture equally as in painting; bronzes, terra cotta, cameos, medals, drawings, &c.; and is situate in the upper floor of the great building called the "Uffizi," which serves in the lower floors for other uses.
		to the above. The chief part of these collections was brought together in the museum under King Frederic William III., and, as the building was not from the first moment spacious enough, a second building, connected with the same by a covered archway, has been constructed by his present Majesty; so that, when quite finished, they will contain all the above-mentioned collections within them. Should the space at a remote period become too confined, there is room for further buildings in the immediate neighbourhood, which already belongs to the administration of the Royal Museums.	
2. Are the different collections, or any portions of them, arranged in altogether separate edifices?	2. The building which contains the Royal Museum of Painting and Sculpture contains also the Royal Museum of Natural History, and the rooms destined for the sittings of the Royal Academy of Science, Literature, and Beaux-Arts, and for the Royal Society of Medicine.	2. Disposed of by the foregoing.	2. In the same building, but in separate rooms, according to the collections of the different schools of painting.
3. What are the precise definition and limits of the classes of objects exhibited or preserved in the galleries under the head of "Antiquity and Fine Art"?	3. The collections of the Royal Museum of Painting and Sculpture are divided into two principal sections; the one appropriated to the arts of design, the other to statuary. The first section comprises two divisions, viz., The first division, which itself comprises two sub-divisions; 1. From the origin of the art to the time of Rubens. 2. From Rubens to the 19th century. The second division also comprises two sub-divisions; 1. Objects of art, by masters who have died since the beginning of the 19th century. 2. Those by living artists. The second section is composed of three divisions, namely, First division, composed of the productions of sculptors of all periods. Second division, composed of the works of living artists. Third division, composed of casts from original works in other collections. Separate rooms are, as far as possible, assigned to each division and sub-division. The Royal Museum of Arms and Antiquities is divided into two principal sections. The first section comprises all ancient offensive and defensive arms, as well as articles of every kind having reference to archæology, and especially to the national archæology. The second section comprises fire-arms, as well as all modern offensive and defensive arms.	3. The principal part of the Museums consist of: 1. The collection of choice casts, of sculpture and architectural parts of edifices of all countries and periods. To these are joined, 2. The ethnographical collection. 3. The collection of northern antiquities. 4. The collection of Egyptian antiquities. 5. The collection of antique sculptures, and of the greater sculptures of the middle age down to the present time. 6. The antiquarium, which comprises: a. The inscriptions. b. The painted vases. c. The unpainted clay works (terra cotta). d. The objects of glass, mosaic, fresco painting, and such like. e. The bronzes. f. The cut stones (gems). g. The ornaments. h. The ancient coins. i. The coins of the middle age, and of later times. 7. The collection of historical curiosities of the Royal House, of this country and of other countries; models of monuments, models of constructions of the middle age, made exactly on the same scale. 8. Collection of the smaller works of art of the middle age and of modern time, in wood, ivory, glass, majolika, porcelain, seals, and such like. 9. The picture gallery. 10. The collection of hand drawings, miniatures, and prints (usually called "copper engraving" cabinet). With this is connected a library specially established for the purposes of the institution, with a sphiragusical collection, and an archæological apparatus.	3. All works having reference to the fine arts are admissible to the museum, except copies and material reproductions; and they are dependent on the same director.
4. Does, for example, the pictorial department include painted vases, antique frescoes, or engravings and original drawings?	4. No; the painted vases and antique frescoes, if there were any, would be kept in the Museum of Arms and Antiquities. The engravings and original drawings are deposited in the Royal Library.	4. The collection of paintings contains no vases, or antique or modern frescoes; the two former are to be found in the antiquarium, the latter are placed in the 10th department, where they are seen to better advantage; only one fresco painting taken from the wall (out of a palace at Mantua), the Giulio Romano, has found a place in the picture gallery.	4. The same department may contain them, provided they are separate from each other.

Fig. 39. (top) *Report from the Select Committee on the National Gallery* (London, 1853). (bottom) Detail from the first page: "Answers to Queries on the Galleries and Museums of Fine Arts in Different Countries."

the turn of the century a characteristic response to the heterogeneous art objects uncovered by archaeology had been (as I have argued) the desire to look behind them, to identify some more coherent lost original such as Knight's phallus, Barry's Atlantis, or Blake's visionary temples. By the middle of the nineteenth century, however, the movement in culture was no longer toward identifying one originary locus but toward amassing and organizing. Heterogeneity was dealt with not by the fiction of a pure unsullied source but through the attempt to house the material in a structure that would identify the significance and relative importance of its holdings (George Eliot's Casaubon is worse than wrong in his search for a key to all mythologies—he is belated).[15]

The tension between inclusivity and order is graphically illustrated in the apparatus attached to the committee's report. Folded into the end of the volume is appendix VII, three extraordinarily long pages summarizing the information collected from museums around Europe in response to a list of queries (fig. 39). Like the works of art themselves, information is now available and welcome from all parts of Europe; at issue is how best to present valuable material in a usable structure. The ambition to organize and delimit drives the questions. Are the national collections housed under one roof, contiguous, or separate? What are "the precise definition and limits" used to organize the collections? The answers received, however, vividly demonstrate the arbitrary quality of the categories being compared: Munich and St. Petersburg, for instance, keep their Greek vases in the same building as their paintings; in Rome and Berlin, where vases are considered archeological objects, they are kept firmly apart (Florence will allow them in the same department, "provided they are kept separate from each other"). While St. Petersburg proudly describes its "rich collection of moulds of the best ancient sculptural productions" (along with other reproductions), and France also admits to a collection of casts, Florence claims to allow no copies in its museums. The drive toward completion that inspires the committee yields an unwieldy heterogeneous quantity of data requiring tabulation in a potentially endless, and not always comfortable, system of display. Pages overflow the book that contains them; answers expand beyond their limits—in the detail reproduced here, for example, Berlin encroaches on space assigned to Belgium.

The debate over the shape of the buildings that might house the English collections demonstrates a similar conflict between information gathering and structure. One of the most revealing plans presented to the committee is that of Edmund Oldfield, an assistant in the department of antiquities at the British Museum (fig. 40). His description of his "Plan for a Museum of Antiquities in an Open Situation" suggests a potentially endless telescoping structure like that of appendix VII:[16] "The

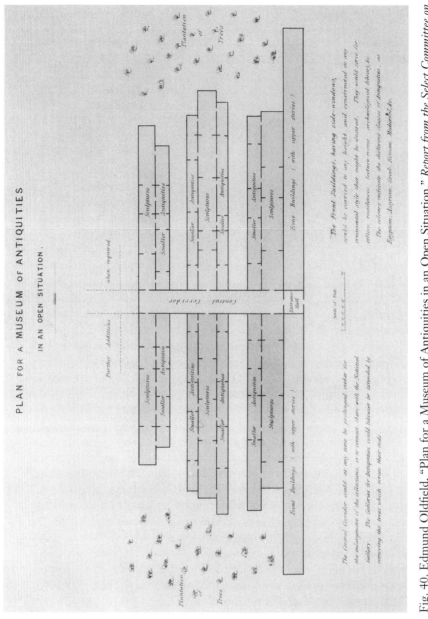

Fig. 40. Edmund Oldfield, "Plan for a Museum of Antiquities in an Open Situation." *Report from the Select Committee on the National Gallery* (London, 1853).

Central Corridor could at any time be prolonged for the enlargement of the collections, or to connect them to the National Gallery. The Galleries for Antiquities could likewise be extended by removing the trees which screen their ends. The Front Buildings could be carried to any height" (plan facing p. 595). Oldfield could not be clearer; the main merit of the proposed building is that it is expandable. The importance of this quality is demonstrated when Oldfield is asked his opinion of the proposal simply to build a massive dome over the central court of the British Museum in order to create a space for the display of antiquities. The question leads to the following exchange:

> No; it would confine us in every direction.
> You think it would be objectionable?—I do.
> That would not allow the scheme of arrangement which you think desirable?—No; nor would it admit of much extension.
> You require I think you say, an almost unlimited extension for antiquities?—Yes; I think it would be most desirable. (nos. 8366–69)

The museum that Oldfield designs is not characterized by its decoration, or even its size, but by its "almost unlimited" ability to grow. As the committee member (Lord Seymour) questions him about how he would restrict the antiquities housed in the building, it becomes clear that Oldfield is anticipating a perpetually increasing collection. He does not disagree with Seymour's challenge: "I do not know what you call the most catholic principle, ... except that of adopting and taking in everything" (no. 8376). The point, as Lord Seymour realizes, is not the specific objects that may or may not be included, but the idea that the principle behind a museum may demand perpetual expandability: "Then, if we should find, as we have found, the palaces of some other ancient dynasties, we must build for them again?—Provided it be a new class of remains, and likely to instruct the public, I think we should" (no. 8377).

The new ambitions for the museum expressed by Oldfield are also indicative of the basic dilemma facing the committee. If the role of the museum is no longer to present a limited set of known masterpieces, but to display and accommodate a constantly growing collection, how is the material to be accommodated and organized, and to what end? Behind the committee's inquiries into issues of organization, restoration, and display is an anxious sense that the quantity of items in the national museums had well outpaced the vague principles that had dictated their acquisition.[17] The heterogeneous nature of the material entering the collections only served to further undermine preexistent assumptions.

Greece or Nineveh: Canons and Artistic Hierarchies

Milnes's longest intervention when he served as a member of this committee was on the subject of the Elgin Marbles. Specifically, the question that troubled him was whether those works were being exposed to undue competition from the Assyrian fragments recently installed in the British Museum. That the biographer of Keats should come to the defense of works that will always be associated with that poet cannot be surprising, but the issue that provoked him has wider cultural implications.

Milnes was not alone in being anxious about the implications of the arrival of such extraordinary pieces as the Assyrian monuments and other nonclassical art. Indeed, concern was justified: from 1834 to 1851, the Egyptian holdings of the museum went from occupying 1,773 square feet of the museum to 9,044. Even more dramatically, the Assyrian collection grew from 218 to 2,736 square feet, most of the pieces arriving at the museum from the end of the 1840s to the early 1850s (fig. 41). Though the space devoted to classical material doubled in size in this period, it was the dramatic increase in work from outside ancient Greece or Rome that was met with the greatest resistance.[18] This is the background to the exchange between Keats's biographer and Sir Richard Westmacott, professor of sculpture at the Royal Academy and the man responsible for the placement of statues at the British Museum, on the question of whether the imposing Nineveh statues were detracting from attention due to the Elgin Marbles:

> Do you think the liberal introduction into the British Museum of works of earlier and oriental art, has had any effect upon the interest felt by the public with regard to the Elgin Marbles? (no. 9052)

Westmacott denies any problem ("None whatever, I should say"), because he considers the merits of the Greek work self-evident and transcendent, while the interest of the "earlier and oriental" art is purely archaeological. Nevertheless, Milnes insists:

> Do you think that as many persons attend and take an interest in the Elgin Marbles, when they are side by side with the Nineveh sculptures, as would take an interest in them if the Elgin Marbles were alone? (no. 9055)

Milnes is describing a physical as well as an intellectual challenge—a number of the Assyrian works had been located "temporarily" in a roofed-over corridor between the Elgin rooms and the main gallery, a physical encroachment on the privileged space of the Greek marbles.[19] This exchange between Milnes and Westmacott, representative as it is of

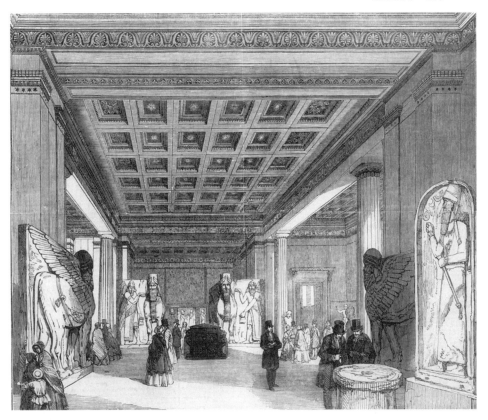

Fig. 41. "The Nineveh Room, at the British Museum," *Illustrated London News*, February 12, 1853.

the struggle between inclusive and exclusive attitudes toward a burgeoning canon, has been described as "one of the most crucial artistic encounters of the century" (Haskell, 102). In the context of the entire report, it becomes evident that Oldfield's perpetually expandable museum is an extreme manifestation of catholicity as a response to accumulation, whereas crowning the buildings of the British Museum with a dome would be the physical declaration of the limits of possible expansion, declaring the canon complete. There is a third way, however, one that does not require walls—it is the creation of a canon within the canon, a hierarchy of the collection that instructs those interested that, though the museum may keep growing, certain objects or artists are to be ranked high above the mass of the competition.

Francis Haskell locates the impetus to create a catalogue raisonné of what *should* be admired (as opposed to what is on display) as early as the 1790s, but the issue was clearly reaching a critical point by midcentury. Haskell draws our attention to the prevalence and popularity of pictorial "hierarchies of artists" around the middle of the nineteenth century. He focuses on Paul Delaroche's immensely successful mural in the Hemicycle of the Ecole des Beaux-Arts in Paris, showing a pantheon of painters since antiquity gathered in a calm Elysium, and on the similar groups—including poets, musicians, and architects—carved on the podium of the Albert Memorial by Henry Armstead and John Philips (figs. 42, 43). Haskell uses these visual equivalents to D'Israeli's biographical compendia to demonstrate a nineteenth-century canon under constant revision.[20] The very fact of inclusion in a hierarchy of this sort, more than the actual rank ascribed, indicates the value of the artists depicted. Though visual pantheons have a long history in art— including most notably Raphael's *School of Athens* and *Parnassus* in the Vatican—it is evident that representations of this sort had become more important in the middle years of the nineteenth century, and more public.

Haskell makes clear that the process of selection and organization of artistic hierarchies is the inevitable result of a widening canon of work: "the breakdown of a hierarchy of values was implicit in the very breadth of taste that had been assumed by the middle of the eighteenth century," he notes, adding that "it is sometimes difficult to see why this breakdown only came about rather later."[21] Ziff links the growing importance of the genre to the cultural urge to order art. He connects the production of Delaroche's mural to the 1837 founding of the *Commission des monuments historiques*, the growing interest in Vasari, and the increasing popularity of depictions of scenes from the lives of painters in academic painting of the 1820s and 1830s. He cites the *Elysium* that James Barry painted on the walls of the Royal Society of Arts at the end of the eighteenth century, and Ingres's 1827 *Apotheosis of Homer*. But the key difference between the work at midcentury and its earliest predecessors, as Ziff notes, is that whereas previous efforts tended to include artists as *part* of the inventory of human achievement, Delaroche's Hemicycle is a heaven only of artists and the history of art.[22]

A similar fascination with groupings of artists is also evident in a contemporary document including literary and artistic figures. In 1848, the nascent Pre-Raphaelite Brotherhood assembled a list of their "immortals," which William Holman Hunt later reproduced in his *Pre-Raphaelitism and the Pre-Raphaelite Brotherhood*:[23]

We, the undesigned, declare that the following list of Immortals constitutes the whole of our Creed, and that there exists no other Immortality than what is centred in their names and in the names of their contemporaries, in whom this list is reflected:—

Jesus Christ****
The Author of Job***
Isaiah
Homer**
Pheidias
Early Gothic Architects
Cavalier Pugliesi
Dante**
Boccacio*
Rienzi
Ghiberti
Chaucer**
Fra Angelico*
Leonardo da Vinci**
Spenser
Hogarth
Flaxman
Hilton
Goethe**
Kosciusko
Byron
Wordsworth
Keats**
Shelley**
Haydon
Cervantes
Joan of Arc
Mrs. Browning*
Patmore*

Raphael*
Michael Angelo
Early English Balladists
Giovanni Bellini
Georgioni [sic]
Titian
Tintoretto;
Poussin
Alfred**
Shakespeare***
Milton
Cromwell
Hampden
Bacon
Newton
Landor**
Thackeray**
Poe
Hood
Longfellow*
Emerson
Washington*
Leigh Hunt
Author of Stories after Nature*
Wilkie
Columbus
Browning**
Tennyson*

Like the gatherings depicted in the Ecole des Beaux-Arts mural and the Albert Memorial podium, the document is an assembly from across the ages, a transhistorical canon of artists arranged so as to indicate their relative importance, irrespective of original era or nation. The list of the Brotherhood differs from other such canonizing gestures only in the explicitness of its language of devotion, giving voice to what is implied in the glorious treatment in the visual arts.[24] Religion is self-consciously evoked in the Islamicizing language of the pledge of the Pre-Raphaelites:

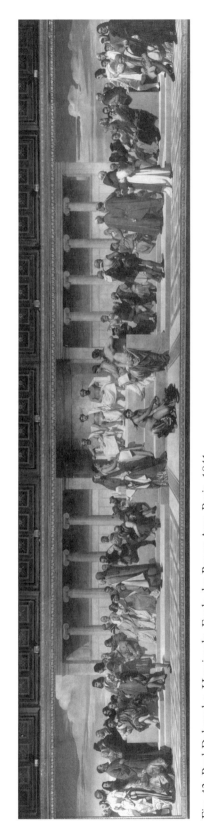

Fig. 42. Paul Delaroche, Hemicycle, Ecole des Beaux-Arts, Paris, 1841.

Fig. 43. Henry Hugh Armsted, Poets and Musicians, podium frieze, the Albert Memorial, London, 1864–1872.

"there exists no other Immortality than what is centered in their names and in the names of their contemporaries."[25] The text insists on the importance of the artists themselves; their names become a litany, their images icons.[26]

The members of the Pre-Raphaelite Brotherhood celebrate the need to identify levels of significance in a world in which cultural canons are steadily expanding. The ranking within the canon indicates an element of competition behind the need to make such a list and pledge oneself to it with such emphasis. If this hierarchy were self-evident, no catalog would be needed; the list indicates a desire for order far more than it presents a record of established fact. It is worth noting, also, that nonpainters substantially outweigh painters in this pantheon. Even more striking is the paucity of starred painters. Only Fra Angelico, Leonardo, and Raphael rate that honor, and the last two rank no higher than Coventry Patmore or Longfellow, while Thackeray gets as many stars as the painter of the Gioconda. Discipline boundaries blur in the search for cultural idols; what is significant to the makers of this canon is not the specific practices of individual painters or poets but their position as markers of the value of being an artist.

In the famous preface to his *Poems* of 1853, Matthew Arnold provides a surprisingly useful gloss of the sensibility behind the preoccupation with artistic canons:

> The confusion of the present times is great, the multitude of voices counselling different things bewildering, the number of existing works capable of attracting a young writer's attention and of becoming his models immense: what he wants is a hand to guide him through the confusion, a voice to prescribe to him the aim which he should keep in view, and to explain to him that the value of the literary works which offer themselves to his attention is relative to their power of helping him forwards on his road towards this aim. Such a guide the English writer at the present day will nowhere find. Failing this, all that can be looked for, all indeed that can be desired, is that his attention should be fixed on excellent models.[27]

For Arnold, the "multitude of voices" available results in cacophony; he longs for a guide indicating which of the various forms of art available should be followed. But until his dream of the perfect canon-forming critic is realized, it is to specific individual artists of the past that the young writer must turn. Arnold would by no means have been happy with the simplicity of the catalog compiled by the young Pre-Raphaelite Brothers—witness his ambivalence toward Shakespeare later in the preface—but he shares their desire to fix on "excellent models."

The Library

What is the connection between the life of a poet in the first decades of the nineteenth century and the deep and widespread cultural urge to put into an order the creative work (and workers) of the past which is evident in the middle years of the century? The impact of Milnes's biography has to be understood in relation to its appearance in a culture engaged with issues that had been central to Keats's career; Milnes reflected the concerns of his day in what he chose to highlight of Keats's life and work. The biography of Keats is the tale of his schooling in art. Milnes is insistent in his claim that Keats's poems should be viewed as the traces of an education: "let us never forget, that wonderful as are the poems of Keats, yet, after all, they are rather the records of a poetical education than the accomplished work of the mature artist" (243). Unlike Lockhart's emphasis on the nonartistic in Scott's life—the politics, the legal career, the property, the tree planting—Milnes's focus is on the story of Keats as it relates to art. The *Life* is the result of the coming together of two sensibilities deeply and self-consciously invested in an emergent valuation of the artist; it is possible to hear both Milnes and Keats quite clearly in the text, and they are both talking about art. The account is not so much about the growth of a poet, as it is about his placement within culture. The account of Keats's poetic development is the story of his positioning in relationship to other poets, a process that Milnes depicts in order to fix Keats in the culture of the later nineteenth century.[28]

Scholarship has made clear the depth of Keats's involvement in the art world of London in the late teens and twenties, as well as the intimate connection between the visual and literary arts in his milieu.[29] It is a link evident throughout Milnes's *Life*. Consider the range of reference in Keats's 1818 comments on a book of prints: "In it were comprised specimens of the first and second age in Art in Italy. I do not think I ever had a greater treat, out of Shakespeare . . ." (183). In two sentences Keats demonstrates his participation in the new responsiveness to art history as well as the constant ranking that accompanied it. Not only does a relatively unsophisticated connoisseur such as Keats evince a knowledge of the phases of art history, but he is able to admire work that a decade earlier would have inspired only antiquarian interest.[30]

Keats's cross-medium comparison of the prints to the work of Shakespeare is not a casual juxtaposition that should be taken for granted. The ready movement between visual and literary art is an important development in the first quarter of the century. Keats's early mentor, Leigh Hunt, evinces a related sensibility in a nearly contemporary essay. Note the quality of choice that enters culture in the library: "Here we are . . .

with our fire before us, and our books on each side, what shall we do? Shall we take out a Life of somebody, or a Theocritus, or Dante [Petrarch], or Ariosto, or Montaigne, or Marcus Aurelius, or Horace [Molière], or Shakspeare, who includes them all? Or shall we *read* an engraving from Poussin or Raphael?"[31] I quote the original 1819 text, but I have placed in square brackets Hunt's emendations to the 1834 edition, in which Petrarch and Molière took the place of Dante and Horace. I am not interested in tracing the reputations of the authors involved so much as in noting the insistence in the passage on the heterogeneity of culture available. Hunt's readiness to change his list, and the incongruity of substituting a seventeenth-century French comic playwright for a Latin pastoral poet, suggest that his interest is in the variety available rather than in specific texts. Images, furthermore, are an integral part of this world. Etchings from the Old Masters are as readily available as books; they have entered the library to be "read."

Milnes's Keats also moves easily between art and literature. In a telling instance, the biographer selects for praise an excerpt from "I stood tiptoe upon a little hill," an early poem (1816) in which canonical art has a surprising presence:[32]

> The evening weather was so bright and clear
> That men of health were of unusual cheer,
> Stepping like Homer at the trumpet's call,
> Or young Apollo on the pedestal;
> And lovely woman there is fair and warm,
> As Venus looking sideways in alarm. (33)

These gods are clearly statues: Apollo on a pedestal, Venus posed like her image in the Uffizi Tribuna. The casual manner in which Keats introduces statuary into his text is striking. Far from obvious accessories for a description of human contentment on a beautiful evening, these stone gods are incongruous; their presence owes more to a need of the author to evoke them than to any requisite of the poem. The specific sources of these images are evident (and would have been all the more so in 1818), the *Apollo Belvedere* and the *Venus de Medici*. But a stone statue is an unlikely simile for a "woman fair and warm"; the presence of such a figure suggests Keats's eagerness to place the antique knowledge he was acquiring. It is worth pausing also on the strange parallels proposed in the passage: Apollo, Venus, *Homer*. What is the poet doing among these statues? His presence is not only another instance of the intertwining of the plastic and literary arts, but also, and quite significantly, of the conflation of the arts and their makers.

The setting of the fragment as a whole, beyond the passage Milnes quotes, is a Claude landscape inhabited by poets. The peculiar epigraph

from Leigh Hunt that opens the text—"Places of nestling green for Poets made"—indicates Keats's preoccupation with locating writers. The subject of the poem is the wandering of primal bards through a terrain congenial to inspiration, and its tone is indicative of an empathetic identification with their experience: "So felt he, who first told, how Psyche went. . . . So did he feel who pull'd the boughs aside / That we might look into a forest wide" (lines 141–52). "What first inspired a bard of old to sing / Narcissus pining o'er the untainted spring? / In some delicious ramble he had found / A little space, with boughs all woven round . . ." (lines 163–66). Ian Jack notes that each story that Keats tells in this poem "can be used to describe the origin of poetry; and that each of them has been a favourite with painters" (*Keats*, 144), but what is particularly striking is the manner in which the poem situates both sorts of cultural work (poetry and painting) within a still landscape that is also inhabited by the poet. Milnes acknowledges the odd importance of the poet *in* the poem when he describes the culmination of the piece as "the union of the Poet and the Goddess" (33).

The museum culture with which Keats came to be identified tended to conceive of all great artists as sharing one timeless contiguous existence like that of the artists in Delaroche's mural or the statues on the Albert Memorial.[33] Such images work to embody the quality of atemporality which Hans-Georg Gadamer has identified as typical of the "universal library" and the museum. In *Truth and Method* he describes such institutions as "special sites for simultaneity" established by aesthetic consciousness.[34] What Delaroche, Armstead, and Philips transcribed into space was the idea of a timeless fraternity of artists, an idea that had been evoked by the institutions of culture such as the museum and the library, and which was becoming crucial to nineteenth-century concepts of the artist.

Gadamer cites André Malraux, and, indeed, that writer's concept of "*Le Musée imaginaire*" is apposite: Malraux notes that the unavoidable incompleteness of museums "conjures up thoughts of an ideal art museum."[35] The presentation in one space of material from widely different locations and periods invites a sense of timelessness, while the inescapable failure of the museum to fill all the historical niches it identifies evokes a perfect museum that can exist only in the imagination. As we have seen, the attempt to rationalize the museum results either in the concept of an institution that must allow for the possibility of accommodating everything, or in the concept of one that maintains its integrity only by shutting itself off and focusing on the collection in hand. E. H. Gombrich, in a useful historical critique of Malraux's work, translates Malraux's principal concept (*Le Musée imaginaire*) as a "museum of the mind," and like Gadamer with his universal library, he parallels it to a "library of the mind." Gombrich's essay is particularly interesting because

while Malraux's focus is on early modernism, Gombrich locates the roots of an inescapable cultural eclecticism in the eighteenth century, and its fruition in the mid-nineteenth: "if the *Musée Imaginaire* has a real predecessor it is Caxton's Glass House."[36]

A principal aim of Milnes's biography is to place Keats in relation to the ideal museum from which he writes. "I stood tip-toe" is quoted in the *Life* because it is an instance in which Keats creates a timeless landscape of poets.[37] But Milnes's analysis of the poet's classicism provides him with the opportunity for exploring the issue of Keats's own odd contemporaneity with his predecessors. The biographer's preoccupation with what he describes as "the faculty by which the Poet could communicate with Grecian nature" (146) forms part of the project of reclaiming Keats's reputation, of reshaping into a more acceptable form the popular image of Keats as a rather vulgar and undereducated ex-surgeon's apprentice prone to getting in over his head in his classical references.[38] But Milnes takes his argument a great deal further when he writes on "the process by which the will of Keats came into such entire harmony with the sensuous workings of the old Grecian spirit . . . not only did his imagination delight in the same objects, but . . . it was, in truth, what theirs under certain circumstances might have been" (146). Like Delaroche or Armstead, Milnes conceives of the great poets existing together in timeless beauty, in this case because they all share the same imagination. Milnes proposes an almost biological connection: "natural consanguinity, so to say, of intellect, soon domesticated him with the ancient ideal of life" (6).

Milnes stops repeatedly to wonder at the development of Keats's mind; he is particularly concerned to address what he takes to be the incongruity between Keats's inexhaustible sensibility and his small learning. Describing the problem as "quite inexplicable by any of the ordinary processes of mental education," he develops the theme at length:

> If his classical learning had been deeper, his seizure of the full spirit of Grecian beauty would have been less surprising; if his English reading had been more extensive, his inexhaustible vocabulary of picturesque and mimetic words could more easily be accounted for; but here is a surgeon's apprentice, with the ordinary culture of the middle classes, rivalling in aesthetic perceptions of antique life and thought the most careful scholars of his time and country. (279)

One solution to the mystery of Keats's intellect is that as a poet he naturally shares a world with antiquity. Like Homer striding through a beautiful day accompanied by statues that are gods, Milnes's Keats inhabits a world of strange intimacy with cultural artifacts.

The biographer rather forces into his analysis of Keats's classicism a passage by Leigh Hunt on the mythological in Shakespeare. Hunt is moved to find evidence of an eternal commonality of artists in Shake-

speare's passages evoking the classical tradition: "all great poets," Hunt declares, "look at themselves and the fine world about them in the same clear and ever-living fountains" (108).[39] Milnes develops the idea of a continuity in the poetic species when he comments on the passage: "Every word of this might have applied to Keats" (108). D'Israeli's atemporal catalog is here taken to its extreme, the nonchalance with which the biographer transfers the description from one poet to another itself demonstrating the theme of an innate sharing of qualities among artists. Milnes suggestively proposes that Hunt's lines have "more than an accidental bearing on the kind of classical knowledge which Keats really possessed" (107).

Milnes's answer to the problem he poses is anticipated by Keats himself, when, in an 1818 letter to his friend Benjamin Bailey, Keats notes the accumulation of knowledge and transforms it into a process not of culture but of mind: "Twelve days have pass'd since your last [letter] reached me.—What has gone through the myriads of human minds since the 12th? We talk of the immense number of books, the volumes ranged thousands by thousands—but perhaps more goes through the human intelligence in twelve days than ever was written" (54). The imagination is like Hunt's library, only more so; it opens out to a nearly limitless universe. As Keats puts it in a letter to his brother later the same year: "I feel more and more every day, as my imagination strengthens, that I do not live in this world alone, but in a thousand worlds." Typically, as Keats elaborates on his myriad worlds, he moves easily between identifying with characters and with writers: "according to my state of mind, I am with Achilles shouting in the trenches, or with Theocritus in the vales of Sicily" (169).

To understand the significance of Keats's residence in the library, one need only compare the placement and valuation of literary figures, which is so central to Milnes's *Life*, with similar instances in the work of an earlier biographer such as Johnson. In that author's *Lives of the Poets*, Cowley finds a copy of Spenser on his mother's windowsill, a discovery that inclines him to the poet's vocation, but that is the last of the discussion of his debt to the past. Johnson does not depict his poets sifting through the ore of their predecessors. Monckton Milnes's Keats, on the other hand, is preoccupied by an internalized literary past. When Keats asks: "Did our great poets ever write short pieces?" (45), he locates his ambition to write an epic within literary history; Milnes follows his poet in this idea. *Hyperion* is to be understood in relation to Milton; Spenser, Fletcher, and Jonson are cited as sources for *Endymion* (58); and *Lamia* is written "after much study of Dryden's versification" (210).[40]

The preoccupation with the arranging of self and others in a tradition is another element in which the biographer follows his subject. Consider

Milnes's paradoxical discussion of the influence of Spenser: "precisely those defects which are commonly attributed to an extravagant originality may be distinguished as proceeding from a too [in]discriminate reverence for a great but unequal model" (7).[41] That is to say, Keats is not the undereducated Cockney that his early critics had made him out to be. On the contrary, the peculiarities of his writing are due to the presence of august precursors embedded in his texts. Milnes is forthright about the overwhelming presence of influence that has made Keats so intriguing to later critics:

> I am unwilling to leave this . . . without a word of defence against the objections that might with some reason be raised against the originality of his genius, from the circumstance that it is easy to refer almost every poem he wrote to some suggestion of style and manner derived from preceding writers. . . . you can always see reflected in the mirror of his intellect the great works he is studying at the time. . . . In the case of Keats, his literary studies were apparently the source of his productions, and his variety and facility of composition certainly increases very much in proportion to his reading. (242–43)

Although Milnes will go on to argue that Keats does add some touch of originality to what he appropriates, that his work is a record of an ongoing poetical education and not its final fruit, these answers are trite when compared with what Milnes has tried to do in the biography as a whole, and in this very passage. Other poets are "reflected in the mirror," which is Keats's intellect; the language of reflection that Milnes—quoting Hunt on Shakespeare—applied to the timeless relationship of poets is here used to characterize the very mind of Keats. It is not at all a problem that Keats is always writing from within the library; it is his strength in his own day, and what he has to offer at midcentury—the possibility of integration with an otherwise overwhelming world of choices.

In the context of the internalized cultural complex that so preoccupied him, Keats's most characteristic prediction resonates strongly. "I think I shall be among the English Poets after my death," he writes (163); it is a location with an almost material presence in his thought.

"A Perfect Treasure House": The Museum of the Mind

In his work as well as his letters, Keats had described an Elysium even more complete than that of Delaroche. The early "Sleep and Poetry" (1817) transposes a critical history of poetic development into a landscape of poets:

> O for ten years, that I may overwhelm
> Myself in poesy; so I may do the deed

That my own soul has to itself decreed.
Then will I pass the countries that I see
In long perspective, and continually
Taste their pure fountains. (lines 96–101)

Surrounded by Leigh Hunt's collection of graven reproductions, Keats half dozes into an aesthete's version of a medieval dream-vision. He enters the very sort of library the older poet had described in his *Indicator* essay, but it has become at once a landscape by Poussin and a picture gallery of Claudes and Titians. Keats insists on the autogenous nature of his vocation ("the deed / That my own soul has to itself decreed"), but he situates himself in a wide swath of territory, which is both a painting and a library; the countries that he sees "in long perspective" are evocations at once of seventeenth-century canvases and of stages in his poetic growth.[42]

Keats's drowsing vision naturalizes an intellectual complex that is central to what later nineteenth-century writers would see in his work; the ready interplay of literature and art is represented in the odd sensory confusion of his memory:

Thus I remember all the pleasant flow
Of words at opening a portfolio

Things such as these are ever harbingers
To trains of peaceful images . . . (lines 337–40)

Portfolios open to reveal words, not etchings; paintings are sites of poetry and poets. Keats is explicit on the intertwining of cultural work:

It was a poet's house who keeps the keys
Of pleasure's temple. Round about were hung
The glorious features of the bards who sung
In other ages—cold and sacred busts
Smiled at each other. . . .
. .
Then there were fauns and satyrs taking aim
At swelling apples with a frisky leap. (lines 354–61)

Certainly, these lines describe the prints and casts Hunt had accumulated, but the very title of the piece (*not* "Painting and Poetry") indicates that Keats's concern is poetry rather than the visual arts. Indeed, after surveying various images of seventeenth-century classicism, Keats's eyes come to rest on a *poet* moving in a manner reminiscent of Homer in "I stood tip-toe": "Petrarch outstepping from the shady green . . ." (line 389).

"Where's the Poet?"

The works Milnes includes in the biography are selected to illustrate the library from which Keats writes. Milnes was the first to publish "Spenser, a jealous honourer of thine," "Oh Chatterton! how very sad thy fate," and "To Lord Byron." They are, in that order, the first three complete poems in the *Life*. Indeed, the very first poem in the biography is dedicated to the author whose excessive influence Milnes identifies as meretricious:

> Spenser! a jealous honourer of thine,
> A forester deep in thy midmost trees,
> Did, last eve, ask my promise to refine
> Some English that might strive thine ear to please.
> But, Elfin-poet! 'tis impossible . . ." (Milnes 8)

Already in this first stanza the importance to Keats of the figure of the poet is evident. The bald address that opens the sonnet—both apostrophe and invocation—represents the author's confidence that the power of the single name of a poet will hold the attention, will validate the work. It assumes a shared understanding of the interest to be found in such a subject. Compare this opening with that of Coleridge's "Monody on the Death of Chatterton" (1790–94), which does not mention the subject of the poem until the third stanza, and which justifies its attention to an artist by setting it in the context of a meditation on death. Wordsworth's 1802 sonnet to Milton ("Milton! thou should'st be living at this hour"), Keats's more direct antecedent, has as its subject the contrast between a decadent society and the moral and political authority of Milton. The value of the poet is described, not assumed—and it is expressed in moral, not entirely literary terms. While Wordsworth's presence in his text is circumspect, and that of Coleridge in his "Monody" not openly at issue, Keats's piece revolves around the characteristic relationship between the poet of the past and his modern counterpart; its subject is a modern inadequacy which is so clear that its nature need not be specified. The modern who requests the poem is nameless; his admiration, is jealous; he is a mere logger in the natural growing forest that is Spenser's work. Keats invokes, recounts, and fails, all in the space of five lines.

In the *Life* as in this poem, the appropriate response before past artists is abasement. It is an almost physical position that Keats identifies in an 1817 letter to the printer Benjamin Robert Haydon: "the cliff of Poetry towers above me" (27). Once again, the point is developed by Milnes, who quotes an annotation made by Keats in his Shakespeare: "The genius of Shakespeare was an innate universality; wherefore he laid the achievements of human intellect prostrate beneath his indolent and kingly gaze: he could do easily men's utmost—his plan of tasks to come

was not of this world" (108–9). Like Fuseli at the foot of a fragmentary Colossus, or modern man in Hazlitt's essay on Coleridge, overwhelmed by the magnitude of past accomplishment, the poet in Keats is dwarfed by past cultural achievement. But in Keats the poet in particular lays man low: "As to what you say about my being a Poet, I can return no answer but by saying that the high idea I have of poetical fame makes me think I see it towering too high above me" (44).

Keats's meditations on his career have largely to do with his inadequacy for the task of placing himself among the elevated company of other poets. Religious terms enter his discussion more often than not, as he establishes the vocabulary for the greatness of a poetic vocation.[43] His terms anticipate those which the Pre-Raphaelites will adopt: "I have not the slightest feeling of humility towards the public, or to anything in existence but the Eternal Being, the Principle of Beauty, and the Memory of Great Men" (87). Thus, in the 1817 letter to Haydon: "There is no greater sin, after the seven deadly, than to flatter one's self into the idea of being a great poet, or one of those beings who are privileged to wear out their lives in the pursuit of that honour. . . . I never quite despair, and I read Shakespeare" (29). This is the language of a fervent novice expressing both the fear of sin woven into his sense of vocation and the avoidance of despair by reading in a reassuring text. Religious imagery and attitudes are transposed into sometimes humorous celebrations of the artist—"in the name of Shakespeare, Raphael, and all our Saints, I commend you to the care of Heaven" is Keats's valedictory salute in the foregoing letter (30). Elsewhere, he suggests that his brother and sister in America read Shakespeare every Sunday at ten "and we shall be as near each other as blind bodies can be in the same room" (178). The choice of the Sabbath for this shared act underlines the religious role that Shakespeare is fulfilling, but note also the proximity to be achieved—the distance to be overcome—through culture. Is this the faculty that by Milnes's account is so developed in Keats as to allow him to share an imagination with the Greeks?[44]

The language of abjection in Keats's poems is often overtly religious. Consider "On Seeing a Lock of Milton's Hair" (first published in volume form in Milnes), in which a relic of the older poet disturbs the neophyte:

> Thy spirit never slumbers,
> But rolls about our ears
> For ever and for ever!
> O what a mad endeavor
> Worketh He,
> Who to thy sacred and ennobled hearse
> Would offer a burnt sacrifice of verse
> And melody. (56)

The subject of this poem is inadequacy before a fragment of the poet of the past. As in the sonnet on Spenser, it is "a mad endeavor" even to write verses in honor of Milton, but the source of failure is the exaltation of the poetic calling to a divine height.[45] And yet, the young poet predicts that once his style has matured he will be able to hymn "Of thee and of thy works and of thy life" (57). By the last line of the poem the older poet has become a primal antediluvian figure, but Keats's terms put into play the transhistorical intimacy of artists. Though he is shocked when the relic of Milton is first identified, he is also strangely comfortable with it, because: "I thought I had beheld it from the flood" (57).

Thus, the sacred provides more than a pattern of abasement. When he describes the autotelic nature of the poet in a letter of 1818, Keats also draws on religion for his terms: "The Genius of Poetry must work out its own salvation in a man. It cannot be matured by law and precept, but by sensation and watchfulness in itself. That which is creative must create itself" (155). In a related strategy, Milnes finds the justification for poetic biography in the Christlike inglorious glory of the poet:

> He who deserves the higher reverence must himself convert the worshipper. The pure and lofty life; the generous and tender use of the rare creative faculty; the brave endurance of neglect and ridicule; the strange and cruel end of so much genius and so much virtue; these are the lessons by which the sympathies of mankind must be interested, and their faculties educated, up to the love of such a character and the comprehension of such an intelligence. (281–82)

Milnes's language here reveals the religious paradigm behind his suggestion, cited earlier, that the public must learn to adapt to the poet's own poetic ideal. Whereas in a similar passage Scott simply noted the incongruity of miserable lives culminating in posthumous celebration, Milnes uses the paradox as a means of invoking the Christian model.

"Where's the Poet? show him! show him!" demands Keats, and his question yields to invocation in the poem of that title (202). Like the engraving of the author of *Waverley* at the head of Chambers's book, Keats's answer combines a magnificent and an invisible image. When his predecessors do not simply loom over him, the artist maintains his power by being only partly seen. As Keats puts it in two famous formulations:

> I must say of one thing that has pressed upon me lately, and increased my humility and capability of submission—and that is this truth—Men of genius are great as certain ethereal chemicals operating on the mass of neutral intellect—but they have not any individuality, any determined character. (46)

> As to the poetical character itself . . . it is not itself—it has no character. . . . A poet is the most unpoetical of anything in existence, because he has no identity. (160)

The lack of character of men of genius is what reconciles Keats to the abjection he identifies as necessary before the object of his ambition.[46] The absence of identity is a paradoxical idea in a life so devoted to marking the qualities of distinct poets, but it is characteristic of a nineteenth-century view of the artist that charges the figure with such significance that the only way he can be manifest is in occluded half-visions, in disappointing intimacies, or in fantasies of complete assimilation, which in their exaggeration speak of unbridgeable distance.

"Turning Grandly on His Central Self"

Through the accumulation of extracts from poems and letters Milnes shaped a museum for his poet. Keats himself becomes a fragment, the possibility of whose totality is only to be found in an imaginary temple; the biography becomes a museum whose incomplete holdings evoke the possibility of a greater whole. The reception of the poet formed itself inescapably around issues related to the organization of art: display, transience against permanence, surfeit. The relationship to past art and artists developed in Milnes's *Life* is vital to Keats's appeal to readers at the middle of the nineteenth century. Samuel Phillips, the reviewer of Milnes's biography for the *Times*, finds little good to say about the work. It is striking, then, that the terms he uses in praising the poet are unmistakably derived from the biographer:

> It is the spirit of Keats that at the present moment hovers over the best of our national poesy and inspires the poetic genius—such as it is—of our unpoetic age. Had he lived he would eventually have towered above his companions; dying before he was 26 years of age he took his place at once among the examples whom he so passionately loved, and the models he so successfully imitated and so closely approached.[47]

If he had lived, the reviewer suggests, Keats would have reached the eminence he himself had identified. But in spite of his early death, Keats has become the spirit behind contemporary poetry. Phillips's language is of models, of examples; not simply a poet, Keats is acknowledged as a site for the workings of influence—covert or acknowledged.

For Arnold too, Keats brought to mind thoughts of influence and models. Keats is the preeminent instance in Arnold's writings of the risks involved in the necessary practice of seeking out "excellent models."[48] He is the cautionary figure in Arnold's account of the dangers posed by past models at a time when they are crucially important; Arnold could not avoid Keats because the earlier poet was the specter of a certain kind of influence. It is indeed odd that Keats, a writer for whom he often professed ambivalence, was the principal modern named in Arnold's 1853

preface to his own poems. But even before that piece, Arnold's response to the poet was striking and intemperate. Soon after the publication of the Milnes biography he wrote a letter to Clough:

> What a brute you were to tell me to read Keats's letters. However it is over now: and reflexion resumes her power over agitation.
> What harm he has done in English Poetry.[49]

From the outset, Arnold frames his disturbed response in terms of the poet's influence. But what is the nature of Arnold's unease about that quality which had caused a more sanguine reviewer to describe the poet as a hovering spirit? The letter goes on to make clear that the problem, as it will be in the 1853 preface, is one of selection, of the fear of the variety offered by modernity.

Arnold's anxiety is revealed in the letter to Clough in an uncharacteristic infelicity of style, the repetition of a word—multitudinousness"—that may have seemed inescapable in order to express the quality of awkward accumulation Arnold wished to describe:

> As Browning is a man with a moderate gift passionately desiring movement and fullness, and obtaining but a confused multitudinousness, so Keats, with a very high gift, is yet also consumed by this desire: and cannot produce the truly living and moving. . . . They will not be patient—neither understand that they must begin with an Idea of the world in order not to be prevailed over by the world's multitudinousness: or if they cannot get that, at least with isolated ideas: and all other things shall (perhaps) be added unto them.
> —I recommend you to follow up these letters with the Laocoön of Lessing.

Keats leads Arnold to think of threatening crowds, and the letter as a whole is inspired by a wider fear of the public and its (under)education. But the recommendation of Lessing as a tonic suggests that the challenge for Arnold is not simply the ignorant throng; what unnerves him is the change from a concentrated bounded aesthetic aspiration he links to the eighteenth century (his capitalized "Idea" suggests but does not quite reach the neoclassical "ideal") to a desire for accumulation more to the taste of his own day. Five years later, the letter's dangerous "multitudinousness" will become the preface's bewildering "multitude of voices counselling different things."

Arnold's characteristic description of Keats's work is that which he uses for *Isabella* in the preface: "a perfect treasure house." He is concerned with Keats's lack of structural power, so his metaphor is an edifice that assembles precious items rather than serving as one. After Milnes, the shortcomings of Keats have changed; they are no longer a lack of manliness or fortitude—as they had been earlier in the century—or even an excess of sensuality (though this last still matters to Arnold); the princi-

pal fault is an inability to subsume greater models easily, a tendency to carry them on the surface, rather than integrating them into the poetic structure.

In 1857, visitors to the Art Treasures Exhibition in Manchester crowded into a massive steel and glass edifice to view a remarkable assembly of works of art from collections all over England (fig. 44). On leaving, they could look up to see inscribed in stone on the archway what a contemporary publication described as "the well-known and appropriate line of Keats, —'A thing of beauty is a joy forever.'"[50]

The exhibition is important in the history of taste in England for several reasons—the impetus it gave to the appreciation of early art, the publicity it generated for painting—but what is most original about the event in Manchester is the way it serves as a concrete manifestation of the urge toward the ideal art museum described by Malraux. I cited previously Gombrich's observation that the Crystal Palace should be under-

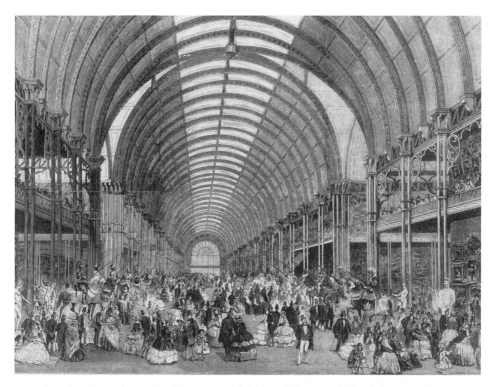

Fig. 44. "Manchester Art-Treasures Exhibition: The Grand Hall," *Illustrated London News*, May 2, 1857.

stood as a material anticipation of Malraux's *Musée imaginaire*, but a truer objective correlative to the "Museum of the Mind" than the Great Exhibition of 1851—with its focus on craft and technology—is to be found in the Manchester Fine Arts Exhibition of 1857. The desire to organize the world of fine art into a coherent whole found its fruition in this event. It was a moment in which the bounds of a collection could be escaped and ideal methods of selection and display put into effect. Indeed, some of the most sophisticated reviews of the event dwelt on it as a model toward which actual museums should strive. In his review, A. H. Layard focuses on the exhibition as paradigm: "The principal interest which attaches to the Manchester Exhibition arises, in our opinion, from the attempt made for the first time in this country to place before the public pictures of various periods, arranged upon the [chronological] system we have described."[51]

Layard, an important figure in the Victorian art world following his epochal discoveries in Assyria, identifies a further benefit to the exhibition in that it affords "many valuable hints at a time when the reconstruction of the National Gallery is in contemplation" (110). It is not its holdings, he argues, that allow the Art Treasures Exhibition to compete with the Musée Napoleon in coverage and with other collections in terms of quality; it is its method of presentation (92). Echoing Oldfield's indifference to the surface of the structure in his plan for a museum, Layard is moved by the example of the exhibition to insist that the design of the front of the new museum is insignificant: "let the façade be erected, but let it be avowed a mere screen" (111).

The organization of paintings at the exhibition was in the hands of Gustav Friedrich Waagen, professor of art history at Berlin University, and curator of paintings at the Altes Museum, but it seems clear that, even before he was put in charge, it was his work cataloging the most significant holdings scattered throughout the nation, *The Treasures of Art in Great Britain* (1854), that gave the impetus and allowed the possibility of the event.[52] It is the realization of a national *Musée imaginaire*, a display not subject to the accidental holdings of one man, or even of the nation, but designed to gather and feature the best art available. Relatively unbound by the limits of ownership or preexistent walls, Waagen was free to follow a scrupulously chronological arrangement.[53] The exhibition produced a number of memorial texts and articles, so that much of its impact was owed to the written word rather than to the unmediated experience of objects. Or rather, the immense exhibition must be identified as at once a textual and a concrete event, its effect all the stronger for following a circular trajectory from text through exhibit and back to text. As a manifestation of an idea, the Art Treasures Exhibition was able to have a different effect in culture from that of more permanent collec-

tions. The ready textualizing of the exhibition allowed for the correction of any flaws in its ideal aspirations. Thus, in a work based on the exhibition, J. B. Warring notes that, as the portrait gallery had interrupted the historical flow of the principal exhibition, "the chronological arrangement so earnestly recommended by His Royal Highness the Prince Consort, has been but partially carried out in the Museum." Warring's own volume however, offers a solution to that physical compromise—"that deficiency . . . will be greatly remedied by the present volume."[54] Layard's own article on the exhibition in the *London Quarterly* takes the form of a *review* of some of the many volumes resulting from the event along with related art-historical publications.[55]

It was widely acknowledged that the exhibit in itself was an artifact impossible to consume; season tickets were sold in order to allow repeated visits, but it was said that "if one person devoted three minutes to looking at each object exhibited, it would take him thirty-three years to do it."[56] The account of a contemporary attempts to convey the overwhelming volume:

> One can study there all the arts of design from their beginnings to the present: painting, engravings, numismatics, goldsmith work, damascening, ceramics, delicate carving, fine cabinetmaking, inlaying, the art of enameling pottery, of doing repoussé work with metals, of cutting crystals. . . . Imagine a palace all of glass, in which would be found gathered the great gallery of the Louvre, the Cluny Museum, the cabinet des Médailles, the reserve deposits of the Cabinet d'Estampes . . .—and you will still have only an imperfect idea of this exhibition.[57]

J. B. Atkinson's two reviews in *Blackwood's* emphasize the gathering together of material that characterized the exhibition; the significance of museums is described as residing in the possibility of assembling dispersed objects, overcoming separation:

> We take it, that a grand international gallery like the present will be comparatively useless, unless it be made the basis of conclusions as wide as the collection is itself extensive. While disconnected works lay scattered in distant churches, criticism could with difficulty assume a consecutive completeness, or throw into its treatment of dissevered parts the system inherent to a united whole. It seems, however, in these days the special use and province of museums, whether of Natural History or of Art, to group together into the completeness of a system materials which formerly lay scattered in individual isolation.[58]

Like Layard, Atkinson is insistent that the strength of the display resides in its chronological arrangement: "It is chronological in the arrangement of the schools—historical as including a series of works more consecu-

tively complete than the world has yet seen under one roof in any one city."[59]

Keats is an apt presence over the building because of his engagement with the problem of art in time; if his words seemed appropriate to carve in one museum, it may be because they had been inscribed in another. "A thing of Beauty is a Joy Forever," is a claim about the immediate object and about eternity. The particular things crowned by this motto in Manchester were brought to a deserted field in Old Trafford and sheltered in a building that—as most commentators remarked—was erected in record speed, but which was also destined to be even more quickly disassembled. Keats's line offers the comfort that somewhere the moment of the exhibition has a longer lasting significance.

In the same year as the Manchester Exhibition, Keats was given a cultural setting less grandiose but no less significant. Elizabeth Barrett Browning included an intriguing tribute to Keats in her narrative of a poetic apprenticeship, *Aurora Leigh* (1857). Her treatment clearly owes as much to her reading of her friend Milnes as to her study of the poet:

> By Keats's soul, the man who never stepped
> By gradual progress like another man,
> But turning grandly on his central self,
> Ensphered himself in twenty perfect years
> And died, not young, (the life of a long life
> Distilled to a mere drop, falling like a tear
> Upon the world's cold cheek to make it burn
> For ever); by that strong accepted soul,
> I count it strange and hard to understand
> That nearly all young poets should write old.[60]

The step that Keats does not take is like that of Homer in "I stood tiptoe," stepping "at the trumpet's call." Both poets are located in the same unreal space in which the author has become a timeless being whose progress is indicated by becoming the subject of another poem. Browning swears on the soul of a poet, but the very syntax of the passage—the odd punctuation and subordination supporting the circularity of her description—enacts the idea of poet become divine. The "self-possession," a term of such significance in Lockhart's description of Scott, here returns; Keats's progress is a turning simply upon himself and involves no outside aim or stimulus.[61] Browning's theme, however, is not the celebration of one poet alone; she extends her observations more widely, and her subject becomes a version of that very intimacy with the antique with which Milnes had been so preoccupied. Like Keats, feeling, even as he is humbled by Milton's hair, an odd half familiarity suggesting that he has

known it since before the flood, Browning is preoccupied at once with the "consanguinity" of the species and its antiquity.

The pervasive influence of Milnes on the later-nineteenth-century rediscovery of Keats ensured that the poet would be understood in relation to two areas of ever growing and interrelated interest in the same period—the visual arts and the figure of the artist. Thus, in an 1860 appreciation of Keats drawing heavily on the work of his biographer, David Masson essentially translates into prose the poetic theory of "Sleep and Poetry"—in the process demonstrating its congruence with a much-discussed current movement in the arts: "This theory, in its historical aspect, I will venture to call *Pre-Drydenism*."[62] Highlighting the quality in Keats that offered so much to artists at this period, Masson identifies Keats's idea of poetry as the literary equivalent of Pre-Raphaelitism. Not only did the poet anticipate the worship of great men we have already seen motivating this group, but he also included in his own verse a cultural history altogether congenial to their rejection of art after the early Renaissance.[63]

Masson is particularly struck by the letters included in Milnes's work, and in his essay he elaborates on the impersonal artistic personality therein described by Keats. Making a Schilleresque distinction between "subjective" poets (by which Masson largely seems to mean Shelley) and "objective" ones (including Homer, Chaucer, Shakespeare, Scott, and Keats) he describes the latter as existing in a closed world of art, which separates them from the rest of the world while connecting them intimately as a group:

> When they betook themselves from miscellaneous action among their fellows to the exercise of their art, they all, more or less, allowed their personality to melt and fold itself in the imagination—all, more or less, as it were, sat within themselves, as within a chamber in which their own hopes, convictions, anxieties, and principles lay about neglected, while they plied their mighty craft, like the swing of some gigantic arm, with reference to all without. Keats did the same; only, in his case, the chamber wherein he sat had, by his own confession, very few fixtures or other proper furniture. It was a painter's studio, with very little in it besides the easel.

Keats, in Masson's description, is an extreme version of the objective type of poet, one whose interior world identifies him as an artist. Negative capability is that quality which more strongly links the writer not to the world but to other poets. Masson evokes a figure of strength reminiscent of "Might half-slumbering on its own right arm" in "Sleep and Poetry"—but he also includes the quality of emptiness that is prevalent in Keats's descriptions of the poetic character. When he acts as a poet, his mind is an empty room furnished only with an easel.

In Keats as mediated through Milnes, there is both that quality of absent power (or power through absence) of the Chambers frontispiece, and the concern with assembling and organizing of the Lockhart cathedral. It is an inescapable temptation in the history of reputations to describe a trajectory from blindness to revelation, but in the case of Keats, it is more to the point that his wider appreciation had to await a time when culture would be as concerned as he with the placement and arrangement of art. I have described already Matthew Arnold's anxious response to Keats and Keats's biography, focusing on his treatment of the earlier poet as an instance of weak response to past models. When Arnold volunteered to write the introduction to the selections from Keats in T. H. Ward's edition of *The English Poets*, he allowed himself the opportunity of returning to a poet who was clearly a disturbing presence in his thought. Not surprisingly, before Arnold revisited Keats in the 1880s, he went back to Milnes; the biographical material in the preface to Keats is clearly from that text. He quotes and praises, for instance, the letter in which Keats declares: "I have not the slightest feeling of humility towards the public or to anything in existence but the Eternal Being, the Principle of Beauty, and the Memory of great men," describing this particular formulation as "a passage where one may perhaps find fault with the capital letters, but surely with nothing else."[64] Arnold inescapably also reverts to Shakespeare in this later preface, but now he can locate something of Keats's timeless relationship to past writers: "Shakespearian work it is; not imitative, indeed, of Shakespeare, but Shakespearian, because its expression has that rounded perfection and felicity of loveliness of which Shakespeare is the great master" (215). In this nonimitative identification Arnold describes a quality Keats aspired to establish and Milnes to transmit. The image of rounded self-sufficiency is used by Arnold as by Browning, in whose poem of twenty-three years earlier Keats was "ensphered," "turning grandly."

In this essay Arnold finds a space for the ideal in Keats, which he had not discovered when he wrote the letter to Clough; it is in the poet's "passion for the Beautiful," as expressed in the first line of *Endymion* and the last lines of the "Ode on a Grecian Urn." Arnold still criticizes the lack of "architectonic" structure in Keats; what has changed is that now this failure is situated in a biographical context, ascribed to Keats's early demise: "therefore I have chiefly spoken here of the man, and of the elements in him which explain the production of such work" (215). Principal among those elements is the poet's death. His untimely passing allows Arnold to find a reason why Keats was limited to achieving perfection in smaller pieces: "In shorter things, where the matured power of moral interpretation, and the high architectonics which go with complete

development, are not required, he is perfect" (215). "Matured power" is not entirely a term of value here, as it would have been in Arnold's earlier remarks; it is a description of what Keats had no time to develop.

Following Milnes, Arnold accepts the fragment as the figure for Keats; the broken off part is now allowed its own dignity. The term recurs as he closes his preface, and the very end of Arnold's piece serves as an instance:

> To show such work is to praise it. Let us now end by delighting ourselves with a fragment of it, too broken to find a place among the pieces which follow, but far too beautiful to be lost. It is a fragment of an ode for May-day. O might I, he cries to May, O might I

> "thy smiles
> Seek as they once were sought, in Grecian isles,
> By bards who died content on pleasant sward,
> Leaving great verse unto a little clan!
> O, give me their old vigour, and unheard
> Save of the quiet primrose, and the span
> Of heaven and a few ears,
> Rounded by thee, my song should die away
> Content as theirs,
> Rich in the simple worship of a day!"[65]

We saw already in Milnes the tendency to characterize Keats as a site for the display of fragments, and I suggested that Arnold's description of the poet's work as "a perfect treasure house" follows the biographer in this. But note the odd integration of the poem into Arnold's own text in this passage—largely by means of a hinge of rhyming pronouns (I, he, I, thy). Arnold binds Keats's material tightly into his own, and why not? The verse treats of yet another Elysium, of the shared space of bards who die, "content on pleasant sward."

In his edition of the poems Stillinger reviews the possible punctuation of what is the eighth line of the passage as quoted by Arnold (identical in Milnes). He notes the ambiguity of "Rounded," and glosses it as either "whispered or whispered to." But, while recognizing the ambiguity, I prefer the definitions included in the Oxford English Dictionary: "Of periods: neatly finished; well turned; Of sounds or the voice: Sonorous, mellow, harmonious"—in reference to the song, or, in reference to the effect of this poetic spring on the poet: "Brought to a full, complete, finished or perfect state." After all, the shared closed circle of perfection is what Arnold echoes earlier in the passage cited previously on Keats: "that rounded perfection and felicity of loveliness of which Shakespeare

is the great master." It is also what Browning meant by finding Keats ensphered and turning on his central self at the same time as his life follows the antique pattern of his predecessors.

By closing with this verse, Arnold acknowledges that quality of cohabitation with past artists that was so important to Keats and to his presence in the nineteenth century. In discussing the felicity of Keats's verse, Arnold is explicit: "'I think' he said humbly, 'I shall be among the English poets after my death.' He is; he is with Shakespeare." It seems that we are a long way from the 1853 preface in which Keats had served as an illustration of incoherent response to influence and Shakespeare as an instance of the danger of a great model, and yet it may not be so far at all. Indeed, it may be more accurate to say that Arnold is presenting precisely the same territory from an altered perspective. The nested quotation in this sentence is reminiscent of that description of a poetic Elysium that Arnold connects so tightly to his own text: the "O might I, he cries to May, O might I . . ." in one passage is answered with "'I think,' he said humbly 'I shall' . . ." in the other. Arnold's words entwine themselves inextricably around both quotations. In this second instance, as in the first, a brief murmur of pronouns and echoing phonemes enacts the close relation between "he" and "I." In both instances, Arnold at once locates Keats and declares his own presence in that world of creators which the poet had always imagined for himself, and which was an important part of Keats's patrimony to the nineteenth century.

PART THREE

ABSENCE AND EXCESS:

THE PRESENCE OF THE OBJECT

Chapter Six

OUTLINE, COLLECTION, CITY:

HAZLITT, RUSKIN,

AND THE ENCOUNTER WITH ART

THE HISTORY of the encounter with the art object does not, evidently, take place in isolation; it is affected by developments in society, which include changes in methods of reproduction and travel as well as shifts in the institutions of art education. In English culture, where the visual arts have never been entirely at home, the experience of art has been particularly affected by its mediation through reproduction and exhibition. The first two parts of this book have been concerned with the manner in which the form of the artist took shape in relation to the ever more crowded museum of the nineteenth century, but that very crowding called for a sensibility that would evaluate, sift, and organize conceptually the material entering the museum; it called, in short, for the critic, a figure whose work it became increasingly harder to separate from that of the artist as the century wore on. This part is concerned with the representative anxieties of two key nineteenth-century critics. The preeminence of Ruskin in the period is undisputed, and my discussion focuses on his writings, but I draw also on William Hazlitt's important essays on art. Taken together, these texts vividly demonstrate not only the difference of ideas to be expected between a writer from the beginning and one from the middle of the nineteenth century, but the way both authors respond to the altogether different relationship to art *possible* at the times in which they wrote.[1] Of particular interest is the manner in which Hazlitt's relationship to art is configured around a desire that was seldom satisfied, whereas Ruskin's develops in response to a disturbing surfeit of art. For Hazlitt, as for Ruskin, the question of art was at once deeply personal and inescapably social. The forms with which Hazlitt describes his longing for and Ruskin his fear of surfeit are at once individual and more widely cultural; as such, they serve as vivid markers of the dramatic changes in the situation of art in the first half of the nineteenth century. The impossibility of representing directly the subjective encounter with art results in a proliferation of figural language standing in for the shocks or pleasures of the experience. Many of the most effective figures used in the period were derived from the very in-

stitutions and media that made the encounter possible. My discussion focuses on three recurring elements in the writings of the critics: the seductive outline of the reproduced image, fantasies of perfect or imperfect museums, and the city as model for the ideal or the failed encounter with art. The outline, the museum, and the city are at once important elements in the nineteenth-century culture of art and symbols of the encounter with art itself.

"ASKING FOR THE OLD PICTURES": HAZLITT'S DREAM OF THE LOUVRE

As we have seen, the love of art raises far more questions than it answers. By the nineteenth century, and with growing urgency as the century wore on, the challenge to culture was how best to organize the burgeoning quantity of art available. The predicament became all the more pressing as champions continued to emerge for once disdained periods and artists. The fascination with the fine arts and the conceptual crises it provoked led to the emergence of a new kind of expertise, one concerned from the outset with modulating the difficult encounter between art and audience even as it attempted to explain the possible relations among art of the past, contemporary artist, and public. Alongside the museum, and as a necessary response to the same need to organize objects of admiration, the nineteenth century saw the rise to prominence of the critic.

William Hazlitt's essays, possibly the most cosmopolitan English writings on art before those of Walter Pater, are nevertheless marked by a regretful sense of enforced provincialism. Indeed, he is nowhere more cosmopolitan than in his recognition of his isolation from the experience of art. The written catalog entry, the outline of an engraved reproduction—these were the habitual forms of his encounters with the art he loved. For this author, active less than twenty years before Ruskin, each sight of an important painting becomes an epoch in his life, longed for, enjoyed in the act, and savored lovingly in memory. His accounts of actual presence before an art object always take place in relation to the far more frequent periods of absence, which are represented by the empty outline or the catalog entry.

Hazlitt traces his "first initiation in the mysteries" of painting to the epochal Orleans Gallery, that astonishingly rich collection of the duc D'Orleans brought to London by a group of investors to be displayed (1798–99) and sold. "It was there," he claims in "The Pleasure of Painting," that "I formed my taste, such as it is" (8:14).[2] It is typical of Hazlitt to date his affection. His response to the art on display, however, was in no way that of an innocent eye: "We had all heard of the names of Tit-

ian, Raphael, Guido, Domenichino, the Carracci—but to see them face to face, to be in the same room with their deathless productions, was like breaking some mighty spell—was almost an effect of necromancy! From that time I lived in a world of pictures" (8:14). The mighty spell was cast by the *anterior* knowledge of these artists separated from the actual experience of their works. The names of great artists were more than familiar to the young Hazlitt; it was the possibility of viewing their work that was new.[3] Hazlitt was not alone in his sense that the Orleans exhibition marked a new, if much-prepared-for, development for art in England; in the words of a contemporary, "The interest which this famous collection had excited was beyond anything which had preceded it. The amateur was anxious to secure the genuine works of those masters which had long been sought for in England; and the present was among the first opportunities which had occurred where the same could be obtained to any extent."[4]

The theme of long desire meeting brief gratification runs throughout Hazlitt's writings on art. As he writes of another such encounter as late as the 1820s: "We know of no greater treat than to be admitted freely to a Collection of this sort, where the mind reposes with full confidence in its feelings of admiration, and finds that idea and love of conceivable beauty, which it has cherished perhaps for a whole life, reflected from every object around it" (10:7).[5] Both long-checked desire and brief relief are represented in this passage. Admission is not always possible, not always free, and when it does happen, the experience of works of art imparts not new knowledge, but confirmation of the faith of a lifetime—treat indeed to rest the mind in these circumstances!

If the Orleans exhibition provided the originary experience of first-hand knowledge shaping Hazlitt's well-prepared-for love of art, "The Pleasure of Painting" makes clear that it was his visit to Napoleon's Louvre three years later that would forever shape his taste and nostalgia. Also known as the Musée Napoléon in the time of which he writes, the Louvre was, in its existence and dissolution, emblematic for Hazlitt of crucial losses in art and politics.[6] It is all the more remarkable then that, by bracketing the experience in a reminiscence of textually titillated anticipation, Hazlitt denies the quality of absolute originality of experience to the very museum he celebrates:

> I never shall forget conning over the Catalogue which a friend lent me just before I set out. The pictures, the names of the painters, seemed to relish in the mouth. There was one of Titian's Mistress at her toilette. Even the colours with which the painter had adorned her hair were not more golden, more amiable to sight, than those which played round and tantalised my fancy ere I saw the picture. (8:15)

In Hazlitt's characteristically complex nostalgia, the remembered joy of the event is not caused by a sudden revelation before some unexpected canvas. His memory sends him back to that anticipatory moment in which he longed to know what he *already* loved. Hazlitt's affection is evidently for the youthful imagination able to challenge Titian in its colorist's touch. There is no mistaking the relish with which he revisits his enthusiastic conning of the catalog. One canvas elicits this typical response: "I read the description over and over with fond expectancy, and filled up the imaginary outline with whatever I could conceive of grace and dignity, and an antique *gusto*—all but equal to the original." Given the ritual of expectation that Hazlitt describes, it is not to be doubted that, "not to have been disappointed with these works afterwards, was the highest compliment I can pay to their transcendent merits" (8:15).

We may compare the description Hazlitt offers of himself as a child in "On Reading Old Books" (1821), an essay written a year after "The Pleasure of Painting" in which the interplay of the broken charm of ignorance with the joy of expectation is also his subject.[7] In this piece he describes his habit of poring over the engravings in Cooke's editions of the British novelists: "To what nameless ideas did they give rise,—with what airy delights I filled up the outlines, as I hung in silence on the page." Not a collection of paintings this time, but *Tom Jones*, "was the first work that broke the spell," which was his distance from literature (12:222–23). The enchantment in this essay, like that in "The Pleasure of Painting," is broken by the presence of a work of art. The pleasure Hazlitt is describing is that of a reader trying to give life to the characters depicted on the page, whether in description or illustration. He is consistently nostalgic for the outline, for forms requiring the work of the imagination in order to be filled in.

The critic's emphasis on the reproduction or, what is perhaps stranger, on the unillustrated catalog is abundantly clear in "On a Landscape of Nicolas Poussin." In this companion to "The Pleasure of Painting" he writes of the yearly exhibitions of Old Masters at the British Gallery (begun in 1806): "The works are various, but the names the same. . . . We read certain letters and syllables in the catalogue, and at the well-known magic sound, a miracle of skill and beauty starts to view" (8:173).[8] Hazlitt is detailing a normal part of the internalization of the hermeneutic circle of art appreciation: the student, taught to anticipate marvels at the locus of a name, fears disappointment when brought to the test of personal response to the object. As he will say about traveling, "we visit *names* as well as places" (10:281; emphasis in the original).[9] Nevertheless, it is impossible not to conclude that for Hazlitt the absence of the art object, its replacement by the record of the written work, by an engraved reproduction, and ultimately by memory, is *more* significant than any

direct encounter with the artwork.[10] Thus it is that, on returning to a Rembrandt he had remembered with admiration, he finds it falling beneath the level of his memory:

> The picture was nothing to me; it was the idea it had suggested. The one hung on the wall at Burleigh; the other was an heir-loom in my mind. Was it destroyed, because the picture, after long absence, did not answer to it? No. There were other pictures in the world that did, and objects in nature still more perfect. This is the melancholy privilege of art; it exists chiefly in idea, and is not liable to serious reverses. (10:65)[11]

What he here calls art's "melancholy privilege" is Hazlitt's theme when writing on collections of art. We will see later what a contrast this makes with Ruskin. In Hazlitt the mind takes over the role of gallery, so that the actual condition of the objects comes to have far less importance than the subjective lives of these objects in the viewer's memory: "Pictures are a set of chosen images, a stream of pleasant thoughts passing through the mind. It is a luxury to have the walls of our rooms hung round with them; and no less so to have such a gallery in the mind, to con over the relics of ancient art bound up 'within the book and volume of the brain, unmixed (if it were possible) with baser matter!'" (8:173). "Melancholy privilege" is an oxymoronic formulation, at once sadly wistful and powerful. If his youthful relationship to art is defined by the practice of imbuing reproduction and description with plenitude, maturity brings a retrospective sadness, the memory of loss. In either case, neither the materiality of an art object nor the actuality of experience is as significant as what happens in the mind of the art lover. The sad prerogative of art is to be the object of an asymptotic passion, ever veering away as it approaches consummation.

The Orleans exhibition was always intended to be temporary and its paintings were soon dispersed in various collections (some of them eventually finding their way to the National Gallery at its founding in 1824). It is the Louvre that figures in Hazlitt's mind as the manifestation of the *Musée imaginaire* (or "gallery in the mind") most to be mourned. The *Life of Napoleon*, which contains Hazlitt's most spirited defense of the museum, also expresses the political significance he read in its existence: "Those masterpieces were the true handwriting on the wall which told the great and mighty of the earth that their empire was passed away" (13:212). The triumph of wresting these objects from royal and ecclesiastical collections was a manifestation of humanism challenging *ancien régime* entitlement.[12] All of Hazlitt's memories of this locus of realized desire are tinted with the knowledge of its loss. His dream of the Louvre early in 1822 is a Wordsworthian vision of vanished youthful promise: "I dreamt I was there a few weeks ago, and that the old scene returned—

that I looked for my favourite pictures, and found them gone or erased. The dream of my youth came upon me; a glory and a vision unutterable, that comes no more but in darkness and in sleep: my heart rose up, and I fell on my knees, and lifted up my voice and wept" (12:24).[13] In "On the Pleasure of Painting," this dream is crueler. It is presented not simply as being about the loss of actual objects, which—as I have noted—would not necessarily lead to undue distress, but also about the fear that the aura lent by memory may fade: "I sometimes dream of being there again—of asking for the old pictures—and not finding them, or finding them changed or faded from what they were, I cry myself awake!" (8:17).

The Walk to the Print Shop

"The Pleasure of Painting" concludes with a plea for the continuation of the yearly exhibitions at the British Gallery, and with an account of some important English collections on which its organizers may draw (8:174). The significance of these temporary collections resides in the fact that without them the works of artists fall into the boundless incoherent fecundity of unchecked admiration: "Their works seem endless as their reputation—to be many as they are complete—to multiply with the desire of the mind to see more and more of them; as if there were a living power in the breath of Fame, and in the very names of the great heirs of glory 'there were propagation too!'" (8:174).

Hazlitt's most substantial contribution to the study of the fine arts, his account of the private collections available for viewing in England, *Sketches of the Principal Picture-Galleries in England* (1824), is an early attempt to give some form to this proliferating admiration. Guides to the collections as well as memoirs of specific visits, these sketches are presented as excursions that surpass to the point of overwhelming the mere reproductions on which we have seen the critic place such value; they offer an intriguing contrast to the emphasis on reproduction and memory in earlier esssays. Still, Hazlitt's celebration of the object itself needs to be taken with a grain of salt: "A capital print shop (Molteno's or Colnaghi's) is a point to aim at in a morning's walk—a relief and satisfaction in the motley confusion, the littleness, the vulgarity of common life: but a print-shop has but a mean, cold, meagre, petty appearance after coming out of a fine Collection of Pictures" ("Mr. Angerstein's Collection," 10:8). There is a touching bad faith at work in this passage. At every point its texture gives Hazlitt away, revealing that his true familiarity is with the urban hurly-burly, which he associates with those inadequate vendors of reproductions. The specificity of their shops comes with satisfaction to his pen and thoughts; he knows their names, he knows how to reach them. They are "capital," as a pet might be, or a joke, or a favorite restaurant. The reader easily follows the emotional logic behind Hazlitt's

relief, walking from a chaotic street scene to the ranks of portfolios propped open for inspection in a printseller's establishment at the turn of the nineteenth century—exuberant quantity controlled and organized. The fact that the world of crowds and reproductions is Hazlitt's own makes poignant his admission of the loss of charm of these special sites, the realization of the meagerness and pettiness of what they offer after the experience of—his turn of phrase is appropriately pompous—"a fine Collection of Pictures." The print shops, those *capital* places, are, we sense, the true home of Hazlitt's aesthetic sensibility, city dweller that he was, consummate denizen of a capital. Fine collections are something to visit from time to time, almost always *out* of town, at some country seat belonging to a member of a hated class.

Between the adjectives "capital" and "fine" lies a world of complex affection and disappointment, but it is important for us to understand not Hazlitt's personal disillusion so much as the cultural moment that makes it possible. Hazlitt's association of Napoleon with the possibility of a gathered coherent collection is not at all figurative. The upheavals of the revolutionary and Napoleonic eras dislodged for the first time a large number of acknowledged masterpieces and affected dramatically the nature of the experience of art. The formative years of Hazlitt's development as a connoisseur were precisely those in which an interest in works of art was coming to be widespread in educated English culture. And yet, though the canon of painters in the early years of the nineteenth century was essentially that which had been established for roughly two centuries, at this time of great interest the objects themselves were most subject to becoming either inaccessible because of instability on the Continent or strangely portable. Hazlitt's epochal experience of the Orleans collection was only possible because of the political turmoil in France.[14]

Goethe's response to the Musée Napoleon is worth citing for its prescient sensitivity to the questions raised by the new fluidity of art:

> There was a time when, with few exceptions, works of art remained generally in the same location and place. However, now a great change has occurred that, in general as well as specifically, will have important consequences for art. Perhaps there is more cause than ever before to realize that Italy as it existed until recently was a great art entity. Were it possible to give a general survey, it could then be demonstrated what the world has now lost when so many parts have been torn from this immense and ancient totality. What has been destroyed by the removal of these parts will remain forever a secret. Only after some years will it be possible to have a conception of that new art entity which is being formed in Paris.[15]

Hazlitt's texts register something of the new instability of the art object that Goethe describes. The Louvre under Napoleon offered not only a liberation from class prerogative in art but also the simple opportunity to

see what was understood to be great art. After they were gathered from their far-flung homes by Napoleon's men and established at the Louvre, a great many such masterworks could indeed be encountered in one place—including the Laocoön and the *Apollo Belvedere*, unwieldy objects historically associated with other locations. But Hazlitt could make his way to this ideal museum only in the brief moment allowed him by the Peace of Amiens, and, of course, the material was separated once again upon the defeat of Napoleon.[16] The important cultural development in this period is not so much the relocation of admired art objects, which could always be undone, but the loosening of their bonds to specific places.

As Goethe indicates, the Musée Napoléon gathered together objects that it had once been necessary to visit in place, that had required the expense and time of a Grand Tour. The period in which Hazlitt was writing not only discovered a new mobility in the work of art; as might be expected, it also saw drastic and related alterations in the institutions of travel. To understand the changes that the encounter with art was undergoing requires a sense of the related metamorphosis of the traditional institution of the Grand Tour. This voyage to culture had had a typical form: a wealthy young man, often accompanied by a tutor or other companion, finished his education by making his way through Europe. Such an expedition might be prolonged for up to three years, including a significant stay in Rome, the home of ruins, the mother of art.[17] The pages devoted to Rome in Goethe's *Italian Journey* may be taken as drawing on this tradition, though the serious application with which Goethe addresses himself to the art of the place anticipates later developments. The more typical visitor would leave with a few casts, perhaps a portrait of himself among the ruins by Pompeio Batoni, or one of Giovanni Panini's intriguing painted galleries of the celebrated sights. Such images of confident travelers and noted monuments indicate that the aim of the voyage was the acquisition of recognized culture at a fixed site, an activity essentially for the wealthy. Over the years, this ritual of travel served to certify the value of certain locations by linking the experience of the most significant works to specific places. For the traveler with a real interest in art it was all the more important to make the trip; the scarcity of notable artwork in England served as a primary cultural incentive or justification for the tour.[18]

In contrast, the possibility of wider social access to culture is what the public museum stood for. The French Revolution made royal collections generally accessible, while Napoleonic conquest allowed the possibility of access to work that privilege had experienced in a dispersed form.[19] But the wars, which had dislodged so much art from its fixed location and made it available to the French public, had also served to make Europe a

difficult place for the English. The instability of Europe in this time of war with England meant that after the four months Hazlitt spent in Paris in 1802—largely, by his account, at the Louvre—he was not to return in person to that city or museum for more than twenty years. *Notes of a Journey through France and Italy*, the narrative of his first return to the Continent, picks up many of the themes he had developed in his writings on the Louvre in the teens. The sad nostalgia of "Pleasure" and "Poussin" finds bitter confirmation in this visit. Hazlitt's account of his tour of the Continent is, typically, at once melancholy and acerbic. His tale of loss is detailed:

> The first thing I did when I got to Paris was to go to the Louvre. . . . I had gazed myself almost blind in looking at the precious works of art it then contained—should I not weep myself blind in looking at them again, after a lapse of half a life—or on finding them gone, and with them gone all that I had once believed and hoped of human kind? . . . I was no longer young; and he who had collected them, and "worn them as a rich jewel in his Iron Crown," was dead. (10:106)

Hazlitt feels the want of the missing pictures, enumerates the famous ones now gone (10:113). His despair at the failure of the actual, however, is mollified by the mind's ability to recuperate a coherent memory of beauty. The critic's characteristic sensitivity to the signs of privilege in power is evident throughout his account of the museum: in what can only be a symbolic confusion he pretends to mistake the bust of the recently dead king of France over the door for that of Memnon "or some Egyptian God." Indeed, the doors of the Louvre under a monarchy offer a range of affronts to Hazlitt's revolutionary sensibilities: "Instead of the old Republican door-keepers, with their rough voices and affectation of equality, a servant in court-livery stood at the gate" (10:108). But, if the entrances guarded by privilege distress him, the keep of his mind offers a possibility of shelter: "There was one chamber of the brain (at least) which I had only to unlock and be master of boundless wealth—a treasure house of pure thoughts and cherished recollections" (10:107). As with the Rembrandt at Burleigh House, Hazlitt's point is at once about the failure of the real and about the centrality of the perceiver at the moment of art appreciation.

The Great Metropolis of Art

While the outline of the reproduction serves as Hazlitt's figure for the controlled reception of art, it is the city that stands for uncontrolled or uncontrollable reception (a printshop, we remember, was relief from urban confusion). I have discussed Hazlitt's mental and physical returns to

the Louvre, but it is his disappointment with Rome that is most telling in this regard, and most remarkable in terms of the history of the response to art. "This is not the Rome I expected to see," he writes on reaching that capital (10:233). The city does not answer to the images of glorious history that he brought with him, nor do its museums satisfy his ideals of art on display. Not surprisingly, the Louvre serves as his point of comparison: "The picture-galleries in Rome disappointed me quite. I was told there were a dozen at least, equal to the Louvre; there is not one" (10:237). The problem is one of coherence, what he calls "unity": "The Vatican is rich in pictures, statuary, tapestry, gardens, and in views from it; but its immense size is divided into too many long and narrow compartments, and it wants the unity of effect and imposing gravity of the Louvre" (10:241). Hazlitt finds wanting the Vatican's extraordinary collection—including, among other masterworks, the now returned Laocoön and *Apollo Belvedere*, Michelangelo's Sistine Chapel and Raphael's Stanze (fig. 45). His chief complaint is of division and incoherence. We may compare what he says elsewhere about the Louvre under Napoleon, when it held as much of this work as was portable:

> The effect was not broken and frittered by being divided and taken piecemeal, but the whole was collected, heaped, massed together to a gorgeous height, so that the blow stunned you, and could never be forgotten. This was what the art could do, and all other pretensions seemed to sink before it. School called out to school; one great name answered to another, swelling the chorus of universal praise. (*Life of Napoleon*, 13:212)

That his disappointment with Rome is more than a mere tourist's cavil, or even the old Bonapartist's resentment of Louvre restitutions, is evident in "English Students at Rome," an intriguing late essay on the relationship between existing artistic work and contemporary artists, which takes the city as topic and metaphor.[20] In a stark reversal of neoclassical sentiment, Hazlitt finds Rome more mortuary than mother of the arts—"the very tomb of ancient greatness, the grave of modern presumption" (17:140). It is an identification not entirely absent in earlier writers, but only given its full weight later in the nineteenth century (notably in Hawthorne and James). The problem of the Vatican is the problem of the city as a whole, and its effect on the artist is profoundly disabling. The complaint of lack of organization that he made in his travel writing returns, but in this essay it becomes clear that Rome is *impossible* to organize in any way useful to artists. The source of the difficulty is Rome's very cornucopia of masterpieces:

> You have no stimulus to exertion, for you have but to open your eyes and see, in order to live in a continued round of delight and admiration. The doors

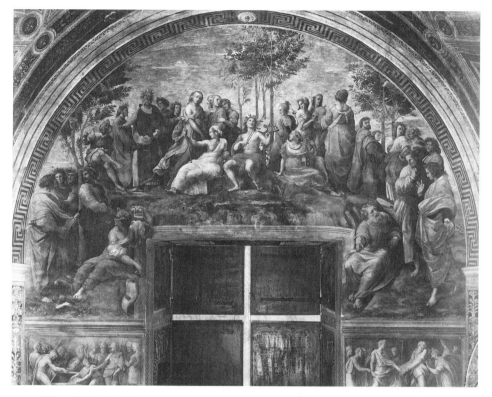

Fig. 45. Raphael, *Parnassus*, 1509–11. Rome, Vatican, Stanza della Segnatura.

of a splendid banquet of all that is rich and rare in Art stand ready open to you, you are invited to enter in and feast your senses and your imagination gratis; and it is not likely that, under these circumstances, you will try to earn a scanty meal by hard labour. (17:135)

Distraction and puzzlement, a great feast that overwhelms by what it offers—the language and concerns of this essay echo those we have heard already, in Hazlitt's treatment of modernity in "Mr. Coleridge," an essay in which the present moment led to talking, not doing, because the disconcerting accumulation of antique matter overwhelmed the viewer.[21] In this piece, Rome itself becomes a figure of such modernity: "If it were nothing else, the having the works of the great masters of former times always before us is enough to discourage and defeat all ordinary attempts" (17:138).

The critic translates to Rome class-based clichés of the city, ironically dubbing this most regal metropolis with a term of opprobrium with which he was all too familiar:

The same thing occurs here that is objected to the inhabitants of great cities in general. They have too many objects always passing before them, that engage their attention and fill up their time, to allow them either much leisure or inclination for thought or study. Rome is the great metropolis of Art; and it is somewhat to be feared that those who take up their abode there will become, like other *cockneys*, ignorant, conceited, and superficial. (17:135; emphasis in the original)

The knowledge the city facilitates is debilitating not because of any weakness in the material experienced, but because the individual artistic will is fragmented before so many varied sources of stimuli or inspiration. The challenge is to achieve unity: "What single individual will presume to unite . . . [the characteristics of all the great artists]? Yet those who are familiar with all these different styles and their excellences, require them all" (17:139). Hazlitt recognizes, as Ruskin will after him, the danger of broken and incoherent knowledge of the past splintering individual attention. Whereas Hazlitt's response is elegiac irony, the broken remnants of the past serving as evidence of the impossibility of creativity in modernity, Ruskin will answer with an anxious rage for order.

"An Excessive and Therefore Unusable Capital": Valéry and the Problem of the Museum

Among the starkest presentations of the condition that troubled Hazlitt and Ruskin is that articulated in Paul Valéry's 1923 essay, "The Problem of the Museum." The city has an important analogical function in the piece; like the museum, it is a modern space characterized by abrupt claims on the attention and inexplicable combinations serving only to unbalance the viewer: "I am lost in a turmoil of frozen beings," writes Valéry of his entry to the museum, "each of which demands, all in vain, the abolition of all the others."[22] The inability to focus on a project or goal, which Hazlitt identifies as characteristic of his artistic city and its myriad competing attractions, is like the effect of Valéry's museum. "What likelihood is there" of the artist's simply following his own genius, writes Hazlitt, "from the moment that all the great schools, and all the most precious *chefs-d'oeuvre* of art, at once unveil their diversified attractions to his astonished sight" (17:139). The impossible challenge described is that of finding a single creative response to a disparate collection of incommensurate beauties.

Valéry is clear, the problem of the museum is a problem of the wider culture in which it is situated, at once symptom and result:

Only an irrational civilization, and one devoid of the taste for pleasure, could have devised such a house of incoherence. This juxtaposition of dead visions

has something insane about it, with each thing jealously competing for the glance that will give it life. They call from all directions for my undivided attention, maddening the live magnet which draws the whole machine of the body toward what attracts it. (203)[23]

The museum is a failure as much of pleasure as of intellect. Clarity and delight are lost because the relationship between spectator and object cannot achieve the focused attention necessary for either. Objects are given the privilege of the place by virtue of merits, which are in turn lost in the crowd in which they find themselves. As with Hazlitt, the challenge is caused by the irreconcilable contradiction between claims of uniqueness and conglomeration:

> Just as a collection of pictures constitutes an abuse of space that does violence to the eyesight, so a close juxtaposition of outstanding works offends the intelligence. The finer they are, the more exceptional as landmarks of human endeavor, the more distinct must they necessarily be. They are rarities whose creators wanted each one to be unique. (204)[24]

The breaking apart of attention in the museum is a figure for modern culture, while the museum as world is a figure for modernity as impossible choice and therefore confusion: "our heritage is a crushing burden. Modern man . . . is . . . impoverished by the sheer excess of his riches." Continuing the figure from finance, Valéry describes a situation resulting in the "accumulation of an excessive and therefore unusable capital" (204).[25]

It is not only on works of art, however, that the museum exerts its dangerous pull. Valéry's very next paragraph is on the absorption of *everything* by the museum: "The museum exerts a constant pull on everything that men can make. It is fed by the man who creates and the man who dies. *All things* end up on the wall or in a glass case" (205).[26] As in Hazlitt, there is a ready slide between museum and city: "The glorious chaos of the museum follows me out and blends with the living activities of the street. . . . We live and move today in the same state of dizzying conglomeration that we inflict as a torture on the arts of the past" (205–6).[27] In his essay on English students in Rome, Hazlitt is willing to give up the field, simply to spin metaphors for the impossibility of new creative work, to generalize from his discovery of an incoherent city of art: "Modern art is, indeed, like the fabled Sphinx, that imposes impossible tasks on her votaries, and as she clasps them to her bosom pierces them to the heart" (17:139). As we will see, Ruskin is well aware that modern art inhabits Rome in the way Hazlitt understands it. The later critic responds to the variety of incompatible claims of the city of art with a proliferation of texts whose apparent conviction repeatedly gives way to the expression of an anxious fear of being overwhelmed.

RUSKIN IN THE PRESENCE OF ART: ART, TREASURE, EXHIBITION

I have dwelt on the centrality of loss or absence in Hazlitt's essays on art; the characteristic experience these works describe is a tantalizing episode of intimacy that interrupts only to exacerbate the habit of longing over images reproduced on paper or in memory. Ruskin, however, begins from the challenge of excess that Hazlitt discovered in Rome: "Not too much is the first law; not in disorder, is the second. *Any order* will do, if it is fixed and intelligible: no system is of use that is disturbed by additions, or difficult to follow" (26:204; my emphasis). This, from *Deucalion* (1876), is about the design of nineteenth-century museums, but it is written from a world that would be all-too-recognizable to Valéry.[28] The "any" is an admission around which Ruskin's hortatory certainty admits a fatal weakness. The enumeration of what he calls laws is followed by an indifference as to specific regulations demonstrating that the anxiety over the effects of excess motivating his claims is far more present to the critic than the systematic rules he begins by invoking. The order is arbitrary; the threat of unorganized excess is real. Recourse to careful arrangement, here as elsewhere in Ruskin, becomes a manifestation of uneasiness rather than of certainty. "In all museums intended for popular teaching," Ruskin stipulates earlier in *Deucalion*, "there are two great evils to be avoided. The first is, superabundance; the second, disorder" (26:203). This statement, made at the midpoint of the century separating Hazlitt's last visit to the Louvre and Valéry's record of his own response to the same institution, is evidently only possible when museums have become common enough for their arrangement to become a concern. Ruskin's injunctions address a dilemma inconceivable before the presence of art has become a challenge, a potentially troubling superabundance. The difference is at once practical and conceptual; for Ruskin, access to art is not achieved by making one's way to a forbidden city open for a brief span, to a nobleman's country seat for a brief supervised visit. His personal wealth and, more, the new mobility of the Englishman and of the artwork are at play everywhere in his career and texts. If Hazlitt's writing on art is marked at every point by the difficulties of seeing the work he admires, the situation is quite different by Ruskin's day. The work of the later critic is only made possible by the historical fact of tourism, the ready access to a Continental world of art.[29]

After the hiatus caused by the Napoleonic Wars, the Grand Tour never regained its previous cultural significance, metamorphosing instead into a more convenient form of travel that allowed the participation of a far more varied range of classes. The Tour's importance was lost in the new possibility of regular crossings to Europe. If my account so far has been

about distance, about what is powerful because it is inaccessible, by the 1830s the problem is not absence but presence, and, therefore, accumulation and control, the very issues at stake contemporaneously in the period of museum design, construction, and debate discussed in the previous section. That Ruskin's work takes shape as the story of his voyages is more than a biographical detail; his account of direct encounters with art is related to his concern not only with the contingent personal experience of the traveler, but with the way it may serve as a model for modern man confronting an unwieldy mass of objects and information. The question before him is how to deal with the new possibility of access to the artwork, whether it results from the movement of the object or of the spectator.

The relationship between viewer and art object is neither simple nor constant in the writings of Hazlitt and Ruskin. I have touched on the way difficulty of access affected Hazlitt's engagement with painting, shaping his art appreciation around desire, absence, and memory. Difficulty is also an important component of admiration for Ruskin, but his writings reveal an anxiety about surfeit that only emerges in Hazlitt when he considers the fate of art students in Rome. A useful comparison can be drawn from the treatment of the modern book by both critics, an object no longer precious because no longer scarce. The following passage, from Hazlitt's *Picture Galleries*, is ambivalent, at once an expression of the desire for more and of the charms of rarity:

> Throw open the folding-doors of a fine Collection, and you see all you have desired realized at a blow. . . . The disadvantage of pictures is, that they cannot be multiplied to any extent like books or prints; but this, in another point of view, operates probably as an advantage, by making the sight of a fine original picture an event so much the more memorable, and the impression so much the deeper. A visit to a genuine Collection is like going on a pilgrimage—it is an act of devotion performed at the shrine of Art! It is as if there were but one copy of a book in the world, locked up in some curious casket. (10:8)

The very exuberance of the gesture to which Hazlitt invites us, throwing open a door to reveal an Ali Baba cavern of satisfaction (another "*fine*" collection), is a wish fulfillment that can only be based on dearth. While Hazlitt is writing from a situation of scarcity, Ruskin's challenge is how to administer abundance so as to maintain the aura that absence so readily provided. In *The Political Economy of Art*, Ruskin is less romantic on the topic of the scarce book—describing as "evil" the technological limits which in the Middle Ages allowed access to literature only to a few—but his comparison between the change in accessibility of literature since the advent of printing and the still limited access to art is deeply troubled by the possibility of too ready access:

It is only in literature that private persons of moderate fortune can possess and study greatness: they can study at home no greatness in art; and the object of that accumulation which we are at present aiming at . . . is to bring great art in some degree within the reach of the multitude; and both in larger and more numerous galleries than we now possess, and by distribution . . . in each man's home, to render the influence of art somewhat correspondent in extent to that of literature. Here, then, is the subtle balance which your economist has to strike: to accumulate so much art as to be able to give the whole nation a supply of it, according to its need, and yet to regulate its distribution so that there shall be no glut of it, nor contempt. (16:60–61)

Ruskin made the above comments at the Manchester Art Treasures Exhibition, a triumph of organization and logistics impossible at any time before that in which it took place. The cultural and technological infrastructures required for it to come about were not simply wanting but inconceivable in earlier decades. The exhibition was stunningly successful in making available to the new world of art lovers a vast quantity of work that had hitherto been unavailable; it was also a triumph in publicizing the virtues of particular artworks and artists and raising the public profile of the fine arts generally in nineteenth-century Britain. The organizers of the exhibition invited Ruskin, the nation's recognized artistic authority, to speak to them on the occasion of their notable achievement at Old Trafford. The critic, however, responded to the moment with two lectures challenging everything that the exhibition stood for. The theme of useful accumulation versus glut developed in the passage is typical of Ruskin's lectures at Manchester. The Art Treasures Exhibition, assembling as it did an extraordinarily large collection of work and as impressively massive an audience, was an ideal place for Ruskin to draw attention to the need for a subtle balance that would have been unimaginable to Hazlitt. He shares with the organizers of the exhibition the desire to make art more widely accessible, but the pressure resulting from a thronging audience as well as from the accumulation of art itself inspires a fear of losing value in quantity. The exhibition at Manchester was undermined by a manifold impermanence closely related to its size. Not only was the event itself temporary, but it required a form of hurried and overwhelmed attention, which could not be anything other than fleeting.

Ruskin gave the remarks he delivered at the Manchester Art Treasures Exhibition two titles: "The Political Economy of Art" and "A Joy Forever (and its price on the market)." The first title is the one under which the lectures delivered on 10 and 13 July 1857 were originally published, in December of the same year. The second title is that of their 1880 reissue; together they indicate much about what is remarkable in the critic's response to the exhibition. Ruskin himself identified these lectures as the beginning of the second part of his career, when he turned most

fully toward social questions ("political economy"), but the theme of right management that he develops is also directly engaged with the problem of art: how is art to be usefully administered when it is seen as a stream of goods needing conceptual organization?[30] The second title Ruskin gave his comments ("A Joy Forever") is meant to place them firmly in the context of the exhibition for which the first line of *Endymion* served as epigraph: "The title of this book,—or, more accurately, of its subjects, . . . will be, perhaps, recognized by some as the last clause of the line chosen from Keats by the good folks of Manchester, to be written in letters of gold on the cornice, or Holyrood, of the great Exhibition which inaugurated the career of so many." By sending his readers back twenty-three years, Ruskin invites them to consider the relationship between this event and his argument. Ruskin's theme is the irony of endless time—of "forever"—crowning the physical manifestation of an impermanent phenomenon, one perhaps only a vague memory in the reader's mind at the moment of reading. Ruskin reads with hyperbolic literalness a phrase certainly selected, as he himself suggests, with less thought than he gives it.[31] He uses the conceit of felicity to adduce one of the principal themes of his talk, the importance of *permanence* in art:

> The motto was chosen with uncomprehended felicity: for there never was, nor can be, any essential beauty possessed by a work of art, which is not based on the conception of its honored permanence, and local influence, as part of appointed and precious furniture, either in the cathedral, the house, or the joyful thoroughfare, of nations which enter their gates with thanksgiving, and their courts with praise. (9:11)

Permanence, Ruskin argues, must be understood in two ways—as what art should aim for and as what the audience of art should try to ensure for its masterpieces. The question of time that is so central to Ruskin's consideration of this exhibition ("forever" and its alternatives) is intimately related to the topic of accumulation.

That there existed a clear connection between the accumulation and display of art and the formation of modern artists was a fundamental belief of nineteenth-century supporters of the arts. As we have seen, it was a relationship that had been insisted on by theorists and polemicists since the previous century and one that had unmistakable effects in shaping the art institutions of Europe; it motivated as much the cast collections of the Royal Academy (and of the other art academies throughout Europe) as the annual display of privately owned paintings at the British Institute, and it underlay the debate on the British Museum at midcentury. The argument sometimes made, more often assumed, was that the instruction of the artist was best carried out by exposure to the finest art available, or to reasonable copies thereof. A practical corollary often expressed, particularly in the nineteenth century, was that the resulting fine

art would come to influence the productions of British industry, allowing the nation's design to come up to the level of its technology. It is this network of ideas that Ruskin is at all times evoking, challenging, and rejecting in his remarks at Manchester.

The lectures Ruskin gave at the Art Treasures Exhibition engage at once with the long-standing pedagogical argument for societal support of the arts and a newer concern with organizing, arranging, and understanding a large mass of art. Ruskin conflates both issues when he speaks of "wealth," a term he defines in terms of value as well as quantity:[32]

> Now, it seemed to me that since, in the name you have given to this great gathering of British pictures, you recognize them as Treasures—that is, I suppose, as part and parcel of the real wealth of the country—you might not be uninterested in tracing certain commercial questions connected with this particular form of wealth. Most persons express themselves as surprised at its quantity; not having known before to what an extent good art had been accumulated in England: and it will therefore, I should think, be held a worthy subject of consideration, what are the political interests involved in such accumulations; what kind of labour they represent, and how this labour may in general be applied and economized, so as to produce the richest results. (16:17–18)

Both the exhibition of wealth and its description as treasure allow Ruskin to identify questions about accumulation and distribution that hover in a troublesome way around the ostensible aim and most common justification for public exhibitions of art—the creation of artists.[33]

Ruskin sets himself entirely against the notion that the proliferation of great art will naturally lead to the emergence of great artists; the more and better art, the more and better artists. While the description of what an artist should be has always been recognized as one of Ruskin's principal themes, it is important to see how intimately it is linked with his concern for the preservation and organization of already present art objects:

> we have to consider respecting art; first, how to apply our labour to it; then, how to accumulate or preserve the fruits of labour; and then, how to distribute them. But since in art the labour which we have to employ is the labour of a particular class of men—men who have special genius for the business, we have not only to consider how to apply the labour, but first of all how to produce the labourer; and thus the question in this particular case becomes fourfold: first, how to get your man of genius; then, how to employ your man of genius; then, how to accumulate and preserve his work in the greatest quantity; and lastly, how to distribute his work to the best national advantage. (16:29)

"Get," "employ," "accumulate," "distribute," "preserve"—Ruskin's language indicates his concern with objects, as much as with labour. Objects

from the past and current laborers, as well as their potential productions, all stand in a relationship that Ruskin insists on parsing out, one that further involves the public consumers of that labor—the audience of his speech and of the Art Treasures Exhibition. For both audience and artist, Ruskin describes an arduous process in which time and work come together: "it is wisely appointed for us that few of the things we desire can be had without considerable labour, and at considerable intervals of time" (16:58). Ruskin evinces what may seem a surprising concern as to how best to regulate the distribution of even the art he admires most; he is moved to say to hypothetical generous listeners in his audience "who want to shower Titians and Turners upon us, like falling leaves, 'Pictures ought not to be too cheap'" (16:60).

The "political economy of art" and the "forever" of Ruskin's two titles come together in his meditations on permanence. What he calls "*lasting work*" is what was challenged by Pietro di Medici, when he ordered Michelangelo to build him a statue of snow. For Ruskin, this story from Vasari is a figure for what is habitually done by patrons in not demanding permanence from their artists (he calls it "the perfect, accurate, and intensest possible type of the greatest error which nations and princes can commit, respecting the power of genius entrusted to their guidance" (16:39). The struggle to organize quantity, touched on earlier, is directly related to the difficult question of permanence: "Now, the conditions of work lasting are twofold: it must not only be in materials that will last, but it must be itself of a quality that will last—it must be good enough to bear the test of time. If it is not good, we shall tire of it quickly, and throw it aside—we shall have no pleasure in the accumulation of it" (16:41). Ruskin's themes meet at the figure of the audience; he is talking about the responsibility of the public and the nature of its aesthetic fatigue or pleasure. Objective questions of durability and display have analogous subjective effects. Ruskin challenges his hosts by presenting accumulation of the sort they have brought about as fundamentally dangerous to the appreciation of art. In his second lecture, "The Accumulation and Distribution of Art," he develops the conceptual sources of the problems presented by the ambitions of the Art Treasures Exhibition, arguing that the material form of the presentation of art has a crucial effect on the consciousness receiving it:

> The amount of pleasure that you can receive from any great work, depends wholly on the quantity of attention and energy of mind you can bring to bear upon it. . . . If you see things of the same kind of equal value very frequently, your reverence for them is infallibly diminished, your powers of attention get gradually wearied, and your interest and enthusiasm worn out; and you cannot in that state bring to any given work the energy necessary to enjoy it. (16:56–57)

The response of the viewer is necessarily diminished when art is presented in a disconnected though crowded jumble. Ruskin complicates a previous era's hunger for more when he questions whether it is preferable to enjoy many pictures a little or one a great deal:

> The question is not a merely arithmetical one of this kind. Your fragments of broken admirations will not, when they are put together, make up one whole admiration; two and two, in this case, do not make four, nor anything like four. Your good picture, or book, or work of art of any kind, is always in some degree fenced and closed about with difficulty. (16:58)[34]

Ruskin's target is the weakening of what Benjamin would come to call the *aura* of the art object. Benjamin's well-known account in "The Work of Art in the Age of Mechanical Reproduction," suggests that a great deal of the power of art is due to its distance from the audience, the loss of this distance being an integral part of modernity's relationship to art. What is not always remarked on—perhaps because reproduction seems a more urgent question in the present era—is that his analysis of the problem is as much a response to nineteenth-century cultural institutions as to twentieth-century technology. Like Ruskin, Benjamin includes both reproduction and *exhibition* in his account of the experience of art in modernity. Exhibition provides the model for the crisis he anticipates from technological reproduction:

> A painting has always had an excellent chance to be viewed by one person or by a few. The simultaneous contemplation of paintings by a large public, such as developed in the nineteenth century, is an early symptom of the crisis of painting, a crisis which was by no means occasioned exclusively by photography but rather in a relatively independent manner by the appeal of art works to the masses.[35]

The theme dates back at least as far as the stage manager in *Faust* insisting that the satisfaction of the mass audience is only to be achieved through a related massiveness in the object of contemplation.[36] What is particularly interesting for our purposes, however, is the realization on the part of Ruskin as much as Benjamin that exhibition and mechanical reproduction will effect this massiveness, and that this unwieldy accumulation will affect not only the production of contemporary art but the reception of already existing material.

The Administration of Treasure: Stewardship

Ruskin's anxious awareness of a crowded world has a temporal as well as a spatial element, a "forever." The historical sensibility he describes in the Manchester lectures, and the new proximity of art resulting from the

increased facility of travel, makes all of Europe a potential museum with certain attendant historical responsibilities:

> There are two great reciprocal duties concerning industry, constantly to be exchanged between the living and the dead. We, as we live and work, are to be always thinking of those who are to come after us.... each generation will only be happy or powerful to the pitch that it ought to be, in fulfilling these two duties to the Past and the Future. (16:63)

In a passage such as this Ruskin's preoccupation with the line from Keats selected by the organizers of the Art Treasures Exhibition shows its source. Forever is his theme, more particularly, the place of things of beauty in that span of time and the audience's responsibility for assuring it. Hence his answer to complaints made in Parliament the previous week about the money spent on a Veronese by the National Gallery: it "will last for centuries, if we take care of it" (16:53). The ways that "forever" is constitutive of things of beauty is his topic, but for Ruskin this is not a realization about passive appreciation; "if we take care of it" is as much to be emphasized as the intrinsic value of the Veronese.

Once again, Hazlitt's writing in *Picture-Galleries* helps us understand the conceptual distance traveled in a few decades:

> A complaint has been made of the short-lived duration of works of art, and particularly of pictures.... The complaint is inconsiderate, if not invidious. *They will last our time....* Has not the Venus of Medici had almost as many partisans and admirers as the Helen of the blind old bard? Besides, what has Phidias gained in reputation even by the discovery of the Elgin Marbles? Or is not Michael Angelo's the greatest name in modern art, whose works we only know from description and by report? Surely, there is something in a name, in wide-spread reputation, in endless renown, to satisfy the ambition of the mind of man. Who in his works would vie immortality with nature? (10:28; emphasis in the original)

Hazlitt demonstrates in this passage just how much the gallery of the mind is his site of art appreciation. There is a generational solipsism or simple selfishness in his satisfaction in imagining the works' duration to include only "our time." Even more remarkably, it becomes evident, as he warms to his theme, that the object itself may be *unnecessary* to the appreciation of fame, of achievement, of that "name" which is so central to his valuation of art. How different is Ruskin's stern injunction: "Wherever you go, whatever you do, act more for *preservation* and less for *production*" (16:80; emphasis in the original). The voice is that of a new concept of stewardship, which does not recognize Hazlitt's "melancholy privilege of art" to be that "it exists chiefly in idea, and is not liable to serious reverses" (10:65; cited earlier). Hazlitt's indifference to the fate of

the actual object is linked not only to the concept of art as idea, but also to the related fact—so troubling to Ruskin—of the infinite reproducibility of the image. Far from existing chiefly in idea, for Ruskin art exists in fact and demands specific care because it is indeed liable to reverses.[37] More strikingly, caretaking itself becomes a way of finding some relief from the pressure of accretion; this form of focused attention to the work of the past and its situation in the present may serve to make attention more than a transitory experience, and the display of past art more than an element in a cycle of overwhelming accumulation.

Benjamin traces "the social bases of the contemporary decay of the aura" to a desire for intimacy with the art object, which is part of mass society's absorption of uniqueness: "It rests on two circumstances, both of which are related to the increasing significance of the masses in contemporary life. Namely, the desire of contemporary masses to bring things 'closer' spatially and humanly, which is just as ardent as their bent toward overcoming the uniqueness of every reality by accepting its reproduction" ("Work of Art," 225). For Ruskin, the intimacy that will lead to a loss of aura allows the possibility—indeed, the duty—of a new caretaking. His talk in Manchester suggests a conceptual inversion by which the energies that went into assembling a mammoth exhibition of "treasures" from all over the country will be put to use instead in preserving the far greater works scattered throughout Europe. What is manifested in either case is that urge toward closeness that both Benjamin and Valéry describe as characteristic of modernity: "the amazing growth of our technologies," notes Valéry, "the ideas and habits they are creating make it a certainty that profound changes are impending in the ancient craft of the Beautiful." What has changed is the relationship between the viewer and what he calls the physical component: "In all the arts there is a physical component, which can no longer be considered or treated as it used to be, which cannot remain unaffected by our modern knowledge and power."[38] What Valéry calls "ubiquity," the inescapable ease of access to the admired work, is a condition that affects the valuation of *all* objects, not only those being acted on directly either by reproduction or public inspection. As Benjamin will note, "[t]he situation into which the product of mechanical reproduction can be brought may not touch the actual work of art, yet the quality of its presence is always depreciated" (223). Ruskin's concern is to safeguard the importance of Valéry's "physical component," at a time in which both the ubiquity of reproduction and the crowding of the exhibit undermine its ultimate value. That the actual works of art are in fact threatened by war, thoughtless restoration, or unchecked decay only makes their loss of importance more compelling.

The question for Ruskin is whether accumulation will become part of the production of work, or whether it can only be part—both sign and

cause—of chaos and decay. Ordered accumulation, maintenance, and organization become duties for Ruskin in relation to human productivity: "the history and poetry of nations are to be accumulative; each generation treasuring the history and the songs of its ancestors . . . and the art of nations is to be accumulative" (16:64). While acknowledging the ubiquity of the museum, Ruskin tries to give a new meaning to the actions of gathering, of treasuring. It is a sensibility we might call ecological today: the public is to become responsible for the management of art, which, without organization, will suffer more than unintelligibility; it will disappear.[39] The goal of the critic is to promote the possibility that the inexorable universal museum may become a place that encourages work, production rather than storage. A passage such as the following shows the critic's prescient awareness of the museumification of the world, finding relief in a "fancy" that the museum can be a place of work, not simply of consumption:

> Nearly every great and intellectual race of the world has produced, at every period of its career, an art with some peculiar and precious character about it, wholly unattainable by any other race, and at any other time; and the intention of Providence concerning that art, is evidently that it should all grow together into one mighty temple; the rough stones and the smooth all finding their place, and rising, day by day, in richer and higher pinnacles to heaven.
>
> Now, just fancy what a position the world, considered as one great workroom—one great factory in the form of a globe—would have been in by this time, if it had in the least understood this duty, or been capable of it. (16:64)

It is worth noting the catholic expression of the accumulation Ruskin describes.[40] His fantasy is of a museum in which *all* significant achievement is brought together to form a temple that is also a place of productive work. In the fancy of a magnificent museum of all human creation serving as a positive inspiration for work, Ruskin may seem to differ profoundly from Hazlitt and Valéry. It may be more accurate, however, to identify in this fantasy the anxious wish that modernity should not become a dazzling unproductive storage site of the sort which Hazlitt found in Rome and Valéry in the museum.

LEARNED OUTLINES: HAZLITT AND RUSKIN ON FLAXMAN

An undeniable virtue of neoclassical art theory was its efficiency as a pedagogic system; the limited canon of works, the reliance on reproduction, and the conceptual importance of longing made it a very effective, powerful, and easy to teach system of admiration. The theorists of neoclassicism celebrated an absent golden past as it reached them in traces

and fragments. It was a celebration that became ever more untenable as the size of antiquity increased and its objects grew ever more hetero-geneous, but it had always run the risk of stranding the student at the point of longing. Ruskin's anxious preoccupation with the problem of display and organization in a world characterized by the superabundance of objects making claims on the attention inevitably leads him to revise almost beyond recognition the tradition of learning from antiquity that had been so important to the institutional establishment of the plastic arts in the eighteenth century, and which still played an important part in academic art and art appreciation in his own day. He salvages from neo-classicism a sense of the importance of the relationship between contem-porary art and culture and the art of the past, but his account of that relationship is inflected by a new urgency and specificity and by profound doubts as to the value of reduplicating images from an imagined past.[41] The world of which Ruskin is writing does not hold a limited canon of antique art calmly awaiting the attention of the student. A sensibility perpetually impinged on by the existence of a practically unlimited range of art and art objects will see the manifestations of antiquity as more than occasions for the study of tranquillity.

The same year that found Ruskin speaking at the Art Treasures Exhi-bition saw him engaging directly with the challenge of wider education in art. *The Elements of Drawing* is Ruskin's answer to what is for him a difficult question: how to put art in the hands of a public already at risk from the excess of what it knows and experiences? In this text, as in his Manchester lectures, learning is to a remarkable degree about the control of material—about collecting properly in a world full of objects claiming our attention. Aside from its discussion of the obvious technical topics, Ruskin's lessons in drawing describe a carefully calibrated access to, and rejection of, extant work: "You ought, if it is at all in your power, to possess yourself of a certain number of good examples of Turner's en-graved works: if this be not in your power, you must just make the best use you can of the shop windows, or of any plate of which you can obtain a loan. Very possibly, the difficulty of getting sight of them may stimulate you to put them to better use."

Ruskin recommends a list of works that might be purchased by the student, but even as he makes his recommendation, he anxiously takes it back: "Do not get more than twelve of these plates, nor even all the twelve at first; for the more engravings you have, the less attention you will pay to them. It is a general truth, that the enjoyment derivable from art cannot be increased in quantity, beyond a certain point, by quantity of possession" (15:74–76). The voice decrying the splintering of atten-tion among various works of art is the same in this text as in the lectures. The artworks Ruskin is concerned to regulate in this text are largely

reproductions. He identifies those worth having, those to be avoided, and even how they are to be used. To understand the urgency of Ruskin's attack on cheap duplication, it is important to keep in mind the popularity of engraved reproductions of art at this time. The illustrated papers often included examples meant for display, and techniques of engraving had become so much more efficient and economical that it was possible to support a vast demand.[42] *Ariadne Florentina* (delivered in 1872; published 1873–76) and *Cestus of Agalia* (1867) are the texts in which Ruskin is most openly engaged with the topic of engraving and reproduction generally, but he returned repeatedly to the theme. Although the critic's account of engraving is complex and rich, he never wavers in his fundamental mistrust of reproductive work: "I know no cause more direct and fatal, in the destruction of the great schools of European art, than the perfectness of modern line engraving" (*Ariadne*, 22:376).

As a child learns to draw, Ruskin notes in *The Elements of Drawing*, he "should be firmly restricted to a few prints and to a few books." The reasoning is that of Manchester: "it is by the limitation of the number of his possessions that his pleasure in them is perfected, and his attention concentrated" (15:10). Ruskin's anxiety about the culture of mass society drives even this text, with its ostensible goal of merely instructing amateurs in the art of drawing. The theme is inescapable—note the concatenation of museum and reproduction in this discussion of Rembrandt: "Whenever you have an opportunity of examining his work at museums, etc., do so with the greatest care, not looking at *many* things, but a long time at each. You must also provide yourself, if possible, with an engraving of Albert Dürer's" (15:79; emphasis in the original). Like a refined aesthetic pharmacologist prescribing dangerous remedies, Ruskin recommends a dosage and suggests a counteragent. The problem is not one of personal taste, but that the culture of modernity requires guidance even as to how much it is good to know: "It is one of the worst errors of this age to try to know and to see too much" he notes before concluding with a caution, "beware of *handbook* knowledge" (15:76). Of course, the handbook is a guide usually used by the traveler, the new cultural tourist.[43]

Ruskin transforms the values of the eighteenth century as he rejects its methods of learning. Hence his intemperate attacks on the works of Flaxman, that master of eighteenth-century outline. A term of such promise for Hazlitt, outline, according to Ruskin, is not only bad in itself, but corrupting: "all outline engravings from pictures, are bad work, and only serve to corrupt the public taste. And of such outlines, the worst are those which are darkened in some part of their course by way of expressing the dark side, as Flaxman's from Dante" (15:84). Even more damning is his recommendation of Flaxman as the best example of "one type of entirely false art," which it may be useful to inspect "in order to

know what to guard against." "Flaxman's outlines to Dante contain, I think, examples of almost every kind of falsehood and feebleness which it is possible for a trained artist, not base in thought, to commit or admit, both in design and execution" (15:225). Ruskin's attacks on Flaxman are of interest because, as soon becomes clear, his target is not Flaxman alone, but the way of relating to art and its reproduction that that artist represents: "you cannot have a more finished example of learned error, amiable want of meaning, and bad drawing with a steady hand.... All outlines from statuary, as given in works on classical art, will be very hurtful to you if you in the least like them; and *nearly* all finished line engravings" (15:225; emphasis in the original).

Ruskin's long note on the limitations and error of his earlier praise for Flaxman is most fruitfully read as part of a self-conscious revision of his earlier dependence on a late-eighteenth-century aesthetic (15:225n). Hazlitt's romance of the outline, the periodically filled-in shape, Keats's enjoyment "at opening a portfolio" as memorialized in "Sleep and Poetry"—these remnants of the eighteenth century are denied their power by Ruskin: "All outlines from statuary, as given in works on classical art, will be very hurtful to you, if you in the least like them." The longing for antique sculptures and the line illustrations that had spread their fame are both denied merit; they are instances not of simple ignorance, but of "*learned* error." The danger Ruskin describes is one of overvaluation or fetishization—"if you in the least *like* them."

Flaxman represents for Ruskin the poor use of the past. As Ruskin well knew, the presence of outline in neoclassicism is a complex blend of medium and message. Engravings that emphasized outline over surface were the principal means of diffusing images already in existence. (Blake's illustrations to Flaxman's article on sculpture are typical in this regard; his own *Laocoön* is not.) It was a form of representation that came to have a remarkable influence not simply on reproduction, however, but on the *creation* of original work. The eighteenth-century fascination with the image known as *The Origin of Painting* is telling. The Corinthian maiden, Dibutade, drawing her lover's *silhouette* is a representation of the beginning of art in outline (see Part One). The centrality of outline indicated by this recurrent theme has been identified by the art historian Robert Rosenblum in his discussion of the ambition of artists at the turn of the century to create representations of "a distilled immutable ideal, shed of sensuous qualities and fixed for eternity through the precision of drawn or engraved outlines."[44] Flaxman played an extremely important part in the growing importance of outline, not least because hugely influential engravings from his designs transposed the techniques for the reproduction of sculpture and vase painting into a means of creative work.

In Flaxman's work the door to the past swings two ways. The son of a

Fig. 46. John Flaxman, illustration from *The Vision; or Hell, Purgatory, and Paradise of Dante Alighieri*, trans. Henry Francis Cary (New York, 1859). The Vale of Disease, *Inferno*, 29. 46–72. The set of drawings to which this one belongs was first engraved in 1793, but not published in England until 1807.

cast maker and sculptor, Flaxman became an important sculptor in his own right, and professor at the Royal Academy, but his dramatic international influence was undoubtedly due to the engravings of his drawings from Homer and Dante, which were first brought out in the 1790s. Widely available as illustrations of translations from the classics throughout the nineteenth century, these works were produced in a style that was the offspring of neoclassical methods and desires (fig. 46). The precise outline, a quality identified as typical of antiquity in the text of archaeological works, had also been propagated in the illustrations that accompanied and often largely constituted those texts. From his study of engravings of Greek vases, and by making tracings after illustrations in volumes representing ancient works of art, Flaxman developed a technique that has been described as "a compendium of almost every type of artistic masterpiece known to the 18th century."[45]

Flaxman's was a technique of representation that took outline beyond the function of mere *reproduction* of extant work. Methods originally developed to represent historical work were hugely influential in the production of new material; they were copied and adapted by artists as varied as David, Goya, Géricault, and Ingres. Ruskin's attacks on Flaxman

are attacks on an idea of art that promotes an immoderate dependence not on antique art alone but on its mediated representation in engraving. In the 1820s Hazlitt referred to Flaxman's sculptural reliefs as "learned outlines" (10:168), emphasizing their connection to the sculptor's famous outline engravings, and hinting at the relation to pedagogy carried in this form (he might have said, "learning outlines"). Elsewhere, Hazlitt traces the flaws of Flaxman's writings to his occupation: "They may be characterized as the work of a sculptor by profession—dry and hard; a meagre outline, without colouring or advantageous ornament" (16:338).[46] Hazlitt recognizes the artist's inability to escape the limits of the technologies of reproduction: "His compositions as a sculptor are classical,—cast in an approved mould; but, generally speaking, they are elegant outlines" (16:339). In one sentence the critic sums up the depth of the sculptor's creative immersion in reproduction; the words that add up to "classical" are "cast," "mould," "outline." In Ruskin's description of Flaxman's inability to get beyond his reliance on classical work, the sculptor becomes a kind of failed Dante, forever unable to reach even the threshold of Hell as he trips figuratively over the very matter which has in fact stopped his progress: "he stumbles over the blocks of the antique statues—wanders in the dark valley of their ruins to the end of his days."[47]

Ruskin's instruction in art has to be a lesson in taste: "The worst danger by far, to which a solitary student is exposed, is that of liking things that he should not. It is not so much his difficulties, as his tastes, which he must set himself to conquer" (15:219). The problem is, on the one side, the number of works now available ("In these days of cheap illustration, the danger is always rather of your possessing too much than too little" [15:219]), and on the other a fetishization of the signs of absence such as we have seen in Hazlitt's love of the print: "If you happen to be a rich person, possessing quantities of them, and if you are fond of the large finished prints from Raphael, Correggio, etc., it is wholly impossible that you can make any progress in knowledge of real art till you have sold them all,—or burnt them, which would be a greater benefit to the world" (15:226). Ruskin is fighting a rearguard action for aura that demands a relationship to the copy very different from Hazlitt's. It may not be inappropriate to cite two letters, one from Hazlitt and the other one to him. The first is an invitation written to Hazlitt by his publisher, John Hunt, in 1819: "You can have my little parlour to write in, which is a snug place for the purpose, being hung round with prints after Raphael, Titian, Correggio, and Claude."[48] The second is a longer letter from Hazlitt to his first wife, Sarah Stoddart Hazlitt. Note the presence of print, catalog, and copy:

> Both parcels of prints came safe, and I need hardly say that I was glad to see them, and that I thank you exceedingly for getting them for me. . . . The day

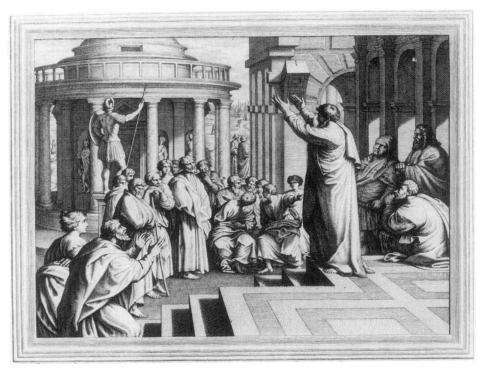

Fig. 47. Simon Gribelin after Raphael, *Paul Preaching at Athens*, 1705. London, Victoria and Albert Museum.

was wet and uncomfortable, and the catalogue did not tempt me so much as I expected. . . . But I have got my complete set of Cartoons, "here I sit with my doxies surrounded," and so never mind. I just took out my little copy of Rembrandt to look at and was so pleased with it.[49]

The enticing snugness described by Hunt, or Hazlitt's own description of his prints from Raphael (fig. 47) as so many sweethearts gathered round him—these are the kind of cheerful relationships to reproduction against which Ruskin warns less than forty years later.[50]

Ruskin's anxieties belong to a day in which reproduction has become all the easier to produce and acquire. In Hazlitt's letter, as in Hunt's, prints are evidently still a special treat. By the time Ruskin is writing, even the original is at risk of succumbing to the pressures of reproduction: "Never buy a copy of a picture, under any circumstances whatever. All copies are bad; because no painter who is worth a straw ever *will* copy" (15:195). Copying was the happy labour of Hazlitt's four months at the Louvre; eight years later the letter cited here shows him contentedly contemplating his own reproduction of Rembrandt. Prints pinned up

around him, catalog on the table, his own imitation canvas before him—Hazlitt's deep engagement with the world of art is unquestionably a happy immersion in simulacra.

In a dialogue he wrote on the topic of his visit to the Vatican, Hazlitt has himself asked his opinion of the frescoes of Raphael and Michelangelo, the only works of note he had not seen years before at the Musée Napoléon.[51] What is his response to the experience of the Sistine Chapel and Raphael's *stanze*? "As far as I could judge," he replies, "they are very like the prints. I do not think the spectator's idea is enhanced beyond this." When he goes on to criticize the works of Raphael that he did manage to see clearly as suffering because "the outline is injured," he is emphasizing his point (17:144). The prints present no viewing problems; *they* certainly have healthy outlines.

For all his gestures toward enchanted encounters with art, Hazlitt is remarkably comfortable in his relationship to the signs of its absence, like the public Ruskin describes demanding prints of Raphael's cartoons, "which you don't care to see themselves" (*Ariadne*, 22:388). Ruskin is stern in his treatment of these popular reproductions: "The Cartoons have been multiplied in false readings; never in faithful ones till lately by photography. Of the Disputa and the Parnassus, what can the English public know?" (*Cestus*, 19:103).[52] These last, the Disputa and Parnassus on the walls of the Vatican, are precisely the paintings that Hazlitt, twenty years before, thought no better than the prints representing them.

Ruskin's relationship to engraving is in no way simple. In *Ariadne* he tries to recover some primary value for a practice he believed to have mistakenly become primarily about reproduction. His argument echoes the theme of stewardship discussed earlier, as he attempts to overcome the destructive power of the modern reproduction: "It is essentially the cutting into a solid substance for the sake of making ideas as permanent as possible, graven with an iron pen in the Rock for ever. *Permanence*, you observe, is the object, not multiplicability;—that is an accidental, sometimes not even a desirable, attribute of engraving" (22:420; emphasis in the original). The desire to preserve meaning against the loss of aura joins that of safeguarding actual monuments. Developments in technology and changes in culture make the allure and promise of reproduction of one era the dangerous crowded assault of another. Hazlitt and Ruskin represent important and related moments in the education of the desire for art in England, but while Hazlitt's pleasure is most noticeable at the rubbing of the lamp, it is all Ruskin can do to try to control the genie.

Chapter Seven

VAST KNOWLEDGE/NARROW SPACE:

THE STONES OF VENICE

> This infinite universe is unfathomable, inconceivable, in its
> whole; every human creature must slowly spell out, and long
> contemplate, such part of it as may be possible for him to
> reach; then set forth what he has learned of it for those
> beneath him; extricating it from infinity, as one gathers a
> violet out of grass, one does not improve either violet or
> grass in gathering it, but one makes the flower visible.
>
> —*John Ruskin*, The Stones of Venice

TRAVEL AND ORGANIZATION

FOR ALL the complexity and variety of Ruskin's great works of the
1840s and 1850s—the interlocking texts of *Modern Painters* I
(1843), *Modern Painters* II (1845), *Seven Lamps of Architecture*
(1849), *Stones of Venice* I (1851), *Stones of Venice* II and III (1853), *Modern
Painters* III and IV (1856), and *Modern Painters* V (1860)—we recognize
at least two concerns that are constant: the nature of the artist in mod-
ernity and the value (and therefore the need for preservation) of antique
art. Ruskin looks backward to a world of art that needs saving and for-
ward to the possibility of creating better contemporary artists, but his
preoccupations are closely allied. In the preceding chapter I described
the crisis caused for Ruskin by the proliferation of art and the un-
suitability of long-standing traditions in the understanding of how art
was to be admired. Ruskin tried to draw his audience's eyes toward Italy
during the course of his lectures at the Art Treasures Exhibition, away
from the art gathered around them. It was in Italy that he found not only
the art he admired, but a vision of the possibility of a more fruitful rela-
tionship to the art of the past for the audience and the artist in modern-
ity. The instability of the artwork and viewer in a new world of ready
movement for both, the shocking heterogeneity and excess of the mod-
ern collection, the unstable and jarring city of heterogeneous objects—
the very elements that had characterized the instability of the relation-
ship to art of the nineteenth century—are recuperated in Gothic Venice,
Ruskin's vision of an ideal city of art. If the fantastic solutions Ruskin

arrives at ultimately fail to be more than fantasies of an ideally productive relation to past art, they nevertheless clarify the desires motivating the crisis, and thereby the form of the crisis itself.

Travel and Collection, or the Treasures of Exile

The very title of Ruskin's first significant work challenges the system of humility toward the past institutionalized by the academies: *Modern Painters: Their Superiority in the Art of Landscape Painting to All the Ancient Masters*. Notoriously, however, Ruskin's simple argument breaks down and the resulting text presents nothing so straightforward as this proposition (the heterogeneity of the work is attested to by the disarming title of the third volume, *Of Many Things*).[1] Where does his plan break apart?— somewhere between Switzerland and Italy. The evolution of *Modern Painters*, that is to say, the controlled explosion of that work, is determined by the repeated shock of Ruskin's encounters with a world of art all too accessible. Ruskin's text becomes the register of the impossibility of maintaining the limited project with which it begins.[2] The attempt to place the crowded fragments of the world in order is central to what is widely regarded as Ruskin's most successful work, *The Stones of Venice*. In the difficult genesis of the text as much as in its very title there is evidence of Ruskin responding to the complex range of fragments now available at home and abroad. Advertised as imminent, "in preparation," at the time *The Seven Lamps of Architecture* was published (1849; see 8:li; 9:xxii), *The Stones of Venice* required for its completion several more visits to Venice and five long years.

Cited at the head of this chapter is the account of the relationship of artist to nature offered near the close of volume 1 of *Stones of Venice* as Ruskin prepares to take the reader from his more general treatment of architecture to within sight of the city itself. This passage offers an abstract yet compelling description of work closely akin to Ruskin's own, of a laborious selection and elaboration that the book as a whole will at once demonstrate and explain. *Stones of Venice* not only describes a process of painstaking gathering, contemplation, and placement of incomplete pieces from an overwhelming world, it repeatedly instantiates the same process. The extrication and arrangement of material which is difficult to reach, if not unreachable, by others becomes Ruskin's theme and method. My analysis follows Ruskin's account of his movement as writer-traveler because it is in the interplay of travel and arrangement that his concept of the artist emerges. Temporary sojourner and committed arranger of the past into new forms, these are the roles assumed by the creative figure in Ruskin's museum world. I conclude with a discussion of the use of nature in "The Nature of Gothic" as a way of identifying

Venice as a fantasy of the proper organization of art. In my reading of this seminal text, the Gothic artist emerges not simply as a nostalgic figure of naive creativity, but as a model of critical work for the modern artist.

Stones is quite openly at once about travel and about organization. Ruskin's research was carried out largely during two extended stays in Venice, but the figure of the voyager and the question of putting material into order are both more than biographical accidents.[3] When, after devoting the bulk of the first volume to architectural principles, Ruskin finally comes to the city that gives the work its title, he writes as an unabashed travel guide: "And now come with me, for I have kept you too long from your gondola: come with me, on an autumnal morning, through the dark gates of Padua and let us take the broad road leading towards the East" (9:412; see also note 1). It is one of the notable oddities of the text, however—and an indication of Ruskin's ambivalent relationship to travel—that he leaves us in 1851 with a loving description of the moment of arrival at Venice just at the advent of the railway (he describes the railway bridge under construction), and he opens the second volume in 1853 with a meditation on the loss of travel's romantic aura consequent upon this new convenience. His tone is deliberately archaic when he writes of

> the olden days of travelling, now to return no more, in which distance could not be vanquished without toil, but in which that toil was rewarded, partly by the power of deliberate survey of the countries through which the journey lay, and partly by the happiness of the evening hours, when from the top of the last hill he had surmounted, the traveller beheld the quiet village where he was to rest, scattered among the meadows beside its valley stream; or from the long hoped for turn in the dusty perspective of the causeway, saw, for the first time, the towers of some famed city. (10:3)

"Distance could not be vanquished without toil"—Ruskin's nostalgia for effort arises from the same sensibility as that which we have seen was so concerned to limit too ready access to art. Another benefit of a prior, more arduous, mode of travel was the possibility of what Ruskin calls "the power of deliberate survey." The difficult process of overcoming distance allowed Ruskin the possibility of the ordered viewing of a whole, either in the measured sequential experience of travel from place to place, or—and the fact that the day's voyage ends on a high prospect is no coincidence— when, "the last hill surmounted," he surveys the landscape.[4]

As the reader-traveler circles Venice, the entire first chapter of the volume becomes a play of perspective and conceptualization jostling and outrunning each other. The view Ruskin affords us from our gondola of the lagoon and the city rising from its waters begins as eighteenth-

century sublime but soon moves into a different register. The undistinguished sight of Venice from this prospect is more than made up for by "the strange rising of its walls and towers out of the midst, as it seemed of the deep sea, for it was impossible that the mind, or the eye could at once comprehend the shallowness of the vast sheet of water which stretched away in leagues of rippling lustre to the north and south, or trace the narrow line of islets bounding it to the east" (10:4). It is characteristic of the sublime employed by Ruskin that while it involves such Burkean elements as distance, obscurity, and strangeness, it also includes a difficulty of conception based on knowledge (in this case, as it will be often, geological). This is the sublime obverse to that comfortable (and picturesque) survey of the previous page, which takes place on the steady ground of "the last hill," or from the perspective of "the long hoped for turn" in the traveler's road, and which includes the comfort of the night's resting place and its clearly evident setting "among the meadows beside its valley stream."

Ruskin's gondola-glide transition from his description of the approach to the city to a historical account of its fate is part of his deployment of the sublime of knowledge. This first paragraph of magnificent travel description blends imperceptibly into a second paragraph of historico-cultural meditation, joined by the perspectival play that characterizes the text as a whole. In the space between the end of paragraph one, on the distant founding of the city, and the opening of paragraph two, on the "last few eventful years, fraught with change to the face of the whole earth," history collapses into a whole at once manifold and surveyable. It is in the third paragraph of Ruskin's opening that his play of perspective meets its most evident source, the arrangement of knowledge. This passage, which begins with geography, witnesses not only static topographic detail, but the passage of millennial time. If it was impossible to conceive of the shallowness of the Adriatic setting of Venice, what is the mind to do with Ruskin's dynamic geology?

> When the eye falls casually on a map of Europe, there is no feature by which it is more likely to be arrested than the strange sweeping loop formed by the junction of the Alps and Apennines, and enclosing the great basin of Lombardy. This return of the mountain chain upon itself causes a vast difference in the character of the distribution of its débris on its opposite sides. The rock fragments and sediments which the torrents on the north side of the Alps bear into the plains are distributed over a vast extent of country, and . . . soon permit the firm substrata to appear from underneath them; but all the torrents which descend from the southern side of the High Alps, and from the northern slope of the Apennines, meet concentrically in the recess or mountain bay which the two ridges enclose; every fragment which thunder breaks out of their

battlements, and every grain of dust which the summer rain washes from their pastures, is at last laid at rest in the blue sweep of the Lombardic plain; and that plain must have risen within its rocky barriers as a cup fills with wine, but for two contrary influences which continually depress, or disperse from its surface, the accumulation of the ruins of ages. (10:9–10)

The presence of time in Ruskin's account makes his map reading a geologist's explanation of history—where else could "soon" be part of any discussion of the distribution by erosion of soil and stones from the Alps? Given that it was impossible for the "mind or the eye" to comprehend, to take in and register, the contradictory evidence of the senses when confronted with a city floating on the ocean, it is worth asking how one could be expected to perceive all that Ruskin here describes, starting from that casual fall of the eye on the map. The map of Europe is the source of the knowledge element in Ruskin's sublime; it is also where his sublime finds relief.

Ruskin will go on from the sedimentary development of the islands on which Venice was built—for which the preceding passage is prologue—to the tides that affected its development (10:10–14; see also appendix 3: "Tides of Venice"). It would be a mistake to read these pages as digressions motivated simply by Ruskin's lifelong fascination with geology. As soon becomes clear, they are integral to a text in which systematic mapping out of historical processes is the counterpart or remedy to a sense of history that otherwise risks becoming overwhelming. Like the traveler surveying the Alps in the earlier passage, Ruskin aspires to a reassuringly connected vision of the relation of things. His interrogation of the ancient stones of this city is part of the process of placing them in a useful relation to the present. The terms Ruskin uses in his description of Venice's location in the midst of the runoff of rock fragments from the Alps shade geological concerns into characteristic art-historical ones. The fate of the city is determined by its position on "the accumulation of the ruins of ages." "Accumulation," "ruins," even the time frame suggested by "ages"—these are elements in relation to which the experience of art, not just geology, must be understood.

This first chapter of *Stones* II, "The Throne," is professedly intended to serve two purposes: to extinguish romantic illusions fed by readings of Shakespeare and, especially, Byron, and to show the strange providentiality behind the city's development. But, underlying these two openly expressed aims is a theme whose significance becomes apparent only on further reading of the text—that the very throne or seat of this remarkable city of art is not autochthonous, that it is rather composed of broken fragments of the past, distant in space as well as in time. Ruskin's insistence on the geologically determined destiny of the city is part of his

concern with the powerful formative effect of past fragments, so it should come as no surprise that his treatment of the human settlement of the lagoon echoes the same theme. Before visiting Venice proper, Ruskin takes his reader to Torcello, which he believed at the time to be the original settlement of the Venetian people when first they fled the mainland, an island he calls "the widowed mother of the city" (10:18). One might expect Ruskin to present the cathedral of Torcello as a place of fundamental beginnings—the primitive manifestation of the Gothic spirit he will go on to describe. What is remarkable about his treatment, however, is his insistence on just the opposite, on the fact that the settlers of Torcello and eventual founders of Venice are exiles from an anterior civilization—not just mothers, but widows. It is this sentiment that motivates his description of the cathedral:

> It has evidently been built by men in flight and distress, who sought in the hurried erection of their island church such a shelter for their earnest and sorrowful worship. . . . There is visible everywhere a simple and tender effort to recover some of the form of the temples which they had loved, and to do honour to God by that which they were erecting, while distress and humiliation prevented the desire, and prudence precluded the admission, either of luxury of ornament or magnificence of plan. (10:20–21)

Critics have pointed out the oddity of Ruskin's account of a cathedral flung up in a hurry. Indeed, it seems likely that the edifice now standing on the island was the result of substantial renovations carried out in the eleventh century on the original seventh-century structure.[5] Archaeological accuracy should not, however, blind us to the fact that Ruskin, of all people, could not have believed that Santa Maria Assunta was constructed in a state of immediate urgency—at least not in any usual understanding of that state. It is in part the exuberant spirit of the Gothic that Ruskin is trying to capture in his account, as he does throughout the book. Beyond the energy he recognizes in the style, however, Ruskin is evidently treating a more somber subject. His aim is to present the builders of Torcello—separated from their source, building with the consciousness of their loss—as a general model of virtuous creation. The plight of the builders of the cathedral is only of interest to us, as it is to Ruskin, because it is symbolic of a general condition:

> I am not aware of any other early church in Italy which has this particular expression in so marked a degree; and it is so consistent with all that Christian architecture ought to express in every age (for the actual condition of the exiles who built the cathedral of Torcello is exactly typical of the spiritual condition which every Christian ought to recognize in himself, a state of homelessness on earth . . .), that I would rather fix the mind of the reader on this general charac-

ter than on the separate details, however interesting, of the architecture itself. (10:21–22)

The signs of exile Ruskin finds in Torcello are present throughout his discussion of Venice, and central to that city's achievement and its lesson for modernity. The residents of the lagoon islands, far from being new men creating in their ignorance a rough and unsophisticated art, are figures attempting to build not only in spite of their condition of exile but in recognition of its significance.

What fascinates Ruskin about Santa Maria Assunta is what it represents about the possibilities of human art (and all that the term entails for him) in exile, which is to say human art in its actual condition. His analysis serves to defend Gothic design against charges of either necessary links to Catholicism or mere unsuccessful imitation of classical forms. Both of these complaints treat the Gothic as part of what for Ruskin were oppressive and lifeless traditions.[6] Hence his sharp response to the words of an earlier critic who had suggested that the capitals of the cathedral were "indifferently imitated from the Corinthian." "[T]he expression is inaccurate as it is unjust," writes Ruskin, "every one of them is different in design, and their variations are as graceful as they are fanciful" (10:22). He devotes pages of text and illustration to the nature of the Venetian capital (returning to the theme again at 10:159–65), but most of his argument is made in these few lines. It is exactly their variety ("every one of them different") and the free fancy they express that makes these capitals far superior to Greek work. Their carving represents the nature and the power of individual creation, not the deadening stylized perfection sought by the Greeks and their followers. The criticism he quotes is not only wrong but misguided; *imitation* of classical models is just what the Gothic artists are *not* attempting, but is precisely what has doomed work since the Renaissance rediscovery of classical antiquity and the standard orders.

Nevertheless, it is important not to misunderstand the limits on the originality of the Gothic craftsman in this argument. Ruskin is not interested in arguing that these medieval workmen drew only on resources native to their new home, any more than he would suggest that the stones on the plains of Lombardy had their source in the ground on which they currently lie. Treasuring fragments from home is a response to the condition of exile. Ruskin is fascinated with what the residents of Torcello (and subsequently Venice) did with the pieces of antiquity they managed to bring with them or to acquire by trade. He dwells on the decoration of the pulpit of the cathedral (fig. 48):

> These blocks, or at least those which adorn the staircase towards the aisle, have been brought from the mainland; and being of size and shape not easily

Fig. 48. Pulpit staircase, Santa Maria Assunta, Torcello, eleventh century.

adjusted to the proportions of the stair, the architect has cut out of them pieces of the size he needed, utterly regardless of the subject or symmetry of the original design. (10:28)

The ready adaptation of preexisting material to new ends is not limited to the pulpit:

> At the lateral door of the church are two crosses, cut out of slabs of marble, formerly covered with rich sculpture over their whole surfaces, of which portions are left on the surface of the crosses; the lines of the original design being, of course, just as arbitrarily cut by the incisions between the arms as the pattern upon a piece of silk which has been shaped anew. (10:28)

Rather than being "indicative of bluntness and rudeness of feeling," this means of working is a sign of confident strength, a Keatsian "redundance of power which sets little price upon its own exertions." Ruskin is rewriting the standards used by exponents of classical architecture to attack the Gothic, but he is also proposing a relationship between past art and contemporary artist that fundamentally challenges not just the architecture but also the instruction in art of neoclassicism and its institutional manifestation, the Academy:

When a barbarous nation builds its fortress-walls out of fragments of the refined architecture it has overthrown, we can read nothing but its savageness in the vestiges of art which may thus chance to have been preserved; but when the new work is equal, if not superior, in execution, to the pieces of the older art which are associated with it, we may justly conclude that the rough treatment to which the latter have been subjected is rather a sign of the hope of doing better things, than of want of feeling for those already accomplished. . . . the exertion of design is so easy to them, and their fertility so inexhaustible, that they feel no remorse in using somewhat injuriously what they can replace with so slight an effort. (10:29)

Antique stones are as important for Ruskin as they were for theorists of the preceding century. Ruskin, however, not only draws attention to a different set of objects of admiration; he proposes an altogether different relationship between the creative artist and past achievement. In place of the abasement before the accredited remains of antiquity, which was the prescription of neoclassicism, Ruskin discovers in Venice a response to antique work that is critical, that admires, judges, sifts, and produces its own work by means of the bold placement of previous material.

The fragment carefully gathered by the traveler and housed in a new system of art—this is the relationship to art of earlier eras Ruskin discovers in Venice; it is also the form of his own encounter with the achievement of the past. The effects of Ruskin's repeated self-correcting forays to Italy are evident throughout his writings. The odd cobbled-together pulpit of Torcello just discussed, much like the church transformed into a smokestack that is the first sight of Venice Ruskin allows on his tour, represents the contingent, serendipitous discoveries of the tourist. The writer's aim is no longer what it had been in neoclassical training—to identify a place in the continuum of institutionalized art history by seeking out its recognized monuments. It is rather to make sense of the jottings and sketchings, the personal instances collected on a long voyage. In an 1846 letter from abroad, Ruskin's father, always intimately engaged with his son's travels and writing, testifies to Ruskin's accumulation of memoranda as the essential constitutive material of his argument:

He is cultivating art at present, searching for real knowledge, but to you and me this is at present a sealed book. It will neither take the shape of picture nor poetry. It is gathered in scraps hardly wrought, for he is drawing perpetually, but no drawing such as in former days you or I might compliment in the usual way by saying it deserved a frame; but fragments of everything from a Cupola to a Cart-wheel, but in such bits that it is to the common eye a mass of Hieroglyphs—all true—truth itself, but Truth in mosaic. (8:xxiii)

The final hyperbole of the three "truths" at the close of this paragraph does not overcome the anxious reechoing triple "buts" that precede it so much as it serves as further evidence of the puzzled mind trying to understand a new idea. Mr. Ruskin's faith in his son is touching, but he is evidently puzzled by a new modus operandi; it is not simply that his son is finding significance in an alternative architecture (a cupola, say), but that he is including in his considerations such humdrum travel details as an intriguing wagon wheel. It is worth noting that he sees enough of what his son is doing to evoke figures of archaic art to describe it— hieroglyphs and, more tellingly, mosaic—as truth in fragments.

More than a personal quirk is revealed in Ruskin's manner of working, in his engagement with the fragmentary. The unstable desire of neoclassicism—to make something new from antique art—is transformed, as Ruskin's encounter with the actual remains of the past does not allow to stand so simple a wish. Furthermore, his researches show him a past that offers alternatives to anxious imitative repetition. His focus on Venice instead of Rome forms part of his attack on neoclassical values, not because the island state presents a counterideal of art to be emulated, but because it provides a countermodel of how to *handle*, *use*, and *place* the rich inheritance of the broken remnants of a lost artistic past.[7] Ruskin's treatment of the decoration of the walls of St. Mark's—the cathedral of Venice—shows him at once wrestling with the problem of the façade in Gothic work and denying that it is a problem at all. He makes what, in keeping with his standards, should be a kind of dishonesty as to material, the main defining virtue of the cathedral:

> Now the first broad characteristic of the building, and the root nearly of every other important peculiarity in it, is its confessed *incrustation*. It is the purest example in Italy of the great school of architecture in which the ruling principle is the incrustation of brick with more precious materials; and it is necessary, before we proceed to criticise any of its arrangements, that the reader should carefully consider the principles which are likely to have influence, or might legitimately influence such a school. (10:93; emphasis in the original)

As Kenneth Clark has pointed out, the sort of work represented by the "incrustation" of St. Mark's would have been anathema to earlier Gothic revivalists.[8] Ruskin himself acknowledges the problem: "It appears insincere at first to a Northern builder, because, accustomed to build with solid blocks of freestone, he is in the habit of supposing the external superficies of a piece of masonry to be some criterion of its thickness" (10:94–95). He responds in part by an intriguing transvaluation of the word "duplicity" (10:94), but his most important argument is the historical defense he has already prepared for in Torcello: the incrustation of

St. Mark's is a typical production of exile. Far from being evidence of deception or insincerity, it humbly embodies the acknowledgment of its separation from the source of the precious thing itself. In the "Lamp of Life," the chapter of *The Seven Lamps of Architecture* most closely prefiguring the concept of the Gothic developed in *Stones*, Ruskin presents the idea behind his praise of St. Mark's: "it is no sign of deadness in a present art that it borrows or imitates, but only if it borrows without paying interest, or if it imitates without choice." Borrowing is akin to imitation, and both responses to art of the past are not to be condemned; on the contrary:

> There is something to my mind more majestic yet in the life of an architecture like that of the Lombards, rude and infantine in itself, and surrounded by fragments of a nobler art of which it is quick in admiration and ready in imitation, and yet, so strong in its own new instincts that it re-constructs and re-arranges every fragment that it copies or borrows into harmony with its own thoughts,—a harmony at first disjointed and awkward, but completed in the end, and fused into perfect organisation; all the borrowed elements being subordinated to its own primal, unchanged life. (8:195)

Ruskin is not speaking metaphorically, or not only metaphorically. He is describing abstractly a use of antique material he has witnessed, even as he attempts to account for the pleasure it has given him: "I do not know any sensation more exquisite than the discovery of the evidence of this magnificent struggle into existence; detection of the borrowed thoughts, nay, the finding of the actual blocks and stones carved by other hands and in other ages, wrought into new walls, with a new expression and purpose given them" (8:195). Like Reynolds in the *Discourses*, Ruskin cites the example of the Spartans, who did not punish theft but the lack of skill indicated by being caught.[9] Whereas the president of the Royal Academy has a lot of trimming to do to fit this idea into eighteenth-century ideas of originality and decorum, Ruskin boldly insists that the two distinguishing characters of what he calls "vital imitation" are "its Frankness and its Audacity."

We should not overlook Ruskin's own audacity in suggesting that work that visibly incorporates actual fragments from the past is more majestic, more filled with life, than work making unsustainable claims of originality. This chapter of *Lamps*, which more than any other in the book is an attack on the neoclassical ideas of architecture Ruskin traces back to the Renaissance, proposes the evident jumble that is Gothic architecture as the sign of a vitality entirely contrary to the symmetry and abasement that are the characteristics of dead architecture (8:199). At the close of the passage cited, we find the memory of Torcello and Venice, the "exquisite sensation of discovery" produced by encountering old walls built

of ancient fragments. Moving beyond the notable aestheticist thrill be-
hind his words in *Lamps*, *Stones* offers a historical account to explain the
value of the incrustation of St. Mark's:

> Consider the natural circumstances which give rise to such a style. Suppose a
> nation of builders, placed far from any quarries of available stone, and having
> precarious access to the mainland where they exist . . . in proportion to the
> preciousness of the stone is the limitation of its possible supply; limitation not
> determined merely by cost but by the physical conditions of the material, for of
> many marbles, pieces above a certain size are not to be had for money. There
> would also be a tendency in such circumstances to import as much stone as
> possible ready sculptured, in order to save weight; and therefore, if the traffic
> of their merchants led them to places where there were ruins of ancient edi-
> fices, to ship the available fragments of them home. (10:95)

The situation of Venice is not only like that prefigured in Torcello; the
condition described at the close of the earlier passage has a more than
coincidental relation to that of mercantile-imperial England at midcen-
tury. The difficulty of access to the materials of their craft leads the ar-
tists of the republic to develop an art assembled from what they do man-
age to get their hands on. Ruskin is vivid in his representation of the
heterogeneous accumulation of material involved: "Out of this supply of
marble, partly composed of pieces of so precious a quality that only a few
tons of them would be on any terms obtained, and partly of shafts, capi-
tals, and other portions of foreign buildings, the island architect has to
fashion, as best he may, the anatomy of his edifice" (10:95–96). Faced
with such a challenge to their ingenuity, what could the builders of St.
Mark's do, but adopt a method of work that allowed them to stretch out
the few precious things available, to design in such a way as to fit in
fragments of anterior work, as they had learned to do in Torcello? The
apparent duplicity of the use of marble coverings for their walls is in fact
a tribute to their faithfulness: "an architect who cared for the preserva-
tion of noble work, whether his own or others', and more regarded the
beauty of his building than his own fame, would have done what those
old builders of St. Mark's did for us, and saved every relic with which he
was entrusted" (10:96). With Ruskin, the term "preservation" is never
fortuitous. The story he tells of the decoration of the cathedral makes its
builders into models for the responsible art citizens he will describe in *A
Joy Forever* ("Wherever you go, whatever you do, act more for *preserva-
tion* and less for *production*").

Between the alluvial deposits of its foundations and the decoration
covering its buildings, medieval Venice is always and at every point a city
of accumulated fragments. The state of exile of the residents of Torcello
has its apotheosis in the island-empire of Venice—when the now wealthy

and powerful city still applied the principles it had used at its earliest foundation. The artists of these islands manifest the condition of nostalgic separation from the sources of beauty because that separation and nostalgia ineluctably shape the development of their art:

> It might . . . have been a question with other builders, whether to import one shipload of costly jaspers, or twenty of chalk flints; and whether to build a small church faced with porphyry and paved with agate, or to raise a vast cathedral in freestone. But with the Venetians it could not be a question for an instant; they were exiles from ancient and beautiful cities, and had been accustomed to build with their ruins, not less in affection than in admiration: they had thus not only grown familiar with the practice of inserting older fragments in modern buildings, but they owed to that practice a great part of the splendour of their city, and whatever charm of association might aid its change from a Refuge into a Home. The practice which began in the affections of a fugitive nation, was prolonged in the pride of a conquering one; and besides the memorials of departed happiness, were elevated the trophies of returning victory. (10:96–97)

To build with ruins or to insert older fragments in modern buildings—it is the inheritance of this artist nation to intercalate past art into its own, to make its own art from intercalation. It should be noted that a technique Ruskin describes as inspired by exile he nevertheless identifies as having been carried out even back in the *preexilic* days of "ancient and beautiful cities." It was part of the beauty of these cities that they were "accustomed to build with their ruins." Actual exile may be the condition in which the need to place carefully the work of the past is most evident, but it is not the only time at which such placement is necessary or beautiful. The engagement with preexisting material may be understood as the result of such a separation from origins. As Ruskin suggested at Torcello, however, exile may well turn out to be a condition at all stages in the production of art.

The Natures of Gothic

What kind of artist is required or revealed by Gothic work? One who is able to find a living use for fragments of dead material from a lost past. The title of the central chapter of *Stones of Venice* is misleadingly straightforward. Ruskin is too metaphorically self-conscious, especially at names, for us to take the "nature" of Gothic for anything so simple as its "character" or "temperament." It is part of the brilliant economy of the piece that nature becomes the standard that saves Gothic architecture at once from its Roman Catholic associations and from the attacks of the heirs of neoclassicism. Understood as a natural architecture, Gothic loses its

Puginesque-traditionalist links to the Roman Church; when it is shown to be a return to nature that moves beyond classical models, the Gothic reveals itself as far more than the failed attempts at superior forms of a technically incompetent people. Indeed, the figure of the artist in this account is such as to make a virtue of a certain kind of imperfection. The root of nature is *naci*, to be born. I have tried to suggest earlier in this chapter reasons why the birth of the Gothic might be far from a simple matter in Ruskin, and yet why it is an unavoidable preoccupation. The entirety of the book might be called "The Nature of Gothic," because at every point his theme is the difficult birth of Venice, daughter of a widowed mother, born into an early knowledge of death, rising, not new, but newly beautiful, from an unreclaimable past.

The Charts of the World

By "nature," Ruskin means at once the setting and the subject of the Gothic. Early in the chapter Ruskin invokes his characteristic trope for the sublime of knowledge, the inadequate map:

> The charts of the world which have been drawn up by modern science have thrown into a narrow space the expression of a vast amount of knowledge, but I have never yet seen any one pictorial enough to enable the spectator to imagine the kind of contrast in physical character which exists between Northern and Southern countries. We know the differences in detail, but we have not that broad glance and grasp which would enable us to feel them in their fullness.

Our knowledge outpaces our ability to conceive what we know because we cannot see so broadly. As Ruskin warms to his theme, the explanation of "Savageness," the first and most important "moral element" (10:184) of the Gothic, he composes a fantasy of perspective that combines his concern for gathering information with his preoccupation with travel:

> *We do not enough conceive* for ourselves that variegated mosaic of the world's surface which a bird sees in its migration. . . . Let us, for a moment try to raise ourselves even above the level of their flight and imagine the Mediterranean lying beneath us like an irregular lake . . . here and there an angry spot of thunder, a grey stain of storm moving upon the burning field; and here and there a fixed wreath of white volcano smoke, surrounded by its circle of ashes; but for the most part a great peacefulness of light, Syria and Greece, Italy and Spain, laid like pieces of a golden pavement into the sea-blue. (10:186; my emphasis)

The world, if seen aright, takes the form of a mosaic, of discrete fragments composing a significant whole. As usual, a proper view must in-

clude not just space, but geological time—indicated by that "fixed wreath of white volcano smoke." As Ruskin's survey continues, his ambitions become evident. He takes the reader quite literally on a tour of the world, from this sunny Mediterranean seascape to the dark and gloomy north, where once again, earth-shaping forces are at work:

> and then, farther north still, to see the earth heave into mighty masses of leaden rock and heathy moor, bordering with a broad waste of gloomy purple that belt of field and wood, and splintering into irregular and grisly islands, amidst the northern seas, beaten by storm, and chilled by ice-drift. . . . And, having once traversed in thought this gradation of the zoned iris of the earth in all its material vastness, let us go down nearer to it, and watch the parallel change in the belt of animal life. (10:186–87)

The interpretation of the art of a people by reference to their physical environment is at least as old as Winckelmann.[10] What is different (and characteristic) in Ruskin's treatment, however, is the literally global vision he brings to bear, and its intersection with his function as guide. "We do not enough conceive," he writes; as in his Manchester lectures, Ruskin's aim is to make the audience indeed conceive what it is now possible to know and in some measure even to experience. The varied world he maps out is precisely *not* the place for such simple comparisons as Winckelmann's, between a gentle south and a blustery north. Ruskin's Gothic craftsman is not the beneficiary of the boon of good weather, but neither is his art in any way ideal. For the idealism of another era, Ruskin substitutes a complex relativism:

> Let us not condemn, but rejoice in the expression by man of his own rest in the statutes of the lands that gave him birth. Let us watch him with reverence as he sets side by side the burning gems, and smooths [*sic*] with soft sculpture the jasper pillars, that are to reflect a ceaseless sunshine, and rise into a cloudless sky; but not with less reverence let us stand by him, when, with rough strength and hurried stroke, he smites an uncouth animation out of the rocks which he has torn from among the moss of the moorlands, and heaves into the darkened air the pile of iron buttress and rugged wall, instinct with work of an imagination as wild and wayward as the northern sea. (10:187)

Freedom or Perfection

In these globe-trotting paragraphs Ruskin describes the setting that gives rise to the historic development in art known as Gothic architecture. I have noted Ruskin's goal of separating Gothic art from the stigma of Catholicism; in order to understand the art-historical polemic motivating the essay, however, it is as important to realize the extent to which his description of the qualities of the Gothic is an attack on two conceptual

pillars of nineteenth-century English art: the pervasive neoclassical inheritance and the relationship between English design and English manufacturing. The six moral characteristics of the Gothic proposed by Ruskin (Savageness, Changefulness, Naturalism, Grotesqueness, Rigidity, Redundance [10:184]) add up to a direct assault on values whose importance had only grown from the late eighteenth century to the middle of the nineteenth. In the art-historical schema he describes, the faults go back to the Renaissance, but this should not blind us to their topicality— Reynolds is as much in his sights as Palladio or Sansovino, and, more than any of them, his target is the tradition of blind repetition of classical motifs.

In the attack on mass production and mechanistic art that is such an important part of this chapter, Ruskin is addressing precisely those questions which were to motivate his talks at Manchester four years later. Ruskin's originality resides not at all in seeing a connection between a growing cultural interest in antique art and the development of modern manufacturing. His argument in *Stones* assumes this link to exist in the reader's mind. The innovation comes in Ruskin's bipartite attack on this cultural commonplace: first, in proposing, rather than the academic artist as an inspiration for industrial design, the Gothic craftsman as a countermodel to the modern industrial laborer; second, in laying the responsibility for the parlous state of the laborer at the feet of a British public too concerned with unnatural perfection or finish. When Ruskin writes that "the modern English mind has this much in common with the Greek, that it intensely desires in all things, the utmost completion or perfection" he is giving voice to a sentiment that might have been uttered by many since the mid-eighteenth century (10:190). The difference is that Ruskin sees something quite different in Greece and in perfection from the ideal world desired by the classical revivalists.

Whereas for the theorists of neoclassicism there had been a direct connection between Greece as the native land of art and as the home of freedom, for Ruskin the perfection of the Greeks is intimately linked to enslavement. In Winckelmann, the rise and fall of Greek art is at all times directly correlated with the state of political bondage or freedom of the Greek people. What he calls the "History of Ancient Art in Its Relation to the External Circumstances of the Times among the Greeks" (books 9–10 of his *History*) goes to extraordinary lengths to support its insistence that every great work is created in a moment of freedom, and that each brief revival of liberty saw a correspondent renaissance in the arts of Greece.[11] If we look back to the insistent distinctions drawn between Assyrian work and Greek, indeed, between *all* nonclassical work and Greek, in the testimony already cited before the 1853 parliamentary committee, it becomes evident that Ruskin is practicing a critical histori-

cism similar to Blake's when he connects Greece to Egypt and Nineveh. He audaciously describes the fascination with Greece as a "temporary enthusiasm," and looks forward to the day "we shall no longer think them a greater people than either the Egyptians or Assyrians" (11:188). Ruskin is not interested in simply replacing one form of antique art with another; his challenge is aimed directly at the values that sustained the long influence of neoclassicism. Consider this description of an artist by a self-acknowledged heir of Winckelmann in the early nineteenth century:

> He is like a builder who has no clear ground; ancient debris of half-ruined walls, mounds, projecting rocks obstruct him, quite apart from the particular ends which are to dictate the construction of his building, and he can achieve nothing but a wild, unharmonious, fantastic structure. What he produces is not the work of his own imagination freely creating out of his own spiritual resources.[12]

Out of context and following Ruskin's meditations on Gothic design, one might hesitate before Hegel's account of the Indian builder. The passage shares much with Ruskin's thought, but Hegel is describing precisely the situation that is *inadequate* for the creation of great art. As we will see in the next chapter Hegel does not propose ideal Greek art as the form most appropriate to every era, but he does, like Winckelmann, insist on freedom as the essential source of ideal art, freedom of a sort only to be found in ancient Greece. The situation of the Gothic artist described by Ruskin is precisely that, like Hegel's Indian builder, he is not free to create out of his own spiritual resources. Having no clear ground is the condition as much on newly settled Torcello as it is in nineteenth-century London. Ancient debris and half-ruined walls, projecting mounds— these are constants in Ruskin's world. Creative work motivated by the belief that it is drawing solely on its creator's "own spiritual resources" will result only in a misguided egotistical and debased art. Hegel describes the artists of Greece as "great and free, grown independently on the soil of their own inherently substantial personality, self-made and developing into what they [essentially] were and wanted to be" (2:719; insertion by the translator).[13] Precisely, Ruskin tells us, and it is for this reason that they have so little to offer the artist of today. Worse, the freedom of the architect in Greece is bought at the price of enslaving the worker.

Hegel follows Winckelmann in his emphasis on the essential freedom of the artist of classical antiquity. "Free independent meaning," "self-conscious subjective freedom," "free vitality"—these are typical of the terms the philosopher uses to characterize Greek art and artists (1:427, 436, 437). Such freedom stands in contrast to the Indian counterexample,

"in this free creation the artist acquires a position quite different from the one he has in the East" (1:470). Similarly, Egyptian art is characterized from the outset as what Ruskin calls servile, "The first thing to mention is the lack of inner and creative freedom" (2:781). As much of the first two books of Winckelmann's *History* is devoted to explaining the categorical and necessary difference of Greek from other ancient arts (due to geography, climate, physical features, social organization), it would be challenge enough for Ruskin to place Greek art on a level with the work of other nations. That he does so in order to describe them all as practicing a demeaning form of enslaving decoration merely clinches his challenge to the inheritors of Winckelmann:[14]

> Of Servile ornament, the principal schools are the Greek, Ninevite, and Egyptian. . . . The Greek master-workman was far advanced in knowledge and power above the Assyrian or Egyptian. Neither he nor those for whom he worked could endure the appearance of imperfection in anything; and therefore, what ornament he appointed to be done by those beneath him was composed of mere geometrical forms,—balls, ridges, and perfectly symmetrical foliage,—which could be executed with absolute precision by line and rule, and were as perfect in their way, when completed, as his own figure statue. (10:189)

It would be difficult to move further away from the idea of the noble free Greek artist executing work in a politically admirable Athens. In Ruskin's account, Greek ornament is evidence of Greek slavery. The insistence on perfection, far from rising as a positive quality of desire, results from a weakness, the *inability* to stomach the appearance of imperfection. Ruskin at once throws into question the historical sensibility behind neoclassicism, the standard of perfection it represents, and the very desire for perfection. Gothic work is, of course, the antitype to all this. As so often in *The Stones of Venice*, good work is what is done with fragments that in themselves are far from perfect. Gothic art at its best involves at once proper desire, wise consumption, and careful arrangement. A Gothic building, in Ruskin's account of the matter, becomes an assemblage of fragments of human frailty and history adding up to more than an aesthetic hodgepodge: "It is, perhaps, the principal admirableness of the Gothic Schools of architecture, that they thus receive the results of the labour of inferior minds; and out of fragments full of imperfection, and betraying that imperfection in every touch, indulgently raise up a stately and unaccusable whole" (10:190).

When the standard is servility or freedom, it is the ordered, controllable work of the Greeks (and their followers) that fails. The ideal beauty that in the eighteenth century had been seen as the glory of Greece is understood to arise from a sort of unnatural squeamishness: "The Greek sculptor could neither bear to confess his own feebleness, nor to tell the

faults of the forms he portrayed" (10:234). Linking the Greeks and their servile work to a modern English sensibility attacks the tradition of dependence on a classical ideal by identifying it as teaching a lesson in slavery and the desire for perfection as a longing for work at once slavish and enslaving.

The limited value of perfection in art was not only Ruskin's theme in this period. Perhaps the best-known account of the matter is in the poetry of Robert Browning. The fault of Andrea del Sarto is what is announced by the subtitle to the poem bearing his name, "The Faultless Painter" (1855). The pathos of his confession is the realization of his less talented rivals that, though "Their works drop groundward," "themselves, I know, / Reach many a time a heaven that's shut to me." Like Browning, Ruskin proposes that perfection will always signify a moral failure, "in the works of man, those which are more perfect in their kind are always inferior to those which are, in their nature, liable to more faults and shortcomings" (10:190). The structural problem with perfection is precisely that presented by Browning, or indeed, that hinted at by Schiller in a related argument; success implies that something limited and circumscribed has been attempted. Animals that build achieve perfection in the structures they construct, but it is a mark of their animal nature that they cannot imagine a project larger than their abilities (10:214).[15] Failure is the mark of the morally heroic attempt, and in Ruskin's humane social analysis, the hero is the worker allowed simply to think. The result of this freedom will be at once the shame of practical failure and the glory of active imaginative expression: "Out come all his roughness, all his dulness, all his incapacity; shame upon shame, failure, pause after pause: but out comes the whole majesty of him also; and we know the height of it only when we see the clouds settling upon him. And whether the clouds be bright or dark, there will be transfiguration behind them" (10:192–93). Ruskin's great man is the anonymous, fallible, laborer of the Middle Ages. To the spirit of the Gothic itself is ascribed the qualities of unsatisfiable longing usually associated with the romantic artist: "It is that strange *disquietude* of the Gothic spirit that is its greatness; that restlessness of the dreaming mind that wanders hither and thither among the niches, and flickers feverishly. . . . and yet is not satisfied nor shall be satisfied" (10:214).

If there were any doubt that Ruskin's concern is more than simply aesthetic, it would not survive Ruskin's indictment of the public's enslaving demand for perfection. When Ruskin becomes a guide to the reader's own room, he brings the lesson home with inescapable intimacy. His paragraphs move inexorably to modernity: from a historical discussion of his topic, to its relation to "the modern English mind," to a direct address, emphatically of the present moment:

And now, reader, look round this English room of yours, about which you have been proud so often, because the work of it was so good and strong, and the ornaments of it so finished. Examine again all those accurate mouldings, and perfect polishings and unerring adjustments of the seasoned wood and tempered steel. Many a time you have exulted over them, and thought how great England was, because her slightest work was done so thoroughly. Alas! if read rightly, these perfectnesses are signs of a slavery in our England a thousand times more bitter than that of the scourged African, or helot Greek. (10:193)

In passages such as this one, Ruskin is taking his argument straight to the heart of the pragmatic motivation for nineteenth-century support of art—the improvement in British industrial design; the slavery he discovers at the heart of classical decoration is only the more evident in modern work. The repetitive nature of classical decoration, like the manufacturing process to which it is closely linked, is as fatal for the creativity as for the life of contemporary artists.

That "The Nature of Gothic" is an attack on industrialism's dehumanization of the worker should be unmistakably clear to any reader; it is worth dwelling, however, on how this central theme of the piece is interwoven with a devastating assault on the neoclassical sensibility. Ruskin's insistence here, as elsewhere, on the virtues of manual labor is completely at odds with that class-based separation of mental work from craftsmanship that had been so important to Reynolds and his contemporaries. I quote a passage from *The Discourses* discussed in Part One:

> The value and rank of every art is in proportion to the mental labor employed in it, or the mental pleasure produced by it. As this principle is observed or neglected, our profession becomes either a liberal art or a mechanical trade. In the hands of one man it makes the highest pretensions, as it is addressed to the noblest faculties: in those of another it is reduced to a mere matter of ornament; and the painter has but the humble province of furnishing our apartments with elegance. (Discourse IV, 10 December 1771; Reynolds, 57)

Ruskin leaves no room for Reynolds's anxious polar opposites, his "either . . . or."[16] After a paragraph marshaling one of his most powerful indictments of mass production ("It is not, truly speaking, the labour that is divided; but the men;—Divided into mere segments of men—broken into small fragments and crumbs of life") Ruskin answers Reynolds by proposing as a solution the "determined demand for the products and results of healthy and ennobling labour" (10:196). To demand anything other than the products of healthy and ennobling *work* is to participate in a grim destruction of humanity; healthy labor is precisely that which does not separate mental and physical action in the way Reynolds describes.

The division of labor is the most vicious shoot of a plant that includes a mistaken idea of originality: "How wide the separation is between original and second-hand execution, I shall endeavour to show elsewhere; it is not so much to our purpose here as to mark the other and more fatal error of despising manual labour when governed by intellect. . . . We are always in these days endeavouring to separate the two. . . . All professions should be liberal" (10:200–201). By this stage in his argument, Ruskin has entirely turned Reynolds on his head. It should be no surprise that Ruskin goes on to develop the topic not in architectural terms, as one would expect from the context, but in relation to painting (he argues that the painter should grind his own colors [10:201]).

Ruskin's list of the "moral characteristics" of Gothic is of course openly and self-consciously anticlassical. When, in considering "changefulness," Ruskin notes that "nothing is a great work of art, for the production of which either rules or models can be given" (10:207), he has in mind the rules and models that are the defining features of neoclassicism and its institutions. That this relatively recent revival of antiquity is an important target of Ruskin's work is only slightly camouflaged by his quick move to blame the Renaissance. Indeed, in Ruskin's account, the decline from the Reformation on is so precipitous as to leave all of history in a pile at the bottom of the declivity: "And thus Christianity and morality, courage, and intellect, and art all crumbling together into one wreck, we are hurried on to the fall of Italy, the revolution in France, and the condition of art in England . . . in the time of George II" (9:45). He is well aware that ideas he blames on the Renaissance were directly propagated by the culture of art at the turn of the century. "The great error of the beginning of this century," he writes at his most Blakean, "is the error of the meanest kind of men that apply themselves in painting, and it is the most fatal of all." This most fatal fault is committed by those who "strive to obtain the inventive powers which nature has denied them," by "study[ing] nothing but the works of reputed designers." The result of such a procedure is nothing better than "perish[ing] in a fungous growth of plagiarism and laws of art" (10:220).

Nature is never far in Ruskin's description of Gothic; it is part of his critique of that extended neoclassicism running from the fourteenth century to his own day, and as such it intersects in intriguing ways with the topic of inherited work. Returning to ideas he developed on Torcello while defending the capitals of Santa Maria Assunta from charges of being poorly done Corinthian, Ruskin carries out a characteristic transvaluation on the question of imitation:

> Both Greek and Roman used conventional foliage in their ornament, passing into something that was not foliage at all, knotting itself into strange cup-like

buds or clusters, and growing out of lifeless rods instead of stems; the Gothic
sculptor received these types, at first, as things that ought to be, just as we have
a second time received them; but he could not rest in them. (10:232)

Gothic craftsmen become examples of the proper use of antique art.
They inherited—"as we have"—a quantity of work from the past, but
they knew, or learned, to reshape this material in order to give it a new
value reflecting their own experience. In this way Gothic is based on a
return to the natural form for which classical work is mere dead and
abstracted imitation—enslaving then as now.[17] The importance of the
Gothic artist is that he recognizes his choice: "He saw there was no
veracity in them, no knowledge, no vitality. Do what he would, he could
not help liking the true leaves better; and cautiously, a little at a time, he
put more of nature into his work, until at last it was all true, retaining,
nevertheless, every valuable character of the original well-disciplined and
designed arrangement" (10:232). Ruskin reverses a fundamental part of
the history of architecture as it was understood from the late eighteenth
century, what he calls "the strange and vain supposition that the original
conception of Gothic architecture had been derived from vegetation."[18]
It is a topic that, like that of incrustation, allows him to develop a cen-
tral theme—the possibility of new creation from the materials of a pre-
existent tradition:

> I have before alluded to the strange and vain supposition, that the original
> conception of Gothic architecture had been derived from vegetation,—from
> the symmetry of avenues, and the interlacing of branches. . . . It is precisely
> because the reverse of this theory is the fact, because the Gothic did not arise
> out of, but developed itself into, a resemblance to vegetation, that this resem-
> blance is so instructive as an indication of the temper of the builders. (10:237)

Naturalism: The Grasp of the Whole

I began this chapter with a passage on the value of careful gathering and
presentation. "This infinite universe is unfathomable, inconceivable, in
its whole; every human creature must slowly spell out, and long contem-
plate, such part of it as may be possible for him to reach." Ruskin is
describing a process not of triumph, but of making do: "extricating it
from infinity, as one gathers a violet out of grass, one does not improve
either violet or grass in gathering it, but one makes the flower visible."
The fact of a crowded world was pressingly evident to Ruskin. In re-
sponse, he is driven to describe the possibility of the site of accumulation
as a place of productive work rather than destructive storage. Events such
as the Manchester Art Treasures Exhibition were moments at which a
constant challenge could be identified for a public unaware that it might

be engaged in destroying the possibility of retrieving anything useful from the clutter. Looking to the subjectivity of a mass audience assailed by ever growing numbers of images divorced from the actual experience of art, or alternatively stunned by the variety of contradictory forms of art available, Ruskin devises strategies to recover the plenitude of the art object, or not to allow it to be emptied out into a world of incoherent heterogeneity or hollow simulacra.

The "moral quality" of Gothic that Ruskin develops at greatest length in "The Nature of Gothic" is self-referential, what he calls "Naturalism." This section, occupying the middle of the chapter, is by far the longest of the six, swollen as it is by what he describes as a necessary digression on the topic of painters. Ruskin here engages in that ordering of great artists which Haskell and others have identified as typical of this period, but it is by identifying the character of their relation to what he calls nature that the critic organizes his pantheon. In order to do so, Ruskin introduces the concept of the "sensualist" to the binary opposition of *naturalisti* and *puristi* he finds in Italian writing on art. The virtue of this addition is that it allows him to move the *naturalisti* from an impure extreme to the privileged central spot. The purity, or moral perfection, of the *puristi*, while better than mere sensualism, misses that engagement with flawed humanity which only the central men have, and which is so fundamental to the values of the chapter as a whole.

Ruskin charts out artists as he did the Gothic, using the language of observation and organization that runs through the text:

> Observe then. Men are universally divided, as respects their artistical quali-fications, into three great classes; a right, a left, and a centre. On the right side are the men of facts, on the left the men of design, in the centre the men of both.
>
> The three classes of course pass into each other by imperceptible grada-tions. . . . Few men, even in the central rank, are so exactly throned on the summit of the crest that they cannot be perceived to incline in the least one way or the other, embracing both horizons with their glance. (10:217)

The invitation to witness, the placing of the reader on an eminence in order to properly survey the matter at hand—these are strategies Ruskin used when he had us look over the map of Europe and over the world that contained the Gothic. The correspondence of form follows from similarity of intention; much like those instances, this is another moment of organization at once acknowledging and attempting to overcome a crowded world: "Let us, then, endeavour briefly to mark the real rela-tions of these three vast ranks of men . . ." (10:224). For Ruskin, engag-ing in such a survey is more than a matter of expository organization; the ability to do so is itself an essential characteristic of central men, "em-

bracing both horizons with their glance." The "gradations" that Ruskin allows among the ranks of men are not unrelated to the gradations of the world's climate, which account for the variety in world art. Most artists, even some greatly admired by Ruskin, inhabit the bands that shade from one type to another. To be truly a central man is exceptional to the point of entering altogether a different category. The gentle physical verb that describes perception as "embracing" two horizons indicates the active nature of the seeing of these men. In one of those moments which make even his system building evocative of Gothic wildness, Ruskin abandons his first chart in order again to divide artists into three, this time on the question of how much of "truth" they admit into their work. His central group is again characterized by its miraculous inclusiveness: "The second, or greatest class, render all that they see in nature unhesitatingly, with a kind of divine grasp and government of the whole. . . . Their subject is infinite as nature, their colour equally balanced between splendour and sadness" (10:222). Even some of Ruskin's most loved painters are not in this elite central category, which includes only six names (Michelangelo, Leonardo, Giotto, Tintoretto, Turner, and sometimes Raphael [10:222]). Many of the purists, by their unwillingness to look at evil, pass up the opportunity of access to the infinite, which is available to those occupying the central category.

Two Museums

The exceptional status of Ruskin's central men is due to the rarity of what they achieve. For the rest of humanity, the confrontation with the world is not from an elevated position taking in both horizons. Down on the ground things just look crowded and confused. Imagined museums become Ruskin's favorite ideal space for the management of knowledge and objects so as to reduce chaos and increase significance. There were several practical manifestations of this interest: Ruskin participated in the debate on the construction of a national gallery in print and in testimony before parliamentary committees; one of the most ambitious plans of his Guild of St. George to be actually realized was the establishment of a museum in Sheffield—a giant painting of St. Marks's dominating its main room.[19]

In closing, I cite just two textual references to the museum from the period under discussion; both are more convincing in the indications they give as to the nature of the problem the museum invites or identifies than as practical solutions. The first, somewhat oblique, reference comes in *The Fall*, the third volume of *Stones of Venice*, as Ruskin traces the collapse of European culture during the revival of interest in classical culture in the Renaissance. The basis of his argument should be familiar

by now: "The human mind is not capable of more than a certain amount of admiration or reverence, and that which was given to Horace was withdrawn from David" (11:129). When he turns to the effect of this new fondness for the classics on painters, the nature of the failure is clear: "The faculties themselves wasted away in their own treason; one by one they fell in the potter's field; and the Raphael who seemed sent and inspired from heaven that he might paint Apostles and Prophets, sank at once into powerlessness at the feet of Apollo and the Muses" (11:130).

The unmistakable reference to Raphael's *Parnassus* (fig. 45) at the close of this paragraph is wonderfully economical. Not only does it culminate a scathing description of the decline in the seriousness of painting from the representation of religious subjects to the representation of classical themes, but the particular subject of the work he chooses to evoke suggests that Raphael has turned to other gods for inspiration (unabashedly revealing as much in the very seat of Roman Catholicism). Raphael of course does not believe in Apollo, but that is precisely Ruskin's theme. A culture that celebrates idols in which it does not believe participates in the emptying-out of meaning from *all* representations: "[T]his double creed, of Christianity confessed and Paganism beloved, was worse than Paganism itself, inasmuch as it refused effective and practical belief altogether" (11:129). Ruskin knows that he is describing the beginning of the museum culture he dreads. It is no coincidence that he chooses from the range of pagan figures painted by Raphael a representation of Apollo and the *muses*. As he develops his argument, it becomes clear that Ruskin is describing the problem of consciousness in the *muse*um that will run through his remarks in Manchester a few years later:

> The habit of using the greatest gifts of imagination upon fictitious subjects, of course destroyed the honour and value of the same imagination used in the cause of truth. . . . The images summoned by art began gradually to assume one average value in the spectator's mind; and incidents from the Iliad and from the Exodus to come within the same degrees of credibility. (11:130–31)

Ruskin soon brings his argument to modernity:

> The more skilful the artist, the less his subject was regarded; and the hearts of men hardened as their handling softened, until they reached a point when sacred, profane, or sensual subjects were employed, with absolute indifference, for the display of colour and execution; and gradually the mind of Europe congealed into that state of utter apathy,—inconceivable unless it had been witnessed, and unpardonable, unless by us, who have been infected by it, which permits us to place the Madonna and the Aphrodite side by side in our galleries, and to pass, with the same unmoved inquiry into the manner of their handling, from a Bacchanal to a Nativity. (11:131)

In one sentence Ruskin goes from past tense to present, as in one paragraph he has traveled from Raphael painting muses at the Vatican to the modern mind at the museum. Valéry was, of course, disingenuous in the bedazzlement he professed to feel before the incongruous conglomeration of the museum (most of us can stroll comfortably through a modern museum, after all, and see images representing a range of incompatible aesthetic and cultural values without the confusion he evinces). For Ruskin, this is precisely the problem; in the home of the muses, even Apollo finds no worshipers.

In 1852, as Ruskin was finishing *The Stones of Venice*, it seemed likely that, in accord with the instructions in Turner's will, he would soon be given the responsibility for the design and organization of a museum of his favorite painter's work. The task of organizing the artist's drawings was put in Ruskin's hands, but the larger project never materialized. Nevertheless, a letter he wrote to his father at this time describes the model museum Ruskin enthusiastically saw himself designing:

> I would build such a gallery as should set an example for all future picture galleries. I have had it in my mind for years. I would build it in the form of a labyrinth, all on ground storey, but with ventilation between floor and ground; in form of labyrinth, that in a small space I might have the gallery as long as I chose—lighted from above—opening into larger rooms like beads upon a chain, in which the larger pictures should be seen at their right distance, but *all on the line*, never one picture above another. Each picture with its light properly disposed for it alone—in its little recess or chamber. Each drawing with its own golden case and closing doors—with guardians in every room to see that these were always closed when no one was looking at *that* picture. In the middle of the room—glass cases with the sketches, if any, for the drawing or picture, and proofs of all engravings of it. Thus the mass of diffused interest would be so great that there would never be a crowd anywhere: no people jostling each other to see two pictures hung close together. Room for everybody to see everything. (13:xxviii–xxix; emphasis in the original)

Here, as elsewhere in his writings, Ruskin anticipated design changes that would become commonplace in modern museums, but more interesting for our purposes are the images he evokes and the goals he sets for his museum. "I have had it in my mind for years," he says, and indeed, the elements he describes—the labyrinth, the golden box—these are terms from treasured fantasy. "In form of a labyrinth" he says twice in a sentence, in a kind of eager stutter proposing a form that he believes will provide endless extendibility, but which we recognize as the architectural shape of difficulty.[20] This is the paradoxical beauty of the plan; every detail is meant to allow for size, attention, and protection: the size of the

crowd, as much as the size of the collection, the protection of the individual items, as much as of the aura threatened by the magnitude of museum and audience. Like Oldfield's plan for a museum of antiquities, this one is also expandable, but it allows for the preservation of significance as it grows because each piece is closed away in its own golden case, tended by its own guardian. If Hazlitt's encounter with a collection had an inherent Arabian Nights quality, Ruskin's will have one by design. In this museum the "mass of diffused interest" in which engravings play a part has a positive quality, breaking up attention so that individual encounters with art become possible. The final result is summarized in that wonderfully cheerful, simple, hyperbolic, somewhat desperate sentence fragment, "Room for everybody to see everything."

PART FOUR

THE DEATHS OF THE CRITICS

Chapter Eight

MODERNITY AS RESURRECTION IN
PATER AND WILDE

FILLING IN THE OUTLINE, OR "WHAT IS REALLY NEW"

THE LONG-LASTING lure of the outline demonstrates that despite its crammed exhibition halls and ever expanding museums, important elements in the nineteenth-century culture of art were far more comfortable with the forms of longing than they were with plenitude, let alone excess. The form of the outline gave a fruitful yet controlled shape to longing. While standing in for the absent object and thereby acknowledging a lack, the suggestive curves of the outline were nevertheless taken to offer rich meanings. An outline presented a notable purity of form liable to provoke ideas quite distinct from those the original objects in all their color and texture might have been likely to support. "Critics of Greek sculpture," notes Pater, addressing a tradition going back to Winckelmann and including a vast number of art lovers throughout the nineteenth century including Pater himself in his early writings, "have often spoken of it as if it had been always work in colourless stone, against an almost colourless background."[1] Stone without color against a blank background—Pater economically suggests both the experience of the cast and of the illustration as he cautions against taking the representation for the object itself. Elsewhere in this 1880 piece, "The Origins of Greek Sculpture," Pater uses similar terms when he warns against being misled by the reproduced image into settling for a pleasure that is not only inauthentic, but inadequate, given the complex and textured subtleties of the original: "the student must always remember that Greek art was throughout a much richer and warmer thing, at once with more shadows, and more of a dim magnificence in its surroundings, than the illustration of a classical dictionary might induce him to think" (222).

The story of Dibutade—the maiden who invented painting when she sketched the outline of her departing lover's head on a wall—which had so intrigued painters and writers at the end of the eighteenth century, returns in the course of Pater's account of origins. The critic transforms the significance of the legend, however, by a shift in emphasis. He cites the tale in the course of his discussion of the rise in Greek culture of a

new interest in marking artistic achievement. Not only does Pater transfer (or return) the interest to Butade, father of the maiden, presenting her name as a way of memorializing his, he emphasizes the part of the story in which the father "fills up the outline" of his daughter's lover (231). It had never really made sense that this motif was known as "The Origin of Painting," except insofar as it indicated the importance of outline for neoclassical theory and the predominance of painting in the period. After all, the outline *drawn* by the daughter was used as the basis for a kind of plaque by the potter Butade—a ceramic piece, not a painting. The ostensible primacy of outline in antiquity had been seen in the eighteenth century as warrant for a modern admiration of the pure defining edge, but Pater finds in the anecdote a precedent for just the opposite, for the process of *filling in* he recommends to his reader: "Greek art is for us, in all its stages, a fragment only; in each of them it is necessary, in a somewhat visionary manner, to fill up empty spaces, and more or less make substitutions" (205). It was the same recognition of the paucity of available Greek art that had made Winckelmann evoke the longing Corinthian maid watching her lover's ship sail out to sea. Pater is more practically suggestive as he attempts to move beyond a longing based on absence to an admiration responsive to available material. Rather than foregrounding the shapes of longing, Pater makes recourse to recent archaeological finds and textual researches in his effort to recapture, insofar as it is possible, the cultural and material presence of Greek art. His Greece has color and texture; its art is enmeshed in an architecture, the product of historical development. Butade, Pater tells us, became famous for a process of *coloring* clay red; his masks found their place on the eaves of temples (231). At this point of origin Pater finds not white on white, not the empty outline, but color, and art fully embedded in culture.

The Vessel of the Undead

Pater has been linked to developments in nineteenth-century scholarship that gave Greek sculpture an origin, that traced the history of this great beginning. He contributed to the popularization of this new approach by drawing on structures borrowed from the study of Renaissance art, particularly from the recovery of the art of the early Renaissance that had been carried out largely in the second half of the century. His essays describe the merits of preclassical Greek sculpture in terms closely echoing those used to praise art before Raphael, sometimes directly citing or drawing comparison with early Italian Masters. Pater suggests a history that entirely dissents from any idea of the pure originality of Greek art, arriving thereby at an account not simply more accurate but more conge-

nial to his historical sensibility. When he notes that "in Greece all things are at once old and new," he has a general principle in mind: "As, in physical organisms, the actual particles of matter have existed long before in other combinations; and what is really new in a new organism is the new cohering force—the mode of life—so, in the products of Greek civilisation, the actual elements are traceable elsewhere by antiquarians who care to trace them" (215).

The outline is all edge, it suggests limit, unbroken freestanding form. In the nineteenth-century culture of art, it is a reminder and mark of the perfection of earlier work, and of the break or separation between the present and the past: a break and a recognition of perfection to which a long-standing and powerful response had been longing or nostalgia. The borders that move Pater, however, are themselves frayed or broken, permeable, not solid. The principle he describes in relation to "physical organisms" is precisely that which obtains in his history. Everything has existed before; the only novelty is that provided by a "new coherent force." In the previous chapter I cited Ruskin on the special pleasures of recognizing the moments of forceful appropriation of previous work in the Gothic. The cathedral of Torcello, which the earlier critic held up for praise and emulation, was a model of the powerful and sensitive placement of antique art. The inevitable importance of such work for modernity was uncomfortably present to Ruskin, and in need of careful justification. Walter Pater, and Oscar Wilde after him, push boldly toward a further conclusion. Not only do they strive to establish the conceptual and historiographical reasons why modernity should require the recognition of the artist as never fully original, but they notoriously do not shy away from a related conclusion: the labor of selecting, arranging, and juxtaposing required of the artist will inescapably bring his work into close alignment with that of the critic. The filling in of the outline on which Ruskin himself insisted, along with the historical project of preservation and the praise of work that was itself made with past fragments— so much that Ruskin supported would, as a matter of course, contribute to the creation or exacerbation of the very sort of crowded situation he feared, a museum world of constant and heterogeneous claims on the attention like that Valéry would describe years later. In such a world the work of the critic becomes ever more complicated, even as it becomes inescapable.

For a historian with no confidence in innovation, every birth is a resurrection, every death a sleep. This chapter will turn on the shape of death in the work of Walter Pater, which is to say, the shape of a state just prior to "renaissance." The imbricated questions of freedom and the past, which so preoccupied writers on art throughout the century, became

only more complicated with the developing influence of complex theories of inheritance, those associated with Hegel and Darwin in particular. To talk about criticism, for both Pater and Wilde, is to talk about an unavoidable practice imposed by the realization that modernity is not simply in possession of fragments of the past but composed of those very fragments. "He to whom the present is the only thing that is present, knows nothing of the age in which he lives. To realise the nineteenth century, one must realise every century that has preceded it, and that has contributed to its making," says Gilbert in Wilde's "The Critic as Artist," developing the theme of modernity as heredity, which has a wide if subterranean presence in Wilde's work. "The scientific principle of Heredity," he argues, "has become, as it were, the warrant for the contemplative life."[2] In a modernity that recognizes itself as ineluctably composed of the sum of its past, the work of contemplation, of evaluation, the work of the critic, becomes unavoidable—or, is avoided only at a cost.

When Wilde suggests that "we are never less free than when we try to act," he is doing more than expressing a flippant paradox aimed at that nineteenth-century tradition of faith in the deed. To "realise"—whether to conceive aright or to make real the situation of modernity—it is necessary to engage in as full a manner as possible the inescapable presence of the past. Wilde knows that to do so will fundamentally complicate simple accounts of human agency. We are never less free than when we act because our actions are determined by forces outside our ken. Wilde develops these ideas in what is certainly his most Paterian essay, on a page in which he has already cited that critic; indeed, the argument borrows verbatim from ideas first assayed in Wilde's review of *Appreciations*, "Mr. Pater's Last Volume."[3] As is clear from the review, and from "The Critic as Artist," the Pater to whom Wilde looks back is not so much the author of *Appreciations*, as of *The Renaissance*, the work in which Pater had described an insidious ever present web whose influence is all the greater for being in no way separable from the self: "For us, necessity is not, as of old, a sort of mythological personage without us, with whom we can do warfare. It is rather a magic web woven through and through us . . . penetrating us with a network subtler than our subtlest nerves."[4] The weavers of this web have been traced to Goethe's *Faust*, but the disturbing point of the image is the reach of the threads, spun as they are in an unpersoned plaiting and unplaiting of natural forces. "That clear, perpetual outline of face and limb," Pater comments in the "Conclusion" to *The Renaissance* "is but an image of ours, under which we group them—a design in a web, the actual threads of which pass out beyond it" (186–87).[5] With the consciousness that events and actors are woven from materials whose source is beyond knowing, comes the realization that absolute freedom is possible only as illusion, or as that whose loss defines modernity. "What does the spirit need in the face of modern life?" Pater

asks in his essay on Winckelmann, answering himself with a bold frag-
ment: "The sense of freedom." As Wilde well understood, however, it is
precisely in the face of the modernity that raises the question that such
an answer cannot stand unelaborated; the modern, quite limited, sense of
freedom cannot be confused with the absolute unfettered liberty for
whose loss it is attempting to compensate: "That naïve, rough sense of
freedom, which supposes man's will to be limited, if at all, only by a
will stronger than his," Pater continues, "he can never have again" (184). It
is an informing paradox in Pater that the importance of criticism is sus-
tained, demonstrated, even called for, by a sensibility responsive at once to
the implications of evolutionary biology and to those of philosophy.

"To be entirely free, and at the same time entirely dominated by law,"
Oscar Wilde will write in a Paterian moment in *De Profundis*, "is the eternal
paradox of human life that we realise at every moment" (891). Insights and
terms from Pater recur in Wilde because he understood the seriousness of
the earlier critic's claims. Although this discussion focuses on Pater, it
closes with Wilde, an author whose work does not simply offer flamboyant
elaboration of paradoxes learned from Pater, but adds new force to the
claims of death in relation to artist and critic in a modernity characterized
by a superabundance of undying claims on the attention.

The ship that crashes on the coast of England, carrying Dracula and the
dirt-filled coffins that he hopes will be the means of establishing himself
in the modern world is called the *Demeter*. Archaeological researches at
Cnidus in the late 1850s, which brought the statues of Demeter and
Persephone to the British Museum, had also brought the complex figure
of Persephone's mother to the attention of England in the later nine-
teenth century. Nevertheless, it is worth asking what moved Bram Stoker
to name this ship, transporting the undead out of a primitive foreign
Europe, after a goddess of fertility. In the name he finds for the ship,
Stoker makes a connection that, as I suggest in this chapter, he is not
alone in making. Walter Pater also was intrigued by the darker aspects of
this figure for fertility, this ever mournful mother in a perpetual uneasy
truce (compounded of negotiation and surrender) with the underworld.

Twenty-four years before *Dracula*, in the famous description of the
Gioconda at the heart of his essay on Leonardo, Pater makes a compara-
ble connection between the undead and some archetypal maternal fig-
ures. Indeed, possibly the most jarring of the analogous figures he pro-
poses for the *Mona Lisa* in the following well-known passage is the first,
the vampire:

> She is older than the rocks among which she sits; like the vampire, she has
> been dead many times, and learned the secrets of the grave; and has been a
> diver in deep seas, and keeps their fallen day about her; and trafficked for

strange webs with Eastern merchants: and, as Leda, was the mother of Helen of Troy, and as Saint Anne, the mother of Mary. . . . The fancy of a perpetual life, sweeping together ten thousand experiences, is an old one; and modern philosophy has conceived the idea of humanity as wrought upon by, and summing up in itself, all modes of thought and life. Certainly Lady Lisa might stand as the embodiment of the old fancy, the symbol of the modern idea. (99)

The vampire analogy is meant to stand not for immortality but for death. The knowledge Mona Lisa includes in herself has not been acquired in centuries of attentive living, but through periodic descents into the grave, like those of that diver, she has also been in the deep seas. The manner whereby the vampire incorporates life into itself may also give pause; this "perpetual life," which may be "the symbol of the modern idea," sums up not only a range of lives but their deaths as well.[6] The language and themes present in this passage recur throughout Pater's work because of the importance in his thought of the idea of modernity as resurrection: each new event seen as a return. Every new birth carries some of the flavor of the grave and each death is not a complete break, but a temporary quiescence or exile before a return, which, when recognized, suggests that the apparently lost element had never really been entirely gone.

"The Old Way of True Renaissance": Homes and Cemeteries

It is impossible to describe the quiet death of Marius the Epicurean as an anticlimax, not merely because the carefully shaded modulations of thought and experience of the novel of which he is the protagonist are unlikely to yield typical narrative satisfactions, but also because death itself is no sudden dramatic occurrence, so much as the steady burden of the text. From his youth in a half-ruined villa, marked by one serious illness, the early death of his mother, and the even earlier loss of his father, to his adolescent friendship-romance with the ill-fated Flavian, mortality shadows every step of Marius's life. Like the plague brought to Italy from the wars, to which Flavian falls victim and which is the indirect cause of Marius's own demise, death weaves its way through the pageant of late antiquity. In the shapes of death with which it is marked late antiquity finds its meaning in *Marius*. The Goths on the periphery of the Roman Empire, and the plague within are the great historic threats under which the late Roman world has its existence. Pater recurs to the fate we know to expect: far from being a momentary crisis, the plague was "not to depart," he notes, "till it had done a large part in the formation of the melancholy picturesque of *modern* Italy."[7] Nothing is more remarkable in this narrative set at the historic moment that saw the rise

of Christianity at the end of the Roman Empire than the text's refusal to represent dramatic change. Death forms the backdrop against which Marius develops, so that his own demise is best understood as a falling back into a spiritual landscape from which he had barely emerged, rather than as a dramatic loss of individual presence.

The two principal homes in *Marius*—the villa of the protagonist and that of Cecilia, which is also a Christian church—are built over graveyards. Whereas in Marius's ancestral villa, however, the deaths that surround him are fruitless, or their fruit is the always almost dead Marius, Cecilia's home is the site of a rich syncretic culture at its beginning. It is a place of birth, and Cecilia herself is repeatedly identified as a figure of maternity. As Marius enters her house, Pater proposes a notable psychic reaction on his part: "one dominant thought increased upon him, the thought of chaste women and their children" (228). The beauty of Cecilia differs from that of a Greek statue only, but crucially, in that she is perpetually accompanied by children (233). Birth in Pater, however, in no way implies what is called a fresh start. Consider the architecture of Cecilia's home, which is characterized by "a noble taste" the nature of which Pater is at pains to describe:

> a taste, indeed, chiefly evidenced in the selection and juxtaposition of the material it had to deal with, consisting almost exclusively of the remains of older art, here arranged and harmonised with effects . . . so delicate as to seem really derivative from some finer intelligence in these matters than lay within the resources of the ancient world. It was the old way of true *Renaissance* . . . conceiving the new organism by no sudden and abrupt creation, but rather by the action of a new principle upon elements, all of which had in truth already lived and died many times. The fragments of older architecture, the mosaics, the spiral columns, the precious corner stones of immemorial building, had put on by such juxtaposition, a new and singular expressiveness, an air of grave thought, of an intellectual purpose, in itself, aesthetically very seductive. (227–28)

Elements "which had in truth already lived and died many times"—this echo from the description of the Mona Lisa, and the careful suggestion that what is being described is the "way of true Renaissance," invite us to put this passage not only against those of Ruskin discussed in the previous chapter, on the use of antique fragments in Lombard architecture, but also against Pater's own account of the Gioconda. The special beauty and seductiveness of the place arises from the fact that it is composed of fragments. The sensibility that went into the building was that of the collector; the taste of the assembler grants old materials a new birth. We see "grave thought" in this work, meaning at once serious reflection and thought built on and from the grave.

The resurrection or renaissance that characterizes the building is, of course, also descriptive of the spiritual content of Cecilia's home. It is typical as much of the insistently muted contrasts of the novel as of its symbolic use of space, that Marius should find an actual cemetery alongside this home. While it is an arrangement familiar to him from childhood, what he discovers inside these catacombs is new to him, a religion that treats death as a stage on the way to rebirth. It is part of the quiet attraction of Christianity for Marius's temperament that it *continues* his lifelong fascination with mortality, merely superadding the possibility of new birth or resurrection; in this new faith each martyrdom is a *natalitia*, a birthday (231). The resurrection promised by Christianity and that enacted by the materials making up the building in which it is housed are intimately connected. At Cecilia's home-catacomb the graves that hold those new-born into death are themselves sealed with fragments from the old faith pressed into what is not quite a new service, "marble taken, in some cases from older pagan tombs—the inscription sometimes a *palimpsest*, the new epitaph being woven into the faded letters of an earlier one" (230). As was the case in the rise of Greek art from the recombination of already existing elements by the compelling force of a new "mode of life," it is the informing spirit that brings about apparent change. Christianity, like all culture, is built over a grave. Nevertheless, just prior to his first experience of the mass Marius sees the classical fragments shining the brighter in the morning light, "all the details of form and colour in the old marbles were distinctly visible" (246). The dawn of this new religion does not dim, but rather highlights, the beauty of the old material in which it is housed and out of which it is formed.

What is the connection between this house and that other in which the entire novel takes place—"the beautiful house of art and thought which was the inheritance of the age" (121)? In the logic of the novel the relationship is as close as identity; it is all the same house, the same city, the same tomb—Rome: "that city of tombs, layer upon layer of dead things and people" (147). The imperial Rome Pater describes is worth seeing not for itself alone, but for its panoply of antiquities: "That old pagan world, of which Rome was the flower, had reached its perfection in the things of poetry and art.... As in some vast intellectual museum, all its manifold products were intact and in their places, and with custodians also still extant, duly qualified to appreciate and explain them" (132). The Christians, for all the dynamic excitement of their new faith, do not stand outside the museum of culture; their exceptionality resides in the creativity with which they reinvigorate the material they find around them. Though he identifies them as "new people," Pater immediately nuances the claim of originality, his elaboration working back on itself to the point of transforming novelty into renewal: "this new people," he

writes, "among whom so much of what Marius had valued most in the old world seemed to be under renewal and further promotion." The nascent religion leads its members to a cultural practice that is closer to the thought of the contemplative critic than to the passions of the religious convert: "Some transforming spirit was at work to harmonize contrasts, to deepen expression—a spirit which, in its dealing with the elements of ancient life was guided by a wonderful tact of selection, exclusion, juxtaposition, begetting thereby a unique effect of freshness" (239). The "tactful" work of early Christianity is described in the very same terms as Pater used to describe that of the builders of Cecilia's home, and it is precisely the work of organizing within a crowded museum—selecting, excluding, juxtaposing—that is at issue in both instances. Even Christian communion is "not so much new matter as a new spirit, moulding, informing, with a new intention, many observances not witnessed for the first time today" (249).

Pater is clear that, for all its antiquarian detail, the topic of *Marius* is the shape of modernity. He apologizes as a form of emphasis: "that age and our own have much in common—many difficulties and hopes, let the reader pardon me if here and there I seem to be passing from Marius to his modern representative—from Rome, to Paris or London" (181). The following description shows late antiquity to be at one with the contemporary world depicted in the "Conclusion" of *The Renaissance*: "that age of Marcus Aurelius, so completely disabused of the metaphysical ambition to pass beyond 'the flaming ramparts of the world,' but, on the other hand, possessed of so vast an accumulation of intellectual treasure, with so wide a view before it over all varieties of what is powerful or attractive in man and his works" (*Marius*, 116–17). Pater limns a world not only characterized by a skeptical resistance to "metaphysical ambition," but further related to modernity in its access to an overwhelmingly wide and heterogeneous range of culture, "an age with the whole world of classic art and poetry outspread before it, and where there was more than eye or ear could well take in" (113). The action of the novel takes place, as he notes in a formulation so apt he uses it twice in the same paragraph, in "a world almost too opulent in what was old . . . a world, confessedly so opulent in what was old" (120).

Given the resistance to absolute historical breaks Pater openly declares throughout his work and demonstrates so extravagantly in *Marius* by means of the continuities he identifies between nineteenth-century Europe and late antiquity, it should come as no surprise that his treatment of the effect of Christianity on art quietly but absolutely rewrites Ruskin. Much as in *The Renaissance* the inception of the historical Renaissance is placed deep in the Middle Ages so as to negate the sort of "trenchant divisions" Ruskin was prone to making, in *Marius* the birth of Christian

art is no new beginning, but a continuation.[8] "The Gothic style of architecture," that great natural product of medievalism in *The Stones of Venice*, is for Pater "one of the great conjoint . . . products of the human mind" (243). Not the spontaneous creation of the individual genius of the northern craftsman, it represents a collaboration of classical culture and Christian religion. Architecture in *Marius* is concrete evidence for Pater's quiet polemic on the topic of cultural change and continuity. He is fascinated as much by the conversion—not destruction—of preexistent temples by the early Christians as by the emergence of the liturgy of the church from a synthesis of the texts of Judaism and the Greek and Latin languages. It is a process he describes with a symbolically preposterous cultural history: "As if in anticipation of the sixteenth century, the church was becoming 'humanistic,' in an earlier and unimpeachable *Renaissance*" (243).

"Strange Pregnancies"

Whereas recent critics have, not without reason, focused on the sexual suggestiveness in his treatment of Leonardo, Pater himself was as intrigued by what he describes in *Greek Studies* as that artist's "sensitive expression of the sentiment of maternity."[9] He has in mind, no doubt, the well-known representations of Mary, Christ, and Saint Anne in Paris and London—works bearing a redoubled image of motherhood, the Madonna and Child along with the Virgin's own parent. Nevertheless, given his challenge to simple accounts of originality, it is worth considering Pater's sensitivity to the sentiment of maternity generally and in his treatment of Leonardo in particular. In *The Renaissance*, Pater presents the Mona Lisa as an image of a modernity weary because it absorbs all the past, and yet the two prior incarnations he proposes for her are Leda and Saint Anne ("as Leda, was the mother of Helen of Troy, and as Saint Anne, the mother of Mary" [99]). The question to ask is why the Gioconda, in all her glory, is neither Helen nor Mary herself.

Gestation intrigues Pater for two closely related reasons: it represents for him the working of preexistent material into a new form, and—particularly in cases of divinities procreating with humans—the presence of a new informing spirit in matter. As such, it provides a compelling figure for the emergence of new cultural forms. Saint Anne, Leda, and even Psyche, whose story is told in the longest chapter of *Marius*, are all inseminated by gods. Indeed, Psyche undergoes her ordeal as a child gestates in her womb. Her allegory at its simplest level is the story of humanity desiring to know *directly* a divinity whose character—whether monstrous or beautiful—will only be revealed by its manifestation in a half-human shape.[10] Psyche speaks of her hope of at least seeing Cu-

pid's face mirrored in that of their child (86), but it is her unwilling-
ness to wait on the mystery of what is in her womb that drives her initial
catastrophe.

The complex and dangerous interpenetration of the human with the
divine is figured not only in reference to the various classical loves of the
gods but also in Christianity's own singular version of this relationship.
Pater's interpretation of Botticelli's Madonnas is central to his important
revaluation of that painter and it allows his surprising (and self-
consciously provocative) proposal that they hold a charm beyond any
painted by Michelangelo or Fra Angelico.[11] He presents as at once "vi-
sionary" and "realist" Botticelli's depiction of what in Pater's mind is a
supremely indifferent mother of God: "she too, though she holds in her
hands the 'Desire of all nations,' is one of those who are neither for
Jehovah nor for His enemies; and her choice is on her face" (*Renaissance*,
44). Pater's extraordinary idea—Mary as a reluctant participant in her
own destiny, indifferent to its outcome—serves to draw attention to the
difficult interplay between human and divine in this relationship. His
reading of the *Madonna of the Magnificat* is particularly grim (fig. 49):
"Once, indeed, he guides her hand to transcribe in a book the words of
her exaltation, the *Ave*, and the *Magnificat*, and the *Gaude Maria*. . . . But
the pen almost drops from her hand, and the high cold words have no
meaning for her" (44–45). It is a disturbing interpretation of the painting
by which, among other effects, Pater underlines the complexity of the
relationship of Christ to his mother, which is in fact implicit in the work.
He takes His mother's hand as she writes her own song of praise because
it is He who had these very words spoken by His messenger prior to
effecting the conception which they celebrate—His own. The Christ on
Mary's lap is the same god who wrote her destiny on her flesh. The
power being manifested in the act of inscribing is that of the god holding
her hand, not of the ostensible writer.

Pregnancy is not limited to mothers in *The Renaissance*. It recurs at
suggestive moments in the essay on Winckelmann, as at the very opening
of the piece: "Goethe's fragments of art criticism contain a few pages of
strange pregnancy on the character of Winckelmann. He speaks of the
teacher who had made his career possible, but whom he had never seen,
as of an abstract type of culture" (141). The apparently fanciful notion of
Winckelmann as Cupid to Goethe's Psyche—the wandering figure of
creativity inseminated and set in motion by the encounter with a superior
being he has never seen—is given some support by the return of the
word later in the essay, in the description of Goethe's early culture,
which would have gained so much from meeting Winckelmann in "the
pregnancy of his wonderful youth" (157). Pregnancy in these instances is
about potential, and about rich anticipation provoked by the encounter

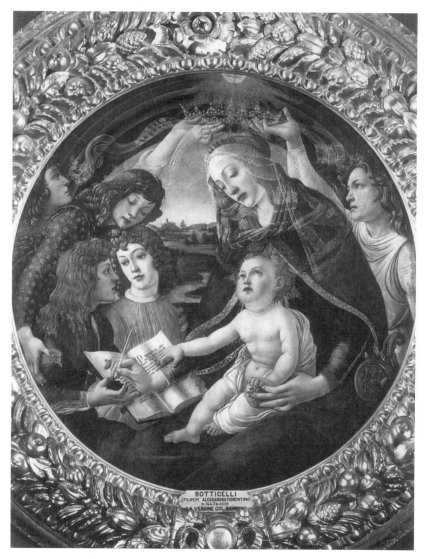

Fig. 49. Botticelli, *Madonna of the Magnificat*, before 1490. Florence, Uffizi.

with a distant source. It is odd, given the proliferation of pregnancy in his writings, that in the same essay Pater offers the following (unattributed) paraphrase from Hegel's *Aesthetics*: "There is no Greek Madonna; the goddesses are always childless" (173).[12] It is an exaggeration contradicted by Pater's own interest in Demeter and Persephone, Venus and Cupid, so why make it here?

Greek sculpture is complete, self-contained, but it holds the seeds of further developments—these are its virtues and its limits as Pater sees them, following Hegel in this early essay—hence the terms by which he describes the frieze of horsemen of the Elgin Marbles as an epitome of classical values, terms he would substantially qualify in later years: "This colourless, unclassified purity of life, with its blending and interpenetration of intellectual, spiritual, and physical elements, still folded together, *pregnant* with the possibilities of a whole world closed within it, is the highest expression of the indifference which lies beyond all that is relative or partial" (174; my emphasis). If the goddesses are childless, it is because Greek art is an ideal that is at once closed off and separate from the contingent and pregnant with a new potential it cannot in itself reveal. The classical is an ideal, but one that can no longer satisfy modernity, an idea expressed in language evocative of the description of the Gioconda. "The presence that rose thus so strangely beside the waters" has its power because it is "expressive of what in the ways of a thousand years men *had come to desire.*" In Pater's careful historicizing, the simpler beauty of an earlier time cannot satisfy present human desires. Art in modernity is engaged with problems that "could no longer be solved, as in Phryne ascending naked out of the water, by perfection of bodily form" (182). The female form rising from the water is a Venusean manifestation of desire, but even the goddess of love in all her glory is inadequate; the beauty of the *Venus de Milo*, in Pater's telling, "is in no sense a symbol, a suggestion, of anything beyond its own victorious fairness" (164). Neither the simple compulsion of Phyrne's perfection, which was argument enough to absolve her of the imputation of crime, nor the triumphant beauty of a goddess can satisfy the desires of modernity. "The road to perfection is through a series of disgusts," writes Pater, summing up Leonardo's drive to move beyond the polished manner he achieved as a student of Verrochio (81). In an argument that owes much to Ruskin's on finish, Pater makes Leonardo's notorious inability to bring his projects to fruition a sign of his ever questing imagination.[13] While the classical ideal offers a perfection ignorant of what modernity knows, the Mona Lisa is the pictorial embodiment of a spirit that knows too much to expect satisfaction.

"Not the Judgment but the Resurrection"

The treatment of Michelangelo in *The Renaissance* goes to great lengths to engage the theme of rebirth, to read the artist's achievement as thematizing the attempt to give creative life to dead material. Pater begins in "Lucca della Robbia," by proposing that sculpture may be the art form in which it is most difficult to manifest the ideal. The solution he pro-

poses is on the one hand the aesthetic of the ruin—the eroded beauty of the Venus de Milo, time "fraying its lines, so that some spirit in the thing seems always on the point of breaking out" (53)—and on the other what he describes as the intentional incompleteness of Michelangelo's works.[14] In "The Poetry of Michelangelo," the same issue returns, not in relation to the material condition of the work—its lack of finish, its decay—but in the nature of the subject represented: "This creation of life—life coming always as relief or recovery . . . is in various ways the motive of all his work. . . . Not the Judgment but the Resurrection is the real subject of his last work in the Sistine Chapel; and his favourite pagan subject is the legend of Leda, the delight of the world breaking from the egg of a bird" (59). Typically, Pater's commitment to an idea is demonstrated by an evident exaggeration. The painting on the west wall of the Sistine Chapel is only not the Last Judgment if we ignore the looming figure of Christ at the heart of the image, exalting saints and condemning sinners. The central moment of Michelangelo's oeuvre and the chapel itself—the creation of Adam—receives similar treatment. This *making* of the first man, rather than being, as one would imagine, "the first and unique act," is a rebirth from death: "With him the beginning of life has all the characteristics of resurrection" (59). As with Cecilia's home, or Christianity itself, a new beginning is always a rebirth. Like Ruskin—though drawing directly on Hegel—Pater identifies the aesthetic qualities of "balance and completeness" of Greek work with "the sentiment of self-contained, independent life" of that culture (59). The life that interests Pater is not self-contained any more than is the story of Leda, or of the egg that gives birth to Helen and results in the Trojan War, that ever ramifying event. There is no egg in any of Michelangelo's major representations of Leda and the Swan, but Pater needs to find language in which to insist, as Yeats will after him, on the importance of that copulation, a fulcrum with the divine on one side and human history on the other.

Leonardo's Deaths

Birth is limited in its claims to originality because death itself does not entirely mark an ending. The treatment of Leonardo in *The Renaissance* draws on two cultural facts: one is the preoccupation with his death in the nineteenth century, and the other is the decimation of his oeuvre by the critical methods of a newly stringent art history. In response to the latter development, Pater offers an erotics of influence closely related to that motivating his account of Botticelli's *Madonna of the Magnificat*. The artist's relationship to death, however, serves Pater best in his development of the darker implications of his vision of culture. The representation of Old Masters in painting was an important phenomenon through-

out the century. The source for all representations of Leonardo's death is ultimately Vasari's rich account.[15] The "legend" of the painter's death is rich in dramatic reversals: a skeptic coming to faith, regret over past doubt expressed as shame that his finished achievements did not live up to his gifts, the honor of the king's presence at the bedside of an artist of illegitimate birth. Leonardo typically was shown at the moment of his demise, generally expiring in the arms of Francis I (an emblem of the new social rank of the artist) or sometimes calling for the Host (the speculative artist returning to his faith). Ultimately, however, Pater denies the value of Leonardo's religious faith and of the attentions of Francis I: "They are of about equally little importance in the estimate of Leonardo's genius. . . . We forget them in speculating how one who had always been so desirous of beauty, but desired it always in such precise and definite forms, as hands or flowers or hair, looked forward now into the vague land, and experienced the last curiosity" (101). Pater does not need the melodramatic presence of a king to validate the artist, and the idea of a repentant Leonardo is altogether foreign to his image of the endlessly speculating modern mind. What is of interest to Pater is the artist's relationship to his own imagination of death; this is as much the critic's own "last curiosity" as Leonardo's.

Pater's description of the *Medusa*, a work by another hand attributed to Leonardo in the nineteenth century, presents it as a more macabre *Mona Lisa*: "The subject has been treated in various ways; Leonardo alone cuts to its centre; he alone realizes it as the head of a corpse, exercising its powers through all the circumstances of death" (83).[16] What Pater means by the power of death is the question behind his essay on Leonardo. In a passage clearly responding to the *Medusa*, Pater writes of Leonardo's participation in a science "seeking in an instant of vision to concentrate a thousand experiences" (83). The symbol of this quest will ultimately be the *Mona Lisa*—the number is echoed in her description because the same meaning is intended: "The presence that rose thus so strangely beside the waters, is expressive of what in the ways of *a thousand years* men had come to desire." Read as a Medusa, the *Mona Lisa* is not only dead, but potentially dangerous for the viewer. Whereas in Michelangelo each birth was a resurrection, in Leonardo the aggregated result of the coming together of all lives is a death. Whereas Michelangelo's Adam was life elicited from rocks—"the first and unique act, the creation of life itself in its supreme form . . . in the cold and lifeless stone," "life coming always as relief or recovery, and always in strong contrast with the rough hewn mass in which it is kindled" (58, 59)—the *Mona Lisa* is older than the rocks among which she sits and her sister, the Medusa, is herself a petrifying vision. As a grimmer version of the *Mona Lisa*, the *Medusa* becomes an image for

the uncanny terror that will accompany descents into the grave even if they are understood to precede resurrection.

"Dreams of Buried Treasure"

Of all of Pater's quiet challenges to standard historical limits, none is quieter yet more striking than the mere fact of his inclusion of Winckelmann in *The Renaissance*. What is this eighteenth-century student of classical art doing in a collection of Renaissance studies? Winckelmann is the subject of the longest of the essays that make up *The Renaissance*, a piece that (when originally printed in the *Westminster Review* in 1867) was only Pater's second published work. In its pages Pater develops an account of the critic much along the lines of his description of the artist in the rest of *The Renaissance*, but with an added personal urgency. Indeed, Winckelmann sometimes shares characteristics with artists (Pater writes of "that true artist's life of Winckelmann in Italy" [151]), sometimes with art *objects*. Goethe, who is in a triangulated relation with Pater and Winckelmann in the essay, is said to have classed Winckelmann with certain works of art "possessing an inexhaustible gift of suggestion" (141). Later, the art historian's influence on Goethe is like that of "a fragment of Greek art itself, stranded on that littered, indeterminate shore of Germany in the eighteenth century" (182). In the following passage Winckelmann becomes a more abstract version of the Mona Lisa: "he seems to realise that fancy of the reminiscence of a forgotten knowledge hidden for a time in the mind itself; as if the mind of one, lover and philosopher at once in some phase of pre-existence . . . fallen into a new cycle, were beginning its intellectual career over again, yet with a certain power of anticipating its results" (155). This is not the place to trace the confessional currents that run through Pater's account of the scholar finding sensual and intellectual freedom in his studies, but, much as the word "culture" has a personal as well as a wider meaning in this essay, the personal rebirth that Winckelmann experiences in the south is related to the rebirth of the classical spirit in modernity.

Pater's theme is a characteristic one, that which remains alive though buried, the once dead reborn: "The spiritual forces of the past, which have prompted and informed the culture of a succeeding age, live, indeed, within that culture, but with an absorbed, underground life" (158). Much of the complexity of this difficult essay, however, is due to the fact that, although Pater does not believe that previous cultural moments entirely pass away, and he is intrigued by their subterranean life, he sees that the classical also has a self-conscious, artificially maintained, tradition: "Hellenism is not merely an absorbed element in our intellectual life; it is a conscious tradition in it" (158). The argument Pater will make

in *Marius*—that Christian art never entirely shed its classical past—is already present in "Winckelmann," expressed in similar terms. But "Winckelmann" has its own emphasis, the pleasures of recovering past culture. The images Pater chooses weave together the vampire's descents into the grave with those of the archaeologist. The pure experience of the ideal—associated with the art of classical antiquity—is insufficient for modernity and, in any case, it is unreachable. Nevertheless, the opening of graves has its own pleasures. It would remain a favorite motif, recurring with remarkable (even obsessive) frequency in his Imaginary Portraits."[17] In "Winckelmann" mourning for a lost Greek ideal is wrong because it is a pleasure to dig up its cadaver—"the deep joy was in store for the spirit, of finding the ideal of that youth still red with life in the grave" (167).[18] Winckelmann's own nature is "itself like a relic of classical antiquity, laid open by accident to our alien, modern atmosphere" (175). Pater's theme is the exhumation of those classical elements which *Marius* will show being buried in Christianity. When culture was ready to move away from the grimness of medieval art, "there came also an aspiration towards that lost antique art, some relics of which Christian art had buried in itself, ready to work wonders when their day came" (180).

Into the trenchant division Ruskin and others had opened between the Middle Ages and the rebirth of classical culture in the Renaissance, Pater throws the rubble of his opened tombs. His contention is not that there were no elements in Christianity denying this connection, but that Christian attempts at denial are part of an ascetic urge to keep covered the dangerous matter interred beneath the foundations of their faith: "there is a sense in which it may be said that the Renaissance was an uninterrupted effort of the middle age, that it was ever taking place. When the actual relics of the antique were restored to the world, in the view of the Christian ascetic it was as if an ancient plague-pit had been opened" (180). By identifying asceticism as that urge within Christianity which denies the influence of the classical, Pater can propose the return to the antique as a counterurge also always present in Christian culture. Rather than the schism between classical sensuality and true religion that was insisted on by midcentury Christian writers, Pater insists on the co-existence of two conflicting drives. The risk of infection is not due to a foreign body intruding into a hitherto safe environment, but to the reopening of a contaminated site that had been only temporarily closed.

"A Strange Inverted Home-Sickness"

Pater's preoccupation with mortality is evidently more than a decadent affectation. He is particularly sensitive to the challenges of a nineteenth century motivated by various forms of historically configured desires in

art yet confronted by ever more troubling theories of human develop-
ment. Thus, in "Poems by William Morris," the early text he later canni-
balized for the Conclusion of *The Renaissance* and for his essay, "Aesthetic
Poetry," the critic is concerned to outline the limits of the accessibility of
the past:

> In handling a subject of Greek legend, anything in the way of an actual
> revival must always be impossible. Such vain antiquarianism is a waste of the
> poet's power. The composite experience of all the ages is part of each one of us;
> to deduct from that experience, to obliterate any part of it, to come face to face
> with the people of a past age, as if the middle age, the Renaissance, the eigh-
> teenth century had not been, is as impossible as to become a little child, or
> enter again into the womb and be born.[19]

Paradoxically, our actual, inescapable, *preexistent* relationship to our pasts
makes a simple antiquarianism impossible.[20] The nineteenth century's
manifold historicizing desires are bound to frustration if their aim is re-
vival, not because we are so distant from the past, but because it is so
intimately a part of us, there is so much of it, and it is all unerasable.[21]

Not only is a new birth into a preferred past impossible, but, as we
have seen, death itself is intimately linked to creation. The praise Pater
concedes to the kind of historical revival actually carried out by Morris is
that it captures "one characteristic of the pagan spirit . . . the sense of
death and the desire of beauty; the desire of beauty quickened by the
sense of death" (309). This paradoxical link is not unique to Morris.
Consider the easy motion between creativity and death in the opening
of the surprising last paragraph of the Conclusion to *The Renaissance*
(transcribed almost verbatim from "The Poems of William Morris"):
"One of the most beautiful passages of Rousseau is that in the sixth book
of the *Confessions*, where he describes the awakening in him of the literary
sense. An undefinable taint of death had clung always about him, and
now in early manhood he believed himself smitten by mortal disease"
(190). Creativity requires a looming awareness of mortality. The specter
of death is a muse for Rousseau, as it is for Morris and his pagan models.
I have already noted the remarkable interweaving of home and grave in
Marius. In Pater's earlier work the same connection is established
through the reiteration of an unusual phrase. In "Winckelmann" he links
pagan religion to a premonitory sadness for the loss of the world in
death: "It is with a rush of home-sickness that the thought of death pre-
sents itself" (160). The obvious parallel between idea and biographical
fact is to be found in Winckelmann's reluctant departure from Rome on
the ill-fated journey in which he would meet his end: "as he left Rome, a
strange inverted home-sickness, a strange reluctance to leave it at all,
came over him" (156). As noted, the central theme of "The Poems of

William Morris," published only a year after "Winckelmann," is the powers and limits of historical revivals. The charm that Pater identifies in Morris's work is that it is "neither a mere reproduction of Greek or mediæval life nor poetry, nor a disguised reflex of modern poetry" (300). His terms of praise are striking: "Like some strange second flowering after date, it renews on a more delicate type the poetry of a past age, but must not be confounded with it. The secret of the enjoyment of it is that inversion of home-sickness known to some, that incurable thirst for the sense of escape, which no actual form of life satisfies" (300–301). From an account of a more sensitive use of the past Pater veers into that "inversion" of homesickness which is at once an attraction *to* death and *from* the verge of death toward the life being lost, truly "the desire of beauty quickened by the sense of death." In describing Pater's "Imaginary Portraits" as never quite realized dreams of wish fulfillment, Harold Bloom catches something of the flavor of the critic's complex fantasies, which often seem to be in love with their own frustrations.[22] The other pole of the figure of home—the place where one finds and leaves one's dead—is the figure of the wanderer. At the conclusion of his story, Marius returns to his long-deserted family villa merely to take formal leave of it by burying the family grave plot. It is a loving act, which at once erases and protects the site. Marius dies on the road, as do Abelard and Winckelmann. Michelangelo is born there, while all of Leonardo's life is spent in rootless motion. Homesickness, together with its inversion, amounts to the desire for a home alongside the fear of what it might mean to be at rest.

The Seeds of the Pomegranate

Wandering, birth, and death—by the intertwining use of these motifs Pater writes a complex account of origins. I have noted how archaeology plays an emblematic role in Pater's treatment of the apparent loss and recovery of culture. "The Myth of Demeter and Persephone" (1876) allows him to engage a central story of death and rebirth while responding directly to recent archaeological discoveries. Near the beginning of this chapter I mentioned the oddity of Stoker borrowing the name of Demeter for a ship of the undead. I offer the following in partial explanation. One part of the growing sophistication in the understanding of Greek culture represented in the work of Pater was the new emphasis given to the violent, irrational, dark side of the gods of antiquity.[23] Pater is particularly sensitive to the complex, even contradictory, significance that Greek culture could ascribe to its gods, what he calls "the two faces of the Greek religion" (*Greek Studies*, 142).[24] It is in the duality of these deities that Pater locates their significance, hence the complexity of his treatment of the two sides of the myth of Persephone:

The main theme, then, the most characteristic peculiarities, of the story, as subsequently developed, are not to be found in Homer. We have in him, on the one hand, Demeter, as the perfectly fresh and blithe goddess of the fields, whose children, if she has them, must be as the perfectly discreet and peaceful Kore; on the other hand, we have Persephone, as the wholly terrible goddess of death, who brings to Ulysses the querulous shadow of the dead, and who has the head of the gorgon Medusa in her keeping. And it is only when these two contrasted images have been brought into intimate relationship, only when Kore and Persephone have been identified, that the true mythology of Demeter begins. (94)

The last claim demonstrates the richness of Pater's account of myth in general and of this one in particular. In Homer the significance of the myth is lost because its two faces are kept apart; it is precisely in bringing together fertility and death that the myth has its meaning. Not only are the two versions of Persephone connected, but at an early stage in the development of the myth even the mother and the daughter "are almost interchangeable" (108)–hence Pater's interest in noting that Demeter herself "is the goddess of dark caves, and is not wholly free from monstrous form" (102).

Pater is emphatic on the significance of this myth: Demeter and Persephone "embodied, in adequate symbols" man's "deepest thoughts concerning the conditions of his physical and spiritual life" (276). The later part of his essay is devoted to an analysis of the statues from Cnidus that had been brought to the British Museum twenty years earlier. I close my discussion of Pater with an account of his attempt to read these works by the light of the new comparative mythology. In no way a departure from the concerns we have seen in *Marius* and *The Renaissance*, his treatment of the statues allows Pater to address the interweaving of death and rebirth evident even in earliest antiquity.

The three statues recovered from Cnidus (figs. 50, 51, 52) are identified by Pater, following Newton, as "Persephone as goddess of the dead," "Demeter enthroned," and "probably a portrait statue of a priestess of Demeter who may perhaps, even so, represent Demeter herself" (144). In other words, the group offers two representations of Demeter and one of Persephone, who is of course also a manifestation of her own mother. Identifying the third statue (fig. 52) as perhaps a mourning Demeter allows Pater to transmute her into a sorrowful Mary, "the *mater dolorosa* of the Greeks, a type not as yet recognised in any other work of ancient art" (145). We have seen this contradiction before, the mother as somehow not at home within traditional views of classical antiquity. Like Cecilia, this mourning Demeter features the beauty of antiquity with the added modern touch of motherhood. Even the accidents of time conspire to

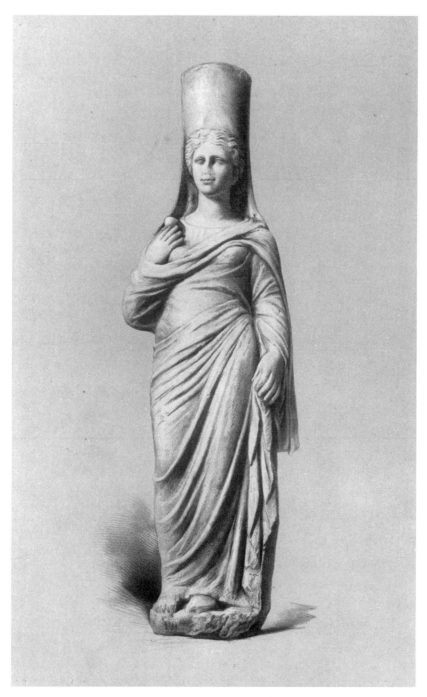

Fig. 50. "Persephone as goddess of the dead." Charles Thomas Newton, *A History of Discoveries at Halicarnassus, Cnidus, & Branchidae*, vol. 1 (London, 1862).

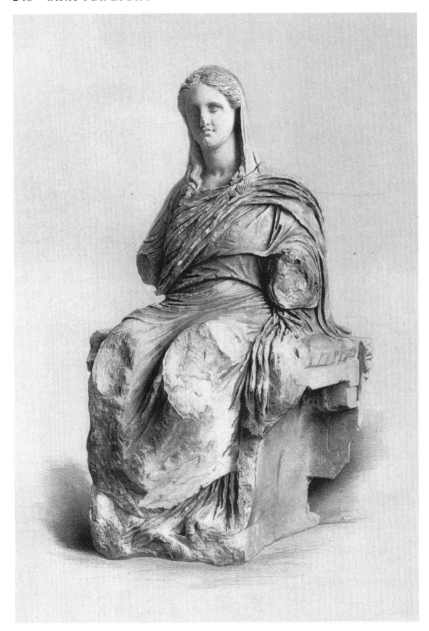

Fig. 51. "Demeter enthroned." Charles Thomas Newton, *A History of Discoveries at Halicarnassus, Cnidus, & Branchidae*, vol. 1 (London, 1862).

Fig. 52. "Probably a portrait statue of a priestess of Demeter who may perhaps, even so, represent Demeter herself." Charles Thomas Newton, *A History of Discoveries at Halicarnassus, Cnidus, & Branchidae*, vol. 1 (London, 1862).

make this statue a version of a Madonna: "There is something of the pity of Michelangelo's *mater dolorosa* [*pietà*], in the wasted form and the marred countenance" (145).[25] If the Elgin Marbles were pregnant, this statue has given birth. As was the case with Psyche, this is a mother undergoing elaborate travails: "If Demeter at all, it is Demeter the seeker . . . in some pause of her restless wandering over the world in search of the lost child, and become at last an abstract type of the wanderer" (145).

At once a bereft homeless wanderer and a mother, the resolution of Demeter's suffering, like that of Psyche's, will come only through a descent into the underworld. Pater is insistent on the identification of Demeter as mother. When he turns his attention to the principal statue of the group (fig. 51), she is in every way a figure of maternity:

> She is represented in her later state of reconciliation, enthroned as the glorified mother of all things. The delicate plaiting of the tunic about the throat, the formal curling of the hair, and a certain weight of overthoughtfulness in the brows, recall the manner of Lionardo [*sic*], a master, one of whose characteristics is a very sensitive expression of the sentiment of maternity. I am reminded especially of a work by one of his scholars, the *Virgin of the Balances*, . . . a picture which has been thought to represent, under a veil, the blessing of universal nature, and in which the sleepy-looking heads, with a peculiar grace and refinement of somewhat advanced life in them, have just this half-weary posture.

Not just any mother, but the mother of all things, not merely reminiscent of a Leonardo, but of a Leonardo who is a master of maternal sentiment—surely this account of Demeter is an overdetermined representation. And not only Christian mothers are evoked, as the passage continues:

> We see here, then, the Hera of the world below, the Stygian Juno, the chief of those Elysian matrons who come crowding, in the poem of Claudian, to the marriage toilet of Proserpine, the goddess of the fertility of the earth and of all creatures, *but still of fertility as arisen out of death*; and therefore she is not without a certain pensiveness, having seen the seed fall into the ground and die many times. Persephone has returned to her, and the hair spreads like a rich harvest over her shoulders; but she is still veiled, and knows that the seed must fall into the ground again, and Persephone descend again from her. (147–48; my emphasis)

If Michelangelo's mournful Mary was Pater's first analogy for the seated Demeter, the later references to Leonardo and to those heads weary from the advance of life evoke the Mona Lisa. The Gioconda echoes turn on patterns of resurrection and death, resurrection requiring a death.

The statue of Persephone is smaller in every way. Rather than mourn-

ing a loss or celebrating a return as her mother does, she is at once at peace and dead: "She is compact of sleep, and death, and flowers, but of narcotic flowers especially,—a *revenant*, who in the garden of Aidoneus has eaten of the pomegranate, and bears always the secret of decay in her, of return to the grave, in the mystery of those swallowed seeds" (148). This is decadent enervation and a perpetual self-betrayal into the grave. As Pater goes on to indicate, the seeds of the pomegranate—the consumption of which binds Persephone to perpetual infernal returns—are emblems of fertility. Kore, the maiden, and Persephone, goddess of the underworld, come together here—her engagement with fecundity fates her to yearly descents to death, her other home. Pater identifies the object in her hand as

> probably the partly consumed pomegranate—one morsel gone; the most usual emblem of Persephone being this mystical fruit, which because of the multitude of its seeds was to the Romans a symbol of fecundity, and was sold at the doors of the temples of Ceres, that the women might offer it there, and bear numerous children; and so, to the middle age, became a symbol of the fruitful earth itself; and then of that other seed sown in the dark underworld; and at last of that whole hidden region, so thickly sown, . . . Botticelli putting it into the childish hands of Him, who, if men go down into hell, is there also. (276)

The last reference is to the *Madonna of the Magnificat*, discussed earlier. In that painting, the right hand of the Virgin writes, while that of the child holds her wrist. Their left hands, however, meet at a fruit in Christ's lap. Reading back from Pater's treatment of these statues, we are invited once again to experience the paradoxical creativity of the Virgin, and perhaps to see her as yet another version of Persephone, unasked, reluctant, bride of divinity. The elements of a mysterious underworld which is at once death and the promise of resurrection meet at the lap of the Savior—suggesting the link between mortality and reproduction, death and origins, that motivated Pater and allowed him to illustrate with historical models a condition he recognized as inescapably modern.

"A Pomegranate Cut with a Knife of Ivory"

> In a world, confessedly so opulent in what was old, the work even of genius, must necessarily consist very much in criticism.
> *Marius*, 120

That the figure of death is so prevalent in the nineteenth-century culture of art is less surprising than that the role it fills is so fruitful. For writers of the second half of the century death serves two closely related yet antithetical functions: it can be understood as a prelude to resurrection or as something that might well be understood as its opposite, the finite point that is longed for in response to excess. Persephone is the final figure Wilde himself offers for the critic at the close of "The Critic as Artist," a calmly contemplative goddess at peace with the fate that frightens mortals, her contemplative nature and her peace shaped by the recognition of death as a stage before rebirth (1058). Indeed, images of death and resurrection are never far from Wilde's discussion of the critical project, particularly when his interest is demonstrating its historical necessity. As it is for Pater, the critical impulse is for Wilde an unavoidable manifestation of modernity, arising at the moment when the range of choices the museum world puts before us is recognized. Modernity, criticism, and the realization of an inescapable inheritance are inextricably intertwined in a passage I have already cited in part: "It seems to me that with the development of the critical spirit we shall be able to realise, not merely our own lives, but the collective life of the race, and so to make ourselves absolutely modern, in the true meaning of the word modernity." The critical project is not optional; it offers the only way to be truly self-consciously modern: "he to whom the present is the only thing that is present, knows nothing of the age in which he lives. To realise the nineteenth century, one must realise every century that preceded it and that has contributed to its making. To know anything about oneself one must know all about others. There must be no mood with which one cannot sympathise, no dead mode of life that one cannot make alive" (1040).

Ruskin himself prefigured not only the realization of the power revealed in reborn art, but the special pleasure of its discovery. "I do not know any sensation more exquisite," he writes in the "Lamp of Life" chapter of *The Seven Lamps of Architecture*, "than the discovery of the evidence of this magnificent struggle into existence; detection of the borrowed thoughts, nay, the finding of the actual blocks and stones carved by other hands and in other ages, wrought into new walls, with a new expression and purpose given them" (8:195). We hear the effects of a similar sensibility at work in Marius's response to Cecilia's home: "Some transforming spirit was at work to harmonize contrasts, to deepen expression—a spirit which, in its dealing with the elements of ancient life was guided by a wonderful tact of selection, exclusion, juxtaposition, begetting thereby a unique effect of freshness" (*Marius*, 239). Wilde gives a name to the creative sensibility or tact Ruskin and Pater had admired; he recognizes the handling of earlier work by Gothic or early Christian art-

ists as a version of that *critical* tact which is the inheritance of modernity. Not only is it the case that "that spirit of choice, that subtle tact of omission, is really the critical faculty in one of its most characteristic moods," Gilbert argues in "The Critic as Artist," but "no one who does not possess this critical faculty can create anything at all in art" (1020).

Like both Pater and Ruskin, Wilde stretches the limits of the modern in his instances, finding the qualities he identifies as inescapable in the nineteenth century already present in earlier eras. Adding his typical emphasis to Pater's reserve, Wilde challenges the historic fantasies that for so long had shaped the appreciation of art. From "The Rise of Historical Criticism," his earliest essay, to "The Critic as Artist," his most fully formed, Wilde is consistent: the critical project has always accompanied creative work; criticism existed even alongside the art of the Greeks, "a nation of art critics" (1015). For all his self-consciousness about the modern situation, Wilde at every point rebuts that influential line of thought which had validated itself in relation to a now lost precritical era. Ernest's long lyrical attempt to evoke such a time is quite correctly identified by Gilbert as not merely unsound, but as an indication that his interlocutor has been giving in to the dangerous temptation of listening to the conversation of his elders (1013–15). "Our historical sense is at fault," notes Gilbert, when we invent a Parnassus in order to mourn the loss of the unselfconscious creativity it represents. At such moments, "we are merely lending to other ages what we desire, or think we desire, for our own" (1020).

Wilde boldly clarifies the necessary link between heredity and criticism suggested in Pater when in response to Ernest's query (provoked by a particularly long Darwinian excursus on Gilbert's part), "But where in this is the function of the critical spirit?" Gilbert answers, "The culture that this transmission of racial experiences makes possible can be made perfect by the critical spirit alone, and indeed may be said to be one with it. For who is the true critic but he who bears within himself the dreams and ideas, and feelings of myriad generations, and to whom no form of thought is alien, no emotional impulse obscure?" (1041). The language of Pater's description of the *Mona Lisa* runs through this passage because the critical spirit arises with the recognition of the inescapable force of transmitted experience in culture, a force of which she was the perfect embodiment. Nevertheless, against the view of culture as inheritance and criticism as a fate that can be denied but not avoided, there is another sense of what death may mean. The Gioconda makes periodic descents into the grave, and Persephone, of course, is not always at peace.

Whereas Pater tends to the elegiac even at his most scandalous, Wilde has access to modes of writing that allow him to dramatize the power of death, to show the danger along with the erotic charge of "that imagina-

tive plane of art where Love can indeed find in Death its rich fulfillment"
(1045). In the opulence of late antiquity, in its self-conscious engagement
with world culture, Wilde, like Pater, found a useful analogue for the
contemporary situation. The period that saw the emergence of Chris-
tianity out of the manifold fragments of late antiquity fascinated both
men because it was a cultural moment of transition into a form of asceti-
cism that in turn attempted to deny the value of the culture out of whose
very elements its own practices and ideas had been built. As the vital
point of exchange between classical culture and later periods, late antiq-
uity also offered a challenge to simpler forms of historicism. It had been
neglected (and frequently despised) by admirers of ideal classical art—
hence the tendentious nature of Gilbert's insistence on the sources of
modern culture in Alexandria, not Athens: his account of the transmis-
sion of classical elements via *Latin* culture is a story of renaissance that
undoes another of the nostalgic claims of links to an original Greece that
had been so important for earlier writers (1021). It did not hurt, of
course, that late antiquity had traditionally been understood as a period
of cultural decay and moral corruption. Bringing the moral and the cul-
tural associations of late antiquity to bear together in *Salome* (1893) al-
lows Wilde to make explicit what Pater had hinted at in *Marius*: the
ascetic impulse, the drive away from life and the negation of experience
may well be identifiable as itself a response to excess, the symmetrical
opposite to luxury. The elaborated excesses and simple brutalities of the
work present asceticism not as renunciation but as intimately linked to
indulgence either as reaction or (more perversely) as its final stage. In the
melodramatic terms offered by the play, the active shape of renunciation
is either murder or suicide, two acts that, in Wilde's telling, are inextrica-
bly confounded.

Seven veils would, of course, be seven too many if the aim of Salome's
dance was to feature simple nudity. The dance that tantalizes with expec-
tation gives an eroticized form to the desires of a modernity in which, as
Pater had noted in "Winckelmann," the problem of culture "could no
longer be solved, as in Phryne ascending naked out of the water, by
perfection of bodily form" (182). The dance of Salome serves as a fitting
center for a play about controlled and uncontrolled looking in a world all
too rich in things to see. Capedocians, Syrians, Nubians, Jews, and Ro-
mans, along with their gods, ideas, and precious objects form more than
the background to the piece; Herod's palace floats on a sea of cultural
excess. The selection of one object of desire out of so many is itself a
problem. The repetitive quality of the language in the play is not simply
due to the elaborately stylized form of the work as a whole; what is
repeated throughout, with staccato insistence interrupting the flow of
elaborate language, is the warning not to focus the attention on any one

object of desire. Not only do characters jealously caution their own objects of erotic attachment not to look at Salome, but Salome herself is warned not to gaze at Iokanaan (who has been placed in a dark cistern, which makes it impossible to see him, but does not shut out his voice). Each one of these warnings at once reflects a personal jealousy and a broader principle. The action of the play takes place in a location between the banquet hall of excess and the dark well from which the ascetic voice emerges. (The two poles of the play are well represented by Beardsley's drawings, with their notable juxtaposition of overelaboration and equally perverse restraint.) The excess the princess is escaping when she discovers Iokanaan is not simply moral self-indulgence but cultural overload:

> Within there are Jews from Jerusalem who are tearing each other in pieces over their foolish ceremonies, and barbarians who drink and drink and spill their wine on the pavement, and Greeks from Smyrna with painted eyes and painted cheeks, and frizzed hair curled in twisted coils, and silent, subtle Egyptians, with long nails of jade and russet cloaks, and Romans brutal and coarse, with their uncouth jargon. (555)[26]

We may understand Herod's incestuous lust for his stepdaughter as on a continuum with the boundless appetite he represents and the world of excess he inhabits; he wants too much because he wants everything. It is Salome's desire that is strange, drawn by the prophet's voice and migrating from his body to his hair until it rests on his lips, the source of his harsh refusals and dark prophesies. When the play begins Iokanaan is imprisoned in the cistern, but he returns to it of his own free will in order to avoid seeing Salome because he is the embodiment of refusal. In exchange for her dance, Herod expects Salome to ask for half his kingdom, but her desire is for precisely the opposite of the kind of plenitude Herod's possessions stand for; she is driven by a desire for death that Herod will satisfy twice over. The long dialogue in which Salome demands that Herod keep his promise, which is at the textual heart of the play as the dance is at its center of its action, is a dialogue between appetite and its refusal (570–73). Herod's language expands in scope—in what he includes in his offers—but he is answered each time by the thin line of Salome's desire.

Like Salome and Iokanaan themselves in Beardsley's illustrations, excess and death are twin elements that the play juxtaposes not simply for contrast but to suggest relation. Herod's desire to control mortality is a mark of his ambition. The Tetrarch's discovery of the Captain of the Guard, dead by his own hand for love of Salome, upsets him not simply because it was not an execution he ordered, but because suicide itself is a troubling choice of nothingness. The discovery is followed by a discus-

sion of the absurdity of taking one's own life, which is not unrelated to
Herod's annoyance a few moments later on learning that Jesus raises the
dead: "I allow no man to raise the dead. This Man must be found and
told that I forbid Him to raise the dead." Given that Herod already
senses the wings of the Angel of Death overhead, his insistence is strik-
ing: "Let them find Him, and tell Him from me, I will not allow him to
raise the dead! To change water into wine, to heal the lepers and the
blind. . . . He may do these things if he will. I say nothing against these
things. In truth I hold it a good deed to heal a leper. I allow no man to
raise the dead. It would be a terrible thing if the dead came back" (565;
ellipsis in the original). The desire to be able to mark an end, for death
to be final, is expressed in the exaggerated self-indulgent language that
characterizes Herod because it is not unrelated to the desire that marks
him throughout.

The question of whether the longing for renunciation—which Wilde
identifies with the longing for death—is motivated by the wish to escape
from desire, or whether it is simply the ultimate manifestation of the very
appetites it ends, recurs at crucial moments in Wilde's work. Not only is
it the very issue that dominates the last exchange between Dorian Gray
and Lord Henry, but it gives shape to the mystery of Dorian's own death.
Lord Henry identifies Dorian's renunciation of the opportunity to spoil a
country maiden not as the turning of a new leaf but as a continuation of
the same story. The ultimate refinement of corruption, he suggests, is
when renunciation itself becomes one of its forms. The expert on plea-
sure and corruption speculates that Hetty, the girl whose heart Dorian
plumes himself on having spared, may well have killed herself as the
result of an action attributable to a selfish desire for the *pleasure* of ab-
negation. As he argues against Dorian spoiling his life with a futile fan-
tasy of renunciation, Lord Henry's terms evoke both Gilbert's language
when writing about the function of the critic given new concepts of in-
heritance, and Pater's when describing the Mona Lisa: "Life is not gov-
erned by will or intention. Life is a question of nerves, and fibres, and
slowly built-up cells in which thought hides itself and passion has its
dreams. . . . The world has cried out against us both, but it has always
worshipped you. It always will worship you. You are the type of what the
age is searching for, and what it is afraid it has found" (*Dorian Gray*, 163).
Their final conversation revolves around the relationship of renunciation
and death. When Dorian goes home, his mind is still engaged with the
challenge to free will and renunciation folded into Lord Henry's words:
"Was it really true that one could never change? He felt a wild longing
for the unstained purity of his boyhood—his rose-white boyhood, as
Lord Henry had once called it" (164). He looks in a mirror to under-
stand himself, but the reflection, of course, shows him only a mask. It is

the painting he needs to confront in order to learn the meaning of his actions. That reflection unfortunately reveals to him that Lord Henry is probably correct on the causes and effects of his rejection of Hetty: "Through vanity he had spared her. In hypocrisy he had worn the mask of goodness. For curiosity's sake he had tried the denial of self" (166).

The complex act of self-murder that closes the book is precipitated by a doubled realization: that his renunciation had indeed been not an escape from the search for new sensations but merely another instance of that search, and that it is impossible to undo the past, or—what is the same thing—to make oneself into another person. The book appears to offer a simple moral: Dorian wants to do away with the evidence of his crimes, and so takes a knife to the portrait that is the only sign that he is different from how he appears. As he himself is responsible for his desires and actions, so his action redounds on his own flesh. Wilde, however, makes sure to clutter this simple conclusion. As Dorian contemplates the knife he intends to use, he reveals not so much a return to morality as a total collapse of his historic sense: "It would kill the past and when that was dead he would be free. It would kill this monstrous soul-life, and, without its hideous warnings, he would be at peace" (167). Dorian's death is less a sign of moral failure, than an indication of the failure of his historicism. "To obliterate any part" of the past, Pater had pointed out years before in his review of William Morris, "is as impossible as to become a little child, or enter again into the womb and be born." Wilde leaves open the possibility that the fantastic death of Dorian Gray is the only way for him to achieve his two impossible goals (to kill his past, to be at peace). Rather than indicating a fantastic disgust, Dorian's action is a manifestation of a principle Wilde will make general when he is in jail, that "each one kills the thing he loves." Lord Henry's challenge to Dorian's self-abnegation should not be forgotten at this climactic moment in the novel. Wilde sets the crisis in a rich enough matrix that we should hesitate to call it a turn away from desire. I have already noted Dorian's "wild longing for the unstained purity of his boyhood," what he remembers Lord Henry had once called "his rose-white boyhood." Dorian's yearning for an impossible return to purity results in a death that might best be read as at once an attempt to escape history and as the final turn in the ascetic renunciation that is the latest form of his desire.

Three years later, Wilde has refined and further stylized his account of the wild longing for rose-white purity. The much-remarked-upon mirroring of Salome and John the Baptist in Beardsley's illustrations is a version of the deadly portrait of desire in *The Picture of Dorian Gray*. Salome's desire is for the negation Iokanaan embodies. In the prophet, Salome has found something altogether whiter and purer than Dorian could have ever imagined:

> Iokanaan, I am amorous of thy body! Thy body is white like the lilies of a
> field that the mower hath never mowed. Thy body is white like the snows that
> lie on the mountains, like the snows that lie on the mountains of Judæa, and
> come down into the valleys. The roses in the garden of the Queen of Arabia
> are not so white as thy body. Neither the roses in the garden of the Queen of
> Arabia, nor the feet of the dawn when they light on the leaves, nor the breast
> of the moon when she lies on the breast of the sea. . . . There is nothing in
> the world so white as thy body. Let me touch thy body. (559; ellipsis in the
> original)

Iokanaan is, of course, true to his role as figure of negation. He reviles
Salome, and, as noted already, her desire wanders from his body to his
hair, until it ultimately settles on his mouth, the very source of his re-
fusal. Her first simile as she tries to explain the attraction of this part of
the prophet is straightforward enough, "Thy mouth is like a band of
scarlet on a tower of ivory." The pure isolation of the tower of ivory is
given new beauty by the band of color; the red band stands out starkly
against immaculate ivory. Both white and red participate in the comeli-
ness described. The second simile Salome offers for the mouth of the
prophet is stranger and more violent: "It is like a pomegranate cut with a
knife of ivory." This figure, with its unnatural quality of arrested action
(the knife that has opened the fruit apparently remaining embedded), is
richly suggestive of the source and aim of the desire of Salome. Wilde
offers a link back to the death and resurrection of Persephone, along
with a mark of violence, which may be taken to suggest either an end or
a new beginning to those cycles (the knife that violates the fruit releases
the seed). A complex understanding of asceticism is offered in the play;
renunciation is absolutely unnatural, figured extravagantly as a longing
for death, but in context it stands revealed as a response to the otherwise
inexorable force of cultural accumulation.

 Herod and Iokanaan stand for two forms of excess, the two forms of
pleasure available to Salome—boundless appetite and a self-abnegation
that in its ultimate form is death. When the head is brought to her,
Salome seizes it, the violence of her desire unabated—"Ah! thou wouldst
not suffer me to kiss thy mouth, Iokanaan. Well! I will kiss it now. I will
bite it with my teeth as one bites a ripe fruit" (573). Seeking out death,
like a Persephone *wishing* to stay in Hell, Salome bites the pomegranate
fruit of Iokanaan's mouth. She finds death twice over; she tastes not the
seeds of the fruit, but the flavor of blood, and, at the moment when the
wished-for kiss is attained, Herod orders her destruction. The contrast-
ing forms of death at the close of the play are significant; the definition
suggested by decapitation with a sword stands out in contrast to the fate
of Salome, obliteration under the shields of the guards. Like Dorian,

Salome brings her death on herself, and it is at once an attempt to escape from *and* an acknowledgment of the condition of excess in which both characters have their meaning. Herod's uncharacteristically laconic command to kill her interrupts Salome as she takes on the luxuriant language that had characterized the Tetrarch. He, in his turn, has evidently come close to learning the lesson of the play. "I will not look at things," he declares fearfully at the close, "I will not suffer things to look at me" (574).

Pater had been quietly scandalous in his own treatment of John the Baptist in *The Renaissance*. Not only did he underline the refined erotic appeal of a figure whose charms "no one would go out into the wilderness to seek" (93), but he dwelt on the manner in which Leonardo's students progressively removed the elements of Christian iconography in their own versions of the piece until it was transmuted into the *Bacchus*, which hung near it (and which had until recently still been attributed to Leonardo). By means of Salome's desire, Iokanaan takes on the irresistibly suggestive qualities of Leonardo's painting of John the Baptist that Pater found so provokingly inviting, and the horrifying, lethal form of the head of the Medusa, which fascinated by its evocation of the power of death. As was the case with the end of Dorian Gray, Salome's actions add up to a form of suicide, but in the play Wilde slows down the process in order to show the elements of a longing for purity, which is itself the culminating point of a situation of excess.

In a seminal essay, Richard Ellmann demonstrated the presence of Wilde's principal critical models in *Salome* and *Dorian Gray*. Ellmann read Iokanaan as that other ascetic John—Ruskin—and behind the invitations of Salome he found lurking the seductive figure of Walter Pater. He noted the evident Paterian qualities of Lord Henry and the more subtle Ruskinian suggestions surrounding the painter of the portrait of Dorian, Basil Hallward. Although its intentions are largely biographical, "Overtures to Salome" establishes the vital presence of contradictory elements from the nineteenth-century culture of art in Wilde's most elaborate imaginative works. Nevertheless, when he turns to the ending of *Dorian Gray* for his conclusion, Ellmann offers a simple moralizing resolution. To claim that the novel "executes a Ruskingesque repudiation of a Pateresque career of self-gratifying sensations" is to shy away from the stranger conclusion suggested by Ellmann's own evidence.[27] "All excess, as well as all renunciation," wrote Wilde, when asked to explain the theme of *Dorian Gray*, "brings its own punishment."[28] I have tried to suggest not only the importance of this paradox in Wilde's writing, but the close relation between excess and renunciation that makes them *both* forms of guilty pleasure. Like Pater, Wilde could not believe in the fully new; like him, too, Wilde placed death and self-abnegation on a contin-

uum of pleasure. In the following passage from a letter, self-revelation acts as a form of seduction, and death, pleasure, and the sacrifice of self are closely allied:

> I myself would sacrifice everything for a new experience, and I know there is no such thing as a new experience at all. I think I would more readily die for what I do not believe in than for what I hold to be true. I would go to the stake for a sensation and be a sceptic to the last! Only one thing remains fascinating to me, the mystery of moods. To be master of these moods is exquisite, to be mastered by them more exquisite still. Sometimes I think that the artistic life is a long and lovely suicide, and am not sorry that it is so.[29]

I quote the passage in its entirety because of the inexorable yet under-motivated movement it makes from the impossibility of novelty to the pleasure of a sacrifice of self, which is ultimately figured as suicide. I have tried to suggest ways in which the deaths of Dorian and Salome should be read as long and lovely suicides, motivated ultimately by the very form of skepticism Wilde here claims for himself.

There has been much discussion over the years of the appropriateness of Beardsley's illustrations for Wilde's play, but there can be little doubt that the artist captured important elements in the author's work. Wilde recognized as much in his often-cited inscription on the French edition of the play: "For Aubrey: for the only artist who, besides myself, knows what the dance of the seven veils is, and can see that invisible dance." Critics have concentrated on the content of Beardsley's scandalous images, but locating the work in relation to the nineteenth-century culture of art allows the possibility of recognizing the stylistic relationship between the text and the work of the draftsman. The artist's sharp lines and planes indicate breaks that his sinuous curves and overelaborations then complicate without entirely mending, suggesting the chastity and limitation of the outline even as both qualities are challenged and overcome.

Beardsley was commissioned to illustrate the English translation of the play after the publisher John Lane saw the drawing of its climactic scene, which had inspired Wilde's enthusiastic dedication, published in *The Studio* in 1894 (fig. 53). In the celebratory article accompanying the young illustrator's images, Joseph Pennell rightly identifies as "most interesting of all" Beardsley's "use of the single line." With this line, notes Pennell, in text facing the first publication ever of the climax of *Salome*, Beardsley "weaves his drawings into an harmonious whole, joining extremes and reconciling what might be oppositions—blending, but not forcing, you properly to regard the concentration of his motive."[30] As will also be the case in his later illustrations, in this first response Beardsley offers two closely related faces and an *apparent* contrast. Behind Salome rises a fan-

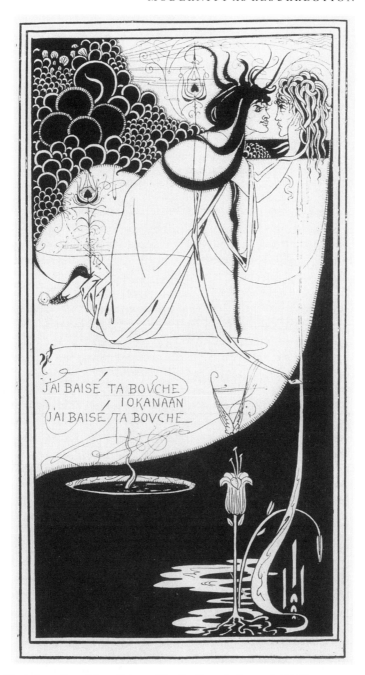

Fig. 53. Aubrey Beardsley, *Salome. The Studio*, vol. 1, no. 1 (1893).

tastic world of elaboration, while a black world of negation opens up beneath the head of Iokannan. However, Beardsley is not interested in lines of simple separation, but in lines, like those that intrigue Pater and Wilde, that form an interconnected web not liable to absolute breaks. As Salome holds up her trophy, the blood that drips down from the wound she has caused rises up as a flower, inescapably contaminating the negative space of the ascetic with new life from death—much as the blood of the beheaded Medusa is said to have given rise to a proliferation of snakes. One tradition holds that Persephone, as queen of the underworld, has in her charge the head of the Medusa; a further responsibility of her life in Hades is to sever the thread of life at the moment of death. I have already cited Pater on the subject of the Medusa. "Leonardo alone cuts to its centre," notes the critic, "he alone realizes it as the head of a corpse, exercising its powers through all the circumstances of death" (*The Renaissance*, 83). If Beardsley has not captured *all* the circumstances of death in his inverted Medusan representation, he certainly has captured two particularly Paterian circumstances, the fascination of mortality in a world of excess, and the manner in which death marks not a complete end, but a transformation into a new beginning. Pennell praises the young Beardsley for precisely this quality in his graphic work, his joining of extremes and reconciling of oppositions.

In the early chapters of this book I describe the longing toward an inaccessible perfectly pure antiquity, which was thrown into crisis by the experience of excess on the one hand and the overwhelming evidence of a sexualized past on the other. Wilde offers a sophisticated alternative to the longing and the disappointment that was so important to the nineteenth-century culture of art. At every point he denies the enabling lacks that had motivated relationships to art throughout the period. Looking back, he find critics wherever there have been artists, and a longing that includes not simply the open representation of lust, but an eroticization of ascetic drives. Looking to his own day, he identifies a century that, far from having lost a connection to the past, has never been able to draw on so much of it—and which realizes with ever growing dread the impossibility of a real break from what has gone before. The achievement and the challenge offered by Wilde, as is the case with Pater, resides in the self-conscious return to matters and motifs that run throughout the nineteenth-century culture of art. Both authors trace the longing and nostalgia of the era to a failure of the historic sense. Rather than the closed-off past indicated by the engraved statue, they offer a past with the sinuous reach of Salome's hair, the mysterious fecundating power of the blood of Iokanaan.

AFTERWORD

LAS MENINAS AS COVER: FOUCAULT, VELAZQUEZ, AND THE REFLECTION OF THE MUSEUM

> Votre beauté m'a troublé. Votre beauté m'a terriblement
> troublé, et je vous ai trop regardée. Mais je ne le ferai plus. Il
> ne faut regarder ni les choses ni les personnes. Il ne faut
> regarder que dans les mirroirs. Car les mirroirs ne nous
> montrent que des masques.[1]

A T THE beginning of this book I drew attention to the nineteenth-century culture of art as a significant phenomenon in literature and culture generally whose nature has been obscured by changes in the values by which we understand the nature of art and artist. Although it is self-evident that this century has seen a turning away from many prevalent nineteenth-century values and *some* nineteenth-century institutions, I have tried to suggest that typical accounts of that turn have been misleading when they have assumed the existence of a stable prior situation. To tell the story of a superannuated system overwhelmed or supplanted by a new self-consciousness, or (as in a more old-fashioned model) to celebrate the double emancipation of independence-seeking artists throwing off the shackles of the institution in order to bring about the triumphant release of a long sought formalism, requires the nineteenth-century culture of art to have been things it evidently was not—namely, stable, unselfconscious, and ultimately (with rare but important exceptions) disconnected from the developments that it in fact anticipated or provoked.[2] I offered a cursory account of the museum-mausoleum tradition in the introduction in order to begin to suggest ways in which some of the stranger elements in the nineteenth-century culture of art anticipated the terms of recent challenges, in particular, the manner in which a sense of mortality or death in relation to art should not be understood as either new or as necessarily offering any simple critique. In the body of the book I have drawn attention to instances in which death and admiration were inextricably entwined (as in the biographies that I discuss in the second section) and in which death, beauty, and the longing for art are discovered to be closely and unavoidably allied (as in the works of Pater and Wilde).

The emphases of this book have been inevitably determined by the interplay of the expectations with which I began the project and the material revealed by research. *Desire and Excess* had its origin in a long-

standing interest in the figure of the modern artist, which was only further stimulated by critical insistence around the time the project was first conceived on the demise of that very figure. It was my impression that the then current declarations of the death of the creator represented not the radical break with the past that some thought, so much as a stage in, or even a culmination of, a tradition that had roots in a previous era. "Fame is the recompense not of the living, but of the dead," explains Hazlitt, prior to discoursing on his reluctance to speak on his contemporaries in *Lectures on the English Poets*. "The temple of fame," he continues, "stands upon the grave." The surprising link between admiration and mortality was a discovery Hazlitt was not alone in making. The fate of Orpheus reminds us that the complex is traceable to very early sources. Nevertheless, it was bound to receive its most developed treatment in the texts of a period preoccupied by artistic achievement.

An important but unforeseen theme in the book is the manner in which past works of art became troubling presences in culture, affecting profoundly the development of the concept of the artist in the nineteenth century as well as haunting the imaginations of individual authors. The accumulation of admired objects could prove fatal to modern ambitions, or surround modern achievement with a nimbus of death. Given that this project started from the attempt to solve a peculiarly elaborate, even Borgesian, murder mystery, one in which victim and perpetrator (say, artist and critic) exist in an elaborate and intimate relationship (to the point of possibly being one and the same), and in which even the fact of the murder is in question, perhaps it should be no surprise that it cannot offer a simple account of perpetrators and victims. Rather, as Borges himself does, with so much more economy and humor, I find myself at the close of my mystery offering in various guises the description of a fantastic collection whose shape determines the nature of the wonders it holds, a collection that is at once setting and cause of the crime. I take this trajectory to be more than coincidental; both the (claims of the) fantastic death of the creator, and the (claims of the) creator's reemergence as critic are phenomena likely to arise in a world itself ever more museal in nature.

In the preface of this book I attempted to evoke not only our distance from the concept of the museum in place at the beginning of the century, but from the memory of that difference. As its name reminds us, at its very origins "museum" does not mean place of accumulation but seat of the Muses. Although it seems clear that, practically speaking, the museum is the structure that protects art that we value, it has never been more appropriate to ask how much that structure acts as shell and how much as a skeleton—that is, how much does the form of the museum simply provide the exterior protection required by valuable objects, and

how much does it provide the interior support that ultimately shapes those objects themselves? To seek answers to these questions is to attempt an act of historical reading, but it is also to attempt to understand a situation in which the challenge of the past has become the face of modernity.

While I have argued that a sense of the complex coherence of the nineteenth-century culture of art has been largely lost outside of specialized studies because values have indeed changed, I have nevertheless attempted to demonstrate that engagement with this phenomenon will help clarify issues that still trouble our own era. My argument is not simply about sources. I have attempted to describe a nineteenth century that is not merely the unwitting transmitter of unstable ideas that it itself did not recognize. Not only do all sides in current debates over what art is or should be bear the traces of a nineteenth-century genealogy, but concepts and approaches discernible in the debates and discussions of the period may well help to clarify recent developments.

In order to suggest the surprising longevity of the issues discussed in the project, I close with a well-known meditation on an artist at work drawn from a contemporary critic. It is a treatment of artist *and* work that in itself may be understood to be describing either a beginning or an end:

> The painter is standing a little back from his canvas. He is glancing at his model; perhaps he is considering whether to add some finishing touch, though it is also possible that the first stroke has not yet been made. The arm holding the brush is bent to the left, towards the palette; it is motionless, for an instant, between canvas and paints. The skilled hand is suspended in mid-air, arrested in rapt attention on the painter's gaze; and the gaze, in return, waits upon the arrested gesture. Between the fine point of the brush and the steely gaze, the scene is about to yield up its volume.[3]

Anticipating the painter's pause that opens Michel Foucault's *The Order of Things*, the U.S. edition of the work until recently reproduced Velazquez's *Las Meninas* on the cover (fig. 54). In the well-known analysis of the canvas that follows the suspenseful drama of this opening, Foucault goes on to describe the image as "a representation, as it were, of Classical representation." Because Velazquez steps away from the canvas he is painting in order to be visible, in order to see the subject he is painting, because the surface of that canvas is in itself not visible to us, and because the painter's gaze, along with the play of reflection and representation in the image as a whole draw in the viewer while calling into question the action of gazing itself, Foucault proposes that the painting carries within itself the confession, acknowledgment, or perhaps evidence of "an essen-

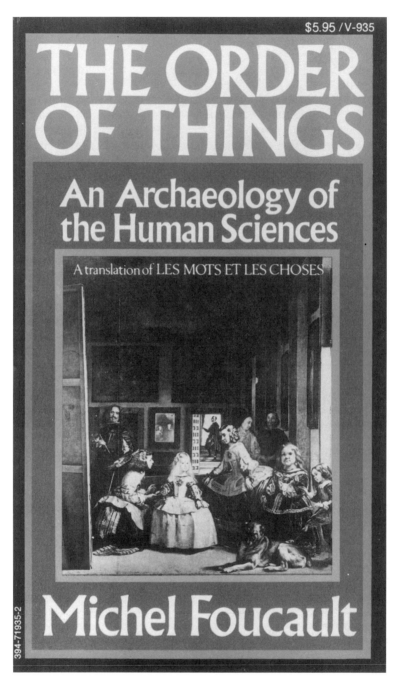

$5.95 / V-935

THE ORDER
OF THINGS

An Archaeology of
the Human Sciences

A translation of LES MOTS ET LES CHOSES

Michel Foucault

394-71935-2

Fig. 54. Velazquez, *Las Meninas*. Cover, Michel Foucault, *The Order of Things* (New York: Vintage, 1973).

tial void: the necessary disappearance of that which is its foundation—of the person it resembles and the persons in whose eyes it is only a resemblance" (16). Given that the argument to be made concerns the disappearance of both author and subject, I am intrigued by the moment of inception that is given over to the painter standing a little back from the canvas (or as the French has it, withdrawn, "retreated," slightly from it, "légèrement en retrait du tableau"). The ironic effect of such an image serving as the opening of a text whose burden is the death of the subject or author is only underscored by the decision to blazon the painting on the cover of the book. After all, whatever else this complex canvas may be, it is undeniably a self-portrait of the artist—indeed, it is not only Velazquez's only incontrovertible self-portrait; it is, in form and content, a declaration of remarkable individual artistic achievement.[4]

That Foucault elects to open with such an image may be read as the strategy of a confident man confronting his subject head-on, but I cannot see it so simply. It is not only that the text begins with an ekphrastic representation of "the painter" unnecessary for the argument, but that the evocative treatment of hand and eye betrays an intrigued fascination, not irony. The exposition lingers with captivated interest on the pause of the artist, on his brush, his gaze—and brush and gaze then recur metonymically throughout the chapter. The whirlpool of perception and representation that Foucault describes will suck in spectator and monarch alike, but it circles always around the rock of the painter, the source of this entire experience. Solidly present, faced with a mammoth canvas that appears to be nearly double his size, Velazquez is the acknowledged orchestrator of the bravura conceit of the scene over which he presides: "In the depth that traverses the picture, hollowing it into a fictitious recess and projecting it forward in front of itself, it is not possible for the pure felicity of the image ever to present in a full light both the master who is representing and the sovereign who is being represented" (16). Even if the terms "master" and "sovereign" did not in themselves draw attention to the parallels being adduced, it is evident that Foucault is describing alter egos in these figures who are never simultaneously present—the master painter, the political sovereign. If it is remarkable that Foucault equates the painter with the king, it is nothing short of startling that the painter should escape the eddies that swallow even that absolute monarch of Spain, the master of the Alcázar. Like Ishmael clinging to a buoyant coffin at the close of *Moby Dick*, Velazquez escapes the maelstrom in which his author places him, riding on an emblem of his own mortality.

The critic's surprising ascription of a work sharing so much with the baroque to a classical period has been attributed to a form of French cultural chauvinism, but this is certainly not the full story. Fascination

with Spanish painters has been a mark of an antiestablishment aesthetic in France since at least the second half of the nineteenth century; the best-known manifestation of this interest probably being Manet's relationship to Velazquez. It might be interesting to put the use Foucault (great lover of Manet) makes of Velazquez in the context of a tradition that looked to Spain for a closer yet more gritty engagement with the world—an unsentimental critical realism. The dazzling combination of masterful brushwork, human realism, and intellectual wit were recognized early in Velazquez's work and have made *Las Meninas* in particular an ideal object for speculation. The reception of the painting has encompassed in its history a range of responses: from the declaration of Luca Giordano to Charles II that *Las Meninas* was "the theology of painting," to Gautier's ironic demand, after considering the canvas for some time, that he be shown the painting, to Manet's joyous declaration that in Spain he had discovered "the painter of painters." As these instances suggest, the virtue of *Las Meninas* has been ascribed to a number of distinct though sometimes overlapping qualities. In the responses cited we find the constellation of values that has guided its appreciation since the work was first exhibited: painting as the profound elaboration of an idea (something approaching theology), as presenting a verisimilitude that challenges reality, and as a triumph of the painter's art.[5] Little wonder that Foucault himself cannot help betraying a fascination with the creative power of this "master," hanging on the suspense of his brush following every glint of the observing eye.

As I am arguing that the charms of the painting are present in Foucault's writing in such a way as to compromise his stated critical goals, it may be worth noting Philip Fisher's suggestion that "the self-portrait is the one form of easel painting that resists being owned."[6] Bearing out Fisher's formulation, a good deal of the resistance *Las Meninas* presents to Foucault resides in its force as an instance of artistic self-representation. Foucault's descriptive language is clear, even melodramatic—there is strength in the eye, skill in the brush; together they form a world on the canvas: "Between the fine point of the brush and the steely gaze, the scene is about to yield up its volume." The process of interpretation begins with an anxious desire to decipher the meaning hidden in the painter's face and gesture: "The skilled hand is suspended in mid-air, arrested in rapt attention on the painter's gaze; and the gaze, in return, waits upon the arrested gesture." The translator can do no better than to ascribe this gaze to the painter, but he loses something of the free-floating ambiguity of the original "*regard.*" There is a moment in the French when it could be (even should be) the gaze of the viewer that is so arrested. Of course, it is impossible for it to be the gaze of the painter that is frozen on the hand or vice versa; Foucault's reading depends on the

easily verifiable fact that Velazquez is looking straight out of the canvas. The ambiguous suspense maintained between eye and hand is a fanciful part of the critic's identification with that creative hesitation between perception and placing of pigment represented in the painting. Evidently, the unmentioned but necessary gaze isolating this frozen moment is that of the critic, Michel Foucault. It should not be missed that the first speculation, in this text characterized by so many, is an identificatory one. Velazquez's pose suggests an act akin to that of preparing a preface to a completed work: "perhaps he is considering whether to add some finishing touch, though it is also possible that the first stroke has not yet been made." Finishing touch and first stroke are two acts in painting equally useful for describing the notoriously paradoxical nature of any preface—the sort of thing this chapter turns out to be.

The detail, richness, and personal investment of Foucault's opening meditation on the figure of an artist is famously bracketed, at the close of *The Order of Things*, by a far starker evocation of representation. On a beach in a place unspecified, a face in the sand is washed away—this is the image Foucault offers for that vanishing of man he so eagerly anticipates. He speculates on the "effect of a change in the fundamental arrangements of knowledge": "If those arrangements were to disappear as they appeared, if some event of which we can at the moment do no more than sense the possibility—were to cause them to crumble, as the ground of Classical thought did, at the end of the eighteenth century, then one can certainly wager that man would be erased, like a face drawn in sand at the edge of the sea" (387).[7] The translator cannot capture the entire vacuity of agency in Foucault's fantasy—"on peut bien parier que l'homme s'effacerait, comme à la limite de la mer un visage de sable." "Un visage de sable," a face of sand, not "a face *drawn* in sand." There is no one to draw here; no action of creative generation interferes with the purity of Foucault's desire for emptiness. Of course, faces do not occur in the sand without a hand to draw or assemble them; it is Foucault's design to indicate that man may be as artificial and out of place as such a representation, as prone to dispersal, and as little to be mourned as the untidy remainder of a childish act. Still, there is an asymmetry between the treatment of this symbol of disillusion and the engagement with Velazquez evident at the opening of the work; the fascination with a specific hand and eye and the world they were able to create implies an entirely different response to creation and creator. If "the ground of Classical thought" has indeed crumbled—a model of the fate awaiting our own episteme—it is difficult to understand the effect of *Las Meninas* (of which evidently Foucault's text is not the least compelling recent evidence), a product of that thought. Foucault's first chapter is not devoted to tallying the grains of sand that no longer make up a face; it demonstrates instead

a deep engagement with a named and demanding work of representation and self-presentation—a work entirely unlike that face of sand in that its loss would be mourned, would leave an identifiable space in the gallery. When *The Order of Things* is shut, it is not a face of sand we hold in our hands, but a representation of a room in a Spanish castle busy with complex human exchanges; several faces look out at us, including the thoughtful countenance of the painter—his hand and brush arrested in midair.

The current name of *Las Meninas* comes from a rare Spanish term meaning page. It is an even rarer feminine and plural form of the word, which is meant to draw attention to the two attendants who wait on the princess at the middle of the canvas. The name, which in French is given as "Les suivantes," and which provided Foucault's original title for the essay that became the first chapter of *The Order of Things*, dates only as far back as the 1840s, where it is found in a catalog of the Prado Museum. An inventory of 1666 describes the image more fully, and with attention to the figure at the center as "The portrait of the empress surrounded by her maids and a dwarf." The more common name in the eighteenth century and well into the nineteenth was, *The Family*, or more exhaustively, *The Family of Philip IV*.[8] The relation between Velazquez and this monarch and his family is well known, attested to by portrait masterpieces dispersed throughout the world's museums. The painter came into formal royal employment in 1623, at the age of twenty-four, when he was appointed court painter; he did not leave this position until his death in 1660.

Velazquez makes an interesting comparison to David, as two great intellectual painters carefully developing their careers in eras of transition in the social position of the artist. However, whereas David, more than a century and a half after the Spanish painter's death, would present as related claims the independence of his artistic imagination from venal concerns and his freedom from subservience to the king (see chapter 1), Velazquez, fully enmeshed in the elaborate calibrations of class and rank of golden age Spain, has recourse to his courtier life to demonstrate his distance from craft or commerce. Over the years, a significant part of Velazquez's output would be images of the royal family, but his duties, and position in the court, came to involve far more than painting. It has been a commonplace of accounts of Velazquez from the nineteenth century onward to bemoan the fact that the king's demands took the painter from his creative work, but the roles Velazquez played outside the studio were clearly of great significance to both monarch and artist (and of incalculable effect on the history of Spanish art and taste). Philip IV, who has been described as among the greatest art collectors in history, en-

trusted Velazquez with important missions to purchase works for his col-lections.⁹ Velazquez was responsible for assembling and organizing the objects and for the elaborate architectural task of decorating the royal residences. Toward the end of the artist's life, the king nominated him for membership in the prestigious Order of Santiago, an extraordinary honor that, in the extremely systematized class hierarchy of seventeenth-century Spain, required an exhaustive investigation of life and lineage. Velazquez was forced to spend months defending not only the rank of his parents but his own activities as a painter. He attempted to ward off the stigma of working for money by insisting that he had only ever painted for the king—a form of courtier's service. In spite of the monarch's strong support, however, Velazquez was only grudgingly granted the honor after special papal dispensation. That this remarkable elevation left its mark on *Las Meninas* is a well-known piece of art-historical lore; the red cross of Santiago on the painter's breast is a posthumous addition ordered by the monarch, blazoning to the world the painter's achieve-ment and the still-living affection of the king.

Given the achievement of Velazquez and both the opportunities and re-sistance he met, it is not surprising that influential and compelling art-historical arguments have been raised for reading the painting as de-signed (even before the king's emendation) to defend and demonstrate the virtue of painting as a liberal art.¹⁰ How does knowing even this small amount of the story of painting and painter affect our sense of the anal-ysis that opens *The Order of Things*? Foucault follows the tradition insofar as he recognizes *Las Meninas* as an intellectual and artistic achievement, a milestone in complex self-conscious representation, but he is indifferent to those elements of the painting which allowed it to be called *The Fam-ily of Philip IV* well into the nineteenth century. The unorthodox form of the image Velazquez has left us has allowed any number of foci to be selected for critical emphasis. Foucault's reading, starting as it does from the painter's eyes and brush and never leaving them for long, is insis-tently author-centric. And yet, it should be difficult to reconcile the titles the painting bore for most of its life—drawing attention to the ladies in waiting, the empress, the family—with a reading of the work as a form of ironizing self-portrait. For all that it is an image of the artist, history tells us what the work itself makes quite clear, that it is an image of the artist enmeshed in and recording his presence in a very particular world. At the center of the canvas the painter has drawn a portrait of the royal family and its close attendants; Velazquez is not merely an observer but a *part* of the latter group. The red cross at Velazquez's breast, which is among the strangest elements of the work for the modern mind, was one of its most moving from its own day until quite recently; the fact that another hand

has entered the painting and marked Velazquez's breast with the honor he desired suggests the role of the king in making the artist on the canvas.

Nineteenth-century critics were quick to identify Velazquez's achievement in this painting—verisimilitude combined with the impromptu poses of its subjects—with the effect of the daguerreotype or photograph. Foucault imagines something like a carefully staged photograph in a mirror, but painting is not an instantaneous art, nor is it a simple matter to represent movement in a still picture. Foucault's reading insists on the static nature of the image as the setting for its dynamic play of glances; the painter's pause and thoughtful meditative gaze outward are "caught in a moment of stillness" (3). But the painting does not, in fact, represent a pause. What does the image of the dwarf in the foreground, his foot raised to kick or step on a dog tell us?—the same thing that the curtsies of the maids-in-waiting suggest, and that the princess's hand just closing on her drink demonstrates. If the entire tableau is meant to be taking place at one moment, there is no reason to believe that Velazquez is pausing at all. The poses of everyone we see, aside from the reflected king and queen, are not only inescapably dynamic, they should be impossible to read as anything but transitory. The dwarf will fall if he attempts to *stand* in such a manner; the waiting maid on the right cannot be expected to keep her back bent at so awkward an angle for long, even if her companion might have more balance in her deep curtsy. The young princess herself is unlikely to stay thirsty. The man at the rear, at the threshold, is either entering or leaving; the woman speaking to the man at the left of the canvas will not keep her head in that position long, nor her hand. The painter's own hand, brush loaded with paint, is in motion; his figure is not "motionless, for an instant, between canvas and paints," but moving, forever in that space.

The names of almost all the protagonists in the painting are known from the earliest sources. Characteristically, Foucault notes this fact, only to declare the need to do without such identifications:

> These proper names would form useful landmarks and avoid ambiguous designations; they would tell us in any case what the painter is looking at, and the majority of the characters in the picture along with him. But the relation of language to painting is an infinite relation. . . . And the proper name in this particular context, is merely an artifice. . . . [I]f one wishes to keep the relation of language to vision open, if one wishes to treat their incompatibility as a starting-point for speech instead of as an obstacle to be avoided, so as to stay as close as possible to both, then one must erase those proper names and preserve the infinity of the task.

For emphasis, Foucault then makes one sentence into a new paragraph summarizing the lesson we are meant to take from his discussion of the

limits of the relation of art and language, particularly what his ideas suggest we should do about the faces of Philip IV and his second wife, Mariana, the king and queen of Spain, in the mirror at the back of the painting: "We must therefore pretend not to know who is reflected in the depths of that mirror, and interrogate that reflection in its own terms" (10).[11] Foucault's claim is striking; he asks us to perform an evident logical impossibility, to forget what we know, in order to gain an interpretative advantage, the ability to interrogate the painted image in what he calls "its own terms." It is not as strange that he proposes a heuristic forgetting as that he suggests that "pretend[ing]" not to know will reveal not something false but an essential quality of the painted reflection. Foucault may be right, but it is important to clarify precisely what are the paintings "own terms" which will be engaged when we pretend not to know who the king and queen are; it is no small matter to forget the parents of the Infanta around whom the painting revolves, the admiring patrons of Velazquez himself, the rulers of Spain and its empire, the direct causes of the painting and its principal audience. We should gain a great deal for pretending not to know so much, and at least we must be clear on the nature of that gain. Foucault calls for a fruitful falsification of the painting, one that may be most usefully understood not on the terms he offers, as the necessary result of a rigorous appreciation of the difference between word and image, but as a putting into practice the lesson of the modern museum. Philip Fisher has suggested that the growth of interest in Rembrandt's self-portraits in the nineteenth century may be taken as symptomatic of what modernity was coming to look for in art—a manifestation of the individual stripped of context.[12] *Las Meninas*, in Foucault's analysis, is forced to signify along a very limited axis of meaning, one that makes into a particular kind of modern image a work that openly represents itself as quite different, a seventeenth-century painting actively committed to the representation of relationships involving ambition, loyalty, affection, and obedience. Such an analysis can only be understood in a very particular way as a means of recovering the reflection's "own terms."

Fisher makes a further observation that only *seems* to contradict his account of the predominance of the self-portrait. He notes that among the most important causes of the alienating effect of modern art is the lack of a sense of for whom the work is made. Modern art is made for no one because it is made to take its place in a museum in which it will be viewable by everyone:

> The anonymity of the modern object can have to do either with the vanishing of the craftsman-maker in his individuality or with the loss of the owner-user in his individuality. The feeling of anonymous objects is that they do not belong to anyone, nor did they come from anyone. . . . This feeling of lack of

belonging is most often described as a lack of intelligibility. With modern art the claim not to "get it" or understand it is a surrogate for the feeling that it does not belong to us or to anyone. Such objects are the inverse of Egyptian tomb objects (for someone but not appearing to anyone) because they appear to everyone but can be said to be for no one. (152)

We may understand Foucault to have taken an image that in fact resists such a fate at every point and to have made the bold attempt to turn it into a characteristic modern museum piece—to effect the vanishing of the craftsman-maker and most especially of the owner-user. Foucault's invitation for us to "interrogate that reflection" on its "own terms," "au ras de son existence"—literally, "at the level of its existence"—demands clarification as to what the relation between the terms of the painting's existence and our own might be. His reading (and not his alone) depends on turning the reflection in the painted mirror into that of the countless members of an anonymous public who will troop by the image in a museum and perhaps engage with the paradox that they are standing at the point of origin of the reflection of the king and queen of Spain. And yet, this paradox, which is evidently part of the achievement of the painting is precisely *not* the terms on which the painting was made, not, in that sense, "the level of its existence." *Las Meninas*, or *The Family of Philip V*, or "The portrait of the empress surrounded by her maids and a dwarf," was painted in the home of the king (in apartments belonging to his dead son) by a well-loved courtier. On completion, it immediately entered the king's private rooms. Foucault imagines a public at the level of the painting's existence when no public is at issue at that level. Erasing the role of the king, he neglects the cross on Velazquez's chest, a mark that reminds us that the figure on the canvas is a work of the king as much as the other way around.

Still, Foucault is quite correct if we understand "the level of its existence" to refer not to the original ground on which the image was formed but to the place in which it now is encountered, the museum.[13] "The cancellation of content" is a practice Fisher identifies as coming from the museum and ultimately affecting the development of modern art; we might say that Foucault is, in this sense, making *Las Meninas* into a work of modern art.[14] Foucault's analysis of the painting and the discussion of the artist that stands at its heart both have their meaning only within that institution. It would be a poor study that stranded the work of Velazquez in the place of its first elaboration, and that is not my intention. Rather, I wish to emphasize the quiet but absolute force of the actual ground of the painting's existence in the museum. To do so is to recognize that the historical location of Foucault's argument is not the seventeenth century, but several centuries later, a time much closer to (even identical with) our own. I have tried to suggest that Foucault's

admiring presentation of the figure of Velazquez in this chapter may be usefully understood as following a nineteenth-century pattern in which admiration coexists with fatality. Like the authors celebrated in nineteenth-century texts, Velazquez rises beyond the limits of representational possibility and then sinks back beneath them; his figure, in Foucault's account, stands at once for power and anonymity, overwhelming presence and loss of self.

I have noted that Velazquez was more than a painter, that he had in his charge the accumulation and arrangement of the king's collection. This part of the relationship between Philip IV and Velazquez is suggested by canvases hanging everywhere in *Las Meninas* where there isn't a window or door. (Continuing the interplay of art and family in the canvas as a whole, the visible paintings at the back of *Las Meninas* are copies of Rubens by Velazquez's son-in-law.) The collection of Philip IV was among the core holdings when the Prado Museum was established in 1818. Formed in one museum, the afterlife of *Las Meninas* has been marked by its presence in another. The painting is displayed with a mirror that allows the viewer to appreciate the illusionistic verisimilitude of the canvas and acknowledges the reflective quality in the image's content; there is a mirror in front as there is a mirror in the back of the work. Foucault's invitation to forget what we know about the reflection at the depth of the canvas is a way of inviting us to remember the world in which we encounter the canvas, a world it has never left, the museum.

To build a museum is to build limits while dreaming of boundless space and time. It is the particular pathos of the structure that its inadequacy is inevitable before its foundation is poured, evident before any objects are displayed. And yet, the discovery that an imaginary museum surrounds us before the actual museum is built follows the construction of the museum. This is one of the principal marvels of the modern museum, the productive nature of its failure. Every art collection ends as it began, an imperfect, contingent, limited result of idiosyncratic passions and accidents of history. Two pressures start to weigh on the museum, however, from the moment it is first conceived as a structure for education rather than pleasure: excess and incompleteness. The prospect of addition is unavoidable, but the problem of inadequate space is nowhere near as powerfully effective as a complimentary problem: the necessary inadequacy of the collection. As Malraux pointed out long ago, the recognition of the inevitable gaps in a collection promotes the imagination of a more perfect or ideal museum, one with a collection no longer limited by the accidental form of (often long lost) individual passions, but which will rather serve the new purpose of rational instruction, or something stranger, of satisfying a fantasy of completeness.

In recent years technology has been brought to bear on the problem of

the museum. So-called blockbuster exhibitions use ever easier modes of communication and transportation in order to make temporarily (more) perfect collections, more complete and better organized. As might be expected, even as exhibitions become larger, mechanical tools that *reduce* the quantity of viewed objects during the museum visit, that focus the attention, have also come to the fore. The tape-recorded tour of a massive exhibition is the technological manifestation of the desire to reconcile infinite expandability and controlled viewing that was so powerful in the nineteenth-century culture of art.

There is little question that the role and effectiveness of technology will continue to grow. Already the computer and related phenomena promise any number of perfect museums that will escape the bounds of the simple collection. When the National Gallery in London put some of its holdings on a CD some years ago, the product was entitled simply "Art Gallery," as though more were for sale than a sample of images from one collection, organized in various categories and experienceable in a number of instructive forms. It evidently will not be long, however, before the aspirations suggested by that unlimited title will be realized, and a general digitized gallery will become available, promising everything. As I hope will have been made clear in the body of this book, however, recent and anticipated solutions to the challenge of the museum have analogous manifestations in the nineteenth century, and can be expected to raise their own challenges, not only the obvious ones of the relation of original to simulacra or reproduction, but most notably those resulting from the challenges of excess, of unstoppably proliferating claims on the attention.

That Foucault cannot help seeing *Las Meninas* in the museum should not be a matter of surprise or blame, any more than it should be that artists are necessary for the creation and understanding of art. Critics, like artists, inhabit a world whose museal nature has only become more apparent with the passing of time. The recalibration of the complex relation among admiration, organization, and excess will only gather pace as the waning of twentieth-century prejudices allows for a clearer view of earlier eras. Valéry warned years ago that everything was at the point of entering the museum, and he was undoubtedly correct. Among the latest elements to enter that site of preservation, organization, and study is the museum itself. Recent years have brought evidence of a steadily increasing sense that the history and formation of museums is worthy of study, while a number of ambitious architectural responses to the challenge of the museum have indicated that the era of thinking of these institutions as either neutral or worse may well be passing.[15]

As I write this conclusion, New York's Museum of Modern Art (an

institution whose founding in 1929 in itself revealed the inextricable links between the nineteenth-century culture of art and movements aspiring to make a new beginning) has just closed an exhibition called "The Museum as Muse," dedicated to the artistic response to institutions of art in the twentieth century. In Italy museums from the Villa Borghese in Rome to the Pinacoteca Ambrosiana in Milan have undergone renovations that make inescapably evident the importance and complexity of the historical and aesthetic functions of the institution. Ambitious renovation has restored to the Classical Gallery at the Metropolitan Museum of Art in New York the light envisioned by nineteenth-century designers—and something of the grandeur of the space and statues it contains. It is worth noting that in France and the United States serious thought has begun to be given to the preservation and display of casts, while in the Palazzo Altemps in Rome one can find in an admirable setting the *Ludovisi Juno* (whose cast Goethe had placed in his rooms in Rome) along with other works of real significance for art lovers well into the nineteenth century. The curators at the Palazzo have carefully displayed the objects in such a way as to indicate the interplay of restoration, amalgamation, and authenticity out of which these admired statues were formed and for which they had until recently been disdained. In order to understand these curatorial developments as more than the result of nostalgia or professional self-regard, it will be vital to keep in view one of the central lessons of the study of the nineteenth-century culture of art, that entry into the museum does not mean the escape from history, so much as a direct engagement with what it means for a culture to preserve, to organize, and, sometimes (and not simply), to admire.

NOTES

1. By culture of art I mean the network of ideas, texts, and institutions that supports the understanding of what art is in a given period, something similar to what the philosopher Arthur Danto means by the Artworld, what the historian Paul O. Kristeller calls the modern system of the arts, or what the critic Peter Bürger calls art as institution. I favor the term culture of art for a number of reasons. Artworld, system, and institution all suggest a preexistent and even organized framework, which would be a better description of what the nineteenth century was perpetually attempting to bring about than of anything it actually inaugurated. The etymological relation of culture to "cultivation" suggests the particularly dynamic work that was done in the nineteenth century in order to *establish* the significance of art in society. The important, though now largely neglected, connection between culture and worship (cf. "cult") also serves as a reminder of the kind of deep admiration that is part of what the authors in my study attempt to understand; it keeps in play the surprising relationship between cultivation and veneration that characterized the response to art in this period. See Peter Bürger, *Theory of the Avant-Garde*, trans. Michael Shaw (Minneapolis: University of Minnesota Press, 1984), 12–13, 22; Arthur Danto, "The Artworld," in *Philosophy Looks at the Arts*, ed. Joseph Margolis (Philadelphia: Temple University Press, 1978), 132–44; and Paul O. Kristeller, "The Modern System of the Arts," in *Ideas in Cultural Perspective*, ed. Philip P. Wiener and Aaron Noland (New Brunswick: Rutgers University Press, 1962), 145–206. Although his focus is substantially earlier than that of this study, Kristeller's essay is of central importance to any historian interested in the emergence of art as a concept. Danto and Bürger are typical of the general tendency in critical response to the nineteenth century in that their real interest is what they take to be the defining break with the past of modern movements (the avant-garde for Bürger, contemporary art for Danto). Bürger is particularly disappointing in his description of the nineteenth century because his project, for all its historical aspirations, is ultimately content to elaborate on the manner in which the avant-garde drew attention to the hitherto unrecognized institutional nature of art in an (unsuccessful) effort to move beyond it. His argument would require substantial revision in order to account for the kinds of self-conscious relationships to the institutions of art that are evident in the authors in this study—well before his avant-garde. By far the most ambitious and sophisticated recent conceptual account of the emergence of the modern artist is that of Pierre Bourdieu in *The Rules of Art: Genesis and Structure of the Literary Field*, trans. Susan Emanuel (Stanford: Stanford University Press, 1996). Although his important treatment of "the artistic field" is too responsive to the unique French situation (its political history and cultural institutions, the role of intellectuals, and the centrality of aesthetic autonomy) to be used as a general model, Bourdieu's formulations and his emphasis on the complex historicity of

aesthetic categories is a vital corrective as much to ahistorical approaches as to the more simpleminded forms of historicism.

2. While self-consciousness about the effects of institutions on culture has been a hallmark of critical analysis over the past twenty years, until very recently much of this work has been limited in the conclusions it has been able to draw about the fine arts by the premises from which it begins. The tendency to start from a desire to unmask the politics ostensibly hidden within institutional structures or from a wish to describe an interest in the arts as having its source in the desire to divert attention away from politics has meant that there has been little recognition of the culture of art as itself an object of interest, deserving study and analysis. Inevitably, attention to the museum has often been overreliant on a view of the institution as essentially an insidious instrument of power. Derived largely from poststructural critiques of anthropology, such approaches have yielded, with some notable exceptions, a limited number of conclusions about the museum generally and the *art* museum in particular.

Didier Maleuvre's otherwise quite interesting and sophisticated recent work shows the difficulty of escaping what are ultimately quite untenable romantic notions about art outside the institution. While at the outset of *Museum Memories* he resists "[t]he idea that art in the museum is no longer authentic" because it "implies that art outside the museum enjoyed a truer, more immanent connection with history and culture," later in his argument Maleuvre offers what is little more than a summary of received opinion on the museum as prison: "The museum is not only the place where art is curated; it is also where art is imprisoned. Society locks away those elements deemed either too dangerous or too precious to move freely in the public domain. . . . It does not seem far-fetched . . . to liken the museum to its nineteenth century cousin, the prison. This quarantining of art constitutes a political gesture because it defines social spaces. . . . In this respect the argument regarding the socialization of art in the museum age is irrefutable: museums have contributed to the alienation of art. They remove artworks from involvement in the polis, neutralize their political thrust, freeze their contents as esthethically remote form. . . . [The museum] erects an esthetic barrier behind which the work of art is as surely neutralized as the sociopath is behind the prison bars." *Museum Memories: History, Technology, Art* (Stanford: Stanford University Press, 1999), 3, 39. The need to gloss over the distinction between protecting the precious and guarding the dangerous (even sociopathic) is a typical result of the utopian model of museum critique when it turns to art. That blurring of distinctions is no stranger, however, than the central underlying fallacy that to place art in the museum is to remove it from a role in the world which is necessarily political. Not only is it the case that art outside the museum is far more distant from the public domain than art in the institution can ever be, but there is no reason to believe that art in the museum—most of which was made by individuals long dead for powerful individuals also long dead in support of established interests now vanished—has a self-evident political thrust *without* the context provided by the museum and related institutions.

3. The most important source on the history and use of casts is Francis Haskell and Nicholas Penny, *Taste and the Antique* (New Haven: Yale University Press, 1988). For casts in Germany, see Suzanne L. Marchand, *Down from Olympus:*

Archaeology and Philhellenism in Germany, 1750–1970 (Princeton: Princeton University Press, 1996), 65–68, 112, 290. On American cast collections, see Clayton Stone, "Antique Casts in America," *Sculpture Review* 3, nos. 1–2 (1987): 26–33, and Russell Lynes, "Ghosts of Sculpture Past," *Architectural Digest* 44 (1987): 26–36. According to Marchand, in the early twentieth century over one hundred cast collections were to be found in Germany, some containing over a thousand pieces (112). Stone notes that by 1922 the Metropolitan Museum was in possession of three thousand casts (31). Two recent editorials visit the question of the contemporary fate of casts in France, and suggest some of the complex ambivalences leading to the dispersal of collections and even to the destruction of their component parts: "Faut-il détruire les moulages?" *Revue de l'art* 5, no. 95 (1992): 5–9, and "Les Moulages dans les musées," *Revue du Louvre et des musées de France* 43 (1993): 5–6.

4. It is worth mentioning that just three objects acquired before 1910 are reproduced in a recent popular guide to the Art Institute. The only piece in the collection before 1900 is a Greek vase evidently included because it was decorated by "the Chicago Painter." Indeed, though much is made of the age of the institution in the introductory matter, only a dozen objects from before 1920 merit inclusion, and well over half of the hundreds of pieces reproduced have been acquired since 1950, most of these in the 1980s. *The Essential Guide: The Art Institute of Chicago*, selected by James N. Wood and Terri Edelstein, with Sally Ruth May (Chicago: Art Institute, 1993).

5. "A racing car whose hood is adorned with great pipes, like serpents of explosive breath—a roaring car that seems to ride on grapeshot—is more beautiful than the *Victory of Samothrace*." Filippo Tommaso Marinetti, "The Founding and Manifesto of Futurism" (1909), *Marinetti: Selected Writings*, ed. R. W. Flint (New York: Farrar, Straus and Giroux, 1972), 39–44; quotation from 41. Early-twentieth-century Baedekers pause at the *Winged Victory* on the magnificent Daru staircase, marking the point of transition to the important painting collections to come. See, e.g., Karl Baedeker, *Paris and Its Environs* (Leipzig: Baedeker, 1914), 95. On the reception of the *Winged Victory*, see Haskell and Penny, *Taste and the Antique*, 333. Museum publications trace the shifting whereabouts of the cast at the Art Institute. The 1910 *General Catalogue of Sculpture, Painting, and Other Objects* (Chicago: Art Institute) shows it still with the later Greek art on the ground floor; the catalog of 1914 locates it above the staircase. In both cases the catalog entry appears in the correct chronological location, although it indicates the exceptional placement of this one piece. On the history of the museum's design, see Linda S. Phipps, "The 1893 Art Institute Building and the 'Paris of America': Aspirations of Patrons and Architects in Late Nineteenth-Century Chicago," *Art Institute of Chicago Museum Studies* 14 (1988): 28–45. The entire issue is a useful resource on developments in the physical arrangement of the Art Institute.

6. For a late expression of the challenge presented to an influential line of art-historical thought by mainstream nineteenth-century art, see Hilton Kramer's attack on the Metropolitan Museum's André Meyer Galleries, "Does Gérôme Belong with Goya and Monet?" *New York Times*, 13 April 1980, sec. 2. See also Douglas Crimp's response (which drew my attention to Kramer's article) in *On*

the Museum's Ruins (Cambridge: MIT Press, 1993), 44–45. On the late entry of nineteenth-century art generally into the canon of work studied in art history, see Jonathan Crary, *Techniques of the Observer* (Cambridge: MIT Press, 1992), 21–23.

7. *The Triumph of Art for the Public* (Garden City, N.Y.: Anchor, 1979) is the entirely apt title Elizabeth Holt gives her collection of sources from this period. A more acerbic but related description is offered in the title of Linda Dowling's study, *The Vulgarization of Art: The Victorians and Aesthetic Democracy* (Charlottesville: University Press of Virginia, 1996). For the important eighteenth-century background to this development, see John Barrell, *The Political Theory of Painting from Reynolds to Hazlitt: The Body of the Public* (New Haven: Yale University Press, 1986), and David H. Solkin, *Painting for Money: The Visual Arts and the Public Sphere in Eighteenth-Century England* (New Haven: Yale University Press, 1993).

8. Crary (*Techniques*), Dowling (*The Vulgarization of Art*), and Martin Meisel (*Realizations: Narrative, Pictorial, and Theatrical Arts in Nineteenth-Century England* [Princeton: Princeton University Press, 1983]) offer vital analyses of intellectual and social developments affecting the cultural place of art in the period. A useful recent anthology is Carol T. Christ and John O. Jordan, eds., *Victorian Literature and the Victorian Visual Imagination* (Berkeley: University of California Press, 1995). For developments in the history of art and taste, see the work of Francis Haskell, particularly *Rediscoveries in Art: Some Aspects of Taste, Fashion, and Collecting in England and France* (Ithaca: Cornell University Press, 1980). See also two earlier volumes by John Steegman, *Victorian Taste: A Study of the Arts and Architecture from 1830 to 1870* (Cambridge: MIT Press, 1971), and *The Rule of Taste: From George I to George IV* (1936; reprint, London: National Trust of Great Britain, 1986). A recent collection illuminating the nineteenth-century culture of art is Brian Allen, ed., *Towards a Modern Art World* (New Haven: Yale University Press, 1995). For a study treating in detail one underconsidered stratum of collectors, see Dianne Sachko Macleod, *Art and the Victorian Middle Class: Money and the Making of Cultural Identity* (Cambridge: Cambridge University Press, 1996). See also Paula Gillett, *The Victorian Painters's World* (Gloucester: Alan Sutton, 1990), esp. the chapter, "Art Publics in Late Victorian England," 192–224. On the Royal Academy, see Sidney C. Hutchinson, *The History of the Royal Academy, 1768–1986* (London: Robert Royce, 1986). For a compendium of related sources, and the international element of the developing public interest in art, see Holt, *Triumph of Art*. Books on individual authors that include important treatment of the culture of art in the period include Elizabeth K. Helsinger, *Ruskin and the Art of the Beholder* (Cambridge: Harvard University Press, 1982); Morris Eaves, *The Counter-Arts Conspiracy: Art and Industry in the Age of Blake* (Ithaca: Cornell University Press, 1992); Robert N. Essick and Donald Pearce, *Blake in His Time* (Bloomington: Indiana University Press, 1978); and Ian Jack, *Keats and the Mirror of Art* (Oxford: Clarendon Press, 1967). Richard L. Stein's *The Ritual of Interpretation: The Fine Arts as Literature in Ruskin, Rossetti, and Pater* (Cambridge: Harvard University Press, 1975) is a useful treatment of writing on art in the nineteenth century as a literary mode. Johannes Dobai provides a compendious resource for the study of authors and issues treated in the first part of this study in *Die Kunstliteratur des Klassizismus und der Romantik in England* (Bern: Benteli, 1974–

77). For the period discussed in this book, Raymond Williams's seminal *Culture and Society* (London: Chatto and Windus, 1958) is still the most nuanced and capacious treatment of the interplay of the terms of his title.

9. That claims of greater historicity—a common enough gambit in recent critical work—have had particular force when made in relation to the subject of taste is a sign of the real difficulty of carrying out such a project. Martha Woodmansee makes a sweeping historical challenge to aesthetic philosophers in *The Author, Art and the Market: Rereading the History of Aesthetics* (New York: Columbia University Press, 1994), 2–7. "Those who make an occupation of aesthetics tend to deny the history of their subject matter," she declares boldly, including even the Marxist work of Terry Eagleton under this charge. What Woodmansee sees as denial, however, M. H. Abrams identified more than forty years ago as an essential methodological problem: "The field of aesthetics presents an especially difficult problem to the historian," he notes at the opening of *The Mirror and the Lamp: Romantic Theory and the Critical Tradition* (1953; reprint, New York: Norton, 1958), 3. Peter Bürger offers an analysis of the question that is still useful, both for its formulations, and for its recognitions of the challenges of arriving at a historicized aesthetics. See esp. "The Historicity of Aesthetic Categories," in his *Theory of the Avant-Garde*, 15–20. The tendency to assume that to historicize is to strip away the achievement or impoverish the experience of the work of art, that its goal or effect is to destroy essential qualities in the object it addresses, has been an important factor in the creation and reception of much current critical work. Pierre Bourdieu has recently challenged this assumption and argued forcefully that taking into account the social conditions of production and reception of art need not result in the destruction of the possibility of an intense response to the aesthetic object. See *The Rules of Art* (esp. xv–xx, though it is a topic that returns throughout that study). *The Rules of Art* is ultimately far more useful for the historian of culture than Bourdieu's *Distinctions* or the earlier *The Love of Art*, works best read as sociological studies of contemporary French culture.

10. On the "scripted" continent, see James Buzard, *The Beaten Track: European Tourism, Literature, and the Ways to Culture, 1800–1918* (Oxford: Oxford University Press, 1993). E. M. Forster at once endorses and mocks the new subjectivism of the twentieth-century traveler in the title and content of the second chapter of *A Room with a View*: "In Santa Croce *with No Baedeker*." The title of his 1908 novel itself is, of course, drawn from a tourist's clichéd desire, frustrated as the work begins.

11. See Richard Altick, *Paintings from Books: Art and Literature in Britain, 1760–1900* (Columbus: Ohio State University Press, 1985). Martin Meisel traces the complex relations among various forms of narrative representations in his magisterial *Realizations*.

INTRODUCTION
THE MUSEUM AS MORTUARY

1. The tendency in much recent critical work to understand all institutions as sharing the coercive effect of the prison, of the malicious if sometimes disguised desire to control and manipulate that has been associated, following Foucault,

with Bentham's panopticon, is surprisingly often based on a sharp distinction between self and culture, which is ultimately extremely difficult to maintain, and which Foucault's writings themselves do not in fact support. Not only does simple self-examination quickly reveal the deep ties joining our selves to culture and its institutions, so that it is impossible to identify the place at which self and culture do not overlap, but the institutions that contribute to our making are themselves evidently reshaped by needs, confusion, even passions, which have more interesting forms than the ultimately banal ones of coercion, complicity, submission, or resistance. The paradigmatic forms for the relation of self and institution may best be looked for not in the ultimately simple power structures of the prison, but in those suggested by the more complex and inescapable interplay of complicity and resistance that characterizes the self in relation to the family, or by the dark promises and disappointments the family shares with the passions of the erotic life. Cf. John Guillory's comments on "mixed conditions": "It may well be impossible, for example, to experience 'just sex,' exclusive of the social meanings of sexual acts. But it would be incorrect on that account to deny the specificity of the sexual. If the revelation of the impurity of the aesthetic tempts one to deny its *reality*, that logical misstep is the consequence of the historical determinations which have produced aesthetic discourse as a *discourse of purity*. . . . the experience of *any* cultural work is an experience of an always composite pleasure.'" *Cultural Capital* (Chicago: University of Chicago Press, 1993), 336. A related attempt to trouble the naive desire to get beyond culture motivates Judith Butler, who asks, "why is it that what is constructed is understood as an artificial and dispensable character?" *Bodies That Matter* (New York: Routledge, 1993), xi. It is no coincidence that Foucault's most nuanced account of the relation of self and culture occurs in his later writings on sexuality.

2. The centrality of the mausoleum for both patron and architect is discussed in Giles Waterfield, *Soane and After: The Architecture of Dulwich Picture Gallery* (London: Dulwich Picture Gallery, 1987), 8; also 15–19. See also Giles Waterfield, ed., *Soane and Death: The Tombs and Monuments of Sir John Soane* (London: Dulwich Picture Gallery, 1996), esp. 53–69.

3. Johann Wolfgang von Goethe, *Wilhelm Meister's Apprenticeship*, trans. Eric A. Blackall, in cooperation with Victor Lange (Princeton: Princeton University Press, 1995), 330–32. Mignon's illness reaches its crisis immediately following Wilhelm's experience of the museum (333). For her funeral at the Hall of the Past, which is also the opportunity for revealing the secret of her origins, see 352–54.

4. Marinetti, "The Founding and Manifesto of Futurism," 42. Theodor W. Adorno, "Valéry Proust Museum," in *Prisms*, trans. Samuel Weber and Shierry Weber (London: Neville Spearman, 1967), 175–85; quotation from 175. For a sophisticated recent treatment of this theme, see Douglas Crimp, "On the Museum's Ruins," in *The Anti-Aesthetic: Essays on Postmodern Culture*, ed. Hal Foster (Port Townsend, Wash.: Bay Press, 1983), 43–56. See also his book, *On the Museum's Ruins*. Andreas Huyssen brilliantly catalogs the aspirations of the museum-hating traditions and places them in relation to the vogue for museums of our own day. See "Escape from Amnesia: The Museum as Mass Media," in Andreas Huyssen, *Twilight Memories: Marking Time in a Culture of Amnesia* (New York: Routledge, 1995), 13–35.

5. Martin Heidegger, "The Origin of the Work of Art" (1936), in *Poetry, Language, Thought*, trans. Albert Hofstadter (New York: Harper & Row, 1975), 17–87; quotation from 40.

6. W. H. Auden, *Collected Poems*, ed. Edward Mendelson (New York: Random House, 1976), 146–47.

7. Though her study focuses on the later nineteenth century in France and Russia, an intriguing and related argument is made in Svetlana Boym's *Death in Quotation Marks: Cultural Myths of the Modern Poet* (Cambridge: Harvard University Press, 1991). See esp. 2–36 and 242–48 for her more general theoretical considerations. See also the treatment of impersonality in Maud Ellmann, *The Poetics of Impersonality* (Brighton: Harvester Press, 1987), 1–17. Ellmann is particularly interesting on the structures by which modernist claims to impersonality become celebrations of the author, how this figure, as she says, "thrives on the chastisement" (6). For a related argument on the nineteenth century, see Tricia Lootens, *Lost Saints: Silence, Gender, and Victorian Literary Canonization* (Charlottesville: University Press of Virginia, 1996).

8. Foucault is careful to place his own challenge to received notions of authorship at the end of a modernist tradition including Nietzsche, Flaubert, Proust, Kafka, and Beckett. Indeed, his lecture exfoliates from a line of Beckett's, which is itself appropriately indeterminate in origin: "'What does it matter who is speaking,' someone said, 'what does it matter who is speaking.'" Foucault describes this nested question as perhaps the most fundamental ethical principle of contemporary writing. Michel Foucault, "What Is an Author?" in *Textual Strategies*, ed. Josue V. Harari (Ithaca: Cornell University Press, 1979), 141–60."[L]e principe éthique, le plus fondamental peut-être, de l'écriture contemporaine." "Qu'est-ce qu'un auteur?" *Bulletin de la Société française de Philosophie* 4 (1969): 73.

Foucault-inspired analyses of the institutions of art have tended to draw less frequently on "What Is an Author" than on his writings on such institutions as the asylum, the prison, and the clinic in order to present the museum as yet another institution for surveillance and regulation. For what is probably the most sophisticated Foucaultian reading of the museum, see Tony Bennett, *The Birth of the Museum: History, Theory, Politics* (London: Routledge, 1995), esp. 59, 63, for his analysis of the limitations of earlier attempts to use Foucault in this context.

9. When challenged after his presentation, Foucault insists that he is not interested in declaring man or the author dead, but rather in describing how it was possible that either category came into being. See the important dialogue following the original delivery of the paper, transcribed in "Qu'est-ce qu'un auteur?" 97–104, esp. 101. Foucault is allusive and suggestive rather than direct in his exposition (hence, in part, the unfortunate weakness of any translation of this much read piece). Peter Lamarque, who offers a careful analysis of the network of implied arguments in the essays of Barthes and Foucault is particularly interesting when he notes the wavering in both authors between description (the author is dead) and prescription (the author should die). Nevertheless, he concludes that it is impossible to miss the polemical desire to do away with the figure present in both texts. Peter Lamarque, "The Death of the Author: An Analytical Autopsy," *British Journal of Aesthetics* 30, no. 4 (1990): 319–31. The most thoroughgoing intellectual contextualization and analysis of Foucault's argument is offered in

Seán Burke, *The Death and Return of the Author* (Edinburgh: Edinburgh University Press, 1992).

10. Cf. Lamarque: "An underlying assumption in both Barthes and Foucault is that there is intrinsic merit in what Foucault calls the 'proliferation of meaning.' Perhaps the fundamental objection to their combined programme is that this assumption is unsupported and untenable. . . . They both assume that more is better." "Death of the Author," 330.

11. I should mention some of the elements this study does not engage, though it might be expected to do so. The project involves some of the central socio-cultural developments most commonly associated with the nineteenth century—among them the rise of mass culture and the related emergence of a middle-class sensibility and audience. The proverbial rise of the middle class has had surprisingly interesting treatment in recent critical writing, and this study does not return to that territory. The presence of the public in the artistic and critical imagination is given a rich treatment by Barrell, Solkin, and Dowling; Bourdieu is an important source for the quite distinct French context. A more troubling absence from my discussion is that of the important narrative and poetic tradition that served to develop, promulgate, and complicate the nineteenth-century culture of art. Not only do I offer no analysis of the self-creation and promotion of that important nineteenth-century figure for artistic glamour and danger—Lord Byron—or of the easily-recognized importance of art and artist in the fiction of George Eliot, Hawthorne, and James, but I am unable even to begin with the vital role of women in the nineteenth-century culture of art. The writings of authors from Madame de Staël to Anna Jameson and beyond form an integral part of the history of the nineteenth-century culture of art. While I regret their absence from this study, due to the constraints of space and my own ignorance when the project began, I take comfort in the fact that the centrality of these authors will become steadily clearer with the emergence of current research. Important studies in this area include Lootens, *Lost Saints*, and Yopie Prins, *Victorian Sappho* (Princeton: Princeton University Press, 1999).

12. Bourdieu is emphatic on the interplay of visual artist and writer determining the emergence of the modern figure of the artist: "If the innovations that led to the invention of the modern artist and art are only intelligible at the level of all the fields of cultural production together, this is because artists and writers were able to use the lags between the transformations occurring in the literary field and the artistic field to benefit, as in a relay race, from advances carried out at different moments by their respective avant-gardes. Thus the discoveries made possible by the specific logic of one or another of the two fields could have a cumulative effect and appear retrospectively as the complementary profiles of one and the same historic process." *Rules of Art*, 132–33.

CHAPTER ONE
DAVID AND FUSELI: THE ARTIST IN THE MUSEUM,
THE MUSEUM IN THE WORK OF ART

1. Walter Jackson Bate offered the seminal outline of the issue in *The Burden of the Past and the English Poet* (London: Chatto, 1971). His insight, that writers at

the end of the eighteenth century were preoccupied by a sense that the works of the past confronted them with an unmatchable achievement, was notably theorized by Harold Bloom in *The Anxiety of Influence* (London: Oxford University Press, 1975) and other works that developed a complex Oedipal model to describe the competition between artists and their precursors. Bloom's work has had its most compelling application in art history in Norman Bryson, *Tradition and Desire: From David to Delacroix* (Cambridge: Cambridge University Press, 1984). My own argument draws on these earlier critics and on Bryson's suggestive analysis of neoclassicism, but seeks to move the discussion beyond the psychology of creative rivalry motivating Bloom and Bryson. To trace the cultural sources of the sense of inadequacy and to demonstrate the links between its development and the formation of institutions of art, is to historicize an anxiety that has tended to be understood as ultimately quite natural, as the normative rivalry of creative minds in Bloomian thought or as the normal self-doubts of an era unable to match earlier accomplishments in Bate.

2. On theories of art and of the artist in the eighteenth century and at the turn of the nineteenth, see Abrams, *The Mirror and the Lamp*, and Lawrence Lipking, *The Ordering of the Arts in Eighteenth Century England* (Princeton: Princeton University Press, 1970). For a recent political treatment, see also Barrell, *Political Theory of Painting*. Useful general accounts of the art history of the period include Henry Hawley, *Neo-Classicism: Style and Motif* (New York: Abrams, 1964); Holt, *The Triumph of Art for the Public* Hugh Honour, *Neo-Classicism* (Harmondsworth: Penguin, 1968); Ann M. Hope, *The Theory and Practice of Neoclassicism in English Painting* (New York: Garland, 1988); David Irwin, *English Neoclassical Art: Studies in Inspiration and Taste* (London: Faber, 1966); Michael Levey, *Rococo to Revolution* (New York: Oxford University Press, 1977); Robert Rosenblum, *Transformations in Late Eighteenth Century Art* (Princeton: Princeton University Press, 1970); and William T. Whitley, *Artists and Their Friends in England—1700–1799* (London: Medici Society, 1928).

3. J. H. Wilhelm Tischbein, "Letters from Rome about New Works of Art by Contemporary Artists," *Der Teutsche Merkur*, February 1786, in Holt, *Triumph of Art*, 28. Tischbein's prescient view is amply supported and developed by later critics. The claims of the art historians are stark; it has been said of the painting not only that it is "the definite statement of the first phase of neo-classicism," but that it "marks an irreparable cleavage between an old and a new world." Hawley, *Neo-Classicism*, 13; Rosenblum, *Transformations*, 71. The following, selected from the vast and constantly growing literature on David, provide a useful account of his work and its context: Anita Brookner, *Jacques-Louis David* (New York: Thames and Hudson, 1987); Thomas E. Crow, *Painters and Public Life in Eighteenth Century France* (New Haven: Yale University Press, 1985), and *Emulation: Making Artists for Revolutionary France* (New Haven: Yale University Press, 1995); J. L. Jules David, *Le Peintre Louis David, 1748–1825* (Paris, 1880); Louis Hautecoeur, *Louis David* (Paris: La Table ronde, 1954); Dorothy Johnson, *Jacques-Louis David: Art in Metamorphosis* (Princeton: Princeton University Press, 1993); Emmet Kennedy, *A Cultural History of the French Revolution* (New Haven: Yale University Press, 1989); and Simon Schama, *Citizens* (New York: Knopf, 1989). Although some of the more exaggerated political claims made about the *Horatii* have been

softened in recent criticism, its importance for the art of the time and as a digest of the art of the period is unquestioned: "it was as if he had ingested the neoclassical movement, naturalized it into French, harnessed it to the approved seventeenth-century models, and thus brought to fruition the disparate efforts of the preceding half century." Brookner, *Jacques-Louis David*, 68. See also Brookner, 69–80, and Honour, *Neo-Classicism*, 71–72, 195n.

4. More recently, the *Horatii* is at the center of David Carrier's discussion of the contradictory nature of art-historical writing. See "David's *Oath of the Horatii*: The Search for Sources of an Eighteenth-Century Masterpiece," in David Carrier, *Principles of Art Historical Writing* (University Park: Pennsylvania State University Press, 1991), 139–55.

5. *Horace*, in *The Chief Plays of Corneille*, trans. Lacy Lockert (Princeton: Princeton University Press, 1957), 112. "Albe est ton origine; arrête, et considère / Que tu portes le fer dans le sein de ta mère." Corneille, *Horace* (London: Harrap, 1976), 1.1.55–56. On the complex question of origins in the play, see John D. Lyons, *The Tragedy of Origins: Pierre Corneille and Historical Perspective* (Stanford: Stanford University Press, 1996), esp. 39–70.

6. The following sources have been suggested for the story in the painting: Livy, Dionysus of Halicarnassus; a recently translated supplement to Plutarch's *Lives* by Thomas Rowe; Rollin's *Histoire ancienne*; Corneille's *Horace*; a ballet by Jean Noverre, *Les Horaces* (1777). The case for the ballet is made in Edgar Wind's important essay, "The Sources of David's *Horaces*," *Journal of the Warburg and Courtauld Institute* 4 (1941): 124–35, but his conclusions are not widely supported. Brookner proposes a psychological argument for the oath (*Jacques-Louis David*, 80). See also Rosenblum, *Transformations*, 68–72.

7. In J. L. Jules David, *Le Peintre Louis David*, 28; quoted and translated in Brookner, *Jacques-Louis David*, 76. David introduces this topic as having to do with size, but it soon turns into a discussion of composition and artistic development: "Elle me fut donnée de 10 sur 10; mais ayant tourné ma composition de toutes les manières, voyant qu'elle perdait de son énergie, j'ai abandonné de faire un tableau pour le Roi, et je l'ai fait pour moi."

8. Disagreements between painters and their patrons were not unheard of before this. The most famous instance is no doubt the tempestuous relationship between Michelangelo and Pope Julius II. But, this well-known example can be misleading. Michelangelo is allowed remarkable license because he is recognized as an exceptional artist; David, at a relatively early point in a career and entirely enmeshed in the French system of art, nevertheless claims the right to *develop as* an artist. For an attempt to see the relationship between pope and painter as an early stage in the autonomy of the modern artist, see Rudolf Wittkower and Margot Wittkower, *Born under Saturn: The Character and Conduct of Artists* (New York: Norton, 1969), 38–40.

9. *Le Frondeur, ou Dialogues sur le Salon par l'auteur du Coup-de-patte et du triumvirat* (n.p., 1785). Quoted and translated in Crow, *Painters*, 218.

10. The need to separate the artist from the stigma of selling his work is not new to the eighteenth century—though one wonders how much a prejudice that is itself the inheritance of the period under discussion motivates propositions such as the following, originally published in 1934: "It is generally reckoned as one of

the reasons for the Greeks' relegation of figurative artists to the rank of the artisan that they, unlike poets and seers, were paid for their productions." Ernst Kris and Otto Kurz, *Legend, Myth, and Magic in the Image of the Artist* (New Haven: Yale University Press, 1979), 113.

11. Sir Joshua Reynolds, *Discourses on Art*, ed. Robert Wark (San Marino: Huntington Library, 1959), Discourse IV, 57. Further references are cited in the text.

12. The description is Walter Jackson Bate's, in *From Classic to Romantic* (New York: Harper and Row, 1946), 79.

13. James Boswell, *The Life of Samuel Johnson* (1791; reprint, London: Dent, 1906), 1:145. Emphasis in the original. Further references are cited in the text.

14. On the class insecurities of the eighteenth-century painter, see Steegman, *The Rule of Taste:* "The social position of artists, until after the middle of the century, was not exalted. . . . The professional artist if attached to or protected by a nobleman, was a servant or a tradesman" (98). For accounts of the variety of relationships possible between painters and their patrons, see Josephine Gear, *Masters or Servants: A Study of Selected English Painters of the Later Eighteenth and Early Nineteenth Centuries* (New York: Garland, 1977). Solkin offers sophisticated analysis of the problem of art and commerce in his *Painting for Money*. For the European situation, see also Remy G. Saisselin, "Neo-Classicism: Virtue, Reason and Nature," in Hawley, *Neo-Classicism*, 3–4. See also Barrell, *Political Theory*, esp. 12–18.

15. Nikolas Pevsner, *Academies of Art Past and Present* (Cambridge: Cambridge University Press, 1940), 30–67, 140–89. On the function of the creation and organization of the academy in England as a central part of abandoning the stigma of craft, see Iain Pears, *The Discovery of Painting: The Growth of Interest in the Arts in England, 1680–1768* (New Haven: Yale University Press, 1988), 107–32. It was not only in England that the stabilization of an insecure social rank was the work of the institution: "a tendency to stress the high social standing of the artist by academic means goes through all the new foundations of the seventeenth and eighteenth centuries." Pevsner, *Academies*, 187. For a recent study of the history and development of academic instruction, see Carl Goldstein, *Teaching Art: Academies and Schools from Vasari to Albers* (Cambridge: Cambridge University Press, 1996).

16. See Schama: "What kind of body language could possibly live up to the grandiloquence of the moment? With a sense that they had finally set themselves into a history worthy of the Romans, they joined in adopting the gesture given to the Horatii by Jacques-Louis David." *Citizens*, 359. The drawing of *The Tennis Court Oath* was shown at the 1791 Salon (along with the *Oath of the Horatii* and the *Brutus*), but the project was abandoned by 1801, when political changes overtook the moment it celebrated. For an exhaustive history of David's unfinished work, see Phillipe Bordes, *Le Serment du Jeu de Paume de Jacques-Louis David* (Paris: Editions de la Réunion des musées nationaux, 1983). For the collapse of the political unity the drawing celebrates, see also Schama's discussion, *Citizens*, 569–72.

17. See esp. Bryson, *Tradition*, 70–82; also Carrier's summary of recent discussion, *Principles*, 144–54.

18. Brookner, *Jacques-Louis David*, 78, cites the sketch. She also gives a useful survey of the pictorial sources, 77–79. See Brookner, pl. 40; Wind, "The Sources of David's *Horaces*," 124–35; Rosenblum, *Transformations*, 68–70; Honour, *Neo-Classicism*, 36; Hawley, *Neo-Classicism*, 13. On David's self-conscious (and self-promoting) use of elements from Poussin in earlier work, see Crow's discussion of *Andromache Mourning Hector* (Salon of 1783), in *Painters*, 211.

19. For example, "a style of painting which approaches colored bas-reliefs." Hawley, *Neo-Classicism*, 13. "Every viewer of the painting must be struck by the *Oath*'s return to a rudimentary or fundamental space." Bryson, *Tradition*, 81.

20. Irwin is quite clear on the link between moral program and style: "The main emphasis in Neoclassical art is on man and his activities . . . it is not concerned with the frivolous and does not allow the setting to dominate." Irwin, *English Neoclassical Art*, 29–30. See also Honour on the movement's dislikes, including: "Deep suspicion of those painterly, illusionistic devices employed by Baroque and Rococo artists." Honour, *Neo-Classicism*, 19. For a sense of the space that artists allowed themselves in a "minor" genre, it is useful to think of the contemporary portrait. Reynolds and Gainsborough, for example, typically place their subjects outdoors, the winds brightening their cheeks, a long vista of countryside opening behind them, the sky enlivened by the swirl of clouds.

21. Reynolds is true to neoclassical standards when he criticizes the choice of subject of Venetian painters for being "mostly such as give them an opportunity of introducing a great number of figures; such as feasts, marriages, and processions, publick martyrdoms, or miracles." Reynolds, *Discourses*, 65; Discourse IV, 1771. The entirety of his analysis is interesting as a vivid demonstration of the neoclassical rejection of space and incident.

22. On the complex function, and changing nature of theatricality in the work of David, see Michael Fried, *Absorption and Theatricality* (Berkeley: University of California Press, 1980) and "Thomas Couture and the Theatricalization of Action in 19th Century French Painting," *Artforum* 8, no. 10 (1970): 41–42.

23. Hawley proposes David's *Oath* as the definitive statement of what he calls "the first phase of Neoclassicism" and discusses Fuseli as the principal contributor to "the second phase" (*Neo-Classicism*, 13–14). Though his division of the movement is not entirely supported by the dates, these painters are figures around which its often contradictory characteristics can be seen to crystallize. On Fuseli, see Marcia Allentuck, "Fuseli's Translations of Winckelmann: A Phase in the Rise of British Hellenism with an Aside on William Blake," in *Eighteenth Century Studies: Papers Presented at the Second David Nichol Smith Memorial Seminar*, ed. R. F. Brissenden (Toronto: University of Toronto Press, 1970), 163–85. See also Frederick Antal, *Fuseli Studies* (London: Routledge, 1956); Henry Fuseli, *The Life and Writings of Henry Fuseli*, ed. John Knowles (1831; reprint, London: Kraus International Publications, 1982), 1:1–21; Eudo C. Mason, *The Mind of Henry Fuseli* (Routledge & Kegan Paul, 1951), 15; Gert Schiff, *Johann Heinrich Füssli, 1741–1825* (Munich: Prestel, 1973); Peter Tomory, *The Life and Art of Henry Fuseli* (New York: Praeger, [1972]). See also Irwin, *English Neoclassical Art*, 44–48. References to the writings of Fuseli are taken from Knowles's edition and cited in the text.

24. The translation, "The artist *in despair before* the magnitude of ancient ruins," is more accurate and useful than the frequently encountered "the artist *moved by* the grandeur. . . ." *Verzweifeln*, with its root of *Zweifel*, or doubt, carries more of the meaning of despair than of a generalized—and, especially in the eighteenth century, often positive—emotional response: "moved." The change of preposition to a closer cognate to *vor* insists on the causal ambiguity in the original, as well as on a physical placement of the artist. I use magnitude instead of "grandeur," because I think the implication of great size in the latter has been almost lost in a more common meaning of generalized magnificence. I would like to insist on the size of the ruin, the *position* of the artist in relation to it, and the bleakness of his response.

25. "The poetic taste for and response to ruins did not exist in the sixteenth or seventeenth century," writes a historian, not long after the development he describes: "it emerged in France at the end of the eighteenth century, together with melancholy." Jean Jacques Ampère, *Portraits of Rome in Different Ages* (1835), quoted in Claude Moatti, *In Search of Ancient Rome* (New York: Abrams, 1993), 172. On ruins in literature in France and elsewhere, see Roland Mortier, *La Poétique des ruines en France* (Geneva: Librairie Droz, 1974). For England, see Laurence Goldstein, *Ruins and Empire: The Evolution of a Theme in Augustan and Romantic Literature* (Pittsburgh: University of Pittsburgh Press, 1977).

26. On this picture, see Irwin, *English Neoclassical Art*, 38. For the important and varied influence of Gavin Hamilton on attitudes toward art and antiquity in the period, see Irwin, 31–38; and Hawley, *Neo-Classicism*, 9–15. See also David Irwin and Francina Irwin, *Scottish Painters: at Home and Abroad, 1700–1900* (London: Faber, 1975), 101–4.

27. Wood and Dawkins made the voyage in 1751. *The Ruins of Palmyra, otherwise Tedmor in the Desert* was published in London, 1753, and followed by *The Ruins of Balbec* in 1757. The books were published together with additions by Wood as *The Ruins of Palmyra and Balbec* (London, 1827). The original edition of *Palmyra* was translated into French the year it came out. Hamilton drew on the original edition for his painting.

28. "O Solitude, romantic maid, / Whether by nodding towers you tread, / Or haunt the dessert's trackless gloom, / . . . / Or at the purple dawn of day, / Tadmor's marble wastes survey. . . ." In Chalmers's *Poets* the passage is annotated as follows, "Alluding to the account of Palmyra, published by Messrs. Wood and Dawkins, and the manner in which they were struck by the sight of these magnificent ruins by break of day." Samuel Johnson and Alexander Chalmers, eds., *The Works of the English Poets* (London, 1810), 475. Johnson, who was especially fond of the poem, quotes this passage from memory in Boswell, *Life of Samuel Johnson*, 2:144. Reynolds owned Wood's account of the voyage, and makes an oblique reference to it in 1774 (see Reynolds, *Discourses*, 94 and note).

29. The inherent and manifold sublimities of Palmyra are insisted on in Wood's text: "We had scarce passed these venerable monuments, when the hills opening discovered to us, at once, the greatest quantity of ruins we had ever seen, all of white marble, and beyond them towards the Euphrates, a flat waste as far as the eye could reach, without any object which showed either life or motion. It is

scarce possible to imagine any thing more striking than this view: so little wall or solid building, afforded a most romantic variety of prospect. But the following plate will convey a juster idea of it than any description." Robert Wood, *The Ruins of Palmyra* (London, 1753), 35. As if the description and image were not sufficiently representative of the sublime, Wood repeatedly speculates on the likelihood that Longinus, whose theories of the sublime had found a new audience in the eighteenth century, was a native of the area (21 and note, 23, 27).

30. In the opening address to the reader, the ship carrying the expedition is described by Wood as freighted with Western culture: "She brought from London a library consisting chiefly of all the Greek historians and poets." Indeed, Wood's whole address insists that the primary interest of this expedition was literary: "Where we thought the present face of the country was the best comment on an ancient author, we made our draftsman take a view, or make a plan of it." Ibid., unnumbered page. In his discussion of the city itself Wood's references include the Old Testament, Josephus, and Pliny.

31. Constantin-François Volney, *The Ruins, or A Survey of the Revolutions of Empires* (Albany, 1822), vi. The play on sacred texts is clearer in the original: "Je vous salue, ruines solitaires, tombeaux saints, murs silencieux! C'est vous que j'invoque; c'est à vous que j'adresse ma prière." As the invocation continues, the ruins take on the qualities not only of the Virgin Mary, but of the Rights of Man: "Combiens d'utiles leçons, de réflexions touchantes ou fortes n'offrez-vous pas à l'esprit qui vous sait consulter! C'est vous qui, lorsque la terre entière asservie se taisoit devant les tyrans, proclamiez déjà les vérités qu'ils détestent, et qui, confondant la dépoille des rois à celle du dernier esclave, attestiez le saint dogme de l'ÉGALITÉ." Constantin-François Volney, *Les Ruines, ou Méditation sur les révolutions des empires* (1791; reprint, Paris, 1792). Further references are to these two editions. The translation is cited in the text.

32. "[M]es yeux se remplirent de larmes; et couvrant ma tête du pan de mon manteau, je me livrai à de sombres méditations sur les choses humaines. . . . Et je demeurai immobile, absorbé dans une mélancolie profonde." Volney, *Les Ruines*, 4.

33. Volney's influential and popular account of his travels in the Middle East, *Voyage en Syrie et en Egypte*, 2 vols. (Paris, 1787), includes detailed information on the ruins of Palmyra, which he never reached. His entire description, much of his discussion, and the illustration he provides are all drawn from Wood and Dawkins, a text he quotes at length and to which he refers his readers. See *Voyage*, 2:256–65.

34. "Chaque jour je sortois pour visiter quelqu'un des monuments qui couvrent la plaine; et un soir que, l'esprit occupé des réflexions, je m'étois avancé jusqu'à la *vallée des sépulcres*, je montai sur les hauteurs qui la bordent, et d'où l'oeil domine à-la-fois l'ensemble des ruines et l'immensité du désert.—Le soleil venoit de se coucher; un bandeau rougeâtre marquoit encore sa trace à l'horizon lontain des monts de la Syrie: la pleine-lune à l'orient s'élevoit sur un fond bleuâtre, aux planes rives de l'Euphrate; le ciel étoit pur . . . l'oeil n'appercevoit plus aucun mouvement sur la plaine monotone et grisâtre; un vaste silence régnoit sur le désert. . . . L'ombre croissoit, et déja dans le crépuscule mes regards ne distinguoient plus que les fantômes blanchâtres des colonnes et des murs. . . . Je

m'assis sur le tronc d'une colonne; et là, le coude appuyé sur le genou, la tête soutenue sur la main, tantôt portant mes regards sur le désert, tantôt les fixant sur les ruines, je m'abandonnai à une rêverie profonde." Volney, *Ruines*, 3–4.

35. This connection, originally in Pliny, is insisted on by Wood. See Wood, *Ruins of Palmyra*, 5, 35.

36. For another version of the opening out of perspective from the contemplation of ruins, compare Diderot's vertiginous description of the source of the "douce mélancolie" of the "poétique des ruines": "Nous anticipons sur les ravages du temps, et notre imagination disperse sur la terre les édifices mêmes que nous habitons. . . . Nous restons seul de toute une nation qui n'est plus; et voilà la première ligne de la poétique des ruines." Denis Diderot, *Salons*, ed. Jean Seznec, 2d ed. (Oxford: Clarendon Press, 1983), 2:227. The passage occurs in the course of his remarkable response to the ruins of the painter and eventual curator of the Louvre, Hubert Robert (2:221–49).

37. Quoted in Nikolas Pevsner, *A History of Building Types* (Princeton: Princeton University Press, 1976), 126.

38. As early as 1752, the new valuations of art and artist inspired Samuel Foote's satire, *Taste*. His aim was to "shew the absurdity of placing an inestimable value on . . . a parcel of maimed busts, erazed [*sic*] pictures, and inexplicable coins, only because they have the mere name and appearance of antiquity, while the more perfect and really valuable performances of the most capital artists of our own age and country . . . are totally despised and neglected, and the artists themselves forced to pass through life unnoticed and discouraged." Foote, *Works* (London, 1809), 1:15, quoted in Allentuck, "Fuseli's Translations," 169. Foote's complaint would be repeated throughout this century and the next.

39. Pevsner is particularly interesting on the inescapable relationship between neoclassical theorists and the establishment and design of museums. See *History of Building Types*, 114–27. The entire chapter is an important source on the history of the museum (111–38). See also Holt, *Triumph of Art*, xxiii, 4; Honour, *Neo-Classicism*, 85–86; and Per Bjurström, ed., *The Genesis of the Art Museum in the 18th Century* (Stockholm: Nationalmuseum, 1993). For more documentation on the history and development of the museum, see my chapter 3 and notes.

40. The cultural importance of these institutions, and the change they represented, are demonstrated by the creation of the Commission of the Museum one day after the overthrow of the monarchy. See Kennedy, *Cultural History*, 220.

41. See Saisselin, "Neo-Classicism," 6.

42. See Irwin, *English Neoclassical Art*, 105–6, 125; Honour, *Neo-Classicism*, 62–66. See also James Sambrook, *The Eighteenth Century: The Intellectual and Cultural Context of English Literature, 1700–1789* (New York: Longman, 1986), 175. Boswell offers an intriguing instance of the process when he annotates Johnson's judicious compromise on the comparative merits of Virgil and Homer with his own insistence that Homer is the better poet. See Boswell, *Life of Samuel Johnson*, 2:141 and note.

43. Giorgio Vasari, *Lives of the Artists*, ed. and trans. George Bull (Harmondsworth: Penguin Books, 1982), 55; my emphasis. Leon Battista Alberti, *On Painting*, trans. John R. Spencer (New Haven: Yale University Press, 1966), 40; my emphasis.

44. "The superiority which art acquired among the Greeks is to be ascribed partly to the influence of climate, partly to their constitution and government and the habits of thinking which originated therefrom, and, in an equal degree also, to respect for the artist, and the use and application of art." Johann Joachim Winckelmann, *History of Ancient Art*, trans. G. Henry Lodge (1764; reprint, Boston, 1873), 2:4. Further references are cited in the text.

CHAPTER TWO
"MONUMENTS OF PURE ANTIQUITY": THE CHALLENGE OF THE
OBJECT IN NEOCLASSICAL THEORY AND PEDAGOGY

1. "On the Imitation of the Painting and Sculpture of the Greeks," trans. Henry Fuseli, in *Winckelmann: Writings on Art*, ed. David Irwin (New York: Phaidon, 1972), 67. Further references are cited in the text. Winckelmann's insistence on "Ideal nature"—a mimesis aiming to abstract the essential or ideal from the contingent world by study and compilation of its most perfect manifestations—is a central tenet of neoclassical criticism. See Honour, *Neo-Classicism*, 101–5. Bate traces the topic in the thought of Johnson and Reynolds (*From Classic to Romantic*, 59–92); indeed, it is inescapable in the latter's *Discourses*. Fuseli is simply following his teachers when, in his own lectures at the academy, he ascribes to "simple local habit" the same status as disease: "By Nature, I understand the general and permanent principles of visible objects, not disfigured by accident or distempered by disease, nor modified by fashion or local habit." Lecture 7, in Fuseli, *The Life and Writings of Henry Fuseli*, 2:313.

2. "Whoever, in order to finish his education, should travel to Italy, and spend his whole time there *only* in copying pictures, and measuring statues or buildings, (though these things are not to be neglected,) would return with little improvement." Discourse XI, Reynolds, *Discourses*, 203; my emphasis. Nollekens's measurements were a personal version of the analysis of the ideal human beauty in classical statues presented in works such as Girard Audran's *Les Proportions du corps humain mesurées sur les plus belles figures de l'antiquité*, an influential manual from 1683, in print and much imitated until the middle of the nineteenth century.

3. Hope gives a good summary of the problem: "many theorists found it difficult to express exactly what else was needed in addition to accuracy of measurement and fidelity in copying. The marbles must not only be studied with infinite care, some further process must take place by which the artist would make the Greek works in some sense his own, would be enabled to create anew rather than merely copy.... For some ... this proved a task beyond their means." Hope, *Theory and Practice*, 97.

4. William Hazlitt, *Essays on Reynolds' Discourses* (*The Champion*, 1814–15), in *The Complete Works of William Hazlitt*, ed. P. P. Howe (London: J. M. Dent, 1930–34), 18:63. Emphasis in the original. Further references to Hazlitt are from this edition, made in the text by volume and page number.

5. Fuseli, Lecture 1, "Ancient Art," in *Life and Writings*, 2:41. On Michelangelo: "where is the great name among the moderns that ever could reach the line and the proportion of the ancients. M. Agnolo filled part of the Capella Sistina with imitations, and sometimes transcripts of the Torso,—will any one stand forth and say that he reached it." Lecture 7, "On Design," 2:317.

6. Gert Schiff, ed., *Henry Fuseli: 1741-1825*, Tate Gallery (London, 1975), 55. See Schiff, *Johann Heinrich Füssli, 1741-1825*, 568.

7. On the relationship of the Fuseli family with Winckelmann, Henry Fuseli's role in making the art historian known in England, and his later disenchantment with the art historian, see Allentuck, "Fuseli's Translations," 163–85.

8. Antal makes the comparison in the course of a discussion of Fuseli's engagement with late Mannerism (*Fuseli Studies*, 102).

9. See Winnifred H. Friedman, *Boydell's Shakespeare Gallery* (New York: Garland, 1976), esp. 24–25, 203–10, and Irwin, *English Neoclassical Art*, 127–31. See also Eaves, *Counter-Arts Conspiracy*, 33–69. For Fuseli's Milton gallery, see Irwin, *English Neoclassical Art*, 131–34, and Gert Schiff, *Johann Heinrich Füsslis Milton-Galerie* (Zurich: Fretz & Wasmuth Verlag, 1963). Also, see Altick, *Paintings from Books*, 43–55.

10. See Schiff, *Johann Heinrich Füssli*, 450–51. The vase was in the important collection of Sir William Hamilton, and Fuseli would have seen it there or reproduced in Baron d'Harcanville, ed., *Antiquités étrusques, grecques et romaines, tirées du Cabinet de M. Hamilton* (Naples, 1766–67). For the influence of this collection on Fuseli and others, see Irwin, *English Neoclassical Art*, 27–28.

11. *Henry Fuseli*, 67. For the *Hamlet* reference, see Schiff, *Johann Heinrich Füssli*, 568.

12. "Throughout the eighteenth century there was a continual flow of books in England that praised the art of Rome," Irwin points out, "and that of Greece as it was known from *description*." Irwin, *English Neoclassical Art*, 22; my emphasis.

13. On the English art market, see Pears, *Discovery of Painting*, 51. The history of the acquisition of sculptures in England is surveyed in Adolf Michaelis, *Ancient Marbles in Great Britain*, 2 vols., trans. C.A.M. Fennell (Cambridge, 1882). For the change represented by the new British demand for ancient sculpture, compare a heading early in the book "No antiquities in England in the sixteenth century" (1:5). See also Haskell and Penny, *Taste and the Antique*, and Michael Clarke and Nicholas Penny, *The Arrogant Connoisseur: Richard Payne Knight, 1751–1824* (Manchester: Manchester University Press, 1982). On the activities of the Dilettanti Society, see Michaelis, *Ancient Marbles*, 1:55–128. See also Lionel Cust, *History of the Society of Dilettanti* (London: Macmillan, 1914); and Cecil Harcourt-Smith, *The Society of Dilettanti, Its Regalia and Pictures* (London: Macmillan, 1932).

14. Steegman notes in *Taste*: "the distinction between Greek, Roman, and Graeco-Roman was not at that time very clearly established. In fact, for the majority of collectors in the eighteenth century the distinction hardly existed at all" (136; see 136–39). See also Irwin, *English Neoclassical Art*, 68–75.

15. Rosenblum, *Transformations*, 48.

16. Cf. Pears on the early seventeenth century: "Not only was there no 'English School' of painting, there was little sign that anyone particularly wanted one." *Discovery of Painting*, 1. Cf. also the title of the chapter on this period in John Summerson, *Architecture in Britain, 1530–1830* (Harmondsworth: Penguin Books, 1969), 245: "Neo-Classicism: Englishmen *Abroad*" (my emphasis). On the early English role in the development of neoclassicism, see Rosenblum, *Transformations*, 34n; Antal, *Fuseli Studies*, 1, 80).

17. Fuseli evokes the Corinthian maid in his very first lecture at the Royal Academy while emphasizing the importance of outline (*Life and Writings*, 2:25). On the subject in the eighteenth century, see Rosenblum, *Transformations*, 20–21, Honour, *Neo-Classicism*, 113. See also Robert Rosenblum, "The Origin of Painting: A Problem in the Iconography of Romantic Classicism," *Art Bulletin* 39 (1957): 279–90; and George Levitine, "Addenda to R. Rosenblum's 'The Origin of Painting,'" *Art Bulletin* 40 (1958): 329–31. See subsequent discussion for Barry's rebuttal of the story.

18. It is worth remembering the assurances of the first president of the academy at a time when the total number of important museums of art in Europe could be counted on one hand and England itself had no readily available art collections of note: "there is no danger of the mind's being over-burthened with knowledge, or the genius extinguished by any addition of images." "To find excellencies, however dispersed, to discover beauties, however concealed by the multitude of defects with which they are surrounded, can be the work only of him, who . . . has extended his views to all ages and to all schools . . . from the East and from the West." Reynolds, *Discourses*, 100, 110.

19. Bate's description of the early Enlightenment as a continuation of Renaissance projects is useful: "The earlier portion of the Enlightenment marks the final subsiding of the European Renaissance: it comprises the consolidation and in some respects the extreme development of the values it inherited." *From Classic to Romantic*, 1. See also Robert R. Wark, in his introduction to Reynolds, *Discourses*, xxiii. On Renaissance Rome and the discovery of antiquity from a nineteenth-century perspective, see Jacob Burckhardt, *The Civilization of the Renaissance in Italy* (1860; reprint, New York: Harper, 1958), 1:175–95.

20. Cf. Immanuel Kant, *Critique of Judgment*, trans. Werner S. Pluhar (1790; reprint, Indianapolis: Hackett, 1987), 50–53 (Akademie edition, 5:209–11). See also Louis Hautecoeur's treatment of the link between nature, antiquity, and reason in neoclassicism in his *Histoire de l'architecture classique en France* (Paris: A. and J. Picard, 1952), 4:1–69.

21. Alex Potts has done important work connecting Winckelmann's art history and his homoeroticism. See *Flesh and the Ideal: Winckelmann and the Origins of Art History* (New Haven: Yale University Press, 1994), esp. 113–44. On the complex relationship of trace, outline, and desire for the historian, see Whitney Davis, "Winckelmann's 'Homosexual' Teleologies," in *Sexuality in Ancient Art*, ed. Natalie Boymel Kampen (Cambridge: Cambridge University Press, 1996), 262–76.

22. For the problem these reconsiderations would cause in Winckelmann's scheme, consider his comments in "On Imitation": "An ancient Roman statue, compared to a Greek one, will generally appear like Virgil's Diana amidst her Oreads, in comparison of the Nausicaa of Homer, whom he imitated" (61). In his letter on Herculaneum, Winckelmann demonstrates the dependence of his system on the dating of canonical works. His nervous discussion of the pitfalls of relying on the analyses of inscriptions of antiquarians—analyses that would place the *Belvedere Torso* substantially later than he would like—concludes with the rhetorical question: "And what would then become of the ideas, we are to entertain of the progress and state of the fine arts among the ancients?" Winckelmann,

Critical Account of the Situation and Destruction by the First Eruption of Mount Vesuvius, of Herculaneum, Pompeii, and Stabia; . . . In a letter . . . To Count Bruhl (London, 1771), 104. Further references in text. On Hellenistic art, see Margarete Bieber, *The Sculpture of the Hellenistic Age*, 2d ed. (New York: Hacker, 1981), and J. J. Pollit, *Art in the Hellenistic Age* (New York: Cambridge University Press, 1986). More remarkable than their errors was the certainty of eighteenth-century scholars in arriving at attributions for works that today are the subject of substantial art-historical disagreement. The *Laocoön*, for example is dated variously to the middle of the second century B.C., to 50 B.C., and to the first century A.D. See Pollitt, *Art*, 271. On William Payne Knight's dating of important statues, see Nicholas Penny, "Collecting Interpreting, and Imitating Ancient Art," in Clarke and Penny, *Arrogant Connoisseur*, 65–81, esp. 77.

23. John Thomas Smith, *Nollekens and His Times* (1828; reprint, London: Century Hutchinson, 1986), 190–91. Nollekens's own testimony is even more strongly in favor of the purchase of the Elgin Marbles (187–89). The reception of the pieces was in no way a simple matter. For an account sympathetic to the aesthetic adjustments required to welcome them—particularly in the ruinous state in which they arrived—see Andrew Ballantyne, "Knight, Haydon, and the Elgin Marbles," *Apollo* 128 (1988): 155–59. On their reception generally, see Michaelis, *Ancient Marbles*, 1:139–53. See also William Linn St. Clair, *Lord Elgin and the Marbles* (New York: Oxford University Press, 1967), and Jacob Rothberg, *Descensus ad terram: The Acquisition and Reception of the Elgin Marbles* (New York: Garland, 1977).

24. Charles Robert Cockerell, *Description of Ancient Marbles in the British Museum*, vol. 6 (London, 1830), ii–iii; my emphasis.

25. Hazlitt is not alone in seeing celebration of the marbles as implying a revision of Reynolds. The preface to an early set of engravings from the marbles includes an entirely gratuitous attack on the first president of the Royal Academy as "deficient in drawing"—the soft forms indicative of ideal nature no longer pleasing as they once did. Richard Lawrence, *Elgin Marbles from the Parthenon of Athens: exemplified by fifty etchings, selected from the most beautiful and least mutilated . . . with explanatory and critical remarks on the style, composition and peculiar excellence of these transcendent relics of Grecian Sculpture* (London, 1818), 5n.

26. Cf. H. B. Nisbet, "Laocoön in Germany: The Reception of the Group since Winckelmann," *Oxford German Studies* 10 (1979): 56: "It was not that the Aegina marbles or the Parthenon frieze received the same kind of adulation with which Winckelmann had greeted the later sculpture, . . . Theseus and Poseidon did not replace Laocoon, they merely reduced and diluted his appeal."

27. Richard Payne Knight, *Specimens of Ancient Sculpture* (London, 1809), 1:xxxix.

28. Quoted in Ballantyne, "Knight, Haydon, and the Elgin Marbles," 156.

29. Cockerell, *Description*, iii. This volume is devoted to the pediments. The volume that followed five years later, on the metopes, continues the challenge to earlier authorities; it is quite critical of Knight and the Dilettanti in particular. Cockerell, *Description of Ancient Marbles in the British Museum*, vol. 7 (London, 1835), 30–31.

30. Cf. a letter from George Beaumont to Robert Haydon, fierce partisan of

the Marbles, suggesting that "the mutilated fragments should be *restored*, as at present they excite rather disgust than pleasure . . . to see parts of limbs, of bodys [*sic*], stumps of arms &c." Quoted in Ballantyne, "Knight, Haydon, and the Elgin Marbles," 157. Joseph Farington quotes the painter Ozias Humphry in 1808, describing the Marbles as "a Mass of ruins." *The Farington Diary*, ed. James Greig (New York: George H. Doran, 1925), 5:46.

31. For the ambivalent response of eighteenth-century artists and critics to Herculaneum and Pompeii, see Honour, *Neo-Classicism*, 43–47. Hope speaks of a "disappointment" with Herculaneum (9). On the significance of erotic art in antiquity, see Catherine Johns, *Sex or Symbol? Erotic Images of Greece and Rome* (London: British Museum Press, 1991).

32. There was a long-lasting association in the public mind between dilettantism and pornography, in part traceable to the long-standing link between philosophy and libertinage in the enlightenment, and certainly influenced by the actual materials with which the dilettanti often dealt. On the career of d'Harcanville, editor of Hamilton's magnificent edition of Greek vases, as well as of forged pornographic antiquities, see Francis Haskell, "Baron d'Harcanville," in his *Past and Present in Art and Taste* (New Haven: Yale University Press, 1987), 30–45. See also Randolph Trumbach, "Erotic Fantasy and Male Libertinism in Enlightenment England," in *The Invention of Pornography*, ed. Lynn Hunt (New York: Zone Books, 1993), 273–82.

33. Thérèse is finally moved to succumb by two images, an intriguing combination of a traditional erotic subject, *The Loves of Venus and Mars*, and one that can only be understood as having archaeological roots, *The Festival of Priapus*. A late-eighteenth-century edition boasts a plate of the former image (plate q) and a version of the latter *Le Magnificat de Priappe*, as frontispiece to the second part. It also features a flying penis at the opening of the first part and classical elements throughout the nonnarrative illustrations. *Le Magnificat de Priappe* is a fantasia in which every classical object (including a simple vase) is tumescent. Considering the fact that the image is concerned to depict the limits of transgressive sex (homosexual sodomy between churchmen, sex between a nun and a monk, etc.), it is an open question whether the sex act in the middle of the piece, between what appears to be some form of female zephyr and a herm, is meant to be the culmination of a natural desire or a transgression of proper limits in relation to art. *Thérèse Philosophe* (facsimile of the edition ca. 1780; Geneva and Paris: Slatkine, 1980).

34. On Rowlandson's observations of Nollekens and his studio, see Gert Schiff, *The Amorous Illustrations of Thomas Rowlandson* (n.p.: Cythera, 1969), xxvii.

35. Pierre Sylvain Maréchal, *Les Antiquités d'Herculanum, ou les plus belles peintures antiques, et les marbres, bronzes, meubles, etc. etc, trouvés dans les excavations d'Herculanum, Stabia et Pompeïa, avec leur explications en français* (Paris, 1780), 7:83. Quoted in Walter Kendrick, *The Secret Museum: Pornography in Modern Culture* (New York: Viking, 1987), 9.

36. He made his change of heart known in reviews for the *Analytical Review* in the 1780s and 1790s. See Allentuck, "Fuseli's Translations," 183–85.

37. Cf. E. M. Butler, *The Tyranny of Greece over Germany* (Cambridge: Cambridge University Press, 1935). Butler, whose subject is the importance of both

Winckelmann and the reaction against him in German culture, reads Lessing's *Laocoön* (1766) as not only about distinctions between the plastic and the literary arts, but as an attempt to recover artistic freedom after the art historian's insistence on "the law of beauty" (51–70). See also Henry Caraway Hatfield, *Winckelmann and His German Critics, 1755–1781* (New York: King's Crown Press, 1943).

CHAPTER THREE
"UNITED, COMPLETER KNOWLEDGE":
BARRY, BLAKE, AND THE SEARCH FOR THE ARTIST

1. John Boydell, preface to the 1789 catalog, *The Boydell Shakespeare Prints* (New York: Benjamin Bloom, 1968), 8.

2. Fuseli was an eager reviewer as well as participant in Boydell's scheme. The terms of his praise describe the project as overcoming precisely those qualities which the eighteenth century had seen as slowing the development of art in the north: "We consider the plan of Mess. Boydell as a nursery of historic painting, as a hint towards the true method of calling forth the grandeur of art in a country whose religion, climate, and fashions, have hitherto repressed it." *Analytical Review* 2 (1788): 236.

3. Schiller's concept of the naive poet is a related contemporary development—also with Shakespeare as a focus. See Friedrich von Schiller, *Naive and Sentimental Poetry* (1795): "Only to genius is it given to be at home beyond the accustomed and to *extend* nature without *going beyond* her." *Naive and Sentimental Poetry and on the Sublime*, trans. Julius A. Elias (New York: Frederick Ungar, 1964), 96. On Shakespeare and nature, see 106–7. For a pictorial representation of this theme and of Christ as model, see Romney's images of Shakespeare's birth (or nativity), esp. *Infant Shakespeare attended by Nature and the Passions*.

4. James Barry, *Letter to the Dilettanti Society* (1793), in *The Works of James Barry*, ed. E. Fryer (London, 1809), 2:583. On Barry, see William L. Pressly, *The Life and Art of James Barry* (New Haven: Yale University Press, 1981), and the catalog Pressly prepared, *James Barry: The Artist as Hero* (London: Tate Gallery, 1983).

5. On d'Hancarville and Knight, see Peter Funnell, "The Symbolical Language of Antiquity," in Clarke and Penny, *Arrogant Connoisseur*, 52–60; also, Haskell, *Past and Present*, 30–45. On Knight, see Andrew Ballantyne, *Architecture, Landscape, and Liberty: Richard Payne Knight and the Picturesque* (Cambridge: Cambridge University Press, 1997).

6. Raymond Lister, *William Blake* (London: G. Bell and Sons, 1968), 4. Geoffrey Keynes identifies Salviati as Gioseffo Porta (1535–85), but Essick suggests Francesco Rossi Salviati (1510–63); in any case, the drawing itself has not been located. Keynes, *Blake Studies* (London: Rupert Hart-Davis, 1949). On the topic of Blake and originality, see Barrell, *Political Theory*, 225–31 (along with the critique of his argument in Eaves, *Counter-Arts Conspiracy*, 149–52). On Blake in relation to the world of art that shaped him and which he challenged, see Robert N. Essick and Donald Pearce, eds., *Blake in His Time* (Bloomington: Indiana University Press, 1978); Robert N. Essick, *William Blake, Printmaker* (Princeton:

Princeton University Press, 1980); Morris Eaves, *William Blake's Theory of Art* (Princeton: Princeton University Press, 1982), and *The Counter-Arts Conspiracy*; and Joseph Viscomi, *Blake and the Idea of the Book* (Princeton: Princeton University Press, 1992).

7. For the annotations, see *Blake: Complete Writings*, ed. Geoffrey Keynes (New York: Oxford University Press, 1974), 604. Further references are made in the text and taken from this edition. On Joseph of Arimathea, see Matthew 27:57–60; Mark 15:43–46; Luke 23:50–53; and John 19:38–42. For a useful discussion of his significance for Blake, see Northrop Frye, *Fearful Symmetry* (Princeton: Princeton University Press, 1947), 142. I owe the reference to Hebrews below to Frye (441n). See also Roger E. Easson, "Blake and the Gothic," in Essick and Pearce, *Blake*, 146.

8. Hope notes that "the long continuous enthusiasm for the Laocoön group was due not only to an appreciation of its artistic merit but also to its part in literary history." Hope, *Theory and Practice*, 15. For a useful history of the piece, see Margaret Bieber, *Laocoön: The Influence of the Group since Its Rediscovery* (Detroit: Wayne State University Press, 1967). On the effect of the statues following Winckelmann, see Butler, *Tyranny*, 43–81. See also Nisbet, "Laocoön in Germany." On Blake and antique statues, see Stephen Larabee, *English Bards and Grecian Marbles* (New York: Columbia University Press, 1943), esp. 99–119, and Morton D. Paley, "'Wonderful Originals'—Blake and Ancient Sculpture," in Essick and Pearce, *Blake*, 191. On the print, see Robert N. Essick, *The Separate Plates of William Blake* (Princeton: Princeton University Press, 1983), 98–101. Also, Robert N. Essick and Joseph Viscomi, eds., *Milton, a Poem and the Final Illuminated Works* (Princeton: Princeton University Press, 1993), 229–33.

9. Quoted (without reference to Pliny) in Paley, "'Wonderful Originals,'" 191. Given the tendency to think of him as an idiosyncratic outsider, it is worth remembering that Blake's circle of friends included such prominent neoclassical thinkers as Flaxman, Barry, and his patron William Hayley. Blake illustrated Hayley's epistolary poem on sculpture addressed to Flaxman and including a long paean to the *Laocoön*, "the master-piece of Sculpture." William Hayley, *An Essay on Sculpture* (1800; reprint, New York: Garland, 1978), Epistle 3, lines 462–509.

10. In this chapter I am interested in exploring the weight Blake could place on art, art objects, and the role of the artist. I do not take up Blake's cosmology, which has been treated in a variety of works, notably, Frye, and which is substantially outside the scope of this chapter. Religion and art are intertwined in a variety of ways in Blake's works; I am more concerned to suggest reasons why this is possible than in outlining his complex system of belief.

11. Pliny, *Natural History* 36.37, in J. J. Pollitt, *The Art of Greece, 1400–31 B.C.: Sources and Documents* (Englewood Cliffs, N.J.: Prentice-Hall, 1965), 202.

12. Robert Lowth, *Isaiah: A New Translation; with a Preliminary Dissertation, and Notes Critical Philological and Explanatory* (Boston, 1834), xlviii. Further references are in the text. See Stephen Prickett, *Words and* The Word: *Language, Poetics and Biblical Interpretation* (London: Cambridge University Press, 1986), 116–17. John C. Villalobos makes the same point in his, "A Possible Source for William Blake's 'The Great Code of Art,'" *English Language Notes* 26, no. 1

(1988): 36–39. On the important influence of Lowth (also the author of *Lectures on the Sacred Poetry of the Hebrews*, 1753) on English poetry, see Prickett, *Words*, 105–23. See also Prickett, "Romantics and Victorians," in *Reading the Text: Biblical Criticism and Literary Theory*, ed. S. Prickett (Oxford: Blackwell, 1991), 182–224, esp. 193–94. Prickett is particularly concerned to demonstrate the ways in which the "biblical tradition, rather than the neo-classical one" became "the central poetic tradition of the Romantics." But it seems more plausible to understand Blake, for one, as aspiring toward a critical conflation of both traditions.

13. Lowth, *Isaiah*, xlvi; my emphasis.

14. Cf. Jerome McGann: "Blake read the Bible in the same way that he read any other ancient text." McGann, "The Idea of an Indeterminate Text: Blake's Bible of Hell and Dr. Alexander Geddes," *Studies in Romanticism* 25 (1986): 313. Cited in Villalobos, "A Possible Source," 38. Villalobos substantially softens this argument in his own conclusion (39), but there is warrant for it in Blake's *A Descriptive Catalogue*: "The antiquities of every Nation under Heaven, is [*sic*] no less sacred than that of the Jews. They are the same thing." Keynes, *Blake: Complete Writings*, 578.

CHAPTER FOUR
HAZLITT, SCOTT, LOCKHART: INTIMACY, ANONYMITY, AND EXCESS

1. Writing only eighteen years earlier and treating an author presenting far more evident challenges to the modern reader, Douce shows markedly more anxiety to justify his study than does Chambers: "He who at this day can entirely comprehend the writings of Shakespeare without the aid of comment, and frequently of laborious illustration, may be said to possess a degree of inspiration almost commensurate with that of the great bard himself." This argument is unavailable to Chambers, writing on a contemporary. Absent the need to explain challenging philological or historical questions, such a project becomes all the more strikingly evidence of the high esteem in which an author is held. Francis Douce, *Illustrations of Shakespeare, and of Ancient Manners with Dissertations on the Clowns and Fools of Shakespeare* . . . (London, 1807), 1:vii. After Douce and anticipating Chambers, it is worth citing John Hobhouse's (1818) *Historical Illustrations of the Fourth Canto of* Childe Harold. An antiquarian text ponderously "illustrating" the Italian and classical references in Byron's verse, Hobhouse's work, like Chambers's, is more a monument to admiration than a work of necessary clarification.

2. See John O. Hayden, ed., *Scott: The Critical Heritage* (New York: Barnes and Noble, 1970), e.g., 74, 86. Scott identified himself to his wider readership in the introduction to *Chronicles of Canongate* (1827). Seamus Cooney outlines Scott's varied and contradictory statements on the topic in "Scott's Anonymity—Its Motives and Consequences," *Studies in Scottish Literature* 10, no. 4 (1973): 207–19. It is hard to disagree with Cooney's observation that on this question "Scott does not understand completely his own motives" (216). The most interesting recent treatments of the topic occur in Jane Millgate, *Walter Scott: The Making of the Novelist* (Toronto: Toronto University Press, 1984), and esp. in Judith Wilt, *Secret Leaves: The Novels of Walter Scott* (Chicago: Chicago University Press, 1985), a

particularly strong and developed psychological reading of the use of alter egos in the *Prefaces* (185–203). Ian Duncan places the play with anonymity in relation to the emerging public persona of the author in *Modern Romance and Transformations of the Novel: The Gothic, Scott, Dickens* (Cambridge: Cambridge University Press, 1992), 177–86. He usefully identifies the paradox that Scott's "'secret' (that everyone knew)" was "a condition of the author's unprecedented cultural visibility" (185).

3. John Gibson Lockhart, *Memoirs of the Life of Sir Walter Scott* (Edinburgh, 1837–38), 7:20. Lockhart produced three revised versions subsequent to this first edition: in 1839 the work grew to ten volumes, in 1842 he published the text in one volume, and in 1848 he brought out an abridgment. Further references to the first edition are made in the text, by volume and page number. The passages I cite saw no substantial changes in later editions.

4. Scott produced a flattering and still anonymous response to Adolphus in the "Introductory Epistle" to *The Fortunes of Nigel* (1822), and Lockhart prints extensive extracts from Adolphus in his biography (Lockhart, *Life*, 5:103–22), further evidence that Scott's anonymity played a complex role in validating the worth of the author. Lockhart prefaces the extracts with the intriguing admission that "previously to the publication of these letters, the opinion that Scott was the Author of Waverley had indeed become well settled in the English, to say nothing of the Scottish mind." What is the value of Adolphus's exercise then, and why reprint so much of it in the biography, unless its ingenious exposition offers more than its apparently low value as revelation? The young author's visit to Abbotsford is, not surprisingly, an odd moment in the biography, one that demonstrates at once the preposterous quality of Scott's anonymity and the commitment to safeguarding the fantasy of a secret: "It seemed at first a little strange, in a scene where so many things brought to mind the Waverley novels, to hear no direct mention of them or even allusion to their existence" (5:300).

5. Recent works illuminating the establishment of particular instances of nineteenth-century admiration include Jerome Christensen, *Lord Byron's Strength: Romantic Writing and Commercial Society* (Baltimore: Johns Hopkins University Press, 1993), and Tricia Lootens, *Lost Saints: Silence, Gender, and Victorian Literary Canonization*.

6. Robert Chambers, *Vestiges of the Natural History of Creation* (1844; reprint, New York: Humanities Press, 1969), 388. The work is still unacknowledged by Chambers's brother in his 1872 memoir, where he even hints at a denial of such authorship. William Chambers, *Memoir of Robert Chambers with Autobiographic Reminiscences of William Chambers* (New York, 1872), 255–56. For accounts of the writing of *Illustrations* and Chambers's first encounter with Scott, see esp. *Memoir*, 156–57, 162–64.

7. Chambers, *Vestiges*, 359, 377. The differences between Darwin and Chambers are as telling as their similarities. As Gillian Beer points out, in contrast to Chambers, Darwin focuses on identifying a process, not an original moment or being. Darwin's work is precisely "not a search for an originator nor for a true beginning." Gillian Beer, *Darwin's Plots* (London: Ark, 1985), 64; see also 11.

8. Chambers, *Memoir*, 162.

9. Cf. Annette Cafarelli: "The tradition of celebrating genius, and the expecta-

tion that biography would confirm it, conflicted with the new post-Johnsonian insights into the relation between lives and works." *Prose in the Age of Poets* (Philadelphia: University of Pennsylvania Press, 1990), 139.

10. Richard Altick writes of "the unbroken prosperity of biography" in the nineteenth century, and of its increased "intellectual significance in the era." *Life and Letters: A History of Literary Biography in England and America* (New York: Knopf, 1966), 82. Altick's work provides a useful panorama of the genre in England from the sixteenth to the twentieth century. See also Francis R. Hart's account of the increasing popularity of the form in the early nineteenth century, in his *Lockhart as Romantic Biographer* (Edinburgh: Edinburgh University Press, 1971), 3–5. Other helpful works include Cafarelli, *Prose in the Age of Poets*, A.O.J. Cockshut, *Truth to Life: The Art of Biography in the Nineteenth Century* (London: Collins, 1974); and Ira Nadel, *Biography: Fiction, Fact and Form* (New York: St. Martin's, 1984).

11. Boswell, *Life of Johnson*, 2:56. Annette Cafarelli's claim that romantic biography demonstrates not a rebellion against Johnson so much as the presence of "unstated Johnsonian subtexts" is important; but, as part of her strategy to raise the stature of the critic, she overstates the case against Boswell, both as writer and influence (see Cafarelli, *Prose*, 3, 14). For similar reasons she tends to underestimate the success of Boswellian works such as Lockhart's (15). Nadel, on the other hand, insists on the centrality of Boswell and Lockhart for nineteenth-century biography—especially Victorian. He notes the important event of Croker's 1831 reissue of the *Life of Johnson* (*Biography*, 15, 43, 68). The debate is clearly influenced by whether the critic focuses on the early or later nineteenth century (Croker's edition providing a good point of demarcation). In the course of his celebration of Boswell's achievement (in an essay inspired by Croker's edition), Carlyle damns Johnson with the faintest of praise: "all Johnson's own Writings, laborious and in their kind genuine above most, stand on a quite inferior level to it [Boswell's *Life of Johnson*]; already, indeed, they are becoming obsolete for this generation; and for some future generation may be valuable chiefly as Prolegomena and expository Scholia to this *Johnsoniad* of Boswell." Thomas Carlyle, "Boswell's Life of Johnson" (1832), in *Critical and Miscellaneous Essays* (New York: Library Edition, n.d.), 2:415. Note the historicizing sensibility behind Carlyle's position, the suggestion that he is describing a necessary cultural development in the move from Johnson to Boswell.

12. "I would paint what has not been unhappily called the *psychological* character." Isaac D'Israeli, *Calamities of Authors; Including Some Inquiries Respecting Their Moral and Literary Characters* (London, 1812), 1:x. Further references are in the text. For D'Israeli, see James Ogden, *Isaac D'Israeli* (Oxford: Clarendon Press, 1969); see also Cafarelli, *Prose*, 90–94.

13. Isaac D'Israeli referred to himself as "a man of two ages" in the preface of his fourth (1828) edition of *The Literary Character* (London, 1828), 1:xlii, acknowledging his links to both the culture of the Enlightenment and romanticism. In the preface to the second edition of *The Literary Character* (1818) he credits Byron's interest in the original work with inspiring him to return to a project he had last touched in 1795. D'Israeli revised *An Essay on the Literary Character* (London, 1795) four times between 1795 and 1840. The second edition, *The*

Literary Character, Illustrated by the History of Men of Genius, Drawn from Their Own Feelings and Confessions (London, 1818), was a substantial recasting of the text. There were subsequent revisions in 1822, 1828 (as *The Literary Character; or the History of Men of Genius, Drawn from Their Own Feelings and Confessions*), and 1840 (along with his *Literary Miscellanies* and *Calamities and Quarrels of Authors*). A posthumous edition was brought out by Benjamin Disraeli in 1859. For the purposes of this chapter, I largely refer to the 1818 text, the first nineteenth-century edition. I cite editions by year and page number in the text. *Calamities of Authors* was first published in 1812, and *Quarrels of Authors* in 1814. For more detailed bibliographical information, see Ogden, *Isaac D'Israeli*, 212, and Cafarelli, *Prose*, 224–25.

14. The phrase entered the work in the 1820s, as a distillation of D'Israeli's 1818 disagreement with eighteenth-century theories of genius. In the earlier text he had cited "the French school in evil times" and Johnson as holding the view that all minds have an equality of potential; D'Israeli insists on the innate difference of the genius. See *Literary Character*, 1818, 19, and 1828, 33–34.

15. On the topic of the organization of print culture in the late eighteenth century and its influence on the career and image of the author, see Alvin Kernan, *Printing Technology, Letters and Samuel Johnson* (Princeton: Princeton University Press, 1987).

16. The description of an international canon of culture becomes only more explicit in later editions: "In the metropolitan cities of Europe the same authors are now read, and the same opinions become established: the Englishman is familiar with Machiavel and Montesquieu; the Italian and the Frenchman with Bacon and Locke; and the same smiles and tears are awakened on the banks of the Thames, of the Seine, or of the Guadalquivir, by Shakspeare, Molière, and Cervantes." D'Israeli, *Literary Character*, 1828, 1:1–2.

17. The geniuses of the first edition are almost entirely writers (novelists and poets) and philosophers. The visual arts find their way into the text only in the 1818 edition, but by the 1820s D'Israeli is emphatic: "It is evident that MILTON, MICHAEL ANGELO, and HANDEL, belong to the same order of minds; the same imaginative powers, and the same sensibility, are only operating with different materials." *Literary Character*, 1828, 1:25.

18. The *Lives of the Novelists* had a genesis similar to that of Johnson's *Lives of the Poets*. The work was a compilation of a series of prefaces to reissues of popular novelists printed in 1821–24 as the "Novelist's Library." For an account of the project, see Cafarelli, *Prose*, 101–6, 227. Though the *Lives* were never printed as a chronological account, Scott frequently implies a history of the development of the genre. This sensibility is behind his account of *Tom Jones*: "Under such precarious circumstances the first English novel was given to the public, which had not yet seen any works of fiction founded upon the plan of painting from nature" (103). As in Johnson, an implied progression is evident in the refinement of literary form traced in the course of the lives, but in both cases the idea of development is undercut by a falling-off in later work. Johnsonian overtones are also evident in Scott's language. His comments on Smollett, for example, echo Johnson on Shakespeare: "from that time, whoever has undertaken the same task has seemed to copy more from Smollett than from nature." Walter Scott, *Biographies*,

vol. 3 of *The Miscellaneous Works* (Edinburgh, 1861), 123. "The first . . . must take their sentiments and descriptions immediately from knowledge. . . . Those whom their fame invites to the same studies, copy partly them, and partly nature." Samuel Johnson, "Preface" (1765), in *Johnson on Shakespeare*, vol. 7 of *Works*, ed. Arthur Sherbo (New Haven: Yale University Press, 1968), 89. Further references to these works are made in the text.

19. Scott and D'Israeli were certainly familiar with each other's work. They met, probably in 1809, and were both involved in founding the *Quarterly Review*. They corresponded, and in 1812 the novelist was asked to review *Calamities of Authors* by the publisher. Scott never wrote a review, but he claimed to find the book—and D'Israeli's *Curiosities of Literature*—"lively and entertaining." Scott cites *The Literary Character* in his "Life of Cumberland" (*Biographies*, 197). See Ogden, *Isaac D'Israeli*, 52, 82–83, 121–23. In the preface to *Quarrels of Authors* (1814), D'Israeli credits Scott's biography of Dryden with being an inspiration for that work. He is also fulsome in his praise of the author in the third edition of *The Literary Character*.

20. On Coleridge's notorious loquaciousness, see Hazlitt's 1823 "My First Acquaintance with Poets": "He did not cease while he staid [*sic*]; nor has he since, that I know of." Hazlitt, *Complete Works*, 17:106.

21. For a related contemporary view of conversation as the fate of an overinformed era, cf. D'Israeli: "when a people have emerged to glory, and a silent revolution has obtained, by a more uniform light of knowledge coming from all sides, the genius of society becomes greater than the genius of the individual: hence, the character of genius itself becomes subordinate. A conversation age succeeds a studious one, and the family of genius are no longer recluses." *Literary Character*, 1818, 92. The blustering fondness for silence running through Carlyle's work is a late version of the same sensibility.

22. Hazlitt explores the issue of belatedness most directly in "Why the Arts Are Not Progressive" (1814), but it is a motivating concern in many of his works. See David Bromwich, *Hazlitt: The Mind of a Critic* (New York: Oxford University Press, 1983), 17, 116–17. On the late-eighteenth-and early-nineteenth-century context, see Cafarelli, *Prose*, 120–28 and James Engell, *Forming the Critical Mind: Dryden to Coleridge* (Cambridge: Harvard University Press, 1989), 45–70.

23. *The Iliad of Homer*, 21, 9–19, trans. Alexander Pope (1715–20), ed. Reuben A. Brower and W. H. Bond (New York: Macmillan, 1965), 470–71. Pope's translation is the one Hazlitt refers to most often—if seldom in flattering terms. Important biblical elements are also present in the passage. I am grateful to Ian Duncan and Martin Meisel for drawing my attention to the "rushing of mighty waters" of Isaiah (17:12) and the sound of far-off battle in Job (39:23–25).

24. The Elgin Marbles were not moved into rooms designed for them until 1832. See the discussion and illustrations of the early display of the marbles in Ian Jenkins, "James Stephanoff and the British Museum," *Apollo*, n.s., 121 (March 1985): 174–81. On Hazlitt and the campaign for the Marbles, see P. P. Howe, *The Life of William Hazlitt* (1947; reprint, Westport, Conn.: Greenwood Press, 1972), 185. Direct references to the pieces recur throughout Hazlitt's essays in the 1820s.

25. Hazlitt, "On the Elgin Marbles" (first published in the *London Magazine*, 1822–23), in *Complete Works*, 9:327; my emphasis, here and subsequently. In

1825, he writes that the pieces have "the buoyancy of a wave of the sea" (12:329), and in 1826 he comments on the "undulation and a liquid flow on . . . [their] surface" (10:168n).

26. Elsewhere, Hazlitt himself uses the same description for Shakespeare, but he adds to the quotation: "He had 'a mind reflecting ages past,' *and present.*" "Lectures on the English Poets," *Complete Works,* 5:47; my emphasis.

27. Cf. *Antony and Cleopatra*:

> Sometimes we see a cloud that's dragonish;
> A vapor sometime like a bear or lion,
>
> .
>
> That which is now a horse, even with a thought
> The rack dislimns, and makes it indistinct
> As water is in water. . . .
> . . . now thy captain is
> Even such a body: here I am Antony,
> Yet cannot hold this visible shape . . . (4.14.1–15)

28. The glittering eyes of the mariner are his principal feature: "'By thy long grey beard and glittering eye, / Now wherefore stopp'st thou me?'" "And thus spake on that ancient man, / The bright-eyed Mariner." "I fear thee and thy glittering eye." Samuel Taylor Coleridge, "The Rime of the Ancient Mariner," lines 3–4, 19–20, 228, in *Samuel Taylor Coleridge,* ed. H. J. Jackson (Oxford: Oxford University Press, 1985), 46–65.

29. On Coleridge and Hazlitt on Schiller, see Frederic Ewen, *The Prestige of Schiller in England, 1788–1859* (New York: Columbia University Press, 1932), 57–75, 87–92.

30. Cf. "On The Living Poets": Scott "never obtrudes himself on your notice to prevent your seeing the subject." Hazlitt, *Complete Works,* 5:154. "On Old English Writers and Speakers" (*New Monthly Magazine,* 1825): "This is the great secret of his writings—a perfect indifference to self" (12:320).

31. In "On the Living Poets," Hazlitt identifies egoism as the link between the Lake Poets and Rousseau: "They were for bringing poetry back to its primitive simplicity and state of nature, as he was for bringing society back to the savage state: so that the only thing remarkable left in the world by this change, would be the persons who had produced it. A thorough adept in this school of poetry and philanthropy is jealous of all excellence but his own. He does not even like to share his reputation with his subject." *Complete Works,* 5:163.

32. While Wordsworthian echoes are clear throughout the sentence, Hazlitt quotes directly from the end of the fifth stanza of the "Ode": "At length the Man perceives it die away, / And fade into the light of common day."

33. Edgar Johnson, *Sir Walter Scott: The Great Unknown* (New York: Macmillan, 1970), 1:619–20, n. 82. See also Hart, *Lockhart,* 237. On Lockhart's methods and the reception of his *Life of Scott,* see Hart, *Lockhart,* 164–252.

34. It is worth noting that an animated disembodied limb is one of the typical forms of the uncanny in Freud's seminal essay on the topic: "Dismembered limbs, a severed head, a hand cut off at the wrist, feet which dance by themselves—all these have something peculiarly uncanny about them, especially when, as in the

last instance, they prove able to move of themselves in addition." Sigmund Freud, "The Uncanny" (1919), in *On Creativity and the Unconscious* (New York: Harper, 1958), 122–61; quotation from 151. Freud's essay is germane at various points in an analysis of this passage. Christensen offers a brief but rich analysis of the passage in relation to work and property (112–13).

35. Roughly half of the *Life* of Scott is narrative written by Lockhart; the other half is letters and reminiscences of Scott and others, but I believe that it is appropriate to treat the book as a coherent text rather than as a grabbag of independent anecdotes. Certainly, Hart's work on Lockhart's treatment of his sources demonstrates that (as was typically the case in nineteenth-century biography) this material—including direct quotations—is almost invariably altered by the biographer's governing intelligence. See Hart, *Lockhart*, 199–252.

36. This "Memoir" is one of the many texts by Scott that are "accidentally discovered." He wrote it in 1808, then added footnotes in 1826, but it first saw the light as the opening section of Lockhart's *Life*. As the biographer notes, questions of biography and self-representation came to preoccupy Scott at a time when his own professional self-definition was taking shape. Scott's "Memoir," Lockhart points out, is contemporary with his *Life of Dryden* (1808): "the only life of a great poet which he has left us, and also his only detailed work on the personal fortunes of one to whom literature was a profession . . . was penned just when he had begun to apprehend his own destiny" (Lockhart, *Life*, 2:163–64). Scott's ambivalence toward the growing public preoccupation with literary biography seems to have been a long-lasting concern; hence this attempt to fix his own early life. "Laurence Sterne," he notes in his life of that author, "was one of those few authors who have anticipated the labours of the biographer, and left to the world what they desired should be known of their family and their life." Scott, *Biographies*, 273.

37. Cf. the outline of D'Israeli's argument evident in a selection of the analytical chapter descriptions to *The Literary Character*: "Genius in society often in a state of suffering. . . . Society offers seduction and not reward to the man of genius. . . . The habitudes of the man of genius distinct from those of society. . . . Literary solitude.—Its necessity" (1828, 1:VII-X).

38. Cf. the defensive class-consciousness in Scott's comment on Lesage: "The profession of his father is not mentioned; but as he bequeathed some property to his son, he could not be of the very lowest rank." Scott, *Biographies*, 390.

39. Numbers 13:33: "And there we saw the giants, the sons of Anak, which come of the giants: and we were in our own sight as grasshoppers, and so were we in their sight." The Israelites cannot enter the promised land because of the presence of these beings, who dwarf them in fact, and in their own estimation. See Numbers 13:31–32 and Joshua 10:36–39.

40. Bertrand H. Bronson's "The Double Tradition of Dr. Johnson," *ELH* 18, no. 2 (1951): 90–106, explores the coexistence of quite contradictory images of Johnson in the nineteenth century: on the one hand the editor of the dictionary, founding man of letters, on the other the rude, untidy, near grotesque individual displayed in Boswell.

41. Samuel Johnson, *Lives of the English Poets* (Oxford: Clarendon, 1905), 2:226. Further references are in the text.

42. The meeting is chronicled in Boswell, *Life of Johnson*, 1:335–39. For a rich analysis of the encounter, see Kernan, *Printing Technology*, 24–47. There is a playful exchange between regent and writer during Scott's 1815 visit to London. The prince toasts the author of *Waverley*, but the still "anonymous" novelist demurs; the prince counters with a toast to the author of the poem *Marmion* (Lockhart, *Life*, 3:342–43). Compare this relationship with that implied by Johnson's response on being asked what he replied to a compliment from the king: "It was not for me to bandy civilities with my sovereign." Boswell, *Life of Johnson*, 1:336.

43. In D'Israeli the result of becoming "Author by Profession" is that "the noblest mind often sinks to a venal dependant, or a sordid labourer." *Calamities*, 2. Cf. the discussion of Scott's productivity in the "Introductory Epistle" to *Nigel*. One of Scott's alter egos comments to another, "You will be supposed to work merely for the lucre of gain," and again, "it is generally held base to write from the mere motive of gain." The main alter ego—the Author of *Waverley*—responds finally that "no work of imagination, proceeding from the mere consideration of a certain sum of copy-money, ever did, or ever will, succeed." Reprinted in *The Prefaces to the Waverley Novels*, ed. Mark A. Weinstein (Lincoln: University of Nebraska Press, 1978), 53–55. Further references to the *Prefaces* are made from this edition, in the body of the text.

44. Johnson identifies the trope in his own *Lives*, commenting on similar claims by Congreve: "There seems to be a strange affectation in authors of appearing to have done every thing by chance" (2:226).

45. See also the review Scott wrote of his own *Tales of My Landlord*, in the *Quarterly* (1817). On the *Prefaces*, see esp. Wilt, *Secret Leaves*, 184–203.

46. "All the complaints which are made of the world are unjust. . . . There is no reason why any person should exert himself for a man who has written a good book: he has not written it for any individual. I may as well make a present to the postman who brings me a letter. When patronage was limited, an author expected to find a Mæcenas." Boswell, *Life of Johnson*, 2:436.

47. On Johnson in the popular imagination, see Bronson: "What we should doubtless find most frequently in the folk-image would be the ideas of physical bulk, sloppy habits of dress, bad manners, loud voice, witty but weighty speech." "Double Tradition," 91. Johnson's presence in the preface to *Peveril* may be in part attributable to Scott having worked simultaneously on that novel and on the preface to *Rasselas*, which would eventually be published in Scott's *Lives*. Both were completed in early 1823. "This has something intercepted *Peveril*," comments Scott, on delivering the lives of Johnson and others to his publisher, his biographical work having delayed his novelistic production. See Johnson, *Sir Walter Scott*, 2:800.

48. There is a similar range of reasons offered in the "General Preface" to the *Magnum Opus*, the postbankruptcy reissues of his work (see Scott, *Prefaces*, 94–97). For an outline of the contradictory reasons offered in these sources, see Cooney, "Scott's Anonymity."

49. "The problem of Johnson's identity is further complicated by circumstances almost, if not quite, unique. The uniqueness lies, of course, in the fact that it is possible to 'know' this man, in his habit as he lived, as intimately as we can 'know' his works." Bronson, "Double Tradition," 90.

50. John Gibson Lockhart, *The Life of Sir Walter Scott*, abridged by the author (1848; reprint, Edinburgh, 1871), 803. Further references are in the text.

CHAPTER FIVE
KEATS: IN THE LIBRARY, IN THE MUSEUM

1. On the need of literature to define itself in relation to the other arts by "comparison, metaphor and analogy," see Philippe Hamon, *Expositions: Literature and Architecture in Nineteenth-Century France*, trans. Katia Sainson-Frank and Lisa Maguire (Berkeley: University of California Press, 1992), 17–21. His discussion of the "architectural object" in literature is also of interest, 26–28.

2. Shelley's defense (written in 1821) moves between the poles of power and anonymity of the famous phrase with which it concludes. Thus, earlier in the essay: "Even in modern times, no living poet ever arrived at the fullness of his fame. . . . A poet is a nightingale, who sits in darkness and sings to cheer its own solitude . . . his auditors are as men entranced by the melody of an unseen musician." "A Defence of Poetry," in *Shelley's Critical Prose*, ed. Bruce R. McElderry Jr. (Lincoln: University of Nebraska Press, 1967), 3–37; quotation from 11.

3. Richard Monckton Milnes (Lord Houghton), *Life and Letters of Keats* (1848; reprint, London: Routledge and Sons, n.d.), 1. Further references are in the text. As my concern is with the mediation of Keats through Milnes's work, I refer to poems and letters as they are presented in his text. Milnes's readiness to alter sources is typical of his era, but the precise content of specific texts does not concern us so much as what he saw fit to use to make his case. On Milnes's revisions and manipulations, see the introduction to H. E. Briggs, "The First Life of Keats: An Edition of Lord Houghton's *Life and Letters of John Keats* with an Introduction, Textual Notes, Critical Notes, Appendices, Bibliography and Index" (Ph.D. diss., University of Michigan, 1942), esp. 33 and nn. 770, 772, and William Henry Marquess, *Lives of the Poet: The First Century of Keats Biography* (University Park: Pennsylvania State University Press, 1985), 42–57. Milnes's text was the principal source for the letters through most of the Victorian period. On their history, see Hyder Edward Rollins, *The Letters of John Keats* (Cambridge: Harvard University Press, 1958), 1:3–9.

4. Milnes refers to *Adonais* as "the complement of and apology for these volumes" (*Life and Letters*, 276), and notes Shelley's interest in publishing a "Life and Criticism" of Keats (277). On Milnes, see T. Wemyss Reid, *The Life and Letters and Friendships of Richard Monckton Milnes* (New York, 1891), and James Pope-Hennessy, *Monckton Milnes* (London: Constable, 1949). On Milnes and Shelley's poem, see Pope-Hennessy, *Monckton Miles*, 1:22, and Reid, *Life and Letters*, 1:73–78. On the conceptual importance of the fragment in romanticism, see Thomas McFarland, *Romanticism and the Forms of Ruin* (Princeton: Princeton University Press, 1981).

5. Walter Jackson Bate and Aileen Ward have demonstrated the complex nature of the poet's attitude toward the public, but it is certainly a Keats contemptuous of his audience's response whom Milnes presents. Keats is most vivid in the letters on the preface to *Endymion*: "the public—a thing I cannot help looking upon as an enemy, and which I cannot address without feelings of hostility"

(Milnes, *Life and Letters*, 87); elsewhere he writes of "the poisonous suffrage of the public" (216). See Bate, *John Keats* (New York: Oxford University Press, 1966), 305. Ward gives a convincing biographical reading of the period that saw Keats's most extreme statements in her *John Keats: The Making of a Poet* (New York: Farrar, Straus and Giroux, 1986), 175; cf. 275, 351–52, for the discussion of Keats's sonnets on fame. See also the illuminating account of this difficult question in her "'That Last Infirmity of a Noble Mind': Keats and the Idea of Fame," in *Evidence of the Imagination*, ed. Donald H. Reiman, Michael C. Jaye, and Betty T. Bennett (New York: New York University Press, 1978), 312–33.

6. On the early reception of Keats and the role of Milnes, see Marquess, *Lives of the Poet*, 5–14, 37–57. Marquess emphasizes the degree to which Milnes's biography "conditioned the rise of Keats's reputation" (59). See also Pope-Hennessy, *Monckton Milnes*, 1:292–95. For an account of Keats's reputation in the nineteenth century, see George H. Ford, *Keats and the Victorians: A Study of His Influence and Rise to Fame, 1821–1895* (London: Archon, 1962). Ford is especially good on the dubious claims of rediscovery of Rossetti and others; this makes his comment on the "turning point" marked by Milnes's work particularly significant. See *Keats and the Victorians*, 69–70, 94. See also G. M. Matthews, ed., *Keats: The Critical Heritage* (New York: Barnes and Noble, 1971). Matthews credits Milnes with writing at the right time rather than creating a revolution in taste, adding force to, rather than initiating, the rehabilitation (31).

7. His own biographer remarks that if Milnes was never to be first-rate either in politics or poetry, he played a vital role as "a sort of liaison figure" between the two worlds. Pope-Hennessy, *Monckton Milnes*, 1:231. On Milnes's work for the Library, see Reid, *Life and Letters*, 1:234–37, and Pope-Hennessy, *Monckton Milnes*, 1:114. See also Miron Grindea, "The London Library," *Adam International Review* (1977), 387–400. On his efforts on behalf of Swinburne and Tennyson, see Reid, *Life and Letters*, 1:296–97, 2:136, 440–41; and Pope-Hennessy, *Monckton Milnes*, 1:230. On his involvement with the British Museum, see Reid, *Life and Letters*, 2:227–79, 404–6.

8. Milnes does not use the term fortuitously, but with reiteration: "nothing but a conviction of the singularity and greatness of the fragment would justify any one in attempting to draw general attention to its shape and substance." *Life and Letters*, 1–2. It is worth drawing attention here to Milnes's youthful efforts, ten years before the *Life*, to represent art and artists in verse. His poems are characterized by a remarkably advanced affection for earlier masters—anticipating the vogue for them later in the century—and an equally unusual interest in the effect of antique remains on these artists. See his *Memorials of a Residence on the Continent and Historical Poems* (London, 1838), esp. "Pictures in Verse," "To Giovanni Bellini," "To Raffael," and "Roman Ruins."

9. For a related discussion of Keats's work and the museum, see Philip Fisher, "A Museum with One Work Inside: Keats and the Finality of Art," *Keats-Shelley Journal* 33 (1984): 85–102. See also A. W. Phinney, "Keats in the Museum: Between Aesthetics and History," *Journal of English and Germanic Philology* 90, no. 2 (1991): 208–29.

10. Useful histories of the British Museum include Edward Miller, *That Noble Cabinet: A History of the British Museum* (Athens: Ohio University Press, 1974),

and Ian Jenkins, *Archaeologists and Aesthetes: In the Sculpture Galleries of the British Museum, 1800–1939* (London: British Museum Press, 1992). See also Marjorie Caygill, *The Story of the British Museum*, 2d ed. (London: British Museum Press, 1992). On the architectural history of the building, and on some Continental antecedents, see J. Mourdant Crook, *The British Museum* (London: Allen Lane, 1972). On the National Gallery, see Angelina Morhange, Introduction, *National Gallery: Illustrated General Catalogue*, rev. ed. (London: National Gallery, 1986), ix–xvii. See also Edward T. Cook, *A Popular Handbook to the National Gallery*, 2d ed. (1888; reprint, London, 1889), xiv–xviii. On the development of museums in Europe, see Pevsner, *History of Building Types*, 111–38; see also Germain Bazin, *The Museum Age* (New York: Universe Books, 1967), trans. Jane van Nuis Cahill (the chapter on the nineteenth century gives the book its title); and Bennett, *The Birth of the Museum*. Theodore Ziolkowski's discussion of the design of the Altes Museum provides a useful account of the important German precedent to the English debate on the organization of museums. See "The Museum," in his *German Romanticism and Its Institutions* (Princeton: Princeton University Press, 1990, 314–22). Further references to these works are in the text.

11. The national collections were discussed not only at the level of government but also in works aimed at a quite general readership. Four years before the committee met, for example, the art historian James Fergusson had offered a new design for the museum intended to rationalize the collection and account for the steady accumulation of material: *Observations on the British Museum and National Gallery, and National Record Office, with Suggestions for Their Improvement* (London, 1849). Similarly, W. I. Bicknell, in a guide to London meant for the general public, is cheered in his dislike for the design of the National Gallery by the thought that "should the number of paintings only increase in the same ratio as they have since the first purchase was made in 1834, the time cannot be very far distant when the accommodation in the entire building will be found altogether inadequate for their reception." *Illustrated London, or A Series of Views in the British Metropolis and Its Vicinity*, engraved by Albert Henry Payne, text by W. I. Bicknell (London, 1847), 1:41. See also G. F. Waagen, "Thoughts on the New Building to Be Erected for the National Gallery of England, and on the Arrangement, Preservation, and Enlargement of the Collection," *Art-Journal* 15 (1853): 101–3, 121–25. Not surprisingly, the Royal Academy's medal in architecture for 1857 was won (by Francis Trimmer Gompertz) for the design of a National Gallery.

12. There had already been substantial institutional changes, as piecemeal and as significant as the renovations of the building itself. Until the 1840s, entry to the museum for the general public had to be arranged in advance; it was closed on holidays until 1837 (substantially affecting the possibility of visits by the working classes); and visits were monitored by guides. In the 1840s, the museum was opened to the nonartist public three days a week and by 1841 holidays brought as many as ten thousand visitors. The loosening of rules resulted in a dramatic increase in attendance; a census in 1843 revealed that half a million people had visited the British Museum. See "Entry as a Privilege," in Kenneth Hudson, *A Social History of Museums* (Atlantic Highlands, N.J.: Humanities Press, 1975), 8–10; Bicknell, *Illustrated London*, 2:299–301; and Bazin, *Museum Age*, 210.

13. Francis Haskell discusses the distance between what was considered good art for artists to see in the period and what was exhibited to please or edify the public. See Haskell, *Rediscoveries* 94–98, 101. Further references are in the text. See also Steegman, *Victorian Taste*, 240. Typical is Bicknell's distinction between the merits of the classical marbles and those of the Egyptian collection in the British Museum: "We sincerely hope that our young artists will avail themselves of these magnificent remains of the Greeks, that the statues and buildings hereafter erected in London, may be imbued with a portion of that lofty spirit which reigns here so triumphantly. . . . The objects in the Egyptian Saloon, though of a very different character from the finished sculptures of the Greeks, . . . are notwithstanding of immense importance in the history of art, pouring an astonishing flood of light upon the history of a singularly interesting people." Bicknell, *Illustrated London*, 2:312. Indeed, the plate accompanying this text shows the Egyptian rooms being gone over with great interest by couples and families; one imagines that the artists are busy sketching in the Elgin and Phigalian Saloons—"truly classical, not to say holy ground" (2:311). The debate between the needs of artists and those of the public was even sharper in the case of the planning of a new museum than it was in the reform of existing institutions. See Ziolkowski on the Altes Museum, *German Romanticism*, 314–17.

14. *Report from the Select Committee on the National Gallery; Together with the Proceedings of the Committee, Minutes of Evidence, Appendix and Index*, vol. 35 of *Reports from Committees* (London, 1853), vi. Further testimony is identified in the text by paragraph number. Morhange notes that 1853 was a "crisis point" in the history of the National Gallery. The committee report did result in important revisions to the Gallery Constitution. See Morhange, *National Gallery*, xiv. Cf. Cook, *Popular Handbook*, xvi.

15. Crook associates the trend toward the construction of museums in the first half of the nineteenth century with an urge to shape the presentation of culture: "the alliance between the cult of the antique and the fashion for organized *Kultur* . . . produced a rash of museum-building during the post-Napoleonic period." He cites the Munich Glyptothek (1816–30) and the Altes Museum in Berlin (1825–28). Crook, *British Museum*, 107–8.

16. On Oldfield, see Miller, *That Noble Cabinet*, 193. Cf. the concern with extensibility in his plan to Fergusson's (*Observations*, 69).

17. Cf. André Malraux, "The art museum invites criticism of each of the expressions of the world it brings together; and a query as to what they have in common." Though he frames his proposition in general terms, André Malraux's ideas on the limits of the museum were also inspired by the irruption of non-Western art into European canons; in his work he is attempting to account for the dramatic growth, under the aegis of modernism, of interest in African and Asian artifacts. See his *The Voices of Silence*, trans. Stuart Gilbert (New York: Doubleday, 1953), 14–15. Further references are in the text.

18. For these figures, and the anxiety caused by the increase in non-Western art, see Miller, *That Noble Cabinet*, 191–93, 196. For the material stresses of placing the new work, see 219. See also Crook, *British Museum*, 197: "By the 1860s the situation was . . . acute—Layard's Assyrian discoveries, Fellowes's Lycian marbles, Rawlinson's Assyrian sculptures, Newton's discoveries in Asia Minor—Brit-

ain's museum waxed fat in prestige and congestion." On the growing interest in Assyrian art in France and England, see Bazin, *Museum Age*, 208–9.

19. Milnes's anxiety was not baseless. The *Illustrated London News* of 2 March 1850 speaks of the great "number of visitors who daily throng the room at the British Museum housing the Assyrian objects." Announcing the arrival of the statues at the museum, the same periodical had offered the line of argument taken by Westmacott, noting "the illustration they afford of passages of Holy Writ" (28 June 1847). Aside from the intrinsic interest of the pieces, public fascination had been fanned by Henry Layard's extremely popular *Nineveh and Its Remains* (1848); see Miller, *That Noble Cabinet*, 218.

20. Haskell, *Rediscoveries*, 8–21. Delaroche worked on his mural from 1837–41; the Albert Memorial podium was sculpted from 1864 to 1872. On Delaroche, see Norman D. Ziff, *Paul Delaroche: A Study in Nineteenth-Century French History Painting* (New York: Garland, 1977), esp. 167–83. For the contemporary popularity and importance of the Delaroche mural in England, see Anna Jameson, *A Description of the Great Picture by Paul Delaroche on the Semicircular wall in the Amphitheatre of the School of the Fine Arts at Paris* (London, n.d.). This popular writer on art refers to the immense mural as "one of the greatest, if not the greatest of the productions of modern times." On the memorial, see Stephen Bailey, *The Albert Memorial: The Monument in Its Social and Architectural Context* (London: Scolar Press, 1981), esp. 67–87; on the influence of Delaroche, see 67. See also Richard Jenkyns, *Dignity and Decadence: Victorian Art and the Classical Heritage* (Cambridge: Harvard University Press, 1992), 2–6; and Elisabeth Darcy and Nicola Smith, *The Cult of the Prince Consort* (New Haven: Yale University Press, 1983). For the early antecedents of the genre, see Richard Brilliant, "Intellectual Giants: A Classical Topos and *The School of Athens*," in his *Commentaries on Roman Art: Selected Studies* (London: Pindar, 1994), 176–87.

21. Haskell, *Rediscoveries*, 23. Steegman sites the breakdown of a stable hierarchy of taste in the middle of the century: "the late 'thirties and 'forties . . . marked the final breaking away from the correct taste prevailing at the beginning of the century, still being followed by some of the older generation." *Victorian Taste*, 233. He links the urge to the "correction" of public taste through institutions of art to the period's loss of bearings: "The nineteenth century, afflicted with doubts, made conscientious efforts to educate the public taste through schools and museums" (4). For a discussion of "the dream of a library" that would organize an infinite quantity of knowledge, see Roger Chartier, *The Order of Books: Readers, Authors, and Libraries in Europe between the Fourteenth and Eighteenth Centuries*, trans. Lydia G. Cochrane (Stanford: Stanford University Press, 1994), 61–88. The problem of the library Chartier describes in eighteenth-century France anticipates in a number of ways that of the museum in the nineteenth century. For an intriguing parallel to the themes of this chapter, see Chartier's discussion of the links between Etienne-Louis Boullée's 1785 fantasy-design of a library and Raphael's *School of Athens* (63).

22. Ziff, *Paul Delaroche*, 170.

23. William Holman Hunt, *Pre-Raphaelitism and the Pre-Raphaelite Brotherhood* (1905; reprint, New York: AMS Press, 1967), 1:158–60. Hunt and Rossetti saw the Delaroche Hemicycle in 1849.

24. Indeed, *The Athenaeum* criticized the Albert Memorial on the grounds that "the subjects of the allegorical groups and the podium reliefs were what the monument actually immortalised." Darcy and Smith, *Cult*, 56.

25. An older and repentant Hunt is interested in the influence on the document of the religious skepticism of the Enlightenment and romanticism, but his discussion ignores the shade of Carlyle lurking behind so emphatic a celebration of great men.

26. The architect of the Albert Memorial, George Gilbert Scott, based his design for the monument on medieval shrines: "The object at which I have aimed is, so far as possible, to translate back again into a real building the idea which must have floated in the imagination of those ancient shrine-makers." Quoted in Bailey, *Albert Memorial*, 45–46.

27. "Preface to First Edition of *Poems*," in Matthew Arnold, *On the Classical Tradition*, ed. R. H. Super (Ann Arbor: University of Michigan Press, 1960), 8–9. Further references are in the text.

28. In a paradoxical phrase Harold Bloom hints at the quality that makes Keats strangely ahead of his time: "Part of Keats's achievement is due then to his being perhaps the only genuine forerunner of the representative post-Romantic sensibility." "Keats and the Embarrassments of Poetic Tradition," in Harold Bloom, *The Ringers in the Tower: Studies in Romantic Tradition* (Chicago: University of Chicago Press, 1971), 138. Cf. Walter Jackson Bate, who first described this "embarrassment" in his *John Keats*, 73–74; see also 124, 325–35. Both authors, of course, followed their work on Keats with wider meditations on the question of poetic influence.

29. See Ian Jack, *Keats and the Mirror of Art* (Oxford: Clarendon Press, 1967), esp. the early sections on Keats's mentors in art, xvii–xxiii, 76. Further references are in the text.

30. Jack supports Sidney Colvin's identification of the work as *Pitture al Fresco del Campo Santo di Pisa intagliate da Carlo Lasino*, a volume in Haydon's library. He further follows Colvin in noting the significance of the book for the Pre-Raphaelites. See Jack, *Keats*, 99; Sidney Colvin, *John Keats: His Life and Poetry, His Friends, Critics and After-Fame* (1917; reprint, New York: Octagon, 1970), 325. See also Holman Hunt, *Pre-Raphaelitism*, 1:25–26. On Rossetti's response to the work, see Ford, *Keats and the Victorians*, 107.

31. Leigh Hunt, *Indicator*, no. 2 (20 October 1819); reprinted in *The Indicator, and the Companion* (London, 1834), 6. Cited in Jack, *Keats*, 7–8; emphasis in the original.

32. This fragment is an early treatment of the theme of Endymion. See Jack Stillinger, *The Poems of John Keats* (Cambridge: Harvard University Press, 1978), 79, 556–59. Further references are in the text. See also Jack, *Keats*, 144.

33. Cf. the discussion of the atemporal world of Delaroche's mural in the piece by Anna Jameson: "The artist, after long and mature consideration, rejected the formality of a chronological series and that sort of monotony which must have resulted from grouping the figures into separate nations and schools. The great men here assembled in friendly convocation, have already taken their place in the Temple of Immortality, where earthly distinctions of time and place are at an end." *Description*, 5.

34. Hans-Georg Gadamer, *Truth and Method*, 2d rev. ed., trans. Joel Weinsheimer and Donald G. Marshall (New York: Crossroads, 1989), 86–87; cf. 134–35.

35. See Malraux, *Voices*, 15, 645. Cf. Philip Fisher, "The Future's Past," *NLH* 6 (1974–75): 587–606.

36. E. H. Gombrich, "Malraux's Philosophy of Art in Historical Perspective," in *Malraux: Life and Work*, ed. Martine de Courcel (London: Weidenfeld and Nicolson, 1976), 169, 174. See also Gombrich, "André Malraux and the Crisis of Expressionism," in his *Meditations on a Hobby Horse* (London: Phaidon, 1963), 78–85.

37. For the most developed—if unsophisticated—artistic Elysium in Keats's work, see his "Ode to Apollo" (1815), first published by Milnes in the "Literary Remains" section of the *Life*. In this piece, a sighted Homer presides over a gathering including Virgil, Milton, Shakespeare, Spenser, and Tasso. Cf. Shelley's account of "The inheritors of unfulfilled renown" in stanzas 45 and 46 of "Adonais."

38. The biographer's many meditations on the "Poetic faculty" are evidence of D'Israeli's influence on Milnes's text. Note also the characteristically D'Israelian language and concerns of the following passage: "The modification of a nature at first passionately susceptible and the growing preponderance of the imagination is a frequent phenomenon in poetical psychology." Milnes, *Life and Letters*, 11.

39. The passage is from Leigh Hunt's *Foliage*, an 1818 collection of poems including several homages to Keats's poetic vocation. See Milnes, *Life and Letters*, 106–7.

40. Cf. Milnes's nuanced accounting of influence in his treatment of Keats and *Paradise Lost*: "his full appreciation of the great Poem was reserved for the period which produced *Hyperion* as clearly under Miltonic influence, as *Endymion* is imbued with the spirit of Spenser, Fletcher, and Ben Jonson." Ibid., 58.

41. The Routledge edition has an error here, which I have corrected based on Briggs.

42. In ninety-five lines Keats traces the development of poetry and his own ambition—from pastoral ("First the realm I'll pass / Of Flora, and old Pan"[lines 101–2]) to epic ("The driver of those steeds is forward bent, / And seems to listen: O that I might know / All that he writes with such a hurrying glow" [152–54]), to the decline of poetry in the last century ("a schism / Nurtured by foppery and barbarism" [181–82]), to the realization of his own ambition ("And they shall be accounted poet kings / . . . / O may these joys be ripe before I die" [267–69]). *Poems*, 71–75.

43. Cf. Bate on Keats's sonnet, "Written in Disgust of Vulgar Superstition." "Nothing could show more strikingly the subjective absorption in poetry into which Keats had fallen than the unintentional transference to poetry—or rather to *poets* . . . of terms, values, even symbols conventionally associated with religion." *John Keats*, 135–37.

44. Cf. Joseph Severn's reminiscence: "Keats . . . made me in love with the real living Spirit of the past. He was the first to point out to me how essentially modern that Spirit is: 'It's an immortal youth;' he would say, 'just as there is no *Now* or *Then* for the Holy Ghost.'" William Sharp, *The Life and Letters of Joseph Severn* (London, 1892), 29. Cited in Phinney, "Keats in the Museum."

45. On images of height in Keats's poetry, see Ward, *John Keats*, 100–101.

46. Bate offers a useful discussion of the biographical roots and philosophical implications of Keats's concept of negative capability, identifying the influence of Wordsworth and especially Hazlitt on the development of Keats's thought on this topic. See Bate, *John Keats*, 233–63.

47. *Times*, 19 September 1848, 3. The piece was published anonymously. Matthews identifies the critic as Samuel Phillips, "staff reviewer"; see Matthews, *Keats*, 320.

48. On Arnold's response to Keats, see Ford, *Keats and the Victorians*, 51–89. Ford notes that Arnold is the great illustration of Keats's impact in the nineteenth century because, for all his careful caveats, his own poetry was so much under the influence of the earlier writer (89). See also his *Matthew Arnold and the Romantics* (Lincoln: University of Nebraska Press, 1963), esp. 116–50.

49. Howard Foster Lowry, ed., *The Letters of Matthew Arnold to Arthur Hugh Clough* (London: Oxford University Press, 1932), no. 24.

50. *The Art Treasures Examiner: A Pictorial, Critical and Historical Record of the Art-Treasures Exhibition at Manchester in 1857* (Manchester, 1857), iv. This volume is a useful resource on the exhibition. Another contemporary account is W. Bürger [Théophile Etienne Joseph Thoré], *Trésors d'art exposés à Manchester en 1857* (Paris, 1857). See also Steegman, *Victorian Taste*, 229, 233–38; Elizabeth Gilmore Holt, ed., *The Art of All Nations, 1850–73: The Emerging Role of Exhibitions and Critics* (Garden City, N.Y.: Anchor, 1981), 164–76; Frank Herrmann, *The English as Collectors: A Documentary Chrestomathy* (London: Chatto and Windus, 1972); Haskell, *Redicoveries*, 158–60; and Ulrich Finke, "The Art-Treasures Exhibition," in *Art and Architecture in Victorian Manchester*, ed. John H. G. Archer (Manchester: Manchester University Press, 1985), 102–26. Herrmann notes that eight weeks after opening, the exhibition was still attended by nine thousand people per day.

51. *London Quarterly Review* 102 (1857): 92. Further references to this article are in the text.

52. *Works of Art in Great Britain* was first published in 1838. It was reissued in 1854, much enlarged and with the editorial help of Lady Eastlake, as *Treasures of Art in Great Britain*. A supplementary volume was brought out in 1857: *Galleries and Cabinets of Art*. See the review of Waagen by Lady Eastlake, *London Quarterly Review* 94 (1854). Similar guides were issued by Anna Jameson in the 1840s, though they were aimed at a more popular market (e.g., *Handbook to the Public Galleries of Art in and near London* [1842] and *Companion to the Most Celebrated Private Galleries of Art in London* [1844]). See Herrmann, *English as Collectors*, 65. On Waagen as curator, see Ziolkowski, "The Museum", 314, 319–20.

53. Cf. the memorandum Waagen prepared with Schinkel, the architect of the Altes Museum, more than twenty years before the Manchester Exhibition: "If one visits the famous painting galleries, one soon realizes that they are not arranged according to any rationally considered plan but rather owe their origin to accidents or hobbyhorses." Friedrich Stock, "Urkunden zur Vorgeschichte der Berliner Museum," *Jarbuch der preussichen Kunstsammlungen* 51 (1930): 209; quoted in Ziolkowski, *German Romanticism*, 319. Waagen, the first art historian to be curator of a major museum, played an important part in the design and arrangement of the Altes Museum (373).

54. J. B. Warring, ed., *Art Treasures of the United Kingdom from the Art-Treasures Exhibition* (London, 1858), 16.

55. *Catalogue of the Art Treasures of the United Kingdom, Collected in Manchester in 1857, Handbook of the Gallery of British Paintings in the Art-Treasures Exhibition: Being a Reprint of Critical Notices Originally Published in the "Manchester Guardian"* (Manchester, 1857); J. A. Crowe and G. B. Cavalcaselle, *The Early Flemish Painters; Notices of Their Lives and Works* (London, 1856); *What to observe at Manchester; a Walk round the Art-Treasures Exhibition, under the Guidance of Dr. Waagen* (London, 1857). The exhibition was reviewed by all the major journals, and its fabrication, inauguration, and progress were reported by the periodical press. See, e.g., *Illustrated London News*, 2, 9, 16 May 1857. Waagen's own review of the exhibition was published in England in the *Art Journal* 19 (1857): 233–36. Other works resulting from the event include W. Blanchard Jerrold, *How to See the Art-Treasures Exhibition*, (London, 1857) and the anonymous *What to See and Where to See It! or the Operatives Guide to the Art-Treasures Exhibition* (London, 1857). On international attention to the exhibition and the many articles that resulted, see Holt, *Art of All Nations*, 166–67.

56. Steegman, *Victorian Taste*, 219.

57. Charles Blanc, *Revue des deux mondes*, 17 October 1857, in Holt, *Art of All Nations*, 171.

58. Joseph Beavington Atkinson, *Blackwood's Edinburgh Magazine* 82 (August 1857): 156.

59. Ibid., 81 (June 1857): 758. An early illustration of the main hall of the exhibition in the *Illustrated London News*, 9 May 1857, was faced, it is worth noting, by a splendid engraving of the newly opened library and reading room of the British Museum, accompanied by a long article expressing relief that the new space would provide some respite from the pressures of "the daily accumulating libraries, now numbering upwards of half a million volumes, besides tracts, pamphlets, manuscripts, music, maps, and newspapers, to an almost incredible number."

60. Elizabeth Barrett Browning, *Aurora Leigh*, ed. Margaret Reynolds (Athens: Ohio University Press, 1992), 1:1004–20.

61. Like Lockhart's Scott, ever losing his material only to come across it later, Milnes's Keats also indites in a manner indicating disinterested creation: "Shorter poems were scrawled, as they happened to suggest themselves, on the first scrap of paper at hand, which was afterwards used as a mark for a book, or thrown anywhere aside. It seemed as if, when his imagination was once relieved, by writing down his effusions, he cared so little about them that it required a friend at hand to prevent them from being utterly lost." Milnes, *Life and Letters*, 176.

62. David Masson, "The Life and Poetry of Keats," *Macmillan's Magazine* 3 (1860): 5 (reprinted in *Wordsworth, Shelley, Keats and other Essays* [London, 1875]). Masson is transcribing "Sleep and Poetry" (lines 181–269), drawing on this early exercise to a degree that would be unusual today. His nostalgic account of Keats's milieu borrows from the poem's content and tone: "what wit there would be, what music, what portfolios of sketches and engravings, what white casts from the antique, what talk about poetry and literature!" (4).

63. Cf. the critic's early essay, "Pre-Raphaelitism in Art and Literature" (1852), which links the aims of the movement to those of Wordsworth. *British Quarterly*

Review 16 (1852): 197–220, reprinted in James Sambrook, ed., *Pre-Raphaelitism* (Chicago: University of Chicago Press, 1974), 71–91. Masson, a friend of Thomas Woolner, was on the margin of the movement from its early days. See William Michael Rossetti's introduction to his reissue of *The Germ* (1899; reprint, New York: AMS Press, 1965), 8.

64. Matthew Arnold, "John Keats," in *English Literature and Irish Politics*, ed. R. H. Super (Ann Arbor: University of Michigan Press, 1973), 210; first published in Thomas Humphrey Ward, ed., *The English Poets*, vol. 4 (London, 1880). On the project of *The English Poets*, see John Sutherland, *Mrs. Humphry Ward* (Oxford: Clarendon Press, 1990), 65; Enid Huws Jones, *Mrs. Humphry Ward* (New York: St. Martin's Press, 1973), 45; and Darrel Mansell, "Matthew Arnold's 'The Study of English Poetry' in Its Original Context," *Modern Philology* 83, no. 3 (1986): 279–85. See also the useful notes in Super's edition. Arnold not only discusses many of Keats's letters, he quotes Milnes directly in the essay (207, 208).

65. For the standard version of "Mother of Hermes! and still youthful Maia," and some textual variants, see Stillinger, *Poems*, 264, 609. The ellipsis is Arnold's.

CHAPTER SIX
OUTLINE, COLLECTION, CITY: HAZLITT, RUSKIN, AND
THE ENCOUNTER WITH ART

1. For a discussion of similarities between the critics and some speculation on influence, see William C. Wright, "Hazlitt, Ruskin, and Nineteenth-Century Art Criticism," *Journal of Aesthetic and Art Criticism* 32 (1974): 509–23. See also Helsinger, *Ruskin and the Eye of the Beholder*, 172–82. That Ruskin was familiar with Hazlitt's *Sketches of the Principal Picture Galleries* is demonstrated by the moment in *Modern Painters* I in which he takes exception to a description of a Cuyp sky that occurs in that work. John Ruskin, *The Complete Works of John Ruskin*, Library Edition, ed. E. T. Cook and Alexander Wedderburn (London: George Allen, 1903–12), 3:350. Further references from Ruskin are from this edition, made in the text by volume and page number. The passage that draws Ruskin's fire is in Hazlitt, *Complete Works*, 10:19.

2. William Hazlitt, "On the Pleasure of Painting" (first printed in *London Magazine* [December 1820]; reprinted in *Table-Talk*, vol. 1 [London, 1821]), in *Complete Works*, 8:14. At the time of the French Revolution, Louis-Philippe-Joseph put on the market what Francis Haskell calls "probably the finest private collection in the world at the time." The duke of Bridgewater, the earl of Gower (later marquis of Stafford) and the earl of Carlisle were the primary purchasers of works by such artists as Raphael, Titian, Domenichino, Annibale Carracci, and Guido Reni. They kept some of the canvases for themselves and exhibited the entire collection in Pall Mall, December 1798–August 1799. See Haskell, *Rediscoveries*, 39–44; and Hermann, *The English as Collectors*, 133–45. Hermann cites William Buchanan's *Memoirs of Painting* (1824): "the introduction of a collection of so much importance as that of the Orleans into this country formed of itself an era" (135).

3. Cf. William T. Whitley, *Art in England*, vol. 1, *1800–1820* (1928; reprint, New York: Hacker, 1973), 1–2: "it is safe to say that at the dawn of the nine-

teenth century the great majority of the people in England had never had an opportunity of seeing a good picture. It is true that exhibitions had been held in London since 1760, but only a small fraction of the population had visited them; and to the royal collections of works of art and those in the great private houses, there was no access for a poor man unless he entered the rooms that contained them in the capacity of a workman or servant. Even for people of the middle class admission to the important private collections was difficult because of the consequent expense."

4. Buchanan, in Hermann, *English as Collectors*, 138.

5. "Mr. Angerstein's Collection" (*London Magazine* [December 1822]), in Hazlitt, *Sketches of the Principal Picture-Galleries in England* (London, 1824). This volume is composed of essays written in 1822–23 and largely published in the *London Magazine* in these years.

6. Hazlitt was one of many English artists and art students who rushed to Paris during the brief interlude of the 1802 Peace of Amiens. On the Musée Napoléon, see Cecil Gould, *Trophy of Conquest: The Musée Napoléon and the Creation of the Louvre* (London: Faber, 1965), and Haskell and Penny, *Taste and the Antique*, 108–16.

7. First published in the *London Magazine* (February 1821). Included in the Paris edition of *Table Talk* (1825). Reprinted in *The Plain Speaker: Opinions on Books, Men, and Things* (London, 1826).

8. "On a Landscape of Nicholas Poussin" (*London Magazine* [August 1821]; reprinted in *Table Talk*, vol. 2 [London, 1822]). On the British Institution or Gallery and its exhibitions, see Whitley, *Art in England*, 1:106–11.

9. *Notes of a Journey through France and Italy Journey* (*Morning Chronicle*, 1824–25; published in volume form, 1826). The magical filling-in of names is already present in the account of his time at the Louvre in *Lectures on the English Comic Writers* (1819): "It was there that I learned to become an enthusiast of the lasting works of the great painters, and of their names no less magnificent." *Complete Works*, 6:149. The concluding pages of this lecture turn to an account of the Musée Napoléon that shades into a remarkable presentation of art as religion, as revelation (6:148–49). Pauline echoes abound: "I had heard of the fame of the Cartoons, but this was the first time I had ever been admitted face to face into the presence of those divine guests" (6:148).

10. Themes of wistful loss run through "The Pleasure of Painting," an elegiac treatment of the sense of fading youth and promise brought home by the recent death of its author's father (16 July 1820). As Howe notes in his edition, "Invited to write a formal obituary, he preferred to write this essay instead." *Complete Works*, 8:334n. Cf. Howe's *Life of William Hazlitt*, 276. It would simply be an acknowledgment of the complex of personal ambition, nostalgia, and politics that motivates Hazlitt at all times to note that if the "Pleasure of Painting" is a form of epitaph for his father, "On a Landscape of Poussin" serves a similar purpose for Napoleon, who died the following year, three months before that essay appeared in the *London Magazine*. The two figures and the practice of his art meet at odd moments; in "Pleasure" Hazlitt remembers finishing one of his first attempts, a portrait of his aged father, on the day he hears the news of the Battle of Austerlitz, Napoleon's great triumph over Austria (8:12–13).

11. "Pictures at Burleigh House" (first printed in *New Monthly Magazine* [April 1822]). For his lost enthusiasm, compare his account of the same piece in "On the Pleasure of Painting": "I had seen an old head by Rembrandt at Burleigh-House, and if I could produce a head at all like Rembrandt in a year, in my lifetime, it would be glory and felicity and wealth and fame enough for me!" Hazlitt, *Complete Works*, 8:9.

12. It was no idiosyncrasy on Hazlitt's part to link the destiny of Napoleon with that of the museum which was given his name. The galleries were inaugurated even before building was quite completed so as to coincide with the first anniversary of Napoleon's seizure of power (9 November 1800). When the collection was at its height in 1810, the marriage of Napoleon and Marie Louise of Austria was celebrated in the Salon Carré. See Haskell and Penny, *Taste and the Antique*, 112, and Holt, *Triumph of Art*, 79.

13. "On Dreams" (*New Monthly Magazine* [March 1823]), in *The Plain Speaker* (1826).

14. Haskell describes the flow of many great paintings to England during the revolutionary and Napoleonic periods as the beginning of the modern art market: "A general conclusion seems to be that the vast upheavals in Europe between 1793 and 1815 encouraged and, above all, enabled both the English and the French to acquire, either privately or publicly and on a massive scale, pictures whose status had already been consecrated by centuries of praise." Haskell, *Rediscoveries*, 70–71; see also 44.

15. Goethe, introduction to *Propyläen* (1798), quoted in Holt, *Triumph of Art*, 76.

16. Cf. Holt, on the effect of the voyage to Paris on the works of art themselves: "In spite of the eventual restitution of the works to their countries of origin, the former association of an art object with a specific location had been broken, and the art work came increasingly to be considered as an object *per se*." *Triumph of Art*, 79.

17. On the Grand Tour, see William Edward Mead, *The Grand Tour in the Eighteenth Century* (1914; reprint, New York: Benjamin Blom, 1972); Jeremy Black, *The British and the Grand Tour* (London: Croom Helm, 1985); Christopher Hibbert, *The Grand Tour* (London: Thames Methuen, 1987). For changes in the practice and institutions of the tour after the turn of the century, see James Buzard, *The Beaten Track: European Tourism, Literature and the Ways to "Culture," 1800–1918* (New York: Oxford University Press, 1993).

18. "Italian paintings were valued greatly in Britain, where they were regarded as the best example of their art. For many tourists seeing these paintings was a major motive for their trip to Italy. . . . It was *necessary* to visit Italy in order to appreciate, to any degree, Italian art and architecture." Black, *British and the Grand Tour*, 214; my emphasis.

19. Gould's descriptions of the provenance of the museum's holdings read like an itinerary of the tour: "In painting it had drawn its greatest strengths from the churches of Belgium and Italy and from the Pitti Palace in Florence. In antique sculpture the most famous treasures had come from the Capitoline museum, the Vatican and the Borghese Collection, all in Rome. Works of secondary importance—on these exalted standards—had been drawn from the princely collections

of Holland, Sardinia, Brunswick, Cassel, Prussia and elsewhere." Gould, *Trophy*, 103–4.

20. First published in the *New Monthly Magazine* (October 1827).

21. Goethe also testifies to the overwhelming effect of the city: "To take in even a small part of everything there is to see here would take a lifetime or, rather, the return of many human beings learning from each other in turn." *Italian Journey*, trans. W. H. Auden and Elizabeth Mayer (Harmondsworth: Penguin, 1970), 364.

22. Paul Valéry, "The Problem of Museums," in *Degas, Monet, Morisot*, trans. David Paul, *Collected Works*, vol. 12 (New York: Bollingen Foundation, 1960), 202–7; quotation from 202. Further references are in the text. It is difficult for translation to capture the hyperbolic strength of Valéry's text. "Je suis dans un tumult de créatures congelées, dont chacune exige, sans l'obtenir, l'inexistence de toutes les autres. Et je ne parle pas du chaos de toutes les grandeurs sans mesure commune, du mélange *inexplicable* des nains et des géants, ni même de ce raccourci de l'évolution que nous offre une telle assemblée d'êtres parfaits et d'inachevés, de mutilés et de restaurés, de monstres et de messieurs." Paul Valéry, "Le Problème des musées," in *Oeuvres*, ed. Jean Hytier (Paris: Gallimard, 1960), 2:1290; emphasis in the original.

23. "Une civilisation ni voluptueuse, ni raisonable peut seul avoir édifié cette maison de l'incohérence. Je ne sais quoi d'insensé résulte de ce voisinage de visions mortes. Elles se jalousent et se disputent le regard qui leur apporte l'existence. Elles appèllent de toutes parts mon indivisible attention; elles affolent le point vivant qui entraîne toute la machine du corps vers ce qui l'attire. . . ." Valéry, "Le Problème des musées," 2:1291; ellipsis in the original.

24. "Comme le sens de la vue se trouve violenté par cet abus de l'espace que constitue une collection, ainsi l'intelligence n'est pas moins offensée par une étroite réunion d'oeuvres importantes. Plus elles sont belles, plus elles sont des effets exceptionels de l'ambition humaine, plus doivent-elles être distinctes. Elles sont des objets rares dont les auteurs auraient bien voulu qu'ils fussent uniques." Ibid., 1292.

25. "notre héritage est écrasant. L'homme moderne . . . est appauvri par l'excès même de ses richesses . . . accumulation d'un capital excessif et donc inutilisable." Ibid., 1292.

26. "Le musée exerce une attraction constante sur tout ce qui font les hommes. L'homme qui crée, l'homme qui meurt, l'alimentent. *Tout* finit sur le mur ou dans la vitrine." Ibid., 1292; emphasis in the original.

27. "Le magnifique chaos du musée me suit et se combine au mouvement de la vivante rue. . . . Nous sommes, et nous nous mouvons dans le même vertige du mélange, dont nous infligeons le supplice à l'art du passé." Ibid., 1293.

28. John Ruskin, *Deucalion: Collected Studies of the Lapse of Waves, and Life of Stones*, 1875–83, in *Complete Works*. The passages quoted come from 1876.

29. Buzard is particularly interesting on the move from Grand Tour to tourism, describing in *The Beaten Track* the ever more sophisticated infrastructure supporting and encouraging a new class of traveler. He also traces the contemporary response to what was often depicted as an onslaught of middle-class tourists to the Continent after 1815. Hibbert offers a useful summary: "The Tour had

never recovered its former importance after having been brought almost to a halt by the Napoleonic Wars. Within a year of the Emperor's defeat at Waterloo, the English Channel was being crossed by steamers; within six years there was a regular steamer service; and within twenty years railway tracks were being built all over Europe and hotels at every terminus." *Grand Tour*, 248. In *Ruskin and Italy* (Ann Arbor: UMI Research Press, 1987), 20, Alexander Bradley notes Ruskin's unacknowledged contributions to *Murray's Handbook for Travellers in Northern Italy* (written 1845, published 1847). Later in his career, Ruskin was not adverse to making his own work useful for travelers. See, e.g., the itineraries proposed in *Mornings in Florence*, or the index for travelers he eventually provided for the third volume of *Stones of Venice* (23:285–457, 11:355–436). The importance for Ruskin of contemporary travel writing is developed in Helsinger's *Ruskin and the Art of the Beholder*.

30. John Rosenberg describes the change in Ruskin after 1860 as being "of emphasis only, not of direction." *The Darkening Glass: A Portrait of Ruskin's Genius* (New York: Columbia University Press, 1961), 41; see also 42–45. Like Rosenberg, most recent readers see close continuities between Ruskin's artistic and social criticism, or perhaps an *inability* to separate his concerns.

31. "A thing of beauty is a joy for ever: / Its loveliness increases; it will never / Pass into nothingness." Keats, *Endymion*, lines 1–3, in Stillinger, *Poems*, 65. The contrast of theme and building returns several times in Ruskin's work: "If anyone had really understood the motto from Keats, which was blazoned at the extremity of the first Manchester exhibition building, they would have known that it was the bitterest satire they could have written there, against the building itself and all its meanings—'A thing of beauty is a joy forever.' It is not a joy for three days, limited by date of return ticket." "On the Present State of Modern Art, with Reference to the Advisable Arrangements of a National Gallery" (1867), in *Complete Works*, 19:209. See also *Aratra Pentelici* (1870), 20:212; and *The Art of England* (1883), 32:323.

32. Cf. *Unto This Last*, in which Ruskin develops his concept of "Illth," an antonym to "wealth" that describes excessive and therefore dangerous accumulation (*Complete Works*, 17:89; 168).

33. James Clark Sherburne places Ruskin's views on plenty in the context of eighteenth- and nineteenth-century economic and social theory. His concern is the manner in which Ruskin challenges what Sherburne describes as a Victorian economic sensibility based on scarcity, but perhaps his title is most useful for us: *John Ruskin or the Ambiguities of Abundance: A Study in Social and Economic Criticism* (Cambridge: Harvard University Press, 1972). See esp. the chapter "Streams of Abundance," 69–93.

34. The danger surfeit poses to the appreciation of beauty is not an isolated topic, but is a recurrent theme in Ruskin's major work. "Let us consider for an instant," he proposes in *The Seven Lamps of Architecture*, "what would be the effect of continually repeating an expression of a beautiful thought to any other of the senses at times when the mind could not address that sense to the understanding of it. Suppose that in times of serious occupation or of stern business, a companion should repeat in our ears continually some favourite passage of poetry, over and over again all day long. We should not only soon be utterly sick and weary of

the sound of it, but that sound would at the end of the day have so sunk into the habit of the ear that the entire meaning of the passage would be dead to us, and it would ever thenceforward require some effort to fix and recover it" (8:155–6). In *Stones* III Ruskin writes of "the charm of association which long familiarity with any scene too fatally wears away" (11:359). *Modern Painters* III moves even further beyond simple example to psychological speculation: "Another character of the imagination is equally constant, and, to our present inquiry, of yet greater importance. It is eminently a *wearible* faculty, eminently delicate, and incapable of bearing fatigue; so that if we give it too many objects at a time to employ itself upon, or very grand ones for a long time together, it fails under the effort, becomes jaded, exactly as the limbs do" (5:182; emphasis in the original).

35. Walter Benjamin, "The Work of Art in the Age of Mechanical Reproduction," in *Illuminations*, trans. Harry Zohn (Bungay, Suffolk: Fontana, 1982), 236. Further references are in the text. Recent critics have noted the similarity between Benjamin's concept of aura and Ruskin's response to the explosion of cheap reproductions in the second half of the nineteenth century. See Linda M. Austin, *The Practical Ruskin: Economics and Audience in the Late Work* (Baltimore: Johns Hopkins University Press, 1991), 4–5; and Helsinger, *Ruskin and the Art of the Beholder*, 138–39.

36. "Die Masse könnt Ihr nur durch Masse zwingen, / Ein jeder sucht sich endlich selbst was aus" (The mass can only be subdued by massiveness, / so each can pick a morsel for himself"). Goethe, *Faust*, trans. Peter Salm (New York: Bantam Books, 1985), lines 95–96.

37. Ruskin is urgent and specific: "I speak of literal facts. Giotto's frescos at Assisi are perishing at this moment for want of decent care; Tintoret's pictures in San Sebastian, at Venice, are at this instant rotting piecemeal into grey rags; St. Louis's chapel, at Carcassonne, is at this moment lying in shattered fragments. . . . And here we are all cawing and crowing, poor little half-fledged daws as we are, about the pretty sticks and wool in our own nests." *Complete Works*, 16:75.

38. Paul Valéry, "The Conquest of Ubiquity" (1928), in *Aesthetics*, trans. Ralph Manheim (New York: Bollingen Foundation, 1964), 225. "La Conquête de l'ubiquite," in *Oeuvres*, 2:1284.

39. Recent work on Ruskin from an ecological perspective emphasizes the element of preservation or stewardship. See Michael Wheeler, ed. *Ruskin and the Environment: The Storm-Cloud of the Nineteenth Century* (Manchester: Manchester University Press, 1995).

40. An intriguing parallel may be drawn between Ruskin and Baudelaire. Responding only two years earlier to the Universal Exhibition of 1855, Baudelaire acknowledges the challenge of a conglomeration of objects belonging to evidently distinct canons of beauty, yet he is moved to suggest the possibility of the assemblage's working toward a greater harmonious whole. See "The Universal Exhibition of 1855: The Fine Arts," in *Baudelaire: Selected Writings on Art and Artists*, trans. P. E. Charvet (Cambridge: Cambridge University Press, 1981), 115–17.

41. Cf. "Pre-Raphaelitism" (1854): "Of all the wastes of time and sense which Modernism has invented—and they are many—none are so ridiculous as this endeavour to represent past history. What do you suppose our descendants will care for our imaginations of the events of former days? Suppose the Greeks,

instead of representing their own warriors as they fought at Marathon, had left us nothing but their imaginations of Egyptian battles.... What fools we should have thought them! How bitterly we should have been provoked with their folly! And that is precisely what our descendants will feel towards us, so far as our grand historical and classical schools are concerned." *Lectures on Architecture and Painting*, in Ruskin, *Complete Works*, 12:151–52.

42. For a useful summary of the topic, see Austin, *The Practical Ruskin*, 4–6. For more detailed art-historical information, see Basil Gray, *The English Print* (London: Adam and Charles Black, 1937); Basil Hunnisett, *Steel-Engraved Book Illustration in England* (London: Scolar, 1980); and Anthony Dyson, *Pictures to Print: The Nineteenth-Century Engraving Trade* (London: Farrand Press, 1984). For many examples of the popular reproduction of paintings, see Rodney K. Engen's catalog, *Victorian Engravings* (London: Academy Editions, 1975).

43. On the explosion of guide books in nineteenth-century England, see John Vaughan, *The English Guide Book c. 1780–1870: An Illustrated History* (London: David and Charles, 1974), esp. 38–53. Also see Buzard, *Beaten Track*, 65–77.

44. Rosenblum, *Transformations in Late Eighteenth Century Art*, 186. For the Continent-wide influence of Flaxman, see *Transformations*, 172–78 and, esp., Sarah Symmons, *Flaxman and Europe: The Outline Illustrations and Their Influence* (New York: Garland, 1984). On Flaxman's illustrations, see David Bindman, ed., *John Flaxman* (London: Thames and Hudson, 1979), esp. 156–81; Irwin, *English Neoclassical Art*, 57–63; David Irwin, *John Flaxman, 1755–1826: Sculptor, Illustrator, Designer* (New York: Rizzoli, 1979), 67–122; and Margaret Whinney, "Flaxman and the Eighteenth Century," *Journal of the Warburg and Courtauld Institutes* 19 (1956): 3–4, 269–82. See also Corrado Gizzi, ed., *Flaxman e Dante* (Milan: Mazzotta, 1986).

45. Symmons, *Flaxman*, 85. "Already archeological publications had conventionalized outline illustration as a method of reproducing works of art: Montfaucon's *Antiquité Expliquée* [1719–1724] ... Stuart and Revett's *Antiquities of Athens* [1762–1816] ... Winckelmann in his *Monumenti Antichi Inediti* [1756]. Flaxman copied all these works and admired the vase illustrations from Tischbein's edition of the vases in the collection of Sir William Hamilton printed in pure outline [1791–95]." *Flaxman*, 103.

46. William Hazlitt, "On Flaxman's Lectures on Sculpture," first published, *Edinburgh Review* (October 1829).

47. John Ruskin, "Pre-Raphaelitism" (1854), in *Lectures on Architecture and Painting*, in *Complete Works*, 12:153. Cf. *Modern Painters* IV (6:371–72).

48. Letter of 15 September 1819; cited in Howe, *Life of William Hazlitt*, 254.

49. Herschel Moreland Sikes, Willard Hallam Bonner, and Gerard Lahey, eds., *The Letters of William Hazlitt* (New York: New York University Press, 1978), 119. The quoted passage is from Gay's *Beggar's Opera*.

50. The Cartoons (1515–16) were brought to England in the 1620s. Their fame as the principal Old Master works in the country grew throughout the eighteenth century, in part thanks to the popular prints of Simon Gribelin (1707), which Hazlitt is fond of citing (fig. 47). On the Cartoons in England, see John Shearman, *Raphael's Cartoons in the Collection of Her Majesty The Queen and the Tapestries for the Sistine Chapel* (London: Phaidon, 1972), esp. 145–64.

51. William Hazlitt, "The Vatican," first printed in the *New Monthly Magazine* (November 1827).

52. When he takes on the reproductions or the Cartoons Ruskin is attacking an influential favorite. See Richard T. Godfrey, *Printmaking in Britain: A General History from Its Beginnings to the Present Day* (New York: New York University Press, 1978), 31: Gribelin's images "had a very wide sale and stimulated the appetite of connoisseurs for larger plates." A later set by Dorigny (1720) was also very influential on artists and connoisseurs. Ruskin disliked not only the reproductions, but the Cartoons themselves, his criticism becoming more frank over the years. He describes the works as "dramatic," not "constant" art, in 1867, while implicitly linking them with the neoclassical work they inspired (*Cestus*, in *Complete Works*, 19:203). *Praeterita* II (1886) has the following intriguing juxtaposition in Ruskin's memory of visits to the palace where they were at the time displayed: "Hampton Court, where the great vine, and the maze were of thrilling attraction to me; and the Cartoons began to take the aspect of mild nightmare and nuisance which they have ever since retained" (35:246–47). See also 3:29.

CHAPTER SEVEN
VAST KNOWLEDGE/NARROW SPACE: *THE STONES OF VENICE*

1. On the development of *Modern Painters*, see Rosenberg, *The Darkening Glass*, 2–41. Rosenberg remarks that, "the book would be less perplexing if Ruskin had known more about art when he began it, or learned less in the course of its composition."

2. Alexander Bradley documents the remarkable number of turning points and "discoveries" that characterized Ruskin's visits to Italy—or at least his accounts of these visits. *Ruskin in Italy*, xi. On Ruskin's Italian turning points, see also Robert Hewison, *John Ruskin, the Argument of the Eye* (London: Thames and Hudson, 1976), 54, 123–25. Hewison speaks of "The crucial tour of Italy in 1845," leading to a second volume of *Modern Painters*, "which speaks in a totally different voice" (54). On what is known as Ruskin's "unconversion" in Turin, see Hewison, *John Ruskin*, 123–25, and George Landow, *The Aesthetic and Critical Theories of John Ruskin* (Princeton: Princeton University Press, 1971), 281–87. For Ruskin's relationship with Italy, see esp. Jeanne Clegg, *Ruskin and Venice* (London: Junction Books, 1981), and the following catalogs of exhibitions: Jeanne Clegg and Paul Tucker, *Ruskin in Tuscany* (Sheffield: Ruskin Gallery, 1993), and Robert Hewison, *Ruskin and Venice* (London: Thames and Hudson, 1978). See also Hewison's "Notes on the Construction of *The Stones of Venice*," in *Studies in Ruskin: Essays in Honor of Van Akin Burd*, ed. Robert Rhodes and Del Ivan Janil (Athens: Ohio University Press, 1982), 131. Jay Fellow leaves wider cultural issues undiscussed. Nevertheless, his rich deconstructive-phenomenological reading of the oeuvre offers a compelling account of perpetually inadequate organization confronting an overwhelming world. See *The Failing Distance: The Autobiographical Impulse in John Ruskin* (Baltimore: Johns Hopkins University Press, 1975) and *Ruskin's Maze* (Princeton: Princeton University Press, 1981).

3. The research for volume 1 kept Ruskin in Venice from November 1849 to March 1850; volumes 2 and 3 saw him there from the beginning of September

1851 to the end of June 1852 (see *Complete Works*, 9:xxiv, 10:xxiii). Helsinger situates Ruskin in the context of several nineteenth-century traditions of travel writing in her *Ruskin and the Art of the Beholder*, 140–63.

4. Helsinger's concept of "excursive sight" is helpful here, a mode of travel writing and visual representation concerned with the unfolding experience of the landscape rather than with the sudden total view (*Ruskin and the Art of the Beholder*, 67–110). In "The Vantage Point of the True Centre: Problems in the Transcendental Altitude of Self," Fellows identifies as a repeated motif Ruskin's elevation of himself as viewer of a world otherwise too flat (*Ruskin's Maze*, 45–59).

5. See Clegg, *Ruskin and Venice*, 108. On Torcello, see Raffaele Cattaneo, *L'architettura in Italia dal secolo VI al mille circa* (Venice, 1888), 288; G. Lorenzetti, *Torcello, la sua storia, i suoi monumenti* (Venice, 1939); and two works by Renato Polacco, *Scultura paleocristiane E Altomedioevali di Torcello* (Treviso: Marton, 1976) and *La Cattedrale di Torcello* (Venice: Canova, 1984).

6. Pugin, the most powerful voice for Gothic before Ruskin, had almost indelibly dyed the movement with his Catholic convictions. "The great obstacle that made it impossible for the majority of Englishmen to accept the doctrines of Pugin was sectarian." Quentin Bell, *Ruskin* (1963; reprint, New York: George Braziller, 1978), 43; see also 44–45. Cf. Kenneth Clark, *The Gothic Revival: An Essay in the History of Taste* (1928, rev. ed. 1962; reprint, New York: Icon, 1983), 195: "For the majority of readers Ruskin succeeded in disinfecting Gothic architecture; and it is because he was the first person consciously to attempt this, because his work could be read free of pollution, that he is remembered as the originator of Gothic Revival doctrines. The dissociation of Gothic architecture and Rome was, perhaps, Ruskin's most complete success." See also Clegg, *Ruskin and Venice*, 108. On the broader history of the response to Gothic, see Paul Frankl, *The Gothic* (Princeton: Princeton University Press, 1960).

7. Ruskin's 1874 preface to the third edition of *Stones* is a chagrined account of the profusion of "Venetian Gothic" architecture his work had inspired in England (*Complete Works*, 9:11–15). "No book of mine has had so much influence on contemporary art as *The Stones of Venice*; but this influence has been possessed only by the third part of it, the remaining two-thirds having been resolutely ignored by the British public" (9:11).

8. See Clark, *Gothic Revival*, 200. For Pugin's contempt for false fronts, see also 142 and 148.

9. "Borrowing or stealing with such art and caution, will have a right to the same lenity as was used by the Lacedemonians; who did not punish theft, but the want of artifice to conceal it." Reynolds, *Discourses*, 106. The reference is from Xenophon's *Anabasis*, 4.6.14 and Plutarch's *Lycurgus*, 17. See Wark's notes to the passage in Reynolds, *Discourses*.

10. Cf. the opening of Winckelmann's *On the Imitation of the Painting and Sculpture of the Greeks* (1755): "To the Greek climate we owe the production of taste," in *Winckelmann: Writings on Art*, ed. David Irwin (New York: Phaidon, 1972), 61. His *History of Ancient Art*, 2:4–5, makes a similar argument.

11. "The independence of Greece is to be regarded as the most prominent of the causes, originating in its constitution and government, of its superiority in

art." Winckelmann, *History*, 2:9–10. "From this whole history it appears that art owed its elevation to liberty" (4:3). See also 2:14–15; 4:133, 139. Cf. John Flaxman, *Lectures on Sculpture* (2d rev. ed., 1838; reprint, London, 1865), 239.

12. G.W.F. Hegel, *Aesthetics* (1835), trans. T. M. Knox (Oxford: Oxford University Press, 1975), 1:478. Further references are in the text.

13. Pater quotes extensively from this passage of Hegel in the course of his essay on Winckelmann, a work strikingly congruent with Ruskin's thought in this one thing, the limits of the value of classical art in modernity. Walter Pater, *The Renaissance*, ed. Donald Hill (Berkeley: University of California Press, 1980), 175.

14. See esp. Winckelmann, *History*, 1:199–205, 240–403. The depth of Ruskin's revisionist impulse may be seen in his discussion of "Lintel Architecture," in which not only is the Greek style far from ideal, but in which the Parthenon finds itself in strange company. Comparing it with Romanesque and Gothic, Ruskin is not satisfied to merely identify the characteristic form of Greek architecture as "the worst of the three," but he goes on to describe it as "considered with reference to stone construction, always in some measure barbarous. Its simplest type is Stonehenge; its most refined, the Parthenon; its noblest, the Temple of Karnak." *Complete Works*, 10:252.

15. "Because the ideal is an infinitude to which he never attains, the civilized man can never become perfect in *his* own wise, while the natural man can in his. He must therefore fall infinitely short of the latter in perfection, if one heeds only the relation in which each stands to his species and to his maximum capacity. But if one compares the species themselves with one another, it becomes evident that the goal to which man strives through culture is infinitely preferable to that which he attains through nature. For one obtains its value by the absolute achievement of a finite, the other by approximation to an infinite greatness." Schiller, *Naive and Sentimental Poetry*, 194.

16. In a lecture of 1875 printed as "Studies in the 'Discourses' of Sir Joshua Reynolds," Ruskin reprises the opinion of the first president of the Royal Academy he expressed in *Modern Painters* III (1856): "he seems to have been born to teach all error by his precept, and all excellence by his example." See *Complete Works*, 5:46, 22:94.

17. Cf. Winckelmann's description of "The Grand Style": "Finally, at the time when Greece attained its highest degree of refinement and freedom, art also became more unfettered and lofty; for the older style was constructed upon a system composed of rules which, though originally derived from nature, had afterwards departed from it and become ideal. The artist wrought more in conformity to these rules than to nature, the object of imitation, for art had created for itself a nature of its own. The improvers of art elevated themselves above this adopted system, and drew nearer to the truth of nature." *History*, 3:198. This higher truth is not a greater intimacy with the contingent in nature, but what Reynolds would know as ideal beauty. See also Winckelmann, "On Imitation" "It is not only nature which the votaries of the Greeks find in their works, but still more, something superior to nature; ideal beauties . . ." (62).

18. See also Ruskin, *Complete Works*: *Stones*, 9:226, 10:258, and *Lamps*, 8:87–88.

19. For a discussion of the topic contemporary with *Stones*, see Ruskin, "Let-

ters on the National Gallery," (1852), in *Complete Works*, 12:411–14. See also "Modern Art," in *Cestus* (1867), 19:219–29. On the Ruskin Museum, see Robert Hewison, *Art and Society: Ruskin in Sheffield, 1876* (London: Guild of St George, 1979), and Catherine W. Morley, *John Ruskin: Late Work, 1870–1890, The Museum and Guild of St George: An Educational Experiment* (London: Garland, 1984).

20. For another description of the virtues of the museum as labyrinth, see Ruskin, "Letters on the National Gallery," *Complete Works*, 12:411. For a study of the image of the labyrinth in Ruskin generally, see Fellows, *Ruskin's Maze*; on labyrinthine museums, see esp. 127–43.

CHAPTER EIGHT
MODERNITY AS RESURRECTION IN PATER AND WILDE

1. Walter Pater, "Beginnings of Greek Sculpture," in *Greek Studies* (1895; reprint, London: Macmillan, 1925), 224. Further references are in the text. This essay was the first of two (the second being "The Age of Athletic Prizemen") originally published in the *Fortnightly Review* in 1880. These were followed in the same year by "The Marbles of Aegina." It has been suggested that this material was originally written for lectures delivered in 1879; and certainly, their lucid pedagogic style bears out the idea. See Frank M. Turner, *The Greek Heritage in Victorian Britain* (New Haven: Yale University Press, 1981), 69–76. Richard Jenkyns, *The Victorians and Ancient Greece* (Cambridge: Harvard University Press, 1980) is also an important source.

2. Oscar Wilde, "The Critic as Artist" (1891), in *The Complete Works of Oscar Wilde* (London: Collins, 1986), 1040. Unless otherwise indicated, further references to Wilde are drawn from this volume and made in the text.

3. Oscar Wilde, *The Speaker*, 1(1890): 319–20. Reprinted in R. M. Seiler, ed., *Walter Pater: The Critical Heritage* (London: Routledge, 1980), 233. For a verbatim transcription, see Wilde, *Complete Works*, 1040.

4. Walter Pater, "Winckelmann," in *The Renaissance: Studies in Art and Poetry*, ed. Donald L. Hill (1873; rev. ed., 1893; reprint, Berkeley: University of California Press, 1980), 185. Further references to the *Renaissance* are from this edition and cited in the text. In "The Critic as Artist," the web stands revealed as trapping net: "[Heredity] has shown us that we are never less free than when we try to act. It has hemmed us round with the nets of the hunter, and written upon the wall the prophecy of our doom. We may not watch it, for it is within us. We may not see it, save in a mirror that mirrors the soul. It is Nemesis without her mask. It is the last of the Fates, and the most terrible." Wilde, *Complete Works*, 1040.

5. Hill, citing a similar reference in *Marius*, draws our attention to the song of the Earth Spirit in *Faust* I (1, lines 155–56). See Hill, *Renaissance*, 454. William Shuter cites *Faust* II in "History as Palingenesis in Pater and Hegel," *PMLA* 86 (May 1971): 412.

6. On Leonardo in general and the *Mona Lisa* in particular as symbols of modernity in the period, see Barrie Bullen, "Walter Pater's 'Renaissance' and Leonardo Da Vinci's Reputation in the Nineteenth Century," *Modern Language Review* 74 (1979): 268–80. Bullen is particularly interesting on the important French influence on Pater's writing on this topic. See also his *The Myth of the*

Renaissance in Nineteenth-Century Writing (Oxford: Clarendon Press, 1994), esp. 273–98. The most thorough conceptual analysis of Pater's historic sense is to be found in Carolyn William, *Transfigured World: Walter Pater's Aesthetic Historicism* (Ithaca: Cornell University Press, 1989). On the topic of burial, the tomb, and related figures of death, see Jay Fellows, *Tombs, Despoiled and Haunted: "Under-Textures" and "After-Thoughts" in Walter Pater* (Stanford: Stanford University Press, 1991), and William F. Shuter, *Rereading Walter Pater* (Cambridge University Press, 1997), esp. 92–108. On the images of rebirth in Pater in relation to the influence of Hegel, see Shuter, "History as Palingenesis," 412–420.

7. Walter Pater, *Marius the Epicurean* (1885; reprint, Harmondsworth: Penguin, 1985), 136; my emphasis. Further references are in the text.

8. It is an open part of Pater's project to insist that the rupture between the Middle Ages and the Renaissance has been exaggerated (*Renaissance*, 1). A general principle of historiography is at stake ("The history of art has suffered as much as any history by trenchant and absolute divisions" [180]), as well as a specific question of interpretation that challenges as much Arnold as Ruskin. See David J. DeLaura, *Hebrew and Hellene in Victorian England: Newman, Arnold, and Pater* (Austin: University of Texas Press, 1969).

9. Walter Pater, "The Myth of Demeter and Persephone" (1876), in *Greek Studies*, 147. Further references are in the text.

10. That Psyche's pregnancy is the precipitating cause of her misfortune is evident from the words of one of her sisters to the other immediately prior to convincing Psyche to try to kill Cupid: "it is a god she bears in her womb. And let that be far from us! If she be called a mother of a god, then will life be more than I can bear." Pater, *Marius*, 77. Cf. also Pater's treatment of Semele, the mother of Dionysus who is destroyed when Zeus appears to her, after much importuning, in the form of lightning. He subsequently carries Dionysus to term in his own thigh. "A Study of Dionysus" (1876), in *Greek Studies*, 24. "Hippolytus Veiled" (1889) offers a detailed chronicle of the incestuous desires of a "so kindly mystical mother." *Greek Studies*, 179.

11. Pater challenges *both* received art-historical ideas on the unchallengeable merits of Michelangelo as the summit of Renaissance painting and the medieval-revivalists' affection for the "pure" Fra Angelico. On the relatively sudden rise of Botticelli's reputation in England, see Michael Levey, "Botticelli and Nineteenth-Century England," *Journal of the Warburg and Courtauld Institutes* 23 (1960): 291–306. For the role of Pater in shaping his reputation, see esp. 303–4. See also Frank Kermode, "Botticelli Recovered," in his *Forms of Attention* (Chicago: University of Chicago Press, 1985), 1–31.

12. It is a reference to the second volume of the *Aesthetics*. See Hill's note, *The Renaissance*, 434, and Hegel, *Aesthetics*, 759. The influence of Hegel is evident and acknowledged throughout the essay on Winckelmann. On the topic in Pater generally, see Shuter, "History as Palingenesis." See also Richard Wollheim, "Walter Pater as a Critic of the Arts," in his *On Art and Mind* (Cambridge: Harvard University Press, 1974), 169–70.

13. It should be said that Pater subtly perverts a key element in Ruskin's argument by making Verrochio, a figure he consistently depicts as a *craftsman*, the seeker after a shallow perfection of work (*Renaissance*, 80–81). In Ruskin's account

it is the Renaissance *artist* who insists on a cold inhuman perfection; the real craftsman always injects personality into his work. For Pater's revision of the widely held opinion that Leonardo's efforts were a mark of dissipation rather than "many-sidedness," see Bullen, "Walter Pater's 'Renaissance,'" 268.

14. "Many have wondered at that incompleteness, suspecting, however, that Michelangelo himself loved and was loath to change it, and feeling at the same time that they too would lose something if the half-realised form ever quite emerged from the stone, so rough-hewn here, so delicately finished there; and they have wished to fathom the charm of this incompleteness." Pater, *Renaissance*, 53.

15. Giorgio Vasari, *Lives of the Artists*, vol. 1, trans. George Bull (Harmondsworth: Penguin, 1965), 270. On the genre, see Francis Haskell, "The Old Masters in Nineteenth-Century French Painting," in *Past and Present in Art and Taste* (New Haven: Yale University Press, 1987), 90–115. For Leonardo, see esp. 92–93, 102–3, 238. On the reputation of Leonardo, see A. Richard Turner, *Inventing Leonardo* (New York: Knopf, 1993); on Pater, his predecessors, and influence, see 100–131.

16. On the attribution of *The Medusa* painting and its popularity in nineteenth-century accounts of Leonardo, see Turner, *Inventing Leonardo*, 114–17.

17. See esp. "Apollo in Picardy" (1893), for the beautiful deadly discus which is uncovered in a tomb. In William E. Buckler, ed., *Walter Pater: Three Major Texts* (New York: New York University Press, 1986). 373–90. In "The Beginnings of Greek Sculpture" Pater generalizes his own preoccupation; he writes of "those sanguine, half-childish dreams of buried treasure discovered in dead men's graves, which seem to have a charm for everyone." Pater, *Greek Studies*, 211. For a useful treatment of the Victorian preoccupation with tombs, see Hilary Fraser, *The Victorians and Renaissance Italy* (Oxford: Blackwell, 1992), esp. 12–42. Fraser identifies the theme of Renaissance as resurrection in history writing of the second half of the century and emphasizes the particular importance of Michelet for Pater in this regard (212–56).

18. The reference to the color of life in the opened grave may well be one more debt to accounts of recent archaeological discoveries—and the debate they precipitated about polychromy and Greek statues. The researches of Charles Newton at Cnidus and Halicarnassus, which resulted in the arrival of the Demeter at the British Museum, also yielded published accounts on which Pater drew when writing his *Greek Studies*. Newton's memoirs of his investigations include discussion of several works with traces of paint, which were eventually to find their way to London—notably a set of red-mouthed lions. See his *Travels and Discoveries in the Levant* (London, 1865), 2:123, 131–32, 271–73. For Pater's knowledge of this text and Newton's other work, see Billie Andrew Inman, *Walter Pater and His Reading, 1874–1877* (New York: Garland, 1990), 130, 148, and esp. 150–53. On Newton and his discoveries, see Jenkins, *Archaeologists and Aesthetes*, 168–95.

19. "Poems by William Morris," *Westminster Review*, n.s., 68, no. 34 (1868): 307. Further references are in the text.

20. Cf. Pater's critique of Renaissance historicism in "Pico Della Mirandola": "They lacked the very rudiments of the historic sense, which by an imaginative

act throws itself back into a world unlike one's own. . . . They had no idea of development, of the differences of ages." Pater, *Renaissance*, 26.

21. Harold Bloom, an important reader of Pater, is too simple in saying that "Pater's entire vision is that of a latecomer longing for a renaissance, a rebirth into imaginative earliness." Bloom, "The Intoxication of Belatedness," *Yale French Studies* 50 (1974): 163–89; quotation from 182. This error is behind his misreading of Pater's career, including the suggestion that Pater retreats from the attitude Bloom incorrectly assigns him in a "semi-withdrawal from his own earlier vision" ascribable to a timorous "last phase" (188). The passage I cite is from 1868, and occurs in an essay that is a trove of early Paterian thought. It is missing this early absolute skepticism as to the possibility of rebirth that misleads Bloom into suggesting that the classical studies "stand a little apart from the rest" of Pater's work (179). Indeed, though *Greek Studies* itself was only released as a volume in 1895, the essays on Demeter and Dionysus were first published just three and four years after *The Renaissance*, respectively.

22. "The power and precariousness alike of Pater's reveries are related to their hovering near the threshold of wish-fulfillment." Bloom, "Intoxication," 180.

23. The work of Nietzsche is an interesting parallel, though neither man is an original researcher in this regard, and there is no evidence of influence between them. In his discussion of Demeter Pater is particularly indebted to Ludwig Preller. For the influences on Pater's account of comparative mythology, see Shuter, "History as Palingenesis," 416–18 and 421. See also Billie Andrew Inman, "The Emergence of Pater's *Marius* Mentality: 1874–5," *English Literature in Transition* 27, no. 2 (1984): 114. She also links the theme of maternity in *Marius* to the Demeter essay.

24. "The gods of Greek mythology overlap each other; they are confused or connected with each other, lightly or deeply, as the case may be, and sometimes have their doubles, at first sight as in a confused dream, yet never, when we examine each detail more closely, without a certain truth to human reason." Pater, *Greek Studies*, 100. Pater's interest in Persephone was part of a quite widespread phenomenon, which included authors as diverse as Ruskin, Rossetti, and Swinburne. On the Victorians and myth, see esp. Turner, *Greek Heritage*, 77–134. See also two essays by Steven Connor, "Myth and Meta-Myth in Max Müller and Walter Pater," in *The Sun Is God: Painting, Literature, and Mythology in the Nineteenth Century*, ed. J. B. Bullen (Oxford: Clarendon Press, 1989), 199–222; and "Myth as Multiplicity," *Review of English Studies* 34(1983): 28–42. The most thorough account of Pater's treatment of the statues from Cnidus is Linda Dowling, "Walter Pater and Archaeology," *Victorian Studies* 31 (1988): 209–31.

25. The original *Fortnightly Review* article has *pietà*, which seems more likely than the repetition of *mater dolorosa*. "The Myth of Demeter and Persephone," pt. 2, *Fortnightly Review*, n.s., 109, no. 19 (1876): 273.

26. *Salome* was first written and published in French in 1893. Its subsequent translation by Alfred Douglas developed into a matter of contention between Douglas and the author, which came to involve the publisher, John Lane, and even Aubrey Beardsley, who offered to make his own translation. For the sake of convenience, and as Wilde himself revised Douglas's work, I cite the Douglas translation reprinted in *Complete Works* (552–75).

27. Richard Ellmann, "Overtures to Salome," in *Oscar Wilde: A Collection of Critical Essays*, ed. Richard Ellman, (Englewood Cliffs, N.J.: Prentice Hall, 1969), 73–91; 88. Ellmann offers a compelling analysis of *Salome* in later work: "Herod's lust for Salome's body pales in comparison with Salome's lust for Iokanaan's bodiless head. Hers is a passion which drowns in its own excess. . . . When death comes to Salome, it takes the measure of her boundless desire. She dies into a parable of self-consuming passion." *Oscar Wilde* (New York: Vintage, 1988), 345.

28. Oscar Wilde, *The Letters of Oscar Wilde*, ed. Rupert Hart-Davis (London: Rupert Hart-Davis, 1962), 258. Wilde reiterated the formulation during the course of the scandal provoked by the novel (e.g., *Letters*, 263).

29. Ibid., 185.

30. Joseph Pennell, "A New Illustrator," *Studio* 1 (1893): 14–19, 18. The "climax" is the scene developed in the earliest manuscript versions of the play, confirming what Wilde's enthusiastic response suggests, that the moment Beardsley chose to illustrate was central to the meaning of the play for its author. See Ian Fletcher, *Aubrey Beardsley* (Boston: Twayne, 1987), 60–61. For the most extensive recent treatment of the appropriateness of Beardsley's illustrations, see Elaine Showalter, *Sexual Anarchy: Gender and Culture at the* Fin de Siècle (London: Bloomsbury, 1991), 149–56. While Showalter's careful consideration of the images, makes unmistakable the complex confessional elements Beardsley recognized in the play, it seems unfortunate for the author of the preface to *Dorian Gray* to be identified as having written a play with "buried and coded messages" needing to be raised to the surface (156).

AFTERWORD
LAS MENINAS AS COVER: FOUCAULT, VELAZQUEZ, AND
THE REFLECTION OF THE MUSEUM

1. Herod, in *Salomé*, Oscar Wilde, *Salomé: A Florentine Tragedy*, *Vera* (London: Methusen, 1908), 70. "Your beauty troubled me. Your beauty has grievously troubled me, and I have looked at you too much. But I will look at you no more. Neither at things, nor at people should one look. Only in mirrors should one look, for mirrors do but show us masks" (Wilde, *Complete Works*, 571).

2. Important challenges to standard accounts of Modernism have tended to come to art history from students of its future rather than of its past. See, e.g., the work of Rosalind Krauss, esp. *The Originality of the Avant-Garde and Other Modernist Myths* (Cambridge: MIT Press, 1985). It is notable, however, that the important essay from which Krauss draws the title of her book not only revolves around the reception of Rodin, an important transitional figure who stands between the nineteenth and twentieth centuries, but involves the afterlife of such key nineteenth-century concerns as the relationship among originality, reproduction, and concepts of genius.

3. Michel Foucault, *The Order of Things: An Archeology of the Human Sciences* (New York: Vintage, 1973), 3. "Le peintre est légèrement en retrait du tableau. Il jette un coup d'oeil sur le modèle; peut-être s'agit-il d'ajouter une dernière touche, mais il se peut aussi que le premiere trait encore n'ait pas été posé. Le bras qui tient le pinceau est replié sur la gauche, dans la direction de la palette; il est,

pour un instant, immobile entre la toile et les couleurs. Cette main habile est suspendue au regard; et le regard, en retour, repose sur la geste arrêté. Entre la fine point du pinceau et l'acier du regard, le spectacle va libérer son volume." *Les Mots et les choses: Une archéologie des sciences humaines* (Paris: Gallimard, 1966), 19. The original version of the piece, was published, illustrated with a plate of the painting, in the last issue of the *Mercure de France* 354, no. 5 (July-August 1965): 367–84.

4. The chapter on *Las Meninas*, though a late and somewhat tentative addition to *The Order of Things*, proved to be one of the popular successes of the text. See Didier Eribon, *Michel Foucault*, trans. Betsy Wing (Cambridge: Harvard University Press, 1991), 155. Foucault's discussion of the painting has inspired and provoked a good deal of critical response, what Martin Jay calls a cottage industry of philosophers, art historians, and critics (*Downcast Eyes: The Denigration of Vision in Twentieth-Century French Thought* [Berkeley: University of California Press, 1993], 402). For a balanced summary of the literature, see Nicole Dubreuil-Blondin, "Le Philosophe chez Velázquez: L'Intrusion de Michel Foucault dans la fortune critique des *Ménines*," *Revue d'art canadienne* 20 (1993): 1–2, 116–29. For the history of the use of a work of art to mark or identify historical change, see Francis Haskell, *History and Its Images: Art and the Interpretation of the Past* (New Haven: Yale University Press, 1993).

5. On the reception of the painting, see Caroline Kesser, *Las Meninas von Velázquez: Eine Wirkungs-und Rezeptionsgeschichte* (Berlin: Reimer, 1994). Foucault's transformation of a baroque work into one from a classical period is touched on in Claude Gandelman, "Foucault as Art Historian," *Hebrew University Studies in the Arts* 13, no. 3 (1985): 266–80. It is a surprisingly important move, given that many of the painting's mysteries arise from considering it apart from characteristic forms of its own day. The growth of Velazquez's reputation was a nineteenth-century development promoted in particular by William Stirling in *Velazquez and His Works* (London, 1855; translated into French ten years later), which in itself was an expansion of his *Annals of the Artists of Spain* of 1848. I cite the Giordano from the former, but its original source is Antonio Palomino, *Lives of the Eminent Spanish Painters and Sculptors* (1724; reprint, Cambridge: Cambridge University Press, 1987), 166. A thorough account of the French reception of Spanish art generally in the nineteenth century is to be found in Ilse Hempel Lipschutz, *Spanish Painting and the French Romantics* (Cambridge: Harvard University Press, 1972). See also Jacques Lassaigne, ed., *Velazquez: Les Ménines* (Fribourg: Office du Livre, 1973). On Foucault's fondness for Manet, a painter on whom he wrote an as yet unpublished work, see Eribon, *Michel Foucault*, 190–91, 323.

6. Philip Fisher, *Making and Effacing Art: Modern American Art in a Culture of Museums* (New York: Oxford University Press, 1991), 17; see also the treatment of artistic self-representation in Richard Brilliant, *Portraiture* (Cambridge: Harvard University Press, 1991), 141–74.

7. "Si ces dispositions venaient à disparaître comme elles sont apparues, si par quelque événement dont nous pouvons tout au plus pressentir la possibilité, mais dont nous ne connaissons pour l'instant encore ni la forme ni la promesse, elles basculaient, comme le fit au tournant du XVIIIe siècle le sol de la pensée classi-

que,—alors on peut bien parier que l'homme s'effacerait, comme à la limite de la mer un visage de sable." Foucault, *Order of Things*, 398.

8. Jacques Lassaigne provides a good account of the history of the title, along with a useful sense of French response to the painter during the period of Foucault's own intellectual formation, in *Spanish Painting from Velazquez to Picasso*, trans. Stuart Gilbert (Geneva: Skira, 1952), 48–69.

9. As Stirling puts it: "To acquire works of art was the chief pleasure of Philip, and it was the only business in which he displayed earnestness and constancy." Stirling, *Velazquez*, 56. On Philip IV as collector, and Velazquez as the curator and developer of his collection, see Jonathan Brown, *Kings and Connoisseurs: Collecting Art in Seventeenth-Century Europe* (Princeton: Princeton University Press, 1994). On the career of Velazquez in context and in relation to his work as a painter and courtier, see esp. Jonathan Brown, *Images and Ideas in Seventeenth-Century Spanish Painting* (Princeton: Princeton University Press, 1978), and two works by Steven N. Orso, *Philip IV and the Decoration of the Alcázar of Madrid* (Princeton: Princeton University Press, 1986), and *Velázquez*, Los Borrachos, *and Painting at the Court of Philip IV* (Cambridge: Cambridge University Press, 1993), 40–96.

10. See esp. Jonathan Brown, "On the Meaning of *Las Meninas*," in *Images and Ideas in Seventeenth-Century Spanish Painting*, 87–110, and Madlyn M. Kahr, *Velázquez: The Art of Painting* (New York: Harper and Row, 1976). On the intellectual and artistic background to Velazquez's professional development, see also Brown, *Images and Ideas*, 21–43, and Orso, *Velázquez*, 40–96. The influence of Francisco Pacheco, Velazquez's erudite and ambitious teacher and eventual father-in-law, is often cited, and his *Arte de la Pintura* (1638; published 1649) is worth noting as a more direct argument for the value of painting as a liberal practice.

11. "Ces noms propres formeraient d'utiles repères, éviteraient des désignations ambiguës; ils nous diraient en tout cas ce que regarde le peintre, et avec lui la plupart des personnages du tableau. Mais le rapport du langage à la peinture est un rapport infini. . . . Or le nom propre, dans ce jeu, n'est qu'un artifice . . . [S]i on veut maintenir ouvert le rapport du langage et du visible, si on veut parler non pas à l'encontre mais à partir de leur incompatibilité, de manière à rester au plus proche de l'un et de l'autre, alors il faut effacer les noms propres et se maintenir dans l'infini de la tâche. . . ."

Il faut donc feindre de ne pas savoir qui se reflétera au fond de la glace, et interroger ce reflet au ras de son existence." Foucault, *Les Mots*, 25.

12. "It is within the 19th century that the ultimate form of the portrait, the self-portrait, and particularly Rembrandt's series of self-portraits, came to be identified in the common mind as the ultimate examples of art and objecthood. . . . The self-portrait is the ultimate form of objecthood and work as well as the apex of imaginable works of art. In the Rembrandt self-portrait there is no world, the background is empty; neither place nor objects exist to compete with the self, identify it, or locate it within social space. . . . No user exists, no owner is possible, no purpose can be imagined. The ultimate anti-image of ordinary social work has been brought into being." Fisher, *Making and Effacing Art*, 153. That not only the self-portrait, but the particularly denuded self-portrait Fisher de-

scribes, may become the misleading model for the study of Velazquez's master-piece is vividly demonstrated in Victor I. Stoichita's direct comparison between a Rembrandt self-portrait showing the artist entirely alone (*Artist in the Studio*, ca. 1628) and *Las Meninas*. Comparing the images, Stoichita observes a number of innovations on the part of the Spaniard, but they have to do almost entirely with the placement of the painter in relation to the represented canvas. The central group plays no role in his analysis aside from a brief line worth quoting for its tonal indifference: "He [Velazquez] also highlights the court scene, which covers the rest of the canvas." Stoichita's "also" introduces a matter of indifference to the art historian, a scene that functions largely to take up space, to "cover the rest of the canvas" that is not devoted to the self-portrait and its related elements (canvas, mirror, frames). Victor I. Stoichita, *The Self Aware Image: An Insight into Early Modern Meta-Painting* (Cambridge: Cambridge University Press, 1997), 250.

13. Foucault is well aware of the creative force of the museum, but he sees it arising quite late: "*Déjeuner sur l'Herbe* and *Olympia* were perhaps the first 'museum' paintings in European art that were less a response to the achievement of Giorgione, Raphael, and Velazquez than an acknowledgement . . . of the new and substantial relationship of painting to itself, as a manifestation of the existence of museums and the particular reality and interdependence that paintings acquire in museums. . . . Flaubert is to the library what Manet is to the museum. They both produced works in a self-conscious relationship to earlier painting or texts—or rather to the aspect in painting or writing that remains indefinitely open. They erect their art within the archive. They were not meant to foster the lamentations . . . through which we reproach our Alexandrian age, but to unearth an essential aspect of our culture: every painting now belongs within the squared and massive surface of painting and all literary works are confined to the indefinite murmur of writing." "Fantasia of the Library" (1967), in *Language, Counter-Memory, Practice*, ed. Donald F. Bouchard (Ithaca: Cornell University Press, 1977), 92–93.

14. Fisher, *Making and Effacing Art*, 21, 166–67.

15. Museum studies and design have seen a real boom in the last twenty years. For two quite distinct examples of recent work (whose prepositional titles are in themselves suggestive), see Victoria Newhouse, *Towards a New Museum* (New York: Monacelli Press, 1998), and Roger Miles and Lauro Salva, *Towards the Museum of the Future: New European Perspectives* (London: Routledge, 1994). Newhouse's work offers a thorough and thoughtful account of recent museum design. For the new sophistication of the response to the museum see two recent studies (from history and literature respectively), Steven Conn, *Museums and American Intellectual Life, 1876–1926* (Chicago: Chicago University Press, 1998), and Maleuvre, *Museum Memories*. Huyssen offers what is probably the most important conceptual treatment of the effects of the recent proliferation of the museum in "Escape from Amnesia: The Museum as Mass Media."

ILLUSTRATION CREDITS

I am grateful to the institutions cited here for permission to reproduce works of art in their collections and for supplying the necessary photographs:

© Ashmolean Museum: 15, 16
Courtesy of Avery Architectural and Fine Arts Library, Columbia University in the City of New York: 5, 11, 22, 27, 50, 51, 52
By permission of The British Library: 30, 31
© British Museum: 24, 25, 26, 29, 37, 38
Courtesy of Ecole Nationale Supérieure des Beaux-arts, Paris: 42
© Fitzwilliam Museum, University of Cambridge: 32, 33
© 1999 by Kunsthaus Zurich. All rights reserved: 9, 17, 21
© Board of Trustees, National Gallery of Art, Washington, D.C., Paul Mellon Collection: 23
Courtesy of New York Public Library, Art and Architecture Collection, Miriam and Ira D. Wallach Division of Art, Prints, and Photographs, Astor, Lenox and Tilden Foundation: 53
Öffentliche Kunstsammlung Basel/Martin Bühler: 19
©Photo RMN: 6, 7, 8
© Royal Academy of Arts, London: 13, 14
© Soprintendenza Archeologica della Provinzia di Napoli e Caserta: 18
© The Trustees of Sir John Soane's Museum 4
V&A Picture Library: 31, 47
Courtesy Yale Center for British Art, Paul Mellon Collection: 40

Illustrations from the following sources are also gratefully acknowledged:
Alinari/Art Resource: 45, 49
Corbis/Patrick Ward: 43
Erich Lessing/Art Resource: 28
Courtesy of Vintage Press: 53

INDEX

Note: Italics indicate the location of an illustration. For works cited frequently in the text, the initial bibliographical reference is given following the short title at the end of the author entry.